Discovering Child Art

Discovering

Princeton University Press Princeton, New Jersey

Child Art

Essays on Childhood, Primitivism

and Modernism

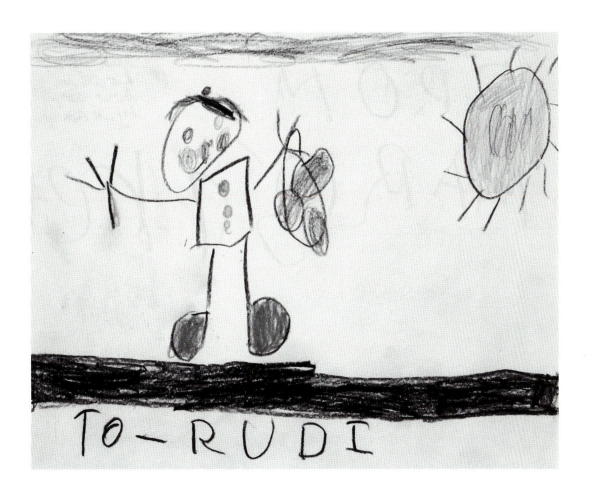

TO-RUDI

Edited by Jonathan Fineberg

Copyright © 1998 by Princeton University Press

Published by Princeton University Press,
41 William Street, Princeton, New Jersey 08540

In the United Kingdom: Princeton University Press, Chichester, West Sussex

Library of Congress Cataloging-in-Publication Data
Kinderzeichnung und die Kunst des 20. Jahrhunderts. English.
 Discovering child art : essays on childhood, primitivism and modernism /
edited by Jonathan Fineberg.
 p. c.m.
 Includes index.
 ISBN 0-691-01188-5 (alk. paper)
 1. Child artists—Psychology. 2. Children's art—Themes, motives.
 I. Fineberg, Jonathan David. II. Title.
 N351.K4713 1998
 704' .054—dc21 97-23803
 CIP

This book has been composed in New Century Schoolbook and Gill Sans

Princeton University Press books are printed on acid-free paper and meet the
guidelines for permanence and durability of the Committee on Production Guide-
lines for Book Longevity of the Council on Library Resources

Printed in the United States of America

10 9 8 7 6 5 4 3 2 1

Design adapted by Bessas & Ackerman

Frontispiece: Child's drawing (Margaret, age 6), *Man carrying a basket of Easter
eggs—"To Rudi."*

Jacket illustration: Paul Klee, *Girl with a Doll*, 1905. Watercolor. Kunstmuseum
Bern, Paul-Klee-Stiftung. © 1998 Artists Rights Society (ARS), New York/VG Bild-
Kunst, Bonn.

Contents

List of Illustrations

Gallery, Moscow. © 1998 Artists Rights Society (ARS), New York/ADAGP, Paris.

37. Mikhail Larionov, *Reclining Woman*, 1920s, gouache on paper, 8¼ × 10½ in. (20.9 × 26.8 cm), Tretyakov Gallery, Moscow. © 1998 Artists Rights Society (ARS), New York/ADAGP, Paris.

38. Mikhail Larionov, *Glass and Sketch of a Nude*, 1930s, oil on canvas, 10 × 14¾ in. (26.5 × 37.5 cm), Tretyakov Gallery, Moscow. © 1998 Artists Rights Society (ARS), New York/ADAGP, Paris.

39. Mikhail Larionov, *Still Life with Napkin*, 1920s, oil on canvas, 17¾ × 31⅞ in. (45 × 81 cm), Tretyakov Gallery, Moscow. © 1998 Artists Rights Society (ARS), New York/ADAGP, Paris.

40. Mikhail Larionov, *Sunday at Noon*, 1920s, oil on canvas, 38⅛ × 55⅞ in. (97 × 142 cm), Tretyakov Gallery, Moscow. © 1998 Artists Rights Society (ARS), New York/ADAGP, Paris.

41. Mikhail Larionov, *Fruit and Sketch of a Nude*, 1920s, oil on cardboard, 10⅜ × 15 in. (26.5 × 38 cm), Musée national d'art moderne, Centre Georges Pompidou, Paris. © 1998 Artists Rights Society (ARS), New York/ADAGP, Paris.

42. *Our Journal* (St. Petersburg: "Svobodnoe iskusstvo," 1916), front cover. Drawing by Zhorzhik A-m [Arnshtam], age 7, collage, pencil, watercolor on paper, 9⅝ × 7⅝ in. (24.5 × 19.5 cm), Russian State Library, Moscow.

43. *Children's Own Drawings and Stories*, collected by A. Kruchenykh (St. Petersburg: "EUY," 1914), typeset book cover, 8½ × 6⅝ in. (21.5 × 17 cm), Russian State Library, Moscow.

44. Elena Guro, *Heavenly Little Camels* (St. Petersburg: "Zhurval," 1914), book cover with drawing by Maryana Erlikh, age 7, watercolor on paper, 8¼ × 6¼ in. (21 × 16 cm), Russian State Library, Moscow.

45. Child's drawing (Garrik A-m [Arnshtam], age 4–5), *Garya's Story*, in *Our Journal*, 1916, pencil, 7⅝ × 9⅝ in. (19.5 × 24.5 cm), Russian State Library, Moscow.

46. Mikhail Larionov, *Autumn,* detail (from *The Seasons*), 1912, oil on canvas, Musée national d'art moderne, Centre Georges Pompidou, Paris. © 1998 Artists Rights Society (ARS), New York/ADAGP, Paris.

47. Mikhail Larionov, *Study of a Soldier's Head*, 1911, gouache on paper, 11⅛ × 8⅞ in. (28.3 × 22.5 cm), Musée national d'art moderne, Center Georges Pompidou, Paris, legs Nina Kandinsky. © 1998 Artists Rights Society (ARS), New York/ADAGP, Paris.

48. Child's drawing (Nina Kulbina, age 8), *Soldiers*, in *Children's Own Drawings and Stories*, pencil on colored paper, 6⅝ × 8½ in. (17 × 21.5 cm), Russian State Library, Moscow.

49. Mikhail Larionov, *Autumn* (from *The Seasons*), 1912, detail, oil on canvas, Musée national d'art moderne, Centre Georges Pompidou, Paris. © 1998 Artists Rights Society (ARS), New York/ADAGP, Paris.

50. Child's drawing (M. E. [Maryana Erlikh], age 7), *Queen of the Christmas Trees*, in *Children's Own Drawings and Stories*, pencil on colored paper, 8½ × 6⅝ in. (21.5 × 17 cm), Russian State Library, Moscow.

51. Child's colored drawing (Maschura, Kandinsky's niece), Gabriele Münter- und Johannes Eichner-Stiftung, Munich, KIZ171.

52. Child's colored drawing (Annemarie, Münter's niece), Gabriele Münter- und Johannes Eichner-Stiftung, Munich, KIZ113.

53. Child's drawing (Ella Reiss), Gabriele Münter- und Johannes Eichner-Stiftung, Munich, KIZ138.

54. Child's watercolor study in four parts (Lydia Wieber, age 13), *Sitting*, from *Der Blaue Reiter*, eds. Vasily Kandinsky and Franz Marc (Munich: Piper Verlag, 1912).

55. Child's drawing (Paulot Seddeler), Gabriele Münter- und Johannes Eichner-Stiftung, Munich, KIZ10.

56. Child's drawing (Paulot Seddeler), Gabriele Münter- und Johannes Eichner-Stiftung, Munich, KIZ89.

57. Vasily Kandinsky, *Mountain with Domed Towers and Two Figures*, 1908–9, pencil on paper, 4⅛ × 3⅜ in. (10.5 × 8.5 cm), Städtische Galerie im Lenbachhaus, Munich, GMS515. © 1998 Artists Rights Society (ARS), New York/ADAGP, Paris.

58. Vasily Kandinsky, *sheet of studies*, ca. 1909, pencil on paper, 8¼ × 6½ in. (21 × 16.6 cm), Städtische Galerie im Lenbachhaus, Munich, GMS1110. © 1998 Artists Rights Society (ARS), New York/ADAGP, Paris.

59. Child's drawing (Wolfgang), Gabriele Münter- und Johannes Eichner-Stiftung, Munich, KIZ5.

60. Child's drawing (Elisabeth Busse), Gabriele Münter- und Johannes Eichner-Stiftung, Munich, KIZ24.

61. Vasily Kandinsky, *Wolflike Animal and Bird*, 1910–11, brush and pen in brown ink on light gray cardboard, 8⅞ × 11 in. (22.7 × 27.8 cm), Städtische Galerie im Lenbachhaus, Munich, GMS388. © 1998 Artists Rights Society (ARS), New York/ADAGP, Paris.

62. Vasily Kandinsky, study for *Improvisation 7* (2nd version), 1910, pencil on paper, 5¾ × 4 in. (14.7 × 10 cm), Städtische Galerie im Lenbachhaus, Munich, GMS517. © 1998 Artists Rights Society (ARS), New York/ADAGP, Paris.

63. Gabriele Münter, study for *Kandinsky at the Tea Table*, ca. 1910, pencil on back of envelope, 7⅞ × 4⅞ in. (19.5 × 12.6 cm), Städtische Galerie im Lenbachhaus, Munich, GMS1007. © 1998 Artists Rights Society (ARS), New York/VG Bild-Kunst, Bonn.

64. Vasily Kandinsky, *Landscape with Female Form and Rider*, ca. 1907, pencil on paper, 9¾ × 6⅛ in. (24.7 × 15.6 cm), Städtische Galerie im Lenbachhaus, Munich, GMS1007. © 1998 Artists Rights Society (ARS), New York/ADAGP, Paris.

65. Child's drawing (Josef Wechsler), Gabriele Münter- und Johannes Eichner-Stiftung, Munich, KIZ114.

66. Child's drawing (Thomas Hermann), Städtische Galerie im Lenbachhaus, Munich, KIZ116.

67. Gabriele Münter, *Untitled*, copy after figure 66, 1914, oil on cardboard, 12¾ × 14½ in. (32.5 × 37 cm), Gabriele Münter- und Johannes Eichner-Stiftung, Munich, Mü 2b. © 1998 Artists Rights Society (ARS), New York/VG Bild-Kunst, Bonn.

68. Child's drawing (anonymous), Gabriele Münter- und Johannes Eichner-Stiftung, Munich, KIZ129.

69. Child's drawing (anonymous), Gabriele Münter- und Johannes Eichner-Stiftung, Munich, KIZ27.

70. Child's drawing (anonymous), Gabriele Münter- und Johannes Eichner-Stiftung, Munich, KIZ4.

71. Vasily Kandinsky, study for the cover of *Der Blaue Reiter*, 1911, watercolor over pencil, 10⅞ × 8½ in. (27.5 × 21.8 cm), Städtische Galerie im Lenbachhaus, Munich, GMS601. © 1998 Artists Rights Society (ARS), New York/ADAGP, Paris.

72. Child's drawing (Niki Zeh), *Teutonic Battle*, 1908–9, photograph of the period, Gabriele Münter- und Johannes Eichner-Stiftung, Munich.

73. Child's drawing (Niki Zeh), *Teutonic Battle*, 1908–9, photograph of the period, Gabriele Münter- und Johannes Eichner-Stiftung, Munich.

74. Child's colored drawing (Martin Mosner), Gabriele Münter- und Johannes Eichner-Stiftung, Munich, KIZ117.

75. Gabriele Münter, *Untitled*, copy after figure 74, 1914, oil on cardboard, 14½ × 12¾ in. (37 × 32.5 cm), Gabriele Münter- und Johannes Eichner-Stiftung, Munich, Mü 3. © 1998 Artists Rights Society (ARS), New York/VG Bild-Kunst, Bonn.

76. Vasily Kandinsky, study for *With Sun*, 1911, colored pencil on cardboard, 11½ × 15⅜ in. (29.3 × 39.1 cm), Städtische Galerie im Lenbachhaus, Munich, GMS443. © 1998 Artists Rights Society (ARS), New York/ADAGP, Paris.

77. Child's watercolor (Otto), Gabriele Münter- und Johannes Eichner-Stiftung, Munich, KIZ192.

78. Child's watercolor (Annemarie, Münter's niece), Gabriele Münter- und Johannes Eichner-Stiftung, Munich, KIZ26.

79. Vasily Kandinsky, *Locomotive near Murnau*, 1909, oil on canvas, 14⅛ × 19¼ in. (36 × 49 cm), Städtische Galerie im Lenbachhaus, Munich, GMS49. © 1998 Artists Rights Society (ARS), New York/ADAGP, Paris.

80. Child's watercolor study (Lydia Wieber), *Arabs*, from *Der Blaue Reiter*, eds. Vasily Kandinsky and Franz Marc (Munich: Piper Verlag, 1912).

81. Children's drawing (Niki Zeh and Oskar Zeh), from *Der Blaue Reiter*, eds. Vasily Kandinsky and Franz Marc (Munich: Piper Verlag, 1912).

82. Children's drawings (Niki Zeh and Oskar Zeh), Gabriele Münter- und Johannes Eichner-Stiftung, Munich.

83. Children's drawing (Niki Zeh and Oskar Zeh), eds. Vasily Kandinsky and Franz Marc (Munich: Piper Verlag, 1912).

84. Children's drawings (Oskar Zeh and F. Zeh), photograph of the period, Gabriele Münter- und Johannes Eichner-Stiftung, Munich.

85. Child's drawings (anonymous), from *Der Blaue Reiter*, eds. Vasily Kandinsky and Franz Marc (Munich: Piper Verlag, 1912).

86. Paul Klee, *Girl with a Doll*, 1905.17, brush and watercolor behind glass, 7×5 in. (17.7×12.9 cm), Kunstmuseum Bern, Paul-Klee-Stiftung. © 1998 Artists Rights Society (ARS), New York/VG Bild-Kunst, Bonn.

87. Paul Klee, *Paul and Fritz*, 1905.19 (A), brush and watercolor behind glass, 5×7 in. (12.9×17.7 cm), Kunstmuseum Bern, Paul-Klee-Stiftung. © 1998 Artists Rights Society (ARS), New York/VG Bild-Kunst, Bonn.

88. Paul Klee, *Rider and Outrider* (Reiter und Vorreiter), study for an illustration, 1911.99, brush and watercolor behind glass, $5 \times 7\frac{1}{8}$ in. (13×18 cm), Private collection, Switzerland. © 1998 Artists Rights Society (ARS), New York/VG Bild-Kunst, Bonn.

89. Paul Klee, *Railroad Station* (Bahnhof), 1911, drypoint etching, plate: $5\frac{7}{8} \times 7\frac{3}{4}$ in. (15×19.7 cm), Art Institute of Chicago. © 1998 Artists Rights Society (ARS), New York/VG Bild-Kunst, Bonn.

90. Paul Klee, *The Child and the Star* (Das Kind und sein Stern), 1912.141, drawing, $3\frac{1}{4} \times 4$ in. (8.2×10 cm), Private collection, Switzerland. © 1998 Artists Rights Society (ARS), New York/VG Bild-Kunst, Bonn.

91. Paul Klee, *Human Helplessness* (Menschliche Ohnmacht), 1913.35, tusche on paper, 7×4 in. (17.8×9.9 cm), Kunstmuseum Bern, Paul-Klee-Stiftung. © 1998 Artists Rights Society (ARS), New York/VG Bild-Kunst, Bonn.

92. Child's drawing (anonymous), Plate 101, from Georg Kerschensteiner, *The Development of the Gift of Drawing* (Die Entwickelung der zeichnerischen Begabung) (Munich, 1905).

93. Paul Klee, *Small World* (Kleinwelt), 1914.120, etching, $5\frac{5}{8} \times 3\frac{3}{4}$ in. (14.4×9.6 cm), Kunstmuseum Bern, Paul-Klee-Stiftung. © 1998 Artists Rights Society (ARS), New York/VG Bild-Kunst, Bonn.

94. Paul Klee, *Fish Magic* (Fischzauber), 1925.85 (R5), oil and watercolor on burlap, $30\frac{3}{8} \times 35\frac{3}{8}$ in. (77×89 cm), Philadelphia Museum of Art, Arensberg Collection, Philadelphia. © 1998 Artists Rights Society (ARS), New York/VG Bild-Kunst, Bonn.

95. Paul Klee, *The Road from Unklaich to China* (Der Weg von Unklaich nach China), 1920.153, tusche on paper, $7\frac{1}{4} \times 11\frac{1}{8}$ in. (18.6×28.2 cm), Kunstmuseum Bern, Paul-Klee-Stiftung. © 1998 Artists Rights Society (ARS), New York/VG Bild-Kunst, Bonn.

121. Paul Klee, *Itinerant Artist: A Poster* (Wander-Artist: ein Plakat), 1940.273 (L13), 12¼ × 11½ in. (31 × 29.2 cm), Private collection. © 1998 Artists Rights Society (ARS), New York/VG Bild-Kunst, Bonn.

122. Felix Klee, *Untitled (Train)*, 1913, pencil on paper, 1⅝ × 6½ in. (4.2 × 16.5 cm), Private collection, Switzerland.

123. Paul Klee, *Upward* (Hinauf), 1939.604 (FF4), pencil on paper, 11⅝ × 8¼ in. (29.7 × 20.9 cm), Kunstmuseum Bern, Paul-Klee-Stiftung. © 1998 Artists Rights Society (ARS), New York/VG Bild-Kunst, Bonn.

124. Paul Klee, *Railway Train* (Eisenbahn-Zug), 1939.609 (FF9), pencil on paper, 10⅝ × 16⅞ in. (27 × 43 cm), Kunstmuseum Bern, Paul-Klee-Stiftung. © 1998 Artists Rights Society (ARS), New York/VG Bild-Kunst, Bonn.

125. Paul Klee, *Alpine Train* (Bergbahn), 1939.556 (CC16), charcoal and watercolor on gessoed jute, 8¼ × 17 in. (20.9 × 43.2 cm), Private collection. © 1998 Artists Rights Society (ARS), New York/VG Bild-Kunst, Bonn.

126. Paul Klee, *Childhood* (Kindheit), 1938.358 (U18), colored paste on paper, 10⅝ × 16½ in. (27 × 42 cm), Kunstmuseum Bern, Paul-Klee-Stiftung. © 1998 Artists Rights Society (ARS), New York/VG Bild-Kunst, Bonn.

127. Paul Klee, *Child at a Party* (Kind bei einem Fest), 1934.136 (Qu16), colored paste and watercolor on paper, 11⅝ × 8 in. (29.5 × 20.3 cm), Private collection, Switzerland. © 1998 Artists Rights Society (ARS), New York/VG Bild-Kunst, Bonn.

128. Paul Klee, *Sick Girl* (Krankes Mädchen), 1937.24 (K4), oil and colored paste on paper, 12¾ × 8¼ in. (32.5 × 21 cm), Private collection. © 1998 Artists Rights Society (ARS), New York/VG Bild-Kunst, Bonn.

129. Paul Klee, *Hungry Girl* (Hungriges Mädchen), 1939.671 (JJ11), colored paste on paper, 12¾ × 8¼ in. (32.5 × 21 cm), Private collection, Switzerland. © 1998 Artists Rights Society (ARS), New York/VG Bild-Kunst, Bonn.

130. Paul Klee, *Burnt Mask* (Brande-Maske), 1939.274 (U14), colored paste and pencil on paper, 8⅛ × 11⅝ in. (20.7 × 29.5 cm), Private collection, Switzerland. © 1998 Artists Rights Society (ARS), New York/VG Bild-Kunst, Bonn.

131. Paul Klee, *For Intimidating* (Zum Abschrecken), 1940.358 (F18), colored paste on paper, 11½ × 8¼ in. (29.2 × 21 cm), Private collection. © 1998 Artists Rights Society (ARS), New York/VG Bild-Kunst, Bonn.

132. Recapitulatory acts. Comparative study of movements of babies and animals from S. S. Buckman, "Human Babies: Some of Their Characters," *Proceedings of the Cotteswald National Field Club* 13 (1899), as reproduced in Stephen Jay Gould, *Ontogeny and Phylogeny*.

133. Omega Workshops (Roger Fry), *Sauceboat, Creamer, Cup and Saucer*, ca. 1913–14, Victoria & Albert Museum, London.

134. Child's drawing (David John, son of Augustus John), *A Snake*, in Roger Fry, "Children's Drawings," *Burlington Magazine* 30 (June 1917).

135. Child's drawing (pupil of Marion Richardson), *A Black Country Landscape*, in Roger Fry, "Children's Drawings," *Burlington Magazine* 30 (June 1917).

136. Boys practicing freearm drawing. Illustration to Joseph Vaughan, *Nelson's New Drawing Course: Drawing, Design, and Manual Occupations (Teacher's Manual, Stage 1)* (London, 1902).

137. Henri Matisse, *Girl with Tulips (Jeanne Vaderin)*, 1910, charcoal on buff paper, 28¾ × 23 in. (73 × 58.8 cm), Museum of Modern Art, New York, Acquired through the Lillie P. Bliss Bequest. © 1998 Succession H. Matisse/Artists Rights Society (ARS), New York.

138. Sample of handwriting by Roger Fry. Illustration to Robert Bridges, "English Handwriting," *S.P.E. Tract No. XXIII, English Handwriting* (Oxford, 1926).

139. Sample of handwriting by Gerard Manley Hopkins. Illustration to Robert Bridges, "English Handwriting," *S.P.E. Tract No. XXIII, English Handwriting* (Oxford, 1926).

140. Joan Miró (age 8), *Flower Pot with Flowers*, 1901, pencil on paper, 8⅜ × 4¾ in. (21.3 × 12.1 cm), Fúndació Joan Miró, Barcelona, FJM20. © 1998 Artists Rights Society (ARS), New York/ADAGP, Paris.

141. Joan Miró (age 8), *Umbrella*, 1901, pencil on paper, 7¼ × 4½ in. (18.4 × 11.4 cm), Fúndació Joan Miró, Barcelona, FJM19. © 1998 Artists Rights Society (ARS), New York/ADAGP, Paris.

142. Child's drawing (anonymous, age 5), *Gesture drawing*, courtesy Cristina Agosti-Gherban and Presses Universitaire de France, Paris.

143. Child's drawing (anonymous, age 4), *Gesture drawing*, courtesy Cristina Agosti-Gherban and Presses Universitaire de France, Paris.

144. Joan Miró, *Mediterranean Landscape*, 1930, oil on canvas, 93⅛ × 61¾ in. (236.5 × 156.8 cm), Private collection. © 1998 Artists Rights Society (ARS), New York/ADAGP, Paris.

145. Joan Miró, *La Manucure évaporée*, 1975, etching in color, 38 × 54¼ in. (96.5 × 138 cm), Private collection. © 1998 Artists Rights Society (ARS), New York/ADAGP, Paris.

146. Joan Miró, *Painting*, 1925, oil and gouache on canvas, 57½ × 44⅞ in. (146 × 114 cm), National Gallery of Modern Art, Edinburgh. © 1998 Artists Rights Society (ARS), New York/ADAGP, Paris.

147. Joan Miró, *Head*, 1930, oil on canvas, 90½ × 65 in. (230 × 165 cm), Musée de peinture et de sculpture, Grenoble (Dupin no. 264). © 1998 Artists Rights Society (ARS), New York/ADAGP, Paris.

148. Joan Miró, *Painting*, 1930, oil on canvas, 59 × 88⅝ in. (150 × 225 cm), De Menil collection, Houston (Dupin no. 263). © 1998 Artists Rights Society (ARS), New York/ADAGP, Paris.

149. Photograph of Simone [Luquet], with the signature "Simone," from G.-H. Luquet, *Les Dessins d'un enfant, étude psychologique* (Paris, 1913).

Acknowledgments

I want to express my thanks here to the authors of these wonderful essays who were so patient with me over the very long gestation of this volume. I am also grateful for considerable assistance along the way from Elena Basner, Jane Block, Katya Shorban, Samuel Edgerton, Claude Hobson, Steven Mansbach, Christopher Quinn and Dmitry Shvidkovsky. Thanks also to the translators of the essays who worked with me to bring these texts into English, to the outstanding staff of Princeton University Press (especially Elizabeth Johnson) who took such care over all aspects of the book, to Gerd Hatje who graciously gave us his film from the German edition, and once again to the Research Board of the University of Illinois at Urbana-Champaign, which has consistently and reliably held the ladder for so many of the impecunious humanists at the University of Illinois. Above all, I want to thank my wife, Marianne, for making it all possible.

Foreword

Jonathan Fineberg

It is the luxury of a book such as this not to require cohesion but to afford the pleasure of "listening in," so to speak, on the thoughts of some of the most interesting minds in the study of art as they ponder questions that interest them in relation to a common theme. The core of new material in this case is the discovery that many of the greatest masters of twentieth-century art collected children's drawings in depth and that these collections directly influenced some of their most celebrated works. Samples of the original collections and the masterpieces indebted to them were presented in my book and exhibition *The Innocent Eye: Children's Art and the Modern Artist* (Princeton University Press, 1997; shown in 1995 in Munich, Germany, and Bern, Switzerland, under the title *Mit dem Auge des Kindes: Kinderzeichnung und Moderne Kunst*).

This book was first conceptualized as a kind of written symposium since we could never gather these people together during the presentation of the exhibition. The essays included here were all written for this book and they range widely both in subject and method, from Rudolf Arnheim's subtle analysis of the nature and diversity of style in child art to scholarly essays in art history that depend heavily on the examination of primary written texts, as in the essays by Christopher Green on Joan Miró and Marcel Franciscono on Paul Klee. This book allows one to venture forth in various directions, rather than demanding a straight path from beginning to end, and this very range of texture and multiplicity of direction in itself offers a variety of provocative intersections between the quite different methods of inquiry and themes embraced here.

E. H. Gombrich leads us through Eugène Viollet-le-Duc's 1879 *Histoire d'un dessinateur*, in which the great nineteenth-century architect, based on Jean Jacques Rousseau's *Emile*, extols an education in drawing as a foundation for honing the child's powers of observation. Dora Vallier draws on her personal recollection of Miró to look at the inspiration of childhood underlying Miró's creative process. Werner Hofmann traces ideas from romanticism to the present that have led artists to look at children's art as a source of inspiration. Yet despite, and perhaps because of, the disparate character of these essays, there are sometimes surprising and interesting relationships among them.

As we think about why an artist such as Miró might wish to recover aspects of childhood in his working process we find interesting connections, for example, to the romantic ideas discussed by Hofmann. Arnheim asserts that art—by both adult artists and children—reflects "ways of coping with the human condition by means of significant form." How, we may ask ourselves, does this idea fit with Viollet-le-

Duc's or Rousseau's notions (discussed both by Gombrich and Hofmann) about "objective" observation? And what impact might "training" of the sort Viollet-le-Duc and Rousseau recommend have on this enterprise of "coping"? This, in turn, may lead us to compare the evolution in the views of Arnheim and Gombrich on the functions of expression and observation in art. There are also historical interweavings, as in Richard Shiff's discussion of Marion Richardson, whose students' drawings were exhibited by Roger Fry together with the works of Larionov, and the profound involvement of Larionov with children's drawings as discussed here by both G. G. Pospelov and Yuri Molok.

Meanwhile, some pairs of essays take up similar themes or artists from different perspectives, creating yet another kind of dynamic dialogue across this volume as a whole. Pospelov and Molok both look at important new documentation on the involvement of Larionov and the Russian avant-garde with children's drawings, but whereas Molok looks chiefly at the intellectual context for this interest, Pospelov centers his study on a close analysis of the role of children's drawings in Larionov's stylistic development. Josef Helfenstein and Marcel Franciscono both address Klee's interest in childhood, but Franciscono's essay brings out its role in Klee's early formal development and in the art theory that informed that development, while Helfenstein offers a strikingly different insight into the artist's complex use of childhood in his later work as a set of metaphors for contemporary history.

John Carlin, as well as Christopher Green, Richard Shiff and Dora Vallier all raise the very important issue of "primitivism" in relation to the modern interest in child art, doing so from quite distinct vantage points that nevertheless complement and support one another. In addition, Carlin picks up some of the key texts and themes discussed by Hofmann (primarily with respect to the late eighteenth and early nineteenth centuries) and looks at them afresh in relation to artists today.

These same romantic traditions come to mind as Troels Andersen discusses the influence of Aksel Jørgensen on the art theory of the Cobra artist Asger Jorn. Furthermore, one inevitably relates Jorn to what we learn in the essay by Barbara Wörwag of Kandinsky's perspective on child art, which also informs our perspective on his great contemporaries Larionov and Klee.

Thus in a number of ways, the essays in this volume create a serendipitous dialogue between one another. This volume aims not to define a narrative of this fascinating aspect of the sources of modern art but rather to open more avenues leading both into and out from it. If there is a unifying theme here, it is that childhood—whether as a source for modern artists, as the locus of art pedagogy, as a metaphor or as a lever into fundamental qualities of the human mind—is something we all have in common, and its persevering influence on modern art speaks to the fundamentally human questions that motivate the work of modern artists.

Paris, 1995

Discovering Child Art

The Art of Unlearning

Werner Hofmann

"He is just what he is, and that is what makes him so beautiful. The forces of law and destiny do not touch him, in the child alone is there freedom. In him there is peace, he is not yet alienated from himself."[1] These sentences appear in Friedrich Hölderlin's novel *Hyperion*, written in the last years of the eighteenth century. They contain Rousseau's credo: the child is still complete; it has not yet succumbed to the alienation that separates the "being" (*être*) from the "appearance" (*paroître*). The child-messiah belongs to the hopes of rejuvenation at the turn of the eighteenth century into the nineteenth. It is sufficient to point to William Blake and to Philipp Otto Runge's call for a complete turnaround: "We must become children if we want to achieve our best."[2]

Would Rousseau have supported this appeal? I doubt this, because his way of thinking in coherent patterns was not aimed at a turnaround in the sense of regression. On the contrary, the child was to be stimulated to develop its innate powers, rather than to be estranged from them, in achieving self-realization. Art instruction also follows this principle. It is important that teacher and student take a common point of departure and that the learning process is not dominated by the teacher:

> Moreover, in this exercise as in all the others, I do not want my pupil to be the only one to have fun. I want to make it even more agreeable for him by constantly sharing it with him. I do not want him to have any emulator other than me, but I will be his emulator without respite and without risk. That will put interest in his occupations without causing jealousy between us. I will take up the pencil following his example. I will use it at first as maladroitly as he. Were I Apelles, I would now be only a dabbler. I will begin by sketching a man as

Translated by Christa Knust and Jonathan Fineberg

lackeys sketch them on walls: a line for each arm, a line for each leg, and the fingers thicker than the arm. Quite a while later one or the other of us will notice this disproportion. We will observe that a leg has thickness, that this thickness is not the same all over, that the arm has its length determined by relation to the body, etc. In this progress I will at very most advance along with him, or I will be so little ahead of him that it will always be easy for him to catch up with me and often to surpass me. We shall have colors, brushes. We shall try to imitate the coloring of objects and their whole appearance as well as their shape. We shall color, paint, dabble. But, in all our dabblings, we shall not stop spying on nature; we shall never do anything except under the master's eye.[3]

Diligence alone does not achieve anything. Further on, Rousseau speaks of a student who for months would draw and paint continuously and who would only come up with *dessus de porte*: "He will make himself esteemed forever for his assiduity, his fidelity, and his morals. But he will never paint anything but pictures for the panels placed above doors [*dessus de porte*]."[4] In this condescending judgment Rousseau seems to forget his contempt for art and instead to place true artistic creativity in a realm to which Diderot refers when he says, "There are probably a number of people able to paint an object as a naturalist, a historian, but as a poet, that's something else."[5]

Immediately after having described his student's progress in drawing, Rousseau gives us a remarkable example of his discriminatory tolerance. The drawings of the boy serve as room decoration. At the beginning, there are the awkward outlines, and at the end of the row there are the drawings in which exact mimesis triumphs.

I arrange them in order around the room, each drawing repeated twenty, thirty times, and each copy showing the author's progress, from the moment when a house is only an almost formless square until its facade, its profile, its proportions, and its shadows are present in the most exact truth. These gradations cannot fail constantly to present pictures of interest to us and objects of curiosity for others and to excite ever more our emulation.[6]

The following idea is striking:

On the first, the crudest, of these drawings I put quite brilliant, well-gilded frames which enhance them. But when the imitation becomes more exact, and the drawing is truly good, then I give it nothing more than a very simple black frame. It needs no adornment other than itself, and it would be a shame for the border to get part of the attention the object merits. Thus each of us aspires to the honor of the plain frame, and when one wants to express contempt for a drawing of the other, he condemns it to the gilded frame. Someday perhaps these gilded frames will serve as proverbs for us, and we shall wonder at how many men do themselves justice in providing such frames for themselves.[7]

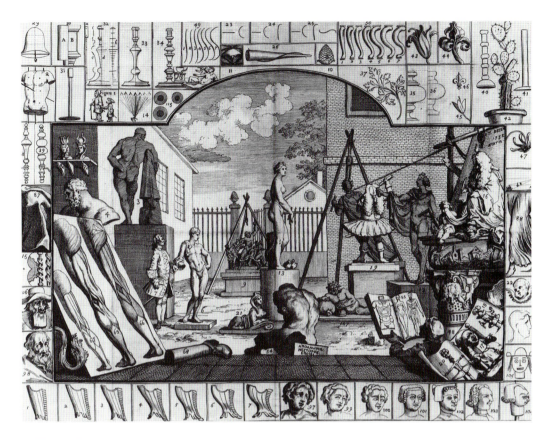

I William Hogarth, *Analysis of Beauty*, 1753, plate I

So there is a hierarchy of values after all in the juxtaposition. The drawings in which the child is able to use the language of imitation are shown as a reward, but without adornment—less is more. Does that not show hidden remnants of Calvinist asceticism?

Rousseau's comparative lineup will remind art historians of the marginal drawings with which Hogarth annotated the first plate of his *Analysis of Beauty* (fig. 1). As in the case of Rousseau, its sequence is irreversible, although in the opposite direction, because it moves from figures 98 and 97 to figure 105. We leave behind, step by step, the lingering impression of the "line of beauty" and move "down to the most contemptible meanness that lines can be form'd into."[8] Hogarth notes explicitly that figure 105 "is composed merely of such plain lines as children make, when of themselves they begin to imitate in drawing a human face."[9]

Neither Hogarth nor Rousseau attach any intrinsic value to the child's first attempts at drawing. Rousseau would like to focus his instruction in art completely on the empirical, factual: draw what you see and understand! Hogarth does not develop a pedagogical program; his goal is an ideal linear metaphor of beauty

which is superior to the world of facts but which nevertheless holds that world together. In the end, we do not detect the slightest attempt to return *ad fontes* by either Rousseau or Hogarth. We find the emphasis in this new approach somewhere else, where we would not have expected it.

In his *Discourses*, which he annually presented as president of the Royal Academy, Sir Joshua Reynolds dealt with art as a problem of language. As the director of an institution that teaches its students artistic skills, and thus serves to improve their capabilities, he surprises us with considerations that aim in the opposite direction. In the third "Discourse" (14 December 1770) he wrote:

> I cannot help suspecting, that in this instance the ancients had an easier task than the moderns. They had, probably, little or nothing to unlearn, as their manners were nearly approaching to this desirable simplicity; while the modern artist, before he can see the truth of things, is obliged to remove a veil, with which the fashion of the times had thought proper to cover her.[10]

Reynolds calls for a language of art that rids itself of all artificial flourish. In his way of thinking, the pristine core of art is synonymous with innocence. In his last academy lecture on 10 December 1790, he returned to this problem:

> In pursuing this great Art, it must be acknowledged that we labour under greater difficulties than those who were born in the age of its discovery, and whose minds from their infancy [!] were habituated to this style; who learnt it as language, as their *mother tongue*. They had no mean state to unlearn; they needed no persuasive discourse to allure them to a favourable reception of it, no abstruse investigation of its principles to convince them of the great latent truths on which it is founded. We are constrained, in these later days, to have recourse to a sort of Grammar and Dictionary, as the only means of recovering a dead language. It was by them learned by rote, and perhaps better learned that way than by precept.[11]

It seems to me that Reynolds here addresses a central linguistic concern of modern times: namely the need to find the right way in which to express truth, immediacy and authenticity. This problem cannot be discussed here in its historic development; it can only be presented by way of some selected examples.

Learning versus unlearning, accumulating versus rejecting—this dialectic opposition appears for the first time paradigmatically in the first of the two etchings with which William Hogarth illustrated his *Analysis of Beauty* (1753). However, in this case it is decided in favor of an accumulated knowledge that goes back to the art of the classics. Relearning the "noble simplicity and quiet grandeur"[12] of the Greeks, as Winckelmann put it, is placed in contrast to unlearning (the outworn formulas

of the eighteenth century). Thus unlearning is, for the time being, compensated by a new learning. Hogarth develops a morphology of how to perceive reality. It includes works of art, everyday objects and formations of nature, which is at the same time a hierarchy: at the top we find the forms in which the S-curved "line of beauty" dominates. In this linear abstraction the language of art coincides with the language of nature. Hogarth is a systematic person who works with "Grammar and Dictionary" in order to classify the various *modi* and fluctuations. His analysis of beauty belongs to the kind of spelling instructions developed in the eighteenth century to codify the "legibility of the world."[13] In doing this he always proceeds from the letter to the word, from the individual parts to the totality. The scribbling of the child precedes the genesis of the beautiful shape; it is like stuttering, which does not suffice to construct words, since it lacks the insight into the innate law of organic structures.

In short, Hogarth's hierarchically ordered world of forms is dominated by an overriding and pervasive culturally stabilizing factor: the art of antiquity. The old masters whose sculptural works are represented in the engraving still speak the "mother tongue," which modern artists have lost behind veils and disguises. The wig as the emblem of "un-nature" stands for the conventions and masks that represent the language of art of the eighteenth century.

This alliance with antiquity and its formal canon was annulled half a century later. The call, more radical then ever before, for a pictorial language freed of rhetorical flourish was placed in opposition to the old patterns, their authority rejected. Novalis said, "Every level of learning begins with childhood. For that reason, the wisest man on earth so closely resembles a child."[14] Heinrich von Kleist invented a poet who advises a painter: "You insist that you must first follow a master, be it Raphael or Correggio, or whomever you choose as your model, when on the contrary, you must turn completely around in a diametrically opposite direction, with your back to the masters. Only thus can you find and climb the pinnacle of art which you seek."[15] The call for unlearning cannot be stated more categorically.

This call for an artistic turnaround, back to infancy (Reynolds), belongs to the same revolutionary climate that provoked the destruction of the political traditions at the end of the eighteenth century. For artists, the revocation turns into an instrument of revolutionary rethinking. Goya provides the whimsical species of the *capriccio* with new dimensions of significance; Blake scolds the Venetians, above all Titian: "such idiots are no artists";[16] David in France and Koch in Germany blame the empty routine of art classes in the academies for the decadence of art; C. D. Friedrich curses skillfulness and calls the painter "who wants to deceive with his imitations" a scoundrel;[17] Overbeck selects as models pictures that "by a simple and *plain* arrangement...produce a certain impression."[18] The meaning of all this is that artistic consciousness now refers to a completely new set of values. This

ascetic radicalism rejects the accumulated knowledge on which Hogarth based his teaching of beauty. But it also has to renounce the "commonplace method"[19] (against which Reynolds warned us), abandoning its polished jargon and learning how to spell things, as it were, in a new way, from the beginning. The meaning of this is a far-reaching break with the tradition of painting begun by Giotto—the idea of accumulated skillfulness. For the first time, the opposite direction is proclaimed and the artist is authorized to unlearn what he had learned.

It is no coincidence that artists related their ideas of a new sign language to Egyptian hieroglyphics, since their decodification began with the discovery of the Rosetta stone (1799). Runge sees in a hieroglyph a "living creature," not just a dead sign. The future that he predicts for painting has to be imagined in terms of hieroglyphics, the change from narrating a history to "landscaping" a painting. Confidently he asks the question: "Does not this new art . . . invite us to reach a highest summit? One which may be even more beautiful than the preceding ones?"[20] (February 1802).

This hope is the central meaning, indeed the message, of Gustave Courbet's *The Painter's Studio* (1855; fig. 2). I will limit myself to this "epiphany" and will neglect the other meanings. It is a triptych in disguise. The two side groups each deal with prototypes of contemporary French society. In another essay, I have pointed out that these two groups, though heterogeneous in themselves, resemble one another in that both are constituted of alienated individuals. The painter at the easel stands out from them. He acts as a "moral figure," conscious and determined, neither hindered by deliberations (like his *actionaires* in the right half of the picture) nor troubled by his private egoism (like the *exploiteurs*) or bereft of initiative like the *exploités* (both are represented in the left group). The task of resuscitation, which Courbet takes upon himself in this self-portrait, involves the landscape on the easel, the seminude model (a reified *Veritas*) and the two boys. In the landscape, man takes possession of nature; he humanizes it by making it his creation. This should not be interpreted as the discovery of a hybrid or imaginary "otherworld," a world of escape, but rather as the raising of an awareness of the innate qualities of nature as a visible sum of an elemental potential. In this landscape, as well as in most landscapes by Courbet, nature is "sublated," removed from wear and tear, shown in its nucleus—as self-reproducing energy—and thus placed in opposition to the human strategy of consumption (which is aimed at production and the destruction of nature). Nature, humanized through art and made conscious, is experienced by two spectators: the woman and the child, as personifications of the natural human being. The boy drawing is the naive, preconscious anticipation of creative activity; he represents the appropriation of the world in unbroken originality. These three figures share a completeness that the surrounding "character masks" have lost. With their power to see and to experience they

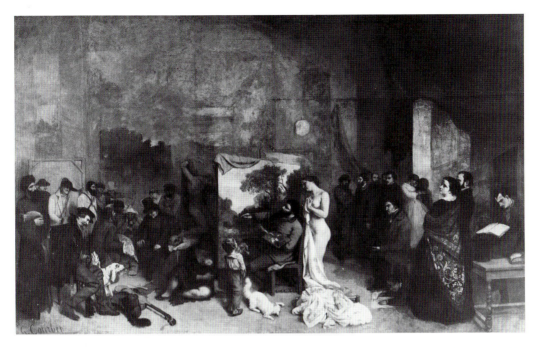

2 Gustave Courbet, *The Painter's Studio, a real allegory describing a seven-year period of my artistic life*, 1855

are related to the painter, who is suspending alienation by his creative appropriation of nature. Like himself and his landscape, the woman and the children are free and independent, outside of industrial consumption and economic speculation. As mediator between man and nature, the painter performs a meaningful task: in one sweeping act he paints humanized nature and natural human beings as partners, together forming a potential totality.

The connection to Hogarth's engraving can be seen in the role of the artist: Hogarth's work provides the artist with an anatomical handbook, enabling him to achieve greater understanding, while the elegant amateur represents the audience, which Courbet later portrays as a colorful collective group. As far as the content is concerned, the accent has shifted drastically: in the center we no longer find the naked human being symbolizing the ideal prototype, but the natural condition, which is represented by the child, the woman and the landscape—three metaphors of originality. In addition, Courbet's picture is a paradigm of the art of unlearning, a fact that becomes evident when comparing it with Ingres' *The Apotheosis of Homer* (1827; fig. 3). Their relationship is like heavy prose to elegant verse. Courbet neglects legibility and its spatial ordering principle, central perspective. In comparison with Hogarth, the child in Courbet's work has gained a new, obviously positive tone: its drawing endeavors to represent the source of creativity, unobscured by convention.[21]

3 Jean-Auguste-Dominique Ingres, *The Apotheosis of Homer*, 1827

This power of origination, however, is dominated in the end by the painter at the easel. I suspect that in this distribution of roles Courbet was inspired by a Rembrandt etching: *Christ Preaching (La petite tombe)* (B.67; fig. 4), in which a child, lying on his stomach at the feet of Christ, is drawing in the sand—probably hieroglyphics. "The Child is Father of the Man"[22]: these words by Wordsworth describe the pristine role of the child in the portrait of the philosopher Proudhon that Courbet painted ten years later (fig. 5). The two little daughters of the philosopher, who is unaware of them, are occupied with two elementary forms of orienting themselves in the world. The older one is learning the alphabet, the younger is pouring water from a pitcher into a bowl.

In A. R. Penck's drawings and pictures these tensions and dichotomies have disappeared. The gradient between high art and scribbling, "artists'" art and child-drawing has been removed. In his introductory note to his exhibition in the Berlin National Gallery, Penck wrote, "Naiveté (in the sense of Rousseau), abstraction, and a formative will, are the three components that dominate the character of my work. This includes a certain political consciousness, as well as a certain political error."[23] His way of thinking, based on Rousseau, leads Penck to carry out what he calls his "standart" concept working collectively with children and amateurs. In 1970 he showed

10 Werner Hofmann

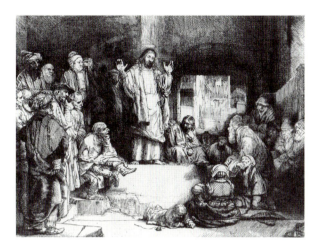

4 Rembrandt Harmensz van Rijn, *Christ Preaching (La petite tombe)*, ca. 1652

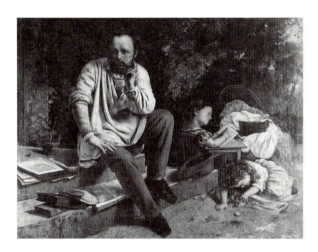

5 Gustave Courbet, *Portrait of the Philosopher Proudhon in 1853*, 1865

an exhibition of these collective works in Dresden. The fact that he based his code on signs (hieroglyphics!) from cave-drawings stems from the assumption that in the stone age there probably were "anonymous pictures by collective painters." It is his aim "to achieve today the same thing with modern tools."[24]

Political consciousness and political errors—this attitude reminds us of the dimension that Courbet, more determined than any other painter of the nineteenth century, tried to incorporate in his art. Penck, too, regards his time "as a dramatic struggle of different powers." These tensions do not happen, however, in precisely dialectical theses and antitheses; they are intertwined in change and hieroglyphi-

6 A. R. Penck, *Transition*, 1963

cally encoded. *Transition* (fig. 6) is the title of a picture painted in 1963 which the painter described as his "most problematic one."[25]

In the case of Hogarth and Courbet the presentation was separated into levels of linguistic forms (*modi*). In the case of Penck there is an overall, unifying level, even though the "hieroglyphics" each remain syntactically accessible. When he was painting collective pictures, Penck once spoke of "training as a painting game."[26] If Courbet awakened forms to life with his brush, then Penck is the painter who (at least temporarily) administers them therapy. The aim of the therapy is to remove the pressure of "asphyxiante culture" (Dubuffet).[27] At the same time, this formal appeal aims at healing the fractures inherent in the "Art of Unlearning" in the nineteenth century from Runge to Cézanne. The aim is a broad, unified scheme of image-making. Penck draws the formal consequences from the insight that Klee had noted as early as 1912:

> One can still find the primal origins of art most easily in ethnographic collections or at home in the nursery. Don't laugh, reader! Children can do it and there is wisdom in the

fact that they can too. The more helpless they are, the more instructive their examples, and already at an early stage one has to save them from corruption. The art works of psychotics are parallel phenomena and consequently neither childlike behavior nor craziness is a derogatory word here but rather a precise description of what is meant. All of that has to be taken very seriously, more seriously than all the art museums, if we want reform today.[28]

In pleading for the unlearning of art Klee calls for the Art of Unlearning. All these renunciations, these demonstrations of unlearning, are charged with ambivalence. They result from willpower. For Reynolds, as we saw, unlearning was a device that was supposed to unwrap "the truth of things." But this device, reformulated again and again over the last two hundred years, could not become the new "mother tongue" once searched for. Instead it merely brought forth disparate dialects. In the case of Klee and Penck, of Miró and Dubuffet, but also already in the case of Töpffer, Courbet and Gauguin, the "natural" is the result of a learned, artistic skill. Two consequences follow from this. First, Töpffer's question should shape our discussion: Has someone used naiveté here in order to disguise himself? This potential ambivalence is overlooked by most supporters of modern "primitivism." Second, the art of unlearning is neither primitive nor "coarse," just as caricature is not "an artless art" as Champfleury maintained in the introduction to his *History of Modern Caricature*. "Artlessness" is never a renunciation of art, but "an outsider art" (Dubuffet).

Result: In cultural developments there is never gain without loss, but also no remembering without forgetting. Unlearning without relearning is meaningless.

1 Friedrich Hölderlin, *Hyperion oder der Eremit in Griechenland* (Berlin: Propy-laenverlag, 1921), 5.

2 Philipp Otto Runge, *Hinterlassene Schriften* (Hamburg, 1840), vol. 1: 7.

3 Jean-Jacques Rousseau, *Emile*, in *Oeuvres Complètes de Jean Jacques Rousseau*, vol. IV (Geneva: Bibliothèque de la Pleaide, 1969), 398; English translation from Rousseau, *Emile or On Education*, introduction, translation and notes by Allan Bloom (New York: Basic Books, 1979), 144.

4 Ibid., 475 (French ed.), 199 (English trans.).

5 Denis Diderot, *Philosophie*, in J. Assezat, ed., *Oeuvres Complètes de Diderot* (Paris: Garnier Frères, 1975), vol. 2: 330.

6 Jean-Jacques Rousseau, *Emile*, 399 (French ed.), 144–45 (English trans.).

7 Ibid., 399 (French ed.), 145 (English trans.).

8 William Hogarth, *The Analysis of Beauty* (1753; reprint, facsimile ed., Yorkshire, England: Scholar Press, 1971), 124.

9 Ibid., 124–25.

10 Sir Joshua Reynolds, "Discourse III," 14 December 1770, lines 260–65, in Sir Joshua Reynolds, *Discourses on Art*, ed. Robert R. Wark (New Haven and London: Yale University Press, 1959), 49.

11 Sir Joshua Reynolds, "Discourse XV," 10 December 1790, lines 419–29; in Ibid., 278.

12 Johann Joachim Winckelmann, "Gedanken über die Nachahmung der griechischen Werke in der Malerei und Bildhauerkunst," 1756, in Johann Joachim Winckelmann, *Kleine Schriften und Briefe* (Weimar, 1960), 44.

13 Hans Blumenberg, *Die Lesbarkeit der Welt* (Frankfurt am Main, 1981).

14 Novalis, "Blütenstaub," in *Novalis Werke*, ed. Gerhard Schulz (Munich, 1969), 333.

15 Heinrich von Kleist, "Brief eines jungen Dichters an einen jungen Maler," in Heinrich von Kleist, *Werke*, ed. W. Waetzoldt, vol. 5: 82.

16 William Blake, *Marginalia*, annotations to Sir Joshua Reynolds' *Discourses on Art*, in David V. Erdman, ed., *The Complete Poetry and Prose of William Blake* (Berkeley: University of California Press, 1982), 651.

17 Caspar David Friedrich, *Briefe und Dokumente*, ed. S. Hinz (Munich, 1974), 104.

18 Johann Friedrich Overbeck, letter to his father from 5 February 1808, in S. Rudolph, ed., *Die Krise der Kunst in Malerbriefen aus dem 19. Jahrhundert* (Stuttgart, 1948), 70.

19 Sir Joshua Reynolds, "Discourse XIV," 10 December 1788, line 65; in Reynolds, *Discouses on Art*, 249.

20 Runge, *Hinterlassene Schriften*, vol. 1: 4, 7.

21 The following is indebted to Meyer Schapiro's masterful scholarship in his "Courbet and Popular Imagery," *Journal of the Warburg and Courtauld Institutes*, IV (1940–41): 164. See also Werner Hofmann, "Ante Gratiam-Sub Gratia in Courbets Atelier," and Pierre Georgel, "L'Enfant au Bonhomme," both in K. Gallwitz and K. Herding, eds., *Malerei und Theorie: Das Courbet-Colloquium 1979* (Frankfurt am Main, 1979), 91 and 105.

22 William Wordsworth, "My heart leaps up when I behold," Stephen Gill, ed., *The Oxford Authors: William Wordsworth* (Oxford and New York: Oxford University Press, 1984), 246.

23 A. R. Penck, in *A. R. Penck*, exh. cat. (Berlin: Nationalgalerie, 1988), 9.

24 Ibid., 35. The quote is from 1975.

25 Ibid., 9.

26 Ibid., 36. The quote is from 1975.

27 Jean Dubuffet, *Asphyxiante Culture*, Liberté nouvelles, collection dirigée par Jean-Francois Revel (Paris, 1968), 14.

28 Paul Klee, *Tagebücher von Paul Klee 1898–1918* (Cologne: Verlag M. DuMont Schauberg, 1957), 276.

Beginning with the Child

Rudolf Arnheim

More than once in the history of Western art, there has been a return to fundamentals. This happened when—and perhaps because—so high a level of refinement had been reached that there was no way of proceeding further in the same direction. Certainly this was the case toward the end of the nineteenth century when the subtlety of color nuances in the watercolors of Cézanne or, under the influence of photography, the complexity of shape relations in Degas had come to strain the mind's power of visual discrimination and organization to the limit. As a matter of survival it became necessary to go back to where it all had started and where it all starts every time a human being sets out to engage in the business of life.

The foundation had to be regained in two respects. In an almost biological sense, the human organism had to recapture the elements of the physical environment, the basic objects made by nature and man, which must be known by their invariant and independent appearance. Directly related to this reacquisition of physical reality was the need to go back to the basic shapes and colors by which things are visually understood, the geometrical primaries and the straight blacks and whites, the reds and blues and yellows, from which the world composes itself.

To break with a tradition that has run its course and to reinvent the world of imagery, artists tend to look around for models. The guidance and inspiration they derive from remote sources demonstrate that productive help can be obtained from communication that is at best partial. Just as European painters and sculptors received a needed impulse from African carvings, about whose meaning and function they knew next to nothing, so the strong influence of children's drawings relied on precepts, interpretations and connnotations that had little to do with the states of mind producing those unassuming pictures. All that was needed were some of the formal properties for which artists were searching to resolve problems of their own.

It is only natural that when critics or historians discuss the influence of children's art on modern art, they are quite specific about the effects to be observed in this or that painter or sculptor. Less attention has been given to the particular models. "Children's drawings" are referred to as though they were a standardized product. If, however, one has had some experience in the field of child art, one knows that its output is almost as varied as that of the adults. Although there are basic traits shared by most of them, no two children have quite the same style. Differences are due partly to the stage of development reached by the child, but also to differences of temperament, to influences from the environment and to levels of talent. Correspondingly, the particular stylistic features impressing a particular artist have not always been the same. I therefore propose to sketch some of the characteristics of children's drawings and then to relate them to a few of their reflections in the work of artists.

The child meets the world mainly through the senses of touch and sight, and typically it soon responds by making images of what it perceives. The tie between stimulus and response is deeply rooted in all organic behavior, but the particular response of answering the percept of a thing or happening with an act of portrayal is a privilege of the human species. Its main psychological function is evident. The picture, far from being a mere imitation of the model, helps to clarify the structure of what is seen. It is an efficient means of orientation in a confusingly organized world. To this end, certain principles of strategy impose themselves. One begins by examining the components of the world's inventory item by item and indeed by identifying each part of every object separately. The definition of each element, however, takes place in the context of the larger whole. Definition and organization begin with the very simplest of shape and relation and proceed step by step to the conception of more complex structures.

Figure 7 is an early human figure, done by a three-year-old girl.[1] It shows, first of all, a difference between intention and execution. Intended is the symmetry of the body. This symmetry is discovered as one of the most relevant features of the human figure. It also governs the child's sense of visual form: shapes are spontaneously symmetrical as long as they are not modified by other functions. The frontality of the round head serves as the roof of a T-shaped structure. Its horizontality is stressed by the two lateral arms, and it reposes symmetrically on the central axis of body and legs. This revealing symmetry, however, is only hinted at in the drawing. Roundness and straightness are kept from perfection by two factors: the motor activity of the child's hand and arm is not yet fully controlled, and the visual judgment of the shapes to be obtained has not yet been sharpened.

It is essential for our purpose to realize that this imperfection in the execution of the drawing is not simply a negative quality. We rather cherish it as a lively illustration of the relation between abstract perfection and human endeavor, between rigid geometry and the spontaneity of muscular freedom—an attractively

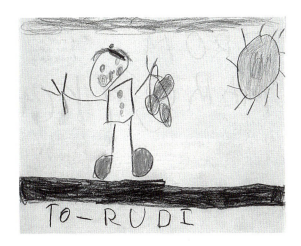

7 Child's drawing (anonymous, age 3), *Tadpole figure*

8 Child's drawing (Margaret, age 6), *Man carrying a basket of Easter eggs—"To Rudi"*

human charm that has not been lost on our artists. The slight deviations from the visibly implied shapes and relations greatly animate, in the judgment of the adult, the dynamics of the intended figure. In a six-year-old's drawing of a man carrying a basket of Easter eggs (fig. 8) there is a loosening of relation between head and trunk and between the eggs and their container, which relieves the schematic conception of the figure and lets us sense an active child at work.

Depending on the temperament of the particular child but also on the mood of the moment and the nature of the subject matter represented, the ratio between the control of formal precision and the spontaneity of motor behavior varies greatly. The two personages of figure 9, drawn by a five-year-old girl, are stirred by a hurricane of motion—a quality more congenial to a painter like Jean Dubuffet than to, say, Paul Klee. The wildness of such a performance does not interfere with the child's access to the scene she is depicting; and the child is equally remote from the romantic sensibility of the adult, who savors all this motion as an image of creative energy in action.

The child, whatever the particular style of his work, is involved in the struggle for conquering the puzzles of a disorderly world. With increasing skill, the intended dominance of the guiding elementary shapes imposes itself. In figure 10, showing Little Red Riding Hood and the wolf, each detail, from the anatomy of the nose to the earrings and the toes, is sharply defined. Remarkable here is the sense of form, the enviable freedom from dependence on the shapes of nature and the visual power of the rectangles and ovals, which characterize the relation between

9 Child's drawing (anonymous, age 5), *Two figures*

10 Child's drawing (Barbara, age 6), *Little Red Riding Hood and the Wolf*

11 Child's drawing (anonymous), *Lady and turtle*

animal and human figure. Far from merely indicating a lack of skill, an inability to represent models more faithfully, the casting of live bodies into fundamental shapes represents a truly creative achievement. Equally significant is the capability of the young mind to accept without question a meaningful equation between the shapes of nature and their thoroughly different representation on paper. The child, although fully capable of seeing the difference between model and picture, operates on the basis of a relation between representation and reality that we are tempted to find much more sophisticated than our own notion of the one simply

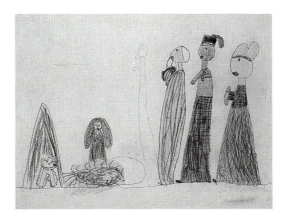

12 Child's drawing (anonymous, age 5), *The three magi*

imitating the other. The child spontaneously accepts the image as an enlightening equivalent of the model, created within the conditions of a particular medium. It understands the nature of the translation and has no trouble practicing it.

The endless variety of aspects which the objects of the world present to our eyes is obediently rendered by painters of the naturalistic tradition. The child, in its search for clarity, ignores the confusion of accidental appearances. It reduces them to the alternative of frontality and profile. The turtle in figure 11 is shown from what we would call on top while the lady appears in profile. This reduction provides the most informative sight available for each single object. It guarantees a finality of presence even to more complex scenes. The approach of the three magi in figure 12 is made compelling by their uncompromising profiles while mother and child, the stable target of the happening, repose in frontal symmetry.

This biblical story, drawn by a five-year-old girl, relies on spatial placement to articulate the relation between the actors. The empty ground on which the figures are drawn has now become a shared setting, in which the encounter is, one might say, choreographed. Our drawing has a pentimento showing that at first there was no interval between the crib and the closest visitor. The compositional correction greatly clarifies the distinction between the two groups.

The transformation of the empty ground into a shared breathing space, an "ether" enveloping the narrative, is a first step in the separation of the represented scene from the medium of representation. Figure 12 still adheres to the plane of the flat piece of drawing paper, but this limitation is transgressed when the subject matter demands it. Figure 13, drawn by a six-year-old Japanese boy, tells a story of mutual assistance: the rabbit helps the lion to free himself from the trap; in return, the lion rescues the rabbit from the hunters. Three of the scenes are arranged in frontal symmetry, allowing for the beautiful composition of the third episode, where the central axis of the two friends

13 Child's drawing (anonymous, age 6), *The rabbit helps the lion*

is opposed by the enemies in profile. In the first scene, however, the approach of the rabbit from a distance resorts to the distinction between foreground and background—a momentous detachment from the base of the pictorial medium.

Once the first step into depth has been taken, the road is open for the complete conquest of space. In the metropolitan scene of figure 14, also drawn by a young Japanese child, a spatial continuum leads from the pedestrians in the foreground all the way through the distant crowd held in the side street by the traffic policeman. This invasion of depth, never undertaken by many early cultures, abandons the elementary adherence to the rules of two-dimensionality, which attracted the painters of our century to the work of young children.

There are other ways in which children go beyond the characteristics of early representation. The drawings of the youngest look very similar under any cultural condition. What degrees of freedom are accessible later depends on the style dominant in the environment. The portrayal of individuality, for example, is all but absent at first and will never be encouraged in some settings. The two dashing figures drawn by an American boy (fig. 15) presuppose the child's acquaintance with the heroes and villains of cartoon illustrations. The copying of such materials is quite common among our children and encouraged by some educators, but fortunately the child's particular drawing style often prevails over the commercial slickness of the model. The military policeman in figure 16 still profits from the geometrical precision typical of the boy's age level.

Yet another elaboration of the basic style comes from the seductiveness of shape and color. In the artistic process, the visual patterns emerging in the medium itself are directly given to the maker's eyes and handled by him. They are therefore closer to his attention than the subject matter of the outer world. From this outer world, a five-year-old girl takes the likeness of a fountain pen (fig. 17).

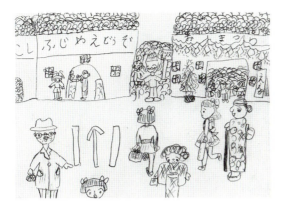

14 Child's drawing (anonymous), *Metropolitan scene*

15 Child's drawing (anonymous), *Two cartoon figures*

Once on paper, the shapes and colors acquire an abstract life of their own, ready to be amplified by further shapes and to arouse new expressive connotations. The aggressive pointedness of the pen inspires the picture of what the girl calls "an evil animal." Carried to its extreme, the eloquence of pure form displaces the subject matter almost entirely and leads to abstract ornaments. Figure 18 was done by an eight-year-old Japanese girl.

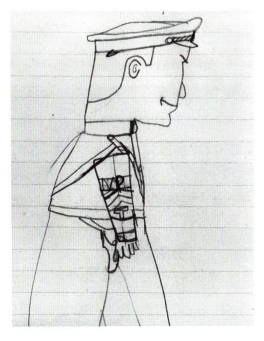

16 Child's drawing (anonymous), *Military policeman*

17 Child's drawing (anonymous, age 5), *Fountain pen*

Beginning with the Child 21

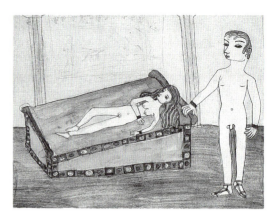

18 Child's drawing (anonymous, age 8), *Abstract ornament*

19 Child's drawing (Rita Weill, teenaged), *Venus and Mars*

Our particular Western tradition of realistic style and standardized subject matter can promote a beautiful refinement of a child's precision of form and tidy representation. The young American teenager who drew *Venus and Mars* (fig. 19) has seen art books and museums; she knows what paintings are supposed to be about. She endows the mythological theme with her own restrained sexuality, but the integrity of her formal control is unimpaired. A picture of this quality will arouse the respect of the adult artist. He will acknowledge her as a young colleague, but her work is less likely to offer him much of the kindred spirit for which artists of our time went to look at the products of kindergarten and early grades. This last example, however, serves to epitomize what I have implied in this brief survey of children's drawings, namely that they can speak to the adult artist not simply because they differ so thoroughly from his own professional tradition but because basically they derive from the same occupation: they, too, are ways of coping with the human condition by means of significant form.

Even so, the difference between the intentions of the artist and those of the child is most evident where the similarity is greatest. Joan Miró's woodcut of a female figure (fig. 20) could hardly have been conceived by someone who had never seen a child's drawing. Both reduce the human form to its simplest frontal symmetry, but the similarity ends there. The difference between naiveté and sophistication begins with the use of the empty ground, which in the young child's drawing would simply be the emptiness of uncultivated space, not yet included in the conception, which is limited to the exploration of single objects. Miró uses this same emptiness to express solitude. His woodcut is one of those he created to illustrate Paul Eluard's book of poems *A toute épreuve*. Our figure appears next to a poem complaining about loneliness:

The world's refusals
Have said their last word
As much as they meet one another they ignore each other
I am alone, I am alone, entirely alone
I have never changed.[2]

Accordingly, the empty ground is not disregarded by the figure but interacts with it in a counterpoint between nonbeing and being. The head, controlled in its position by the sensitive hand of the adult artist, stops just short of taking its place on the neck. The hollows between the arms reach into the body like breasts, and the torso is squeezed into slimness with the help of the fireball, the embodiment of fullest expanse. The frontality of the figure stands for the lack of change of which the poet speaks, but its rigidity is relieved by the placement of three colors. The pairing of eyes and feet is offset by color difference, and the color red unites the ball, the left eye and the right foot in a paradoxical triangle.

Miró's reference in this example is to the particular style of child art in which the elements of geometry are used explicitly to define the shapes of objects. Paul Klee is attracted by the same quality when, with a kind of playful cubism, he submerges the things of nature in abstract networks of form. Whereas the child uses the formal elements to comprehend the objects to which it is unequivocally devoted, Klee develops them into ornaments to estrange his subject from its physical reality (fig. 21). The strands of hair and the folds of garments are transformed into calligraphic scrolls—a stylistic mode that is often a symptom of the mental withdrawal observed in the artwork of schizophrenic patients.

But such alienating stylization is offset in Klee's work by other features, equally related to the drawings of children. One of them is humor. We smile at the excessively large head of his figure, especially when we notice that she is called *Die Heilige*, that is, the holy or saintly woman. At play here is an ambiguity in the way of perceiving deviations from naturalistic correctness. To the child's mind, disproportions are entirely in keeping with representing the world faithfully, and the same is true for the rules of form valid in Klee's pictorial universe. At the same time, however, the adult views such deviations as weaknesses of the child, a lack of skill, a discrepancy between aspiration and achievement, or as the deficiencies of the subject portrayed in the picture. And it is precisely such a contrast that, as Henri Bergson has taught us, constitutes the psychological base of humor. This amusement, although mostly absent from a child's mind, is clearly present in Klee and his grown-up audience.

Another aspect enlivens these childlike creatures, namely the lack of civilized accoutrements. Early figures keep to the essentials; they are assemblies of limbs, devoid of clothing. The adult reads the parsimony of this style as nakedness, a return to the uninhibited innocence of paradise, whose inhabitants are enviably free of the taboos shackling us. The two licentious playmates of Klee's *Let it Happen* (fig. 22) tum-

20 Joan Miró, illustration for Paul
Eluard, *A toute épreuve* (Genf, 1958)

21 Paul Klee, *The Holy Woman*, 1921

22 Paul Klee, *Let It Happen*, 1932

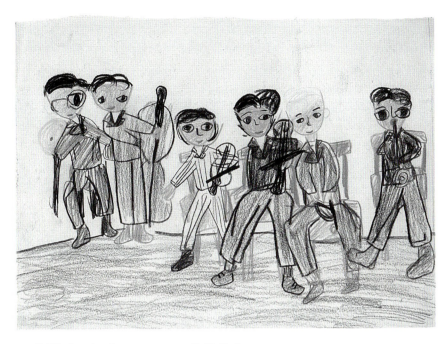

23 Child's drawing (anonymous, age 5–6), *Orchestra*

ble into each other's arms like carefree animals. A similar reduction of civilized society to a state of primordial barbarism is evident in Jean Dubuffet's work when he replaces the elegance of the traditional portraits of ladies with his shockingly carnal displays of naked women.

I shall conclude this brief survey with a confrontation between a child and an artist depicting the same subject of an orchestra at play. The child, a Japanese first grader, is clearly closer to the cheerful noise of reality (fig. 23). The musicians crowd the stage, overlapping one another, and differ in stance and attire. The violins and the trumpet have been imposed on the completed figures, creating an unintended but enlivening transparency, and the chairs, done last, add blue afterthoughts to the foreground action. The small accidents of the child's coping with the problems of depicting the scene, which she experienced in her own setting, help to enrich the visual variety of the picture.

In comparison, Dubuffet's *Grand Jazz Band (New Orleans)* looks austere (fig. 24). The reduction to the geometric elements is more radical because more conscious. The figures are stereotyped, and their parallelism ties them together like a striped piece of fabric. The artist refrains deliberately from expressing the turmoil of the jazz band. The composition is symmetrically arranged around the drummer as the central axis with the pianist and the bass player as lateral wings. A rich texture of pigments and scratchings helps to characterize the painting as a visual

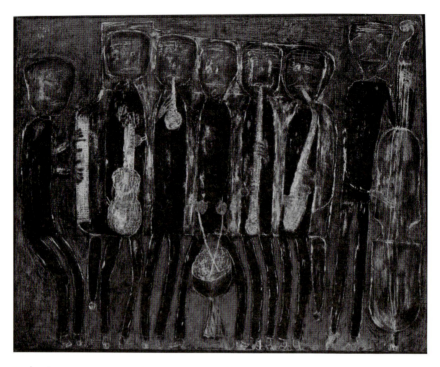

24 Jean Dubuffet, *Grand Jazz Band (New Orleans)*, 1944

delicacy rather than an investigation of folkways. There is much gourmandise in this primitivism. Thus the artist echoes the child across the wide gap between nature eagerly and closely scanned by a young explorer and that tasted as a treat of the senses by the detached, aging mind of an artist of our time.

1 The children's drawings that illustrate this essay are taken from my collection. The Japanese examples were obtained during a Fulbright year in 1959–60.
2 Paul Eluard, *A toute epreuve*, woodcuts by Joan Miró (Genève: Gérald Cramer, 1958), unpaginated: "Tous les refus du monde / Ont dit leur dernier mot / Ils ne se rencontrent plus ils s'ignorent / Je suis seul, je suis seul, tout seul / Je n'ai jamais changé." Translation by Jonathan Fineberg.

Viollet-le-Duc's *Histoire d'un dessinateur*

E. H. Gombrich

In their important study *Legend, Myth and Magic in the Image of the Artist* Ernst Kris and Otto Kurz have collected many anecdotes about the drawings made by children who later became famous masters.[1] We are not told, however, what the sheep looked like that Giotto is supposed to have drawn on a stone as a shepherd boy, though it is implied that it must have been very lifelike to attract the attention of Cimabue, who took the boy into his workshop to teach him.

Eugène Viollet-le-Duc's *Histoire d'un dessinateur* of 1879 fills that lacuna.[2] This didactic novelette written and richly illustrated by the great architect toward the end of his life describes a similar discovery which determines the subsequent life and career of Jean Loupeau, a gifted country lad whose growth into a designer of promise is told on 302 lively pages.

We are first introduced to M. Mellinot, a university professor with painfully conventional attitudes on art and education, and his equally unimaginative son André, who serves throughout the book as a foil to his *frère de lait* Jean, the gardener's boy. The key episode is the encounter between M. Majorin, a well-to-do manufacturer with an independent mind who has a passion for science, nature and art, and eleven-year-old Jean, or rather with a drawing Jean has made of his cat as it played around the porch of his house. André, with his academic arrogance, is immediately moved to criticize the flaws in the drawing. The charm of the ensuing dialogue warrants a full quotation:

> "That's not how you do it," André was saying.
>
> "But I saw it!" protested Jean, abandoning his role of pupil and turning rebel. Since André clearly could not convince Jean he turned to his father.
>
> "Papa! You don't draw a cat like that, do you?"

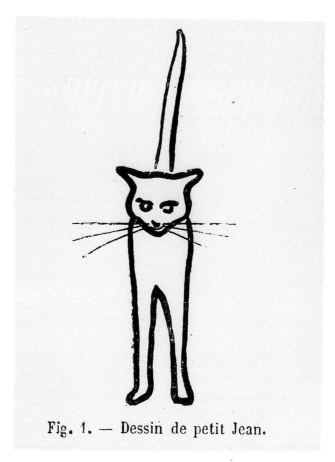

Fig. 1. — Dessin de petit Jean.

25 "Petit Jean's drawing," from Eugène Viollet-le-Duc, *Histoire d'un dessinateur* (Paris, 1879)

"Let's have a look." And André handed M. Mellinot a crumpled scrap of paper containing this sketch [shown in fig. 25].

"If it's a cat at all then it's a two-legged cat. And what's that growing out of its head?"

"That's its tail," ventured Jean shyly.

At this M. Majorin suddenly took notice.

"Ha! May I see?"

He directed so searching a gaze at both the cat and little Jean that the latter began to blush and hang his head, suddenly feeling he had no idea what to do with his hands.

"How old are you?" demanded Majorin.

"Eleven at All Hallows, sir!"

"Do you go to school?"

"Yes, sir, when papa doesn't take me with him to weed the gentlemen's gardens."

"Do they teach drawing at your school?"

"No, sir. Well only sometimes, circles and squares, not very often."

"And do you enjoy doing circles and squares?"

"Not much."

"You like drawing cats better."

"Yes sir."

"Where did you draw this one?"

"By our front door where I was sitting."

"And what was the cat doing?"

"Just going round looking for something."

"And did you ask him to stand still so you could draw him?"

"Oh no sir! He wouldn't have wanted to."

"Well then, how did you manage to draw him?"

"Just by looking...He was coming up to me so nicely, as if he wanted me to feed him—I was just having my tea—and he looked really so funny—just like a real person. I was very careful not to laugh though because cats hate to be laughed at. So I was just looking at him and he was looking at me as well and then I found a bit of paper in my pocket and the pencil André gave me, but when the cat noticed them he went off. Anyway I could still remember how funny he looked and I did this picture."

"But surely you know that cats have four legs."

Jean made no reply to this.

"Why did you give him two?"

"Oh gosh, sir, I just didn't notice, . . . I just didn't see the others."

"Come and give me a hug!"...

If Jean was taken aback by this abrupt conclusion, M. and Mme. Mellinot were utterly astonished.

"May I keep your cat?" asked Majorin.

"Oh yes sir! I'll do lots of others."

M. Majorin was visibly moved. The walk was resumed and the children ran off to play in the woods.

"If only I had a child like that," Majorin said finally, speaking almost to himself.

"Are you saying that because he drew a two-legged cat with a plumed head?" asked Mellinot.

"No. It's because he's a born observer, and with that quality—faculty if you like— you can go far and avoid a multitude of pitfalls."

"I just can't see—I must admit—how drawing a two-legged cat..."

"Exactly. You don't see. Or rather like so many people you've never seen...except through the eyes of other people who've never been able to see either. You see a cat as a four-legged feline with a tail, whiskers and two ears that stick up

and flick about. If one of these items is missing you're not prepared to admit that what you see is a cat at all. Jean isn't bothered by any of that because he's never seen 101 dreadful pictures of supposedly complete cats. He sees the cat in a certain position, thinks it looks interesting and simply notes down the main outlines needed to convey the position he sees. From where he's sitting the cat's head obscures its back and due to this foreshortening the tail appears on the same plane. He doesn't notice the hind legs, which are more or less completely hidden by the front legs, any more than he notices its belly or its sides. His eye managed to take in the shape of the cat and its general outline in a few seconds, and once his mind had grasped this information his hand did its best, though clumsily, to get it down on paper."[3]

Thus, after a few peremptory questions, M. Majorin makes a sudden and uncompromising proposal to Jean's father. For a trial period he will both tutor and support Jean, and if he continues to show the qualities displayed in the drawing, this arrangement will continue until Jean's education is complete.

After some natural hesitation on the part of Jean's father, received rather impatiently, it must be said, by a man in many ways so enlightened as Majorin, and not without the shedding of many tears by his loving mother, Jean embarks on his new life with Majorin.

The book then follows his pilgrimage through geometry, trigonometry, botany, anatomy, zoology, perspective, etc. Much of this is an admirably clear account of these disciplines and their practical application, substantially illustrated with careful and detailed diagrams and drawings, such as the one in which we see little Jean tracing the contour lines of a sandheap while M. Majorin sternly watches him, measuring rod in hand (fig. 26). We learn that Jean was required from the start to keep his own sketch- and notebooks, and in the event of their being spoiled or lost, to recopy everything from the start. Indeed the discipline imposed on the boy is certainly no less strict than that demanded by the orthodox academic curriculum.

M. Majorin, whom little Jean is asked to address as *bon ami,* is altogether rather a martinet most unwilling to indulge his ward. But the author does not entirely forget that he is telling the story of a child with its own emotional needs. Asked to forego a pleasant walk and visit to his family for the sake of practicing his drawing skills, the boy is directed to a corner of the garden where he falls in love with the young shoots he decides to study.

"Well, asks the tutor on his return, you have drawn in the garden all day...are you pleased with what you have done?"

"Oh, not too much, *bon ami,* it is rather hard...and then I had to lie down to see all the plants from close by...you will tell me their names, won't you?"

"Yes, certainly, have you examined them carefully?"

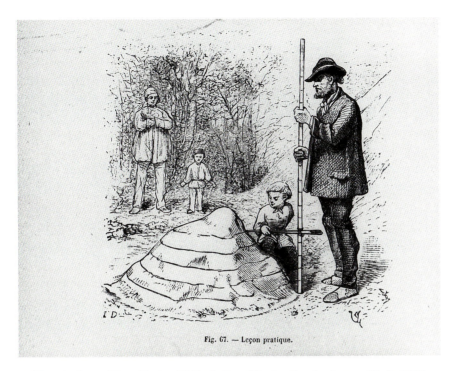

Fig. 67. — Leçon pratique.

26 "Practice lesson," from Eugène Viollet-le-Duc, *Histoire d'un dessinateur* (Paris, 1879)

"Yes, very much, the tiny ones among the dead leaves which tried so hard to push, I freed them very gently of those that were in the way."

"And they thanked you?"

Little Jean blushed a little and did not reply. He did not dare to reveal the experience of that morning even to his friend, it would have seemed a profanation. M. Majorin thought he understood, did not insist further and asked to see the sketches. It was all rather imperfect, but it contained good observations passably rendered, an effort at analysis which did not escape the master. The child had evidently looked with the desire to realize what he saw and to understand it."[4]

Thus even this romantic little episode rapidly returns to the theme of the book, the need to acquire the faculty of observation. As Majorin had explained to his skeptical friend: "I do not want to turn little Jean into an artist, if he has the gift he will become one. I only aim at teaching him how to see correctly, to realize what he sees and to bring him to a point where his observation will serve him in good stead in whatever career he will embark on."[5]

Was, then, the observant little boy who drew the two-legged cat still not quite able to see? We have seen that Viollet-le-Duc's answer to this rhetorical question would have been "certainly not." Little Jean saw slightly more than most children

do, but he still had to undergo a long and laborious apprenticeship till he could fully use his eyes.

No nineteenth-century critic has stated the theory underlying this approach with more force than John Ruskin in an early chapter of *Modern Painters* entitled "That the truth of nature is not to be discerned by the uneducated senses." Ruskin deals at some length with the "influence of the imagination over the senses" which is "peculiarly observable in the perpetual disposition of mankind to suppose that they *see* what they *know* and *vice versa*, in their not seeing what they do not know." It is in this context that Ruskin presents an early version of that theory of children's drawings which remained dominant well into our century:

> Thus, if a child be asked to draw the corner of a house, he will lay down something in the form of the letter T. He has no conception that the two lines of roof, which he knows to be level, produce on his eye the impression of a slope. It requires repeated and close attention before he detects this fact, or can be made to feel that the lines on his paper are false.[6]

Naturally, we need not assume that Viollet-le-Duc derived his conviction from Ruskin. In fact, both the form and the content of his didactic novel appear to be modelled on one of the great classics of educational literature, Rousseau's *Emile* (1762). It is in *Emile* that we read of the care taken by the boy's tutor to teach him to see (or rather to observe) by making him draw:

> Since sight is, of all the senses, the one from which the mind's judgments can least be separated, much time is needed to learn how to see. . . . Children, who are great imitators, all try to draw. I would want my child to cultivate this art, not precisely for the art itself but for making his eye exact and the hand flexible. . . . I will, therefore, carefully avoid giving him a drawing master who would give him only imitations to imitate and would make him draw only from drawings.[7]

An aversion, incidentally, fully shared by M. Majorin. Like Jean, Emile is "to have no other master than nature and no other model than real objects." He should not even be asked to draw "from memory . . . for fear [of] . . . substituting bizarre and fantastic shapes for the truth of things."[8]

Not surprisingly, Rousseau reveals himself not only as the better writer but also as the more inspired educator than Viollet-le-Duc. Reading him we become aware of an element that is utterly missing in the *Histoire*: a sense of humor and playfulness. I am thinking of the delightful episode in *Emile* in which the tutor deliberately lowers himself to the level of the child—something of which M. Majorin seems utterly incapable. Wanting to wean Emile of the childlike style he adopts it himself:

I will begin by sketching a man as lackeys sketch them on walls: a line for each arm, a line for each leg, and the fingers thicker than the arm. Quite awhile later one or the other of us will notice this disproportion. We will observe that a leg has thickness, that this thickness is not the same all over, that the arm has its length determined by relation to the body, etc.[9]

To add zest to the game the tutor arranges a competition with the boy in which the worst drawing is awarded the most sumptuous frame while the best only stands in need of an austere black surround. This spirit eluded the great French architect, but whether he remembered it or not, he had taken his cue from Rousseau, and that for good biographical reasons.

Like Rousseau, Viollet-le-Duc was a determined nonconformist all his life.[10] Born in 1814 into a highly intellectual milieu he refused at the age of eighteen to attend the Ecole des Beaux-Arts, and opposition to academic art teaching was to form a constant theme throughout his life. With that colossal energy that marks the giants of nineteenth-century culture he found time, apart from his incessant activities as an architect and restorer, an archaeologist and author, to turn his attention to the weaknesses of artistic training as he saw it. Having published a series of articles on the subject in the *Gazette des Beaux Arts* of 1862, he was appointed in the following year to the Chair of Art History and Aesthetics in the course of the reorganization of the art schools, but he was soon compelled to resign by student riots allegedly fomented by Ingres and his followers. In a number of spirited articles that still make good reading[11] he castigated the traditional methods of drawing from plaster casts and posed models and explained the convictions, which he later exemplified in the *Histoire d'un dessinateur*:

There is only one method: to develop the student's faculty of observation, to open his understanding to the ever changing spectacle of nature, to analyze the appearances it presents...to see to it that by practice drawing becomes a constant means of translating one's thoughts or impressions, just as the words or the pen become it for the orator or for the man of letters.[12]

In the course of these polemics he accused the establishment of ignoring the teachings of the great outsider Lecoq de Boisbaudron who advocated the systematic training of the memory by work in the open air.[13] That partisanship is significant, for it is in the writings of that zealous reformer that we find another telling precedent for the approach to children's drawings to be found in Viollet-le-Duc's book:

Almost all children, long before they begin really to draw, make what they call pictures of people. These are mostly confused scribbles, to which no one attaches any importance:

Leonardo da Vinci, however, with his wide perception and his great good sense, did not think the subject unworthy of his attention. He made a great distinction between the gifts of the child that always draws the same profiles and one that also draws figures full face and three-quarter, for this shows much more observation.[14]

Maybe it was the alleged authority of Leonardo that emboldened Viollet-le-Duc to begin his didactic novel as he did, though strangely enough Lecoq de Bois-baudron appears to have made up this story. Maybe the champion of memorizing misremembered a passage from da Vinci's *Treatise on Painting* that says something similar but does not mention the drawings of children:

A painter must make every effort to achieve universality for if he can only do one thing well he will never attain a high reputation. There are some for instance who apply themselves to draw well from the nude but they do it always with the same proportions without ever introducing variations while it happens that one man is well proportioned, another fat and short and so on.[15]

It is worth remarking here that Leonardo was also M. Majorin's hero and model: "Leonardo da Vinci"—he explains to Jean at a later stage of his training—"whom I consider the greatest artist of the sixteenth century, completely gives the lie to all those who claim that art and science are incompatible...maybe the main fault of our artists today, despite their undeniable qualities, rests in their not asking that support from science that it can render to art."[16]

Whether or not it was this reference Viollet-le-Duc may have found in Lecoq de Boisbaudron that gave him the idea for the initial episode of his story, its main message must be seen in a different light. Ever since his failure at the Ecole des Beaux-Arts he looked for an alternative method of convincing the French public. Already in February 1864 he had written to Charles-Augustin Sainte-Beuve who had championed his views, "Let us work for the young, the truly young youth, let us live with them and for them, that is the best method of never aging. . . . We have only achieved half of the way. . . . We must arrive at an absolute freedom for all that concerns art."[17]

He was convinced, as he wrote in a letter of 1874, that there was nothing to be gained by addressing the older generation and so we find him negotiating with the publisher Hetzel in 1874 for a series of books that would compel the young to think.[18] He wished these books to be cheap and accessible to artisans who could buy them for their children, for, as he put it, "it is among the so-called lower classes that one can still find the elements to combat prejudice and routine."[19]

The first fruit of this collaboration was *Histoire d'une maison*.[20] Here the subject is the apprenticeship of a young man—somewhat older than Jean—who is drawn into the project of building a house for his newly married sister by a visiting

architect who has no time for the academic curriculum and patiently initiates his pupil into the actual practice of building. The contrast between honest craftsmen and pretentious architects would have pleased Adolf Loos, as would the fictional architect's maxim "I believe that art—at any rate architecture—consists in being truthful and simple." Some comic relief is accordingly offered by a snobbish acquaintance who constantly parades his useless knowledge of the history and the terminology of architecture. Set in an idyllic corner of France but against the somber background of the Franco-Prussian war, the book contains a few more elements of human interest than the later work and can almost be read as a novel in its own right.

There is nothing idyllic in the next of these books, *Histoire d'une forteresse*.[21] It may rather be described as a historical epic graphically recounting the vicissitudes of a particular fortified place, which in the course of the centuries had experienced six sieges and had recently succumbed to the advancing Prussian armies, a tragedy that gives the author the opportunity of deploring the decline of the military spirit among his countrymen and appealing for its renewal for the sake of France. He followed it with a companion piece, *Histoire d'un hôtel de ville et d'une cathédrale*, which is no less imbued with patriotic fervor and celebrates the spirit of independence that marked the history of French cities in a variety of vivid episodes.[22] Yet another weighty volume was devoted to the *Histoire de l'habitation humaine* in which we follow two contrasting observers on their magic journey through many periods and places, including ancient China and India, so as to absorb the lesson that the classical style of building is but one of many possibilities and should not be forced on nations and races for whom it is not suitable.[23] Miraculously these long and ambitious books did not take up all the author's time; he also published a geological account of the Mont Blanc massif and a book on Russian art in these years,[24] but in the end he returned to the question of art education in *Histoire d'un dessinateur*, the last he completed before he died at Lausanne in September 1879.

In the figure of M. Majorin, the tough-minded industrialist, he embodied for a last time his twin ideals of hard work and intelligence. But many of the other themes and preoccupations that marked the earlier volumes are again aired in that book. The cosmopolitan outlook manifests itself in a few remarkable pages on the excellence of Japanese drawings. Like nature itself the Japanese artist creates poetry without even knowing it, because he has acquired the gift of seizing the essential (fig. 27). We are also treated to a visit to the Alps with plenty of geological digressions that would have appealed to Ruskin. But most surprising, perhaps, at least to those of us who have always considered Viollet-le-Duc an uncompromising champion of the Gothic style, is the chapter in which M. Majorin seeks to decide where his pupil's gifts really lie. Possibly to disabuse his readers of their prejudice we are treated to a glorification of the arts of Pom-

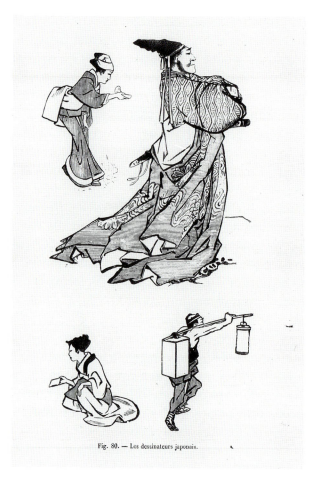

Fig. 80. — Les dessinateurs japonais.

27 "The Japanese draftsman," from Eugène Viollet-le-Duc,
Histoire d'un dessinateur (Paris, 1879)

peii (fig. 28). What Jean is to learn there most of all is the extent to which people have formed a mistaken idea of the ancients ever since the Renaissance. The people of Pompeii followed no rules but those demanded by common sense and practice. Their houses and their utensils are adapted to their needs. Maybe the elegant Romans looked down on Pompeii as provincial, but how superior are their interiors to those of the French *petite-bourgeoisie*! Which offers the author another opportunity to inveigh against the academies, whom he blames for the fatal divorce between "high art" and "applied art," a divorce largely due to Louis XIV, "that great King who did so much harm to our country for which we still have to pay."[25] It was this divorce that led to the lower classes being engulfed in barbarism, a barbarism unknown to the Middle Ages, and it is to the reform of this deplorable state of affairs that Jean will contribute in becoming a designer rather than an artist. The battle against academic prejudice had still to be won,

Fig. 85. — Cuisine portative antique, musée de Naples.

28 "Antique portable kitchen," from Eugène Viollet-le-Duc,
Histoire d'un dessinateur (Paris, 1879)

but in the end our hero dreams of organizing a school of design serving the industries of Paris whose decline would be a calamity for the country.

> Everybody is thus happy...because little Jean had the imagination to draw a cat. This is only part of the moral to be drawn from this truthful story. The other is this: Drawing, taught as it ought to be taught...is the best means of developing the intelligence and training and judgement, for in this way one learns to see and to see is to know (*voir c'est savoir*).[26]

Histoire d'un dessinateur may well be the first publication in which the drawing of a child is reproduced (or reconstructed) without any patronizing or humorous intention. It was not before the next decade that the literature on children's drawings developed in earnest.[27]

Admittedly what the French architect looked for as evidence of talent was not what attracted later students to that topic. He was not concerned with the innocent eye of the child, let alone with its creativity, only with its powers of intelligent observation. But few would deny today that this aspect also merits our attention.

The author would like to thank Jill Tilden who greatly helped me in the writing of this essay, though she modestly disclaims the designation of co-author.

1 Ernst Kris and Otto Kurz, *Legend, Myth and Magic in the Image of the Artist* (New Haven and London: Yale University Press, 1979).

2 Eugène Viollet-le-Duc, *Histoire d'un dessinateur, comment on apprend à dessiner* (Paris: Hetzel, 1879); reprinted as *Learning to draw, or the story of a young designer*, trans. V. Champlin (New York, 1881).

3 Ibid., 5–8.

4 Ibid., 105.

5 Ibid., 67.

6 John Ruskin, *Modern Painters*, part II (London, 1846), section I, ch. 1.

7 Jean-Jacques Rousseau, *Emile or on Education* (1762), Allan Bloom, trans. (New York: Basic Books, 1979), 143–44.

8 Ibid., 144.

9 Ibid., 144–45.

10 Two exhibition catalogues offer the best access to the life and work of the architect:
Eugène Viollet-le-Duc, 1814–1879, with a preface by Max Querrieu (Paris: Caisse Nationale des Monuments Historiques, 1969); and *Viollet-le-Duc*, eds. Bruno Foucard et al., Galeries Nationales du Grand Palais, 19 Feb.–5 May 1980 (Paris: Editions de la Réunion des Musées Nationaux, Ministère de la Culture et de la Communication).

11 *Intervention de l'Etat dans l'enseignement des Beaux-Arts* (Paris: A. Morel, 1864); *Réponse à M. Vitet, à propos de l'enseignement des arts du dessin* (Paris: A. Morel, 1864), is a response to Vitet's article: "De l'Enseignement des arts du dessin," in *Revue des Deux Mondes* (1 Nov. 1864).

12 *Réponse à M. Vitet*, 41.

13 Lecoq de Boisbaudron, *L'éducation de la mémoire pittoresque, 1847, 1867*; *Un coup d'oeil sur l'enseignement des Beaux Arts*, 1872, 1879; *Lettres à un jeune professeur*, 1877. All three works are published in English translation as *The Training of the Memory in Art and the Education of the Artist*, trans. L. D. Luard (London, 1911). For reasons no longer obvious, Viollet-le-Duc does not mention Lecoq de Boisbaudron by name but merely praises his efforts.

14 Lecoq de Boisbaudron, *Training of the Memory*, 149.

15 Leonardo da Vinci, *Traité de la Peinture* (Paris, 1716), ch. XXI.

16 Viollet-le-Duc, *Histoire d'un dessinateur*, 208.

17 *Lettres inédites de Viollet-le-Duc*, Recueillies et annotées par son fils (Paris, 1907), 44–45.

18 Ibid., xii.

19 Ibid., 150.

20 Eugène Viollet-le-Duc, *Histoire d'une maison* (Paris: Hetzel, 1873); reprinted as *The Story of a House*, trans. G.-M. Towle (Boston, 1874).

21 Eugène Viollet-le-Duc, *Histoire d'une forteresse* (Paris: Hetzel, 1874); reprinted as *Annals of a Fortress* (London: S. Low, Murston, Low and Searle, 1875).

22 Eugène Viollet-le-Duc, *Histoire d'un hôtel de ville et d'une cathédrale* (Paris: Hetzel, 1878); reprint, facsimile ed. (Paris, Berger-Levrault, 1978).

23 Eugène Viollet-le-Duc, *Histoire de l'habitation humaine depuis les temps préhistoriques jusqu'à nos jours* (Paris: Hetzel, 1875); reprinted as *The Habitations of Man in All Ages*, trans. B. Bucknall (London, 1876); reprint facsimile ed. (Paris:

Berger-Levrault, 1978).

24 Eugène-Emmanuel Viollet-le-Duc, *Le Massif du Mont Blanc, étude sur sa construction géodésique et géologique, sur ses transformations et sur l'état ancien et moderne de ses glaciers* (Paris: Baudry, 1876); reprinted as *Mont-Blanc: A Treatise on Its Geodesical and Geological Construction, Its Transformations*, trans. B. Bucknall (London, 1877); *L'Art russe, ses origines, ses éléments constitutifs, son apogée, son avenir* (Paris: A. Morel, 1877).

25 Viollet-le-Duc, *Histoire d'un dessinateur*, 245.

26 Ibid., 302.

27 George Boas, *The Cult of Childhood*, Studies of the Warburg Institute, vol. 29 (London, 1966), 79–88.

Larionov and Children's Drawings

G. G. Pospelov

Pondering the connection of Mikhail Larionov's work with children's drawing, we think first of the period 1912 to 1913. In the spring of 1913 at the *Target* exhibition organized by Larionov, children's drawings from the collections of N. D. Vinogradov and A. V. Shevchenko were displayed alongside works of the group's professional members. The catalogue, listing the exhibited works, gives no indication of ownership, and it is possible that some of the works belonged to Larionov himself, or more probably, to Nataliya Goncharova, who, in those years, was giving private lessons to children. According to the reminiscences of A. A. Reformatsky, who attended these classes in his childhood, they took place in Goncharova's home. Having begun as a sculptor in the Moscow School of Painting and Sculpture, Goncharova made her pupils "model cats from blue clay," and furthermore, draw with a crayon or paintbrush.[1] And from these lessons, the artists were able to form an early collection of children's drawings, individual sheets that have survived to the present day.[2]

The years 1912–13 are the period of Larionov's painterly response to impressions from children's drawing. If the beginning phase of his primitivism (1907–9) was oriented toward hairdressers' signs, and the second (1910–11) toward devices of the *lubok* (Russian popular print), then the last (1912–13) was oriented primarily toward children's drawing, on the basis of which one might call this short period, "infantile primitivism." *A Happy Autumn* (fig. 29), *Spring* (unknown private collection),[3] *Venus and Mikhail* (fig. 30) and the four paintings in the cycle *The Seasons* (fig. 31) in fact betray the devices of children's drawing: the canvases of *The Seasons* are wide, with green, yellow, blue and brown picture surfaces respectively (beginning with *Summer*), ruled in right angles (as in children's notebooks). With-

Translated by Roann Barris

40

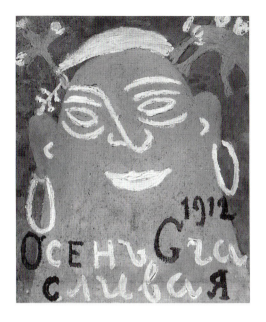

29 Mikhail Larionov, *A Happy Autumn*, 1912

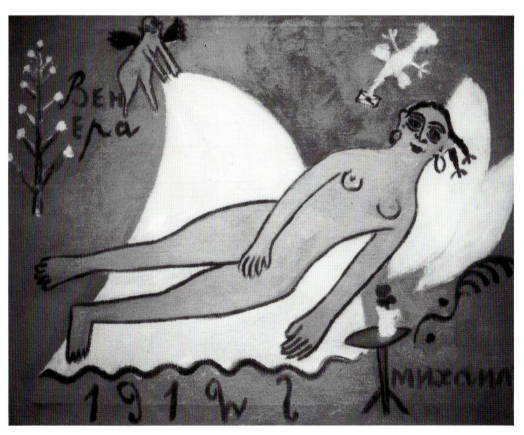

30 Mikhail Larionov, *Venus and Mikhail*, 1912

31 Mikhail Larionov, *The Seasons*, 1912: *Spring* (upper left), *Summer* (lower left), *Autumn* (upper right), *Winter* (lower right)

in these surfaces, fine lines of both white and color are used to create human figures and birds and to write words, such as "A happy autumn . . . with ripe grapes . . . ," in which a childish spelling mistake appears in the word "happy." It seems as though a plum is also glimmering along with the grapes [the word "plum" in Russian is created by the misspelling of "happy"], making the fall still happier. Behind the infantile world one also divines a folkloric or even a mythological

world, with its cult of natural and agricultural cycles, in which "the burning hot summer with stormy clouds" changes into an autumn as "brilliant as gold"; the words "brilliant as fall" fit the picture *A Happy Autumn*, with its good-natured scarecrow and white pines on a yellow background, better than they do the blue *Autumn* from *The Seasons*. However, everything seemingly passes through the prism of a child's perception, influenced by the playful relationship inherent in that perception. Larionov exaggerated that which would also be exaggerated by children, for example, the large "paws" of the figures, with which they lean on the blue, green, or ochre background, or the eyes of the small people and the horse, drawn in full face while the heads turn in profile.

What place do these pictures occupy in the development of Larionov's creative work? On the one hand, they conclude his primitive period. There are many qualities that connect them to the *lubok* and to *lubok*-inspired paintings—a cheerful aggressiveness, a crafty fervor, slightly shocking overtones for the spectator in the blasphemous figures of Spring, and the cupids with little wings from *The Seasons*. The cupid-figures closely resemble the ones in the illustrations for futurist books as, for example, in the splendid *Pomade* of 1913. Moreover, all of this took place in a broad primitivistic context: *The Seasons* hung in the *Target* exhibition not only alongside children's drawings but also with Larionov's *lubok*-influenced *Moldavian Venus* and with four oil-cloth paintings of Pirosmanashvili. In the neighboring halls of this same exhibition at the School of Painting and Sculpture hung the productions of the Second Studio of Sign Painters, as well as a show of Eastern and Russian *lubki* collected by Larionov and the members of his group; these were all displayed alongside one another as constituent parts of a single presentation.

The *Target* show and Larionov's infantile primitivism opened the second half of Larionov's creative production, about which I have already had the occasion to write.[4] A large number of those elements discovered by Larionov in the infantilist pictures—including several motifs and a specific correlation between drawing and painting—were preserved in his work of the next decades. In a profound sense Larionov found himself here, and consequently he expressed and clearly recognized the naive tone in his art, which had not sounded as loudly in his early production.

A peculiarity of Larionov's early period (through 1911) is the particular nondivision of his visual world into separate themes or figures. In sketches for one of his articles of the 1920s, he formulated an original credo of his entire naive phase: "not 'plein-air,' but life from the outside,"[5] and here, it seems, the stress is not only on the phrase "from the outside," but also on the word "life"; he had in mind all the living things that were growing and moving on his canvases. It is as if the glance of the painter slid around the edges of his objects: turning upward, he met intersecting, lacy, woody branches, bathing in the spring blueness (*The Tops of Acacias*, State Russian Museum), while turning toward the earth, he saw grazing geese or amusing turkeys, one of which he included in the frame, but another of which was

half outside its edge (*Turkeys*, State Russian Museum). Even in the primitivist subjects of 1907–11, in some of the barbers or soldiers, it was not the isolated figure (the barber, client or soldier) that was important, but above all the situation, the genres, that united these figures—the grotesque poses of the client and barber, or the movement of the soldiers playing cards on the ground under a fence. In *Soldiers*, from the collection of E. Estorik in London or the one in the Los Angeles County Museum of Art, everything spins in some kind of circular dance that attracts bottles and saddles and cards. It is as if the objects are rushing about in the same way as the legs of the animated soldiers, although those soldiers who are sitting or have just finished a spirited squatting dance are exempted.

In the canvases of infantile primitivism attention was especially concentrated on individual figures, flying birds or slender trees. For young children do not draw the relationships among subjects, but rather the objects themselves—a house with a chimney or small men with parted hands. And it is precisely such self-contained figures that we find in the canvases of *The Seasons*, in which the background is a fully abstracted surface, associated through color with heaven and greenery, with earth, or with "ripe bread-grain" (as is written on *Summer*).

A standing female figure personifies summer, autumn or winter—holding a sickle in her hand (*Summer*), or wearing a shawl (in *Winter*). Her unchanging companions are comic birds, not so much flying as crawling along the background of the pictures, with either wings or toes spread apart at their sides, in the same way as the "paws" of the human figures. These birds—on the earth and in the sky—carry in their beaks sheafs of wheat or grape clusters; the clusters resemble small grape bushes, turned upside-down, and the birds carry them to the personification of Autumn, as if decorating her with a pair of natural earrings.

No less characteristic in her pose is the small reclining female figure in *Venus and Mikhail*. In 1912, when this small canvas was painted, Larionov depicted in a similar pose a *Russian Folk Venus*, and several other *Venuses*. However, these were mountains of flesh, following the tradition of *lubok* pictures, in which the female figures were portrayed with overly fat hips. Here the prototype is children's drawing. Children draw not the flesh, but the contour of objects; the outlines of figures on a sheet of paper attract them more than the presence of bodies on paper. (In this painting, more than in the others, a meaningful association was also preserved, one from urban folklore: in the bird's beak is not a grape stalk but a letter, probably from Mikhail, and nearby is a little table with flowers—a hint at the decor of a corresponding "establishment" where a winged cupid is spreading out an inviting sheet).

The isolation of the individual motifs—the way in which the trees and small objects surrounding Autumn, the bottles of wine and the fruit surrounding Summer are shown in this series—is no less instructive. If in Larionov's landscapes from the first decade of the 1900s the trees are dressed in leaves, here they appear

for the first time without leaves. In the trees are flowers for spring and berries for fall, and it is in this childlike way that something important in nature is reproduced: leaves fall off each autumn; in the summer the branches grow, giving out their juices and fruits. In *The Seasons*, the artist developed the individuality of these motifs to the point of dividing the pictures with fine lines into smaller rectilinear fields. On one of these quadrants in *Spring*, a dancing Spring is accompanied by winged cherubs and birds. But can we imagine *Spring* (from a private collection) and *A Happy Autumn* as the fragments of the larger paintings in which all those very same infantile-mythological characters appear along with the birds crawling around the sky?

The figures in these pictures bear unique archetypes of an infantile world understanding, quite different from, for example, the forms of the urban primitives (despite their individual affinities). Inherent to the images of Pirosmanashvili, which so attracted all the Larionov followers, was a fully defined measure of historical-cultural concretization: his feasting princes are always old Georgian princes, and the beauties from the garden of Ortachal are always maidens from a well-known brothel of Tbilisi. On the other hand, Pirosmanashvili's famous *Deer*, which hung in the *Target* exhibition next to Larionov's *Seasons*, was so humanized, so sadly wise and complicated, that it would have been impossible to connect it with the naive world of children's drawing.

The Larionov figures are completely freed from both concretization and humanization. Before us are what seem to be the most universal forms of our existence in the world. There is such a high degree of generality and symbolism inherent in them, that D. V. Sarab'ianov, in one of his articles, justly called them "cryptograms."[6]

Another line distinguishing the canvases of infantile primitivism from the work of earlier stages in Larionov's primitivism is the emancipation of the painting methods from the character of the depicted objects. We recall how directly connected these methods were with the particularities of the objects in the canvases of the 1900s, and later with the subjects of the soldier paintings. It is as if Larionov's brush learned its organic, long, stretching curves from growing nature, not so much representing the forms of vegetation as reproducing its underlying forces. Individual dabs of paint—with the atmosphere and light between them—covered the surface of Larionov's early canvases as greenery covers a garden; no less clear a connection characterized the movements of the objects and the brush in the canvases of the soldier series. Larionov's brushwork acts like the provocative gestures of the medieval jesters confronting the spectator with not only vulgar subjects but also a shockingly crude manner of handling. Fully rejecting the intensiveness of the colors of the Tiraspol period, the painter concentrated on a whitened soot and ochre, united with a dirty green and a murky raspberry in the soldier paintings. Looking at these canvases, one sees how Larionov's brush plays its part, dragging

behind it a thick wad of black paint, outlining the soldiers in black as if they were demonic. He depicts the crawling soldiers as though he controlled their movements, scrubbing them onto the surface of the painting, inspired by the caricatured graffiti on the fences which Larionov saw often during his military service.

But in the infantile canvases of interest to us here, that connection to the surface loosens for the first time. The organic tendencies still characterize the bushlike clusters of grapes, but they no longer dominate the touch of the painter. The brutal subjects of the soldier series, as well as the coarse aggressiveness of the brushwork, disappear permanently from Larionov's work.

The process by which this change occurred created its own almost tactile sense of the painterly surface. It reminds us of the satisfaction children take, with the tips of their tongues sticking out in pleasurable concentration, filling in the green earth or the blue sky in their drawings. Children are not interested in the result—the finished drawing, which they may even throw away—but in the process. They not only represent the world as it exists, but it is also as if they themselves participate in its formation on the paper sheet. Larionov created a stylistic equivalent to this childlike experience in forming his own universe in his painting. The main thrust of *A Happy Autumn*, for example, is in the lively visual experience it offers, and in the evolving elegance of Larionov's touch. Here one senses not only a natural, but a positively creative impulse, emanating from the overabundance of painting on the surface, anointed with color, and from the slow but deft touches of the brush. One also notices the similarity of line with which the brush outlines the roundness of the lips, the earrings, and the letters *o* and *c* in the infantile inscription "Happy Autumn," uncovering at the same time the denotative and the connotative nature of the painting and letters which were now evident to the painter.

How were these discoveries of 1912 reflected in Larionov's subsequent painting? I will speak only about the easel works of the 1920s to 1930s, for between 1915 and 1919 the artist was little occupied with easel art, being absorbed by theatrical commissions or rapid album drawings. In the series of not great, but nonetheless solid works of the 1920s and 1930s, his infantilist strivings were disseminated boundlessly. From those strivings came the development and adherence to insistent, individualized motifs and the sensation of the artistic work as an elaborated creative expression of the contact of the brush with the canvas.

I will begin with the motifs, inherited from the infantilist canvases. These motifs gradually lost the appearance of a sign on a plane, returning instead to a spatial milieu. Meanwhile, there arose curious works of a transitional type, like the drawing *Bather with Bird* (1922; fig. 32), where before us is a whole, good-natured, folkloric wonder, as in *A Happy Autumn* with the same infantile bird, carrying in its beak a bunch of grapes. It is easy to see that the figure and the bird are, as in the infantilist works, conceived two-dimensionally. Yet depth has returned to the composition as a whole. In the foreground, as if by the leg of the

32 Mikhail Larionov, *Bather with Bird*, 1922

33 Mikhail Larionov, *The Three Graces*, 1920s

walking figure are the volumetric letters *ML* and the number *22*; behind the figure, indicated by pen strokes, are light waves, but deeper in the pictorial space is a sea with a ship, drawn as a child might.

Further along, this process became even more rooted. In *The Three Graces* (fig. 33) or *Bearers* (fig. 34) of the beginning of the 1920s, the vertically extended female figures no longer look like symbols, although everything is still oriented on the plane of the sheet of paper. Here there are, however, already hints at the surroundings—tree trunks in the woods, which, like the figures themselves, extend the length of the paper. In the later *Spring* (fig. 35) this forest is fully represented. Three elongated figures live not on the plane, but in space. One may also observe that a branch, which in *Bather with Bird* was carried by Larionov's favorite infantile bird, is held in this picture by a slender female figure, personifying Spring.

Beginning with *Venus and Mikhail*, the reclining female figure followed almost the same evolution. A bird still accompanies her, as in *Venus with Bird* (fig. 36). (Note, however, that the bird no longer looks toylike, as it did in the infantilist canvases, but neither does it look real. Here it turns into a highly amusing, skinny crow.) The figure and the bird are still subordinated here to the plane, although, in the gestural strokes, the environment is beginning to intrude. The culmination of this evolution is seen in sheets like *Reclining Woman* (fig. 37), where extended

34 Mikhail Larionov, *Bearers*, 1920s

35 Mikhail Larionov, *Spring*, 1920s

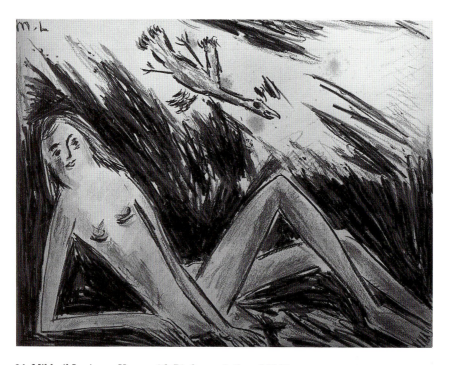

36 Mikhail Larionov, *Venus with Bird*, a variation of 1940s

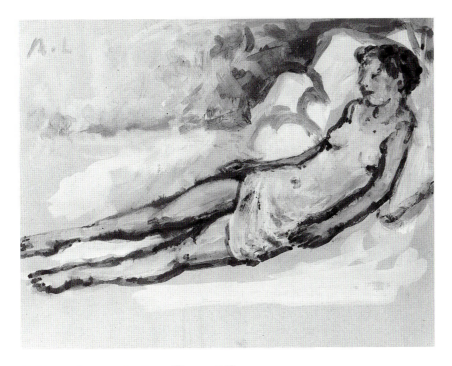

37 Mikhail Larionov, *Reclining Woman*, 1920s

along the picture plane is the figure and washes of white, which reinforce the picture plane; however, there is a lively spatiality, as if satiated with flickering light, conveyed in rose and gray dabs of gouache.

The artist's beloved grape branch made an especially interesting metamorphosis from a planar symbol into a realistically represented object in the 1920s. In *Bather with Bird*, as we just saw (and in several other drawings of this time), the grape branch was still, as before, in the bird's beak. However, in several small still lifes of the 1920s, a branch appears as one of the represented objects. In the still life *Glass and Sketch of a Nude* (fig. 38), the artist features a conventionally rendered grape cluster in the foreground. In *Still Life with a Letter* (1922, Tretyakov Gallery), the same cluster, now denuded of fruit, appears. In *Still Life with Napkin* (fig. 39), he portrayed only a bare snippet of a wooden branch, on which buds of spring flowers are faintly suggested.

It is important that these persevering motifs did not lose the meanings he gave them. Larionov varied them in dozens of works. The subjects of strolls in the woods or fragile figures lying on pillows moved from oils to gouache, and from gouache to pencil and pen, yet always preserved their peculiar, recognizable features. They also now preserved their own type of kinship with the archetypes of an infantile understanding of the world; for with them, as with the images in drawings by children, there are no images derived from concrete reality. Sometimes the artist even returned to the child's

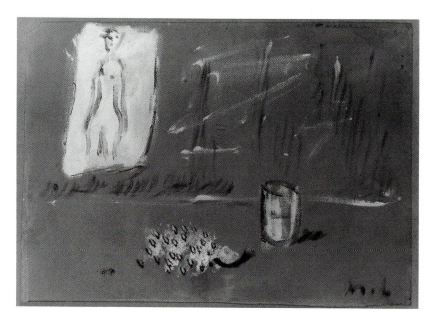

38 Mikhail Larionov, *Glass and Sketch of a Nude*, 1930s

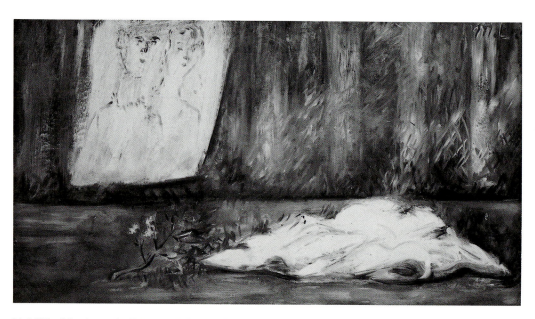

39 Mikhail Larionov, *Still Life with Napkin*, 1920s

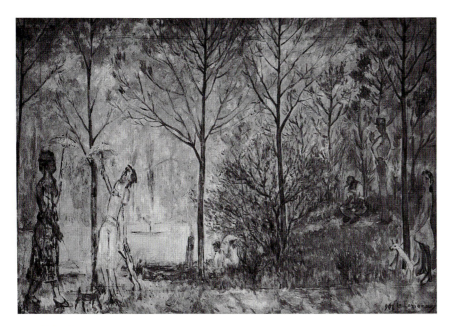

40 Mikhail Larionov, *Sunday at Noon*, 1920s

division of the picture field into independent compartments. In *Sunday at Noon* (fig. 40), a shallow plane of trees, dispersed along the wide surface of the picture, divides into vertical zones. Within these zones are the virtually bodiless, somnambulistic figures of strolling women, with absurd little dogs, with which Larionov now attached almost everything that before was connected to his comic birds.

Finally and importantly, in my view, a special sensation of naiveté emerged in the painterly manner of Larionov's later work. It is important to note at the outset that the world which Larionov represented had changed in the 1920s. If the canvases of the 1900s were characterized, as I have already said, by a fervent life from outside, in the 1920s he increasingly looked to the secluded life within four walls. Having settled in a heavily Latin neighborhood of Paris, filled with art stores and galleries, Larionov led the life of a genuine hermit, associating less and less with the external world. In place of the splendid southern sun and the rose-filled courtyard of his grandmother in Tiraspol, was the almost gloomy light of a secluded studio. A connection to evolving life was preserved here, but in it there appeared a melancholy note, that anemia which occurs in plants growing on a north windowsill.

Yet in this somewhat anemic reality, which was limited in its pretensions, there was nevertheless an intensified animation, as if a new beginning were being created on the inside. If in the early period a vitality in the life around him attracted the artist with its beauty and activity, then now a creative energy hidden in this interior life seemingly replaced it. His world, rejecting its own flesh and color,

pulls everything into itself, fills itself with light and appears to be creating its own personal, ascetic forms.

It began, it seems, in drawings on ballet themes at the end of the 1910s and the beginnning of the 1920s. At that time, pencil and pen were already imitating not a natural body but the artistic gestures of the hands and legs of dancers, reproducing not so much an outline of their bodies as the necessarily imposed lines. In the late works, he portrayed not artists but daily life, yet he sought in this new subject the same animated creative strivings as he had sought earlier, and he conveys not flesh, but lines with a life of their own.

It is understood that the underlying motivation for such an approach was preserved here as well, and I want to show that, in the 1920s, Larionov created a childlike world that relates to these works of the 1910s, using the lines of children's drawings, though not the poses of the ballet artists. The style of children's drawings turned into an original graphic tuning fork, according to which Larionov's own manner in painting and drawing evolved.

In *The Seasons*, Larionov extracted from children's drawings the expressiveness of their symbolism in his cryptograms, and continued to do so in the 1920s. In the album of gouaches known as the *Travels in Turkey*, there are drawings of personages that recall the infantile physiognomies of Summer and Autumn from the cycle of 1912.[7] We have seen that in *Happy Autumn*, Larionov employed expressively drawn contours taken from children's representations, and it is precisely this quality that is fully sharpened in the works of the 1920s, in which the artist acquired an unprecedented consequence and elegance.

This assertion is confirmed by several medium-sized still lifes in which sheets of Larionov's drawings hang on the wall in the background. Similarly, in a relatively large canvas entitled *In the Studio* (private collection), the entire composition consists of sheets on a blank wall. The motif is repeated in several related small canvases, including *Still Life with Coffee Pot* (private collection), *Still Life with Napkin, Fruit and Sketch of a Nude* (fig. 41) and *Glass and Sketch of a Nude* (fig. 39); some show only drawings, in others additional objects are also present.

It is significant that until now it was not possible to identify the sheets represented in these backgrounds as known works by Larionov. In part, this is because in reproducing his own drawings on the walls, Larionov stylized them with an emphatically infantile tone. For example, in the drawing from *Still Life with Napkin*, not only are the thoroughly naive, extended poses of two little boys intensified, but the brushstrokes are more timid in conveying both the almost weightless, interrupted lines of the shoulders and faces, and the faint, fan-shaped strokes of the collar.

Furthermore, Larionov brought all these infantile contours into the surrounding setting. The fan-shaped touches, seen in the collar of one of the boys, were carried over to the colored branch and the surfaces of the table and wall, while the flowing dabs of the figure in *Fruit and Sketch of a Nude* decompose the lightened

41 Mikhail Larionov, *Fruit and Sketch of a Nude*, 1920s

mass of a napkin on the table. In addition, the napkin almost repeats not only the direction in which the female figure is disposed, but, it seems, her entire pose and outline; in *Glass and Sketch of a Nude*, we recognize the vertical lines of a standing figure in the strokes on the wall and in the contours of the small glass. In the latter drawing again, as in *Autumn* of 1912, a standing figure—Venus, Autumn, or Manya the Whore (there are many variants)—and a small cluster of grapes can be found; one is on the sheet of paper, the other on the table next to the transparent glass. Meanwhile, a difference in their brushstrokes is absent, as in the canvases of *The Seasons*. The slanting lines of the nude and the round grapes carry one and the same artistically weighted touch of the brush, where the common ground, perhaps, is in the pauses between the touches, in the slow tempo of the drawing, and in the undestroyed wholeness of the light gray field of the picture, as one finds, perhaps, only in the drawings of children.

Larionov clearly recognized in these late years his connection to children's creativity. From the end of the 1920s Goncharova again conducted classes at home with groups of children. Preserved sheets from these classes, executed with either gouache or wax particles, reveal that these are not spontaneous children's drawings (as in an earlier period, when they were untouched by the hands of a teacher), but rather the works of pupils, clearly followers of Goncharova, among whom there was some striking talent.[8] Some, however, experienced the influence of Larionov, who took a lively part in these classes.[9] If, in the pictures of 1912 or in *Travels in*

Turkey Larionov clearly started from his impressions of children's drawings, then in the 1920s his pupils, in their turn, were infected with his devices. It is not by chance that on some of these sheets there is preserved, as if it is his proud signature, a personal stamp: "The Studio of Larionov."

Finally it seemed to the artist that his connection with the child's world view disseminated into his entire creative life. In the middle of the 1930s he made an interesting notation in his diary:

> I recall my early childhood. Here is the idea, or really, the task, which strangely I set myself at the age of 7: "do not forget, as an adult, the humanistic sensations of childhood." I saw the difference in the feelings of adults and children; from that this thought arose. But, unfortunately, my feelings did not change, and I do not see differences between the past and the present in my personal life. I did not lose the connection with children, but with adults I in no way am able to manage it.[10]

This "connection with children" characterized—I repeat—above all, the late Larionov. After the aggressive pressure of the first two decades of the 1900s, the surplus of creative directions and the experiments, a time of concentration and quiet arrived, of searches for his own defined lines in the world. The same happened after World War I with other masters from the storm and stress of the beginning of the twentieth century, moving from all possible disruptions of form to a spontaneous perception of concrete nature. Every time, this demanded a kind of world-view sanction, a sense of oneself, and in each of the artists it was personal, but there is no space here to talk about this. With Larionov it was the naming of the child's world view, which seemingly merged with his entire creative world—the world of artistic elegance—but in which, in fact, there is a naiveté, a sort of knowing nothing about human history, and perhaps as a result, this world-view is freed from gloom, or more truly, penetrated by an encompassing and unknown light.

1 A. A. Reformatsky, *Vospominaniia*. Private collection in Moscow.

2 The sheets are preserved in the Graphics Department of the Tretyakov Gallery. They were a gift from A. K. Tomilina in the 1980s.

3 Until 1987 it was in the collection of A. K. Tomlinaia in Paris.

4 G. G. Pospelov, "M. F. Larionov," *Sovestskoe Iskusstvoznanie* 79, 2 (Moscow, 1980).

5 The notes of M. F. Larionov, which in 1977 were in the collection of A. K. Tomilina, Paris.

6 D. V. Sarab'ianov, "Vystavka Larionova,"

in *Sovetskaia Zhivopis'* 5 (Moscow, 1982), 197.

7 Larionov. *Voyage en Turquie*. 32 gouaches 1907–09, issued in *pochoir* (stencil). (Paris, undated).

8 The sheets are preserved in the graphics department of the Tretyakov Gallery. They were a gift of A. K. Tomilina in the 1980s.

9 *Gontcharova et Larionov. Cinquante ans a Saint-Germain-des-Prés, Témoignages et documents recueillis et présentés par Tatiana Loguine* (Klincksieck/Paris, 1971).

10 Until 1977, the manuscript was in the collection of A. K. Tomilina in Paris.

Children's Drawing in Russian Futurism

Yuri Molok

Pushing back the frontiers of art, the avant-garde allowed into their territory signboards, *lubki* (popular prints) and children's drawings—forms of art that, though generally classed as folk art, are in many respects very different from one another.

The signboard, despite its use of metaphor, is nevertheless attached to the home, the street, to a specific activity. It is therefore predictable and, as a rule, takes the form of a still life or of compositions consisting predominantly of groups of things, depending on the function of the particular sign. The *lubok*, despite its long existence on the periphery of art as one of the half-forgotten domains of engraving (Mikhail Larionov called it a "great art"),[1] also has its canon, its system of symbols and its tradition.

Even in comparison with other genres close to it, children's drawing is related to forms of art that are not fixed, to subject matters that appear and disappear unpredictably. According to Fedor Shmit, a Russian academic famous for his research on children's drawing in the 1920s, the rules of normative aesthetics dictate that "with children there can be *creativity*, but there cannot be art."[2]

In Russia, an interest in children's drawing arose only in the early twentieth century. The era began with the exhibition *Art in the Life of a Child*, held in 1908 in St. Petersburg, and about which Aleksandre Benois wrote in one of his "Letters of an Artist": "What a charming enterprise. And how needed here in Russia in particularly, where we pay so little attention to childhood."[3] In 1911, the book *L'arte dei Bambini* (Children's art), by Corrado Ricci, appeared in Russian translation, nearly thirty years after its original publication (in Italy in 1887).

In Russia, as in other countries, attempts were made to track the development of children's drawing according to age and thus to establish parallels between the artistic development of a child and that of the history of art in general, from the

Translated by Sophy Thompson

55

neolithic period to the present day. As a result, children's art became a tabula rasa for experiments by psychologists, educational specialists and cultural historians.

Here, however, we will be concerned above all with the ferment of the "childish" in the minds of adults in their artistic explorations of the 1910s, and in the participation, or more precisely the presence of children's drawings at exhibitions of "grown-up" art. The subject is particularly interesting in that it provides insight into the tastes and preoccupations of certain artistic movements, since the exhibited children's art was collected and chosen not by children, naturally, nor by educational experts, but by the artists, according to their specific artistic views. We will be interested not so much in the children themselves, or their drawings, as in the meaning artists were investing in this art that they showed at their exhibitions, art that, it would seem, was so foreign and unusual.

The subject is a colorful one. It will become clear that the domain of children's drawing was home to both open and unspoken disputes, in particular to the battle over who was first to discover this art. Here we need to go into more detail.

A contemporary critic writing about the public at the *First International Exhibition of Painting*, organized by the sculptor Vladimir Izdebsky in 1909–10, was not entirely justified in his complaint that the public did not appreciate the "absolutely innovative approach in the exhibition layout—works by children were exhibited at the same time alongside other works."[4] Izdebsky was not the first person to exhibit drawings by children. Almost two years before him, in the beginning of 1908, the *Fifth Exhibition of Paintings* of the St. Petersburg New Society of Artists (Novoe obshchestvo khudozhnikov), held in the home of Count Stroganov on Nevsky Prospekt, included an "Exhibition of children's drawings" (an exhibition within an exhibition, a text within a text), which was referred to in the general catalogue of the exhibition with the following, revealing, description: "[Drawings] collected by K. A. Syunnenberg, and S. Chekhonin et al."

With this information in hand, it comes as no surprise to find various familiar names among the exhibitors mentioned in a review of the St. Petersburg exhibition, among whom were Nikolai Rerikh's son, Yurik (who we will meet again below), and the daughter of the organizer of the New Society, Dmitry Kardovsky. However, the main stars of this section of the exhibition were from the Benois family. Not only did Benois' two daughters, Atya and Lelya, take part in the exhibition, but so did Aleksandre Benois himself, showing drawings he had done as a child. (When Larionov later exhibited alongside children's drawings these were by no means his own children's works.) It is also telling to note that Benois appeared in the exhibition as a model. Among the exhibits was a portrait of Benois (*Portret Binois*, misspelled "Binois" in the original) and a portrait of his favorite historical figure, Peter the Great (*Petar' Velikai*, also misspelled).[5]

The two portraits were drawn by the young son of one of the exhibition organizers, Konstantin Syunnenberg, famous for his portrait of Dobuzhinsky, *Man*

Wearing Glasses. Syunnenberg, writing under the name Konst. Erberg, authored a collection called *The Purpose of Art* (Tsel' tvorchestva), which included an article entitled, "Genius and Children." He was also the author of numerous articles of criticism, among which is one of particular interest to us here, his review of "The Alphabet in Aleksandre Benois' Painting," printed in the journal *Golden Fleece* (Zolotoe runo). In it he writes, "The real world is boring and miserable. Children, living as they do according to their instinct [he later refers to their "metaphysical instinct"—Y. M.] feel this, perhaps, more deeply than adults."[6] Here, the antithesis between adult and child becomes an extension of the symbolist formula of the discord between life and art. A review of the children's section of the New Society exhibition, written by Maksimillian Voloshin, is similar in spirit. It begins with the question, "Do children learn from adults, or adults from children?"[7]

For the World of Art (Mir Iskusstva) artists, the "childish" was not only a manifestation of a taste for domestic, family art, but also fitted a general conception of Russian symbolism. We should not forget that as early as 1905, three years before the New Society of Artists exhibition, the poet Aleksandr Blok wrote, in an article entitled "Paint and Words" (about writers' drafts), the famous phrase: "Sometimes it is better to draw a few childish scribbles than to write a voluminous work." Yet in the same article, Blok seemed deaf to children's word creation. In his opinion: "Verbal impressions are more alien to children than visual impressions" (the supporters of *zaum* would later insist on the contrary).

For the symbolists, the "childish" had less to do with children than with a realm of memories, half-dreams and half-games, in the style of "children's daydreams." As Osip Mandelstam wrote, no longer as a symbolist but as an acmeist, "to read only children's books, to cherish only children's thoughts."

It is important to remember that the World of Art artists showed an interest in children's creativity before the futurists. They were, after all, the more senior of the contemporaries. Thus, the jealous words of Aleksandre Benois, printed more than once—"Long before any Burlyuks, we, the '*aesthetes*,' collected popular toys, trays, embroidery, *lubki*. . ."[8]—are relevant to our discussion.

The futurists' attitude towards children's creativity was not so much parental, protective or aestheticizing as one of adults of the same artistic age as children. As Velimir Khlebnikov wrote in 1915: "A seven-year-old boy, the young son of friends, read 'Incantation of Laughter.' We chatted with him and felt like conspirators among adults."[9] The idea of the unpredictability of children is shown in Khlebnikov's poem "The World Backwards" (Mirskontsa—the poet insisted that the poem's three-word title, *mir s kontsa*, should be read and written in one word, just as children write). The poem is constructed according to rules that reverse time; adults turn into children, a device that Roman Jakobson defined as a "temporal shift, which is also bare, i.e., without motive"[10]—in other words, which is close to the absence of logic that exists in children. Another of Khlebnikov's poems, "Gods"

(Bogi), is, as Mikhail Gasparov recently observed, "nothing other than a gigantically expanding children's verse, a grand form of the children's verse genre."[11] The Russian futurists made no distinction between that which was "theirs" and that which was "childish." In the disputes with David Burlyuk and Vasily Kamensky over the publishing of poems by a young girl, Khlebnikov maintained that they would not be "a fly in the ointment. There would be no children's section, simply a page with the signature 'Militsa, age 13.'"[12] The poems were later published in the second *Hatchery of Judges* collection (Sadok sudei II [St. Petersburg, 1912]).

We should, or rather, we are obliged to begin looking at "children's futurism" with some examples of children's word creation, since the latter is so closely linked with children's drawing. The Russian futurists, like no one before or after them, were organically and almost intuitively receptive to "syncretic" art forms. The "child and the savage," according to Yury Tynyanov, "became new poetic identities, suddenly confusing the accepted *norms*." The same critic produced, in reference to Khlebnikov, a definition employing two apparently paradoxical terms: "verbal vision."[13]

Looking at Russian avant-garde art, we can also find examples where the "childish" figures as an argument in a futurist manifesto, as a visual argument, or appears directly on the walls of an avant-garde exhibition. In the first futurist manifesto, "A Slap in the Face of Public Taste" (Poshchechina obshchestvennomu vkusu), David Burlyuk, in his "Commentary on the Commentary," referred to children's drawing as an example of free drawing, "in contrast with the Academic Canon, which sees drawing as a fixed entity."[14]

In order to clarify the role that the artists of the Russian avant-garde attributed to drawings by children, it is vital to look at the catalogues of exhibitions held around 1910.

> **1908**: *Fifth Exhibition of the New Society of Artists*, no. 511, "Exhibition of Children's Drawings." The names of the selectors are identified in the catalogue: K. Syunnenberg and S. Chekhonin. As mentioned above, their names and articles about the exhibition make it possible to decipher the list of participants.
>
> **1909–10**: *First International Exhibition of Painting, Sculpture, Engraving and Drawing* (salon organized by Vladimir Izdebsky). The names of the artists of the children's drawings are listed, after Aleksei Yavlensky, Aleksandr and Mikhail Yakovlev, at nos. 743–46: Vitya Fedorov, Anya Vengrizhanovskaya, Armand Altman, Volodya Rodionov.
>
> **1911**: *International Exhibition of Art* (second salon organized by Vladimir Izdebsky). With the participation of Mikhail Larionov. The catalogue lists "Children's Drawings" at no. 438, after Yakulov, Yavlensky and Exter, without further explanation. The "Industrial Section" (no. 439) follows.

1913, 24 March–7 April: *The Target* (Mishen'). The catalogue for this Moscow show includes, along with an introduction by Mikhail Larionov, "Children's Drawings from the Collection of A. Shevchenko" (nos. 153–80, without artists' names or titles), and "Children's Drawings from the Collection of N. Vinogradov" (nos. 201–9, without the artists' names, but with titles: 201–2, *Cossacks*; 203, *Reading a Manifesto*; 204, *Haymaking*; 205, *Village*; 206, *Drawing*; 207, *"Little Russian" Hut*; 208, *On the River*; 209, *On the Edge of the Village*). It is interesting to note that all the subjects here are ones typical of Larionov: soldiers and rural (rather than urban) scenes, as found in folk art. This section was listed alongside "Drawings by Unknown Artists" (nos. 181–200) and "Signs by the Second Corporation of Signboard Painters" (nos. 210–11).

This juxtaposition and classification of children's drawings in the *Target* catalogue, most probably reproduced in the exhibition itself, is clearly not accidental. The history of children's art is anonymous (we do not know the surname of Militsa V., the young girl about whom Khlebnikov enthused, or that of Zina V., the coauthor with whom A. Kruchenykh published the book *Little Piglets*).[15] Larionov equated children's drawings, like images from children's folklore, with images from folk art, which he sought in *lubki*, toys and signboards. Not actually naming children's drawing, but clearly with this in mind, he wrote, in the introduction to the *Target* catalogue, "The purpose of this exhibition includes showing a series of works by artists who do not belong to any movement and who create, for the most part, a work of art through the manifestation of their own self within the work." Further on, he writes that the most important principle behind the exhibition is a "negative attitude toward the praise of individualism."[16] (We should remember that Izdebsky, on the contrary, saw his task as a demonstration of individualism.)

We should note, however, that Larionov's idea of equating children's drawing with folk art images—themselves close to the language of new art—escaped the notice of the art critics of the day. Writing about the *Target* exhibition, in which Goncharova, Malevich and, notably, Larionov took part (the last showing of his *Seasons* series), the author of "Notes of a Layman" (Zametiki profana) seemed to regard the event as little more than a curiosity. The joyless "Notes" finish with a passage about the children's drawings on show at the exhibition: "A small consolation for the visitors, thank god there are children who can draw with more sense than all these *cubists* and *rayists*. . . . Don't let them into 'Target.' . . . What good could come of a child turning into some kind of Larionov. . . ."[17]

So, we can see that the polemic between the various artistic views that characterize this period, and the avant-garde in particular, touched upon the territory of children's drawing. Nevertheless, however much we discuss their differences, we would be unable to reconstruct the polemic using visual examples alone, and it

would be impossible to determine the exact setup and the guiding principles of the various exhibitions if it weren't for one thing: the polemic is reflected in two publications of children's drawings from the 1910s, which have, until now, been given little attention by researchers.

The first is *Children's Own Drawings and Stories. Collected by A. Kruchenykh* (Sobstvennye risunki i rasskazy detei [St. Petersburg: EUY publishers, 1914]). The second, *Our Journal: Our First Book* (Nash zhurnal: nash pervaya knizhka, ed. A. M. Arnshtam [St. Petersburg: Svobodnoe Iskusstvo Publishers, 1916]) appeared two years later. Although in this instance it was the futurists who were the first off the mark, let us look at these publications in reverse order, beginning with the latter.

Our Journal, in the words of its editor Aleksandre Arnshtam, a famous graphic designer and a participant in the World of Art exhibitions, "is a children's venture, brought to life by adults." Nineteen children contributed to the journal, the names of half of whom are not difficult to decipher since they belong to well-known families from the art world. Zhorzhik A-m (age 7) and Garrik A-m (age 4–5) are the sons of Arnshtam himself. Zhenya L-re (age 6–7) and Natasha L-re (age 6) are the young daughters of the Lansere family. Nina K-na (age 7) is Nikolai Kulbin's daughter, and contributed to A. Kruchenykh's album. Vanya K-n (age 7) and Tanya K-na (age 6) are most probably also Kulbin's children. Svetik (age 7) and Yurik (age 10–12) are Nikolai Rerikh's sons: we have already encountered Yurik as one of the participants of the New Society of Artists exhibition in 1908. Koka B-ua (age 10) is, of course, Koka Benois, later to become the artistic director of La Scala theatre. Naya G-ya (age 7) is the daughter of the poet and writer Sergei Gorodetsky. Lidochka Ch-aya (age 9) is not the artist of one of the drawings but the author of the story "Adventures of a Sleepwalker" (Priklyucheniya lunatika) and the daughter, still in good health today, of Kornei Chukovsky, not only a writer of children's books but also an indefatigable collector of children's folklore, presented in his celebrated book *From Two to Five* (Ot dvukh do pyati). (Lidiya Chukovskaya confirmed our reading of several of these coded names.)

Other well-known names also had their prototypes. For example, a drawing by seven-year-old Andryusha S-va, *The Town*, looks very like a Dobuzhinsky. Other similar examples can be found, a point made very clearly by Ya. A. Tugendkhold in his review published in *Northern Notes* (Severnye zapiski): "It is a wonderful idea and a wonderful publication. The one point one might criticize is the one-sided choice of the drawings—almost all of them are by artists' children, in addition to which, many of those children whose surnames are not given can even be identified as the offspring of famous World of Art fathers."[18]

The journal was produced in the style of a luxury art book (fig. 42). The album has a title, a subtitle and a table of contents with an abbreviated list of contributors (giving their first name and the first and last letters of their surname, their age and the page number of their drawing). Each page is elegantly decorated with

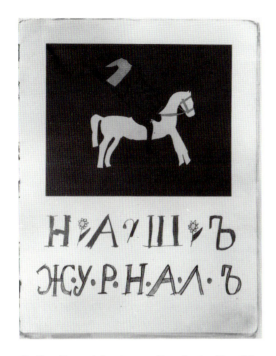

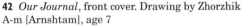

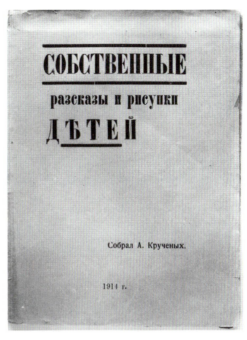

42 *Our Journal*, front cover. Drawing by Zhorzhik A-m [Arnshtam], age 7

43 *Children's Own Drawings and Stories*, collected by A. Kruchenykh (St. Petersburg, 1914), typeset book cover

an ornamental initial letter and a vignette at the end. The album is printed in color on thick matte paper.

Children's Own Drawings and Stories (fig. 43) does not have a colorful cover, a title page, a list of contents or a list of page numbers. The sixteen drawings are in black pencil on thin, reddish colored paper and glued into the book like an unplanned bundle of colored sheets. Children's verses, typed on rough, greenish-silver paper, make up a separate exercise book. This design, as is well known, was used in several futurist publications (e.g., Khlebnikov's *Anthology* [Isbornik] with drawings by Pavel Filonov). In other words, what we are looking at is another futurist publication.

The album contains drawings by only three artists, two of whom figure in the captions, probably written by one of the adults. They are Nina Kulbina (age 8), N. Kulbin's daughter; P. Bakharev (age 7); and an artist known only by the initials M. E. (age 7). It is possible that the latter is Maryana Erlikh, daughter of Ekaterina Nizen (Guro), Elena Guro's older sister. (The drawing by M. E. was created for the inscription on the cover of a posthumous work by Elena Guro, *Heavenly Little Camels* [Nebesnye verblyuzhata], fig. 44.)

Children's Own Drawings and Stories also circulated outside of family circles, but in a milieu that was different in style from the Rerikh-Benois-Lansere circle. In

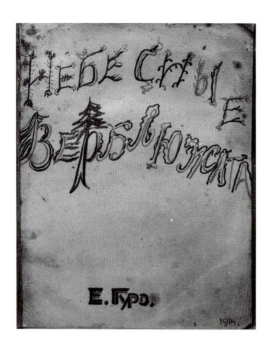

44 Elena Guro, *Heavenly Little Camels* (St. Petersburg, 1914), book cover. Drawing by Maryana Erlikh, age 7

her unpublished memoirs, Nina Nikolaevna Kulbina-Kovenchuk writes about the atmosphere in her family's home, listing their most frequent visitors: Khlebnikov and Kamensky, Evreinov and Sudeikin. She remembers a particular episode: "Somehow at dinner children's drawing came up in conversation. Someone was sent off to buy some blue silk material and a silver cord. The outline of my drawing was traced."[19]

Of course, the contents of the two books are not always different. Drawings by the four-year-old Garrik Arnshtam, for example, could easily have been included in Kruchenykh's publication. There are differences, however, not only in the publication and in the style of the drawings but also in the style of the captions.

Although the editor of *Our Journal* emphatically declared that no adults had taken part, the style of the writing of the script suggests that an adult's hand is responsible for writing the letter forms or indeed the text itself. The text is carefully centered on the page, on an axis. There is no trace of children's handwriting—no mistakes, no blots, no words run-in together, no amusing confusion of printed and handwritten letter forms, which Larionov used so carefully in his *Seasons*. Only the text by the four-year-old Garrik, written at all angles, as if it were one word, is consistent with children's writing and is reminiscent of the text in Larionov's paintings (figs. 45, 46). As far as the general character of the text in *Our Journal* is concerned, it contains none of the childish errors that are typical of children's word creation.

These publications were destined to be different. *Our Journal* was conceived as a cultural action. Its appearance was anticipated in an article by Dmitry Filoso-

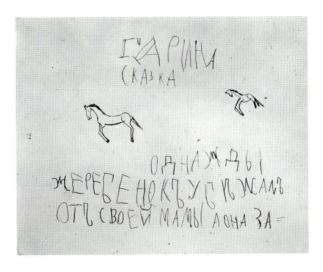

45 Child's drawing (Garrik A-m [Arnshtam], age 4–5),
Garya's Story, in *Our Journal*, 1916

46 Mikhail Larionov, *Autumn* (from *The Seasons*), 1912, detail

fov, and once the journal was published, Benois dedicated a whole article to it in
the newspaper *Speech* (Rech'). In addition, the paper's supplement contained a col-
lection of short statements about children and children's drawings by the leading
names in the cultural world in Russia at the time, from Arkady Averchenko to
Fedor Shalyapin.[20]

Children's Own Drawings and Stories, somewhat surprisingly for the futur-
ists, was a much quieter, more modest affair. We know only of a letter from Roman

Jakobson to Aleksei Kruchenykh, in which Jakobson offers to contribute verses and drawings, "If you are still thinking of publishing another children's book or something similar...."[21]

Mikhail Larionov's position in regard to this publication is not clear. The publication was of course organized by Kruchenykh at a time when he had already moved away from Larionov and had begun to work more closely with Malevich, Rozanova and Filonov. With this publication, however, Kruchenykh— "one of the principal diagnosticians and doctors of poetry," as Malevich referred to him[22]—strengthened the role of children's drawing and writing in the history and poetry of the Russian avant-garde.[23] It is clear that Kruchenykh's tastes and inclinations were not uninfluenced by Larionov. Larionov was, after all, the first artist to illustrate Kruchenykh's first poem "Onetime Love" (Starinnaya lyubov), and it was to Larionov that Kruchenykh dedicated his poem "Half-Alive" (Poluzhivoi). Even the title of the small book, *Children's Own Drawings and Stories*, whether intended or not, is close to *My Own Portrait by Mikhail Larionov* (Sobstvennyi portret Mikh. Larionova). This same portrait was reproduced in Kruchenykh's lithograph postcards, which also included a portrait of Kruchenykh by Larionov.

The facts are not only biographical. The language and spirit of children's drawing were closer to Larionov than to any other artist of the Russian avant-garde. Leafing through the drawings in Kruchenykh's publication confirms this, though it is difficult to find direct analogies and parallels. As far as these are concerned, it is more fruitful to compare Larionov's work with *lubki*, an alley that has been explored in articles by Valentine Marcadé.[24] The symbolic nature of the *lubok* makes it possible to continue along this line and arrive at instances where almost direct parallels can be found.

Children's drawing is altogether different, but we can nonetheless find a fair amount of "paraphrasing": Larionov's simple-hearted irony from eight-year-old Nina Kulbina's oversized soldiers' heads (figs. 47, 48), for example. Or the child-like joy of Larionov's *Seasons* from seven-year-old M. E.'s *Queen of the Christmas Trees* (figs. 49, 50), which is extremely similar in many aspects to Larionov's work: holiday, flowers, birds, mythological characters. In one, the ritual of decorating the Christmas tree and in the other the ritual of the beginning of autumn; one is a full-length portrait of a tree, topped with the queen's crown, the other a portrait, also full-length, of the Goddess of Autumn in the form of one of Larionov's Venuses, with the childlike gestures of the open arms and the spread fingers. The two works even have a similar frontal, symmetrical composition. Larionov's drawings often play with the page in a childlike manner; they can be turned ninety degrees, even upside down. Children's ignorance of the laws of perspective here turns into an effect of double vision. Finally, in the "modern cave painting,"[25] as Susan Compton refers to Larionov's page "Worlds Halfchildren Call Universnight" (Vselenochku

47 Mikhail Larionov, *Study of a Soldier's Head*, 1911

48 Child's drawing (Nina Kulbina, age 8), *Soldiers*, in *Children's Own Drawings and Stories*

50 Child's drawing (M. E. [Maryana Erlikh], age 7), *Queen of the Christmas Trees*, in *Children's Own Drawings and Stories*

49 Mikhail Larionov, *Autumn* (from *The Seasons*), 1912, detail

zovut mir'ya poludeti) from *The World Backwards*, we can see one of the favorite myths of children, the *golovanogi* ("head-legs," written as one word), in which the child explains the absence of the torso in terms of the relative importance, as he sees it, of man's functions—he needs only a head, in order to eat, and legs, in order to walk.

It is well known that Larionov pursued his interest in children's drawing and, in particular, his collection of drawings, until the end of his life.[26] Yet one fact about Larionov's life in Russia is still little-known, his visit to the exhibition *War in Children's Drawings*, organized by V. Voronov in the spring of 1915 in the Stroganov Institute in Moscow. "Our artist-futurists," reported the newspaper *Women's World* (Mir zhenshchiny), "Mrs. Goncharova and Mr. Larionov, picked out several drawings in the exhibition which they then purchased."[27]

In the mid-1930s, when Larionov's works were removed from the walls of Russian museums and his name disappeared from the pages of Soviet art criticism, the famous art historian Anatoly Bakushinsky, who had written a great deal about children's drawing, considered it essential that he remember Larionov's name in a collection entitled *Children's Art* (Iskusstvo detei): "Each artist takes something different from children's art. . . . In Russia, children's art had a particularly strong influence on the early work of M. Larionov and N. Goncharova. . . ."[28]

This was almost the only reminder of these artists' names in Russia during those years. It is surely telling, therefore, that it should have been made in connection with children's art.

1 M. Larionov, "Introduction," *Pervaya vystavka lubka. Organizovana N. D. Vinogradovym*, exh. cat. (Moscow, 1913).

2 F. Shmit, "Novye nablyudeniya v oblasti izucheniya detskogo risunka," *Problemy sotsiologii iskusstva* (Leningrad, 1926), 55.

3 A. Benois, "Iskusstvo v zhizni rebenka. Khudozhestvennye pis'ma," *Rech'*, no. 289 (26 November 1908): 3.

4 I. Buzhinska, "O dvukh vystavakh v Rige letom 1910," *Chteniya Matveya. Sb. dokladov i materialov po istorii latyshskogo iskusstva* (Riga, 1991), 165.

5 S. Chatskina, "Malen'kie khudozhniki," *Russkaya shkola*, no. 2 (1908): 61.

6 K. Syunnenberg, "Ob 'Azbuke' v kartinakh Aleksandra Benua," *Zolotoe runo*, no. 3 (1906): 134. On the polemic surrounding the publication of this book, see Y. Molok,

"'Azbuka' Aleksandra Benua v nachale i v kontse veka," *Russkaya mysl'*, literary supp. no. 12 (28 June 1991): viii–ix.

7 M. Voloshin, "Vystavka detskikh risunkov," *Rus*, no. 76 (17 March 1908); abridged version in *Liki tvorchestva* (Leningrad, 1988), 2271–72.

8 A. Benois, "Vystavka 'Soyuza molodezhi.' Khudozhestvennye pis'ma," *Rech'* (December 19, 1912). See also: D. Burlyuk, *Galdyashchie 'Benua' i novoe russkoe natsional'noe iskusstvo* (St. Petersburg, 1913), 5.

9 V. Khlebnikov, "Zapiski iz proshlogo" (1915), *Sobranie proizvedenii V. Khlebnikova*, vol. 4 (Leningrad, 1930), 323. On Khlebnikov's interest in children's chants and rhymes, see letter from K. Chukovsky to A. Parnis, 22 November 1968, in *Literaturnoe obozrenie*, no. 4 (1982): 108–9.

10 R. Jakobson, "Noveishaya russkaya poeziya. Nabrosok pervy: Podstupy k Khlebnikovu" (1921), *Raboty po poetike* (Moscow, 1987), 284.

11 M. L. Gasparov, "Schitalka bogov. O p'ese V. Khlebnikova 'Bogi,'" *Russkii avantgard v krugu evropeiskoi kul'tury* (Moscow, 1994), 268.

12 Letter from V. Khlebnikov to M. Matyushin, c. 1912. An article by Khlebnikov entitled "Pesni 13 vesen" is devoted to Militsa's poems. V. Khlebnikov, *Neizdannye proizvedeniya* (Moscow, 1940), 338ff.

13 Yu. Tynyanov, "O Khlebnikove," *Sobranie proizvedenii V. Khlebnikova*, vol. 1 (Leningrad, 1928): 24.

14 D. Burlyuk, "Kubizm. Poverkhnost'-ploskost," *Poshchechina obshchestvennomu vkusu* (Moscow, 1912), 101.

15 V. Zina and A. Kruchenykh, *Porosyata* (St. Petersburg, 1913). A contemporary critic has recently suggested that Zinaida Gippius is in fact behind the Zina V; see L. Katsis, "K semantike odnogo futuristicheskogo teksta," *Iskusstvo avangarda: yazyk mirovogo obshcheniya* (Ufa, 1993). Without entering fully into this question, we should note that this use of children's pseudonyms was common at the time.

16 M. Larionov, "Foreword," *Vystavka kartin gruppy khudozhnikov 'Mishen,'* exh. cat. (Moscow, 1913).

17 "'Mishen.' Po kartinnym vystavkam. Zametki profana," in "Razvlechenie," supplement to the newspaper *Mokovskii listok*, no. 14 (1913): 6; source: S. Dundin.

18 Ya. Tugendkhold, "O detskikh risunkakh i ikh vzaimodeistvii s iskusstvom vzroslykh," *Severnye zapiski* (1916): 124.

19 The memoirs of N. N. Kulbina-Kovenchuk (St. Petersburg, private archive).

20 See D. Filosofov, "Zhorzhik i Garrik," *Rech'*, no. 42 (13 February 1915): 2;

A. Benois, "O detskom tvorchestve," *Rech'*, no. 144 (27 May 1916). I was informed of the *New Journal* supplement by G. Klimov.

21 Letter from R. Jakobson to A. Kruchenykh, after 1 August 1914, in *Jakobson-budetlyanin. Sb. materialov*, ed. B. Jangfeld (Stockholm, 1992), 75.

22 Cited in N. Khardzhiev, "Polemika v stikhakh. K. Malevich protiv A. Kruchenykh i I. Klyuna," *Russkii literaturnyi avangard. Materialy i issledovaniya*, eds. M. Martsaduri et al. (Trento, 1990), 207–8.

23 Later, in 1923, a new book was published: *Sobstvennye rasskazy, stikhi i pesni detei* (Children's own Stories, Verses and Songs), collected by A. Kruchenykh in 1921–22. There were no children's drawings actually included in this publication, although a child's drawing was used for the book cover.

24 See V. Marcadé, "O vlianie narodnogo tvorchestva na iskusstvo russkikh avangardnykh khudozhnikov desyatykh godov 20-go stoletiya," *Communication de la délégation française* (Paris, 1973), 279–98.

25 S. Compton, *The World Backwards: Russian Futurist Books, 1912–1916* (London, 1978), 92.

26 A. Parton writes about this in *Mikhail Larionov and the Russian Avant-Garde* (Princeton, N.J., 1993), the most recent biography of the artist. See also: "Pis'ma N. S. Goncharovoi i M. F. Larionova k Ol'ge Resnevich-Sin'orelli," *Minuvshee 5* (1988).

27 M. Lakhovskaya, "Voina v risunkakh detei," *Mir zhenshchiny*, no. 2 (1915): 9; source: S. Dundin.

28 A. Bakushinsky, "Iskusstvo detei," *Iskusstvo detei. K mezhdunarodnoi vystavke detskogo risunka* (Leningrad, 1935), 15.

"There Is an Unconscious, Vast Power in the Child"

Notes on Kandinsky, Münter and Children's Drawings

Barbara Wörwag

Vasily Kandinsky stayed in Moscow and Odessa for nearly three months at the end of 1910. Kandinsky had emotional ties to the Russian homeland, which caused him during his later years in Munich to return there almost every year. But in addition to these personal motives, the purpose of this trip was to strengthen the existing contacts of the Neue Künstlervereinigung München, founded at the beginning of 1909, to Russian artists' groups. In practical terms, it was a matter of fostering prospects for participation in exhibitions by the members of the NKVM. At the time there were close ties to the group Jack of Diamonds (Karo-bube), an avant-garde exhibition association in Moscow, and to the International Salon Izdebsky in Odessa. "Now all 8 of our Munich friends are invited by me to take part in the Dec. exhibition 'Jack of Diamonds' with two jury-free entries," Kandinsky wrote to Gabriele Münter.[1] One also learns from Kandinsky's correspondence with Münter that he "was totally engulfed by Moscow and the impressions here" and greatly enjoyed his position in the center as both an enthusiast and an innovater of art.[2] He associated with artists, writers and musicians; meetings with the art couple Larionov and Goncharova, among others, are documented.[3]

On 18 November Kandinsky arrived in Odessa to visit parents and relatives. We discover that Izdebsky, the sculptor and secretary of the salon bearing his name, was in the process of setting up his second International Salon there: "That Izd. is doing 2nd Salon is great (. . .) And energetically rubbing people's noses in 'new' art."[4] "Izd. was here yesterday. We spoke a lot. He asked me to write a foreword for the catalogue."[5] Clearly, Izdebsky consulted with Kandinsky shortly before the opening of his second salon, and the latter may have asserted his influence, for besides the Russian avant-garde—represented by the brothers Burlyuk, Larionov

Translated by Andrew Ziarnik

and Goncharova, Tatlin and others—Kandinsky himself had a share in the exhibition: he included fifty-three paintings and studies, and Münter, Jawlensky and Werefkin each exhibited several works, too.

The cover of the small catalogue bears a woodcut by Kandinsky with the motif of the *Knight with his Lance*,[6] and among the numerous contributions are an essay by Izdebsky entitled "The Future City" and, of particular note, Kandinsky's remarks on "Content and Form," in which he explains what the phrase "'new' art" means for him. It says here, among other things, "The work whose outer form completely reflects the inner content is magnificent (that is like the eternally unattainable ideal). In this way the form of the artwork is determined by the essence of the inner necessity."[7] These remarks, which are essential for Kandinsky's later work, were to be more extensively formulated in the essay *On the Spiritual in Art* published about a year later. In our context it is worth noting that "children's drawings" are also on the list of works exhibited, next to still lifes, landscapes, portraits and pictures of markets and winter fairy tales. It can be presumed that the inclusion of this "primitive" genre in Izdebsky's salon can be attributed to Kandinsky's influence, and it may further be true that Kandinsky found his aspiration for an equivalence of "outer form" and "inner content" most fully realized in the pictorial inventions of children.

The interest in art's new forms of expression, especially in the art of "primitive people," was widespread in the first years of our century and can be understood within the context of a far-reaching process of cultural reorientation. The artists of the Russian avant-garde found rich impetus to the primitivistic tendency in, above all, folk art and the painting of icons.[8] The artists of the Blaue Reiter circle (which separated from the NKVM at the end of 1911) turned not only to the folk art of Upper Bavaria but also particularly to the art of children and the naive. Kandinsky later expressed his feeling that "The destructive separation of one art from another, (...) of art from folk art, children's art, from ethnography, the solidly built walls between these often identical phenomena which, in my eyes, are so related, in a word, the synthetic relationships, haunted me."[9] He also further acknowledges primitivism in both of his publications of 1912, *On the Spiritual in Art* and *Der Blaue Reiter* almanac. Franz Marc states in the latter that "The genuine persists always next to the genuine, no matter how different its expression might be," and connects "genuine" art with the aspect of primitiveness that he also discovered in folk art.[10] Even just the choice of pictures for the almanac clearly documents their appreciation of "primitive" art.

The impulse to collect children's drawings presumably originated with Kandinsky as early as the first years of our century; Gabriele Münter later joined him. The exact moment of the beginning of the joint collection can no longer be determined exactly. However, the dating of the children's pictures that have survived—apart from one single page from 1890, which probably was added later—

extend from 1905–06 through 1914. Münter's interest in children's drawings continued even after her separation from Kandinsky. Thus, a number of pages by Swedish children, which Münter had collected there during her stay with friends in 1916–17, have also come down to us. A folder with children's drawings has also been preserved from the time of her artistic new beginning in Munich around 1922–23; the most recently dated ones from this group are from 1930 and 1932. The collection, which grew to over 250 drawings and colored pages, resides today in the archive of the Gabriele Münter- and Johannes Eichner-Stiftung in Munich.

There is hardly any hint of the joint collecting activity in the correspondence between Kandinsky and Münter. Nevertheless, Kandinsky reported from his homeland about numerous experiences with the children of his relatives and friends, about birthday parties and outdoor excursions together. He also talked of a visit to a toy exhibition in Moscow.[11] This should not be surprising, since near Moscow there were several centers for the production of wooden toys (which were collected by Kandinsky—as we know from photographs of his studio—and by other artists).[12] The signatures of a number of sheets from the collection indicate a Russian origin. In addition to drawings by Maschura (fig. 51) and Lilja, the children of Kandinsky's sister, there are other pages with Cyrillic inscriptions, among them thirty drawings by a girl about ten years old named Lilja Kenda Dekabr; on some others Wanitschku (Wanjalein) can be deciphered from the clumsy handwriting of a child. Various inscriptions are in Kandinsky's own hand.

Artist colleagues also collected children's drawings for him. Several early childhood drawings come from Paulot Seddeler,[13] presumably a son of Nikolaj Seddeler, who is pictured together with Kandinsky and Dimitry Kardovsky in a photograph from 1899, and who probably belonged to the group of Ažbé students from Russia.[14] In addition, there are drawings by the little Bloch, one of Albert Bloch's sons, and by Iván Grünewald, the son of a Swedish painter. Reproductions of several drawings by Oskar and Niki, the graphically talented sons of the Munich architect Zeh, have survived, and Kandinsky was probably referring to these when he wrote in his correspondence to Franz Marc regarding the selection of the pictures for the almanac: "Then we bring an Egyptian next to a little Zeh, a Chinese next to Rousseau, a folk picture next to Picasso and so on and so forth."[15]

A substantial part of the collection came from Münter's side. The identity of the children is usually easily determined from the signatures and the greetings. "Greetings to Aunt Ella and Uncle Was. Kiss from Friedel," writes Friedel (Elfriede Schroeter), one of Münter's nieces, on the back side of a postcard with a colorfully painted fairy-tale motif.[16] Annemarie (Mückchen), the daughter of Münter's brother Carl, even captured her own family in a picture (fig. 52). Thirty drawings come from yet another niece, Käthchen Busse. A folder inscribed by Münter, which survives from that time, carries the legend "Children's School Herford." This probably means that Münter herself or relatives following her instructions collected

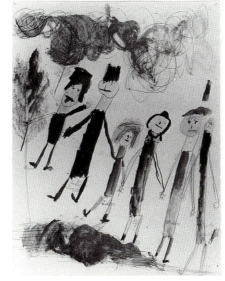

51 Child's colored drawing (Maschura, Kandinsky's niece)

52 Child's colored drawing (Annemarie, Münter's niece)

drawings in the kindergarten there. Yet another bundle includes grades and apparently was created in the drawing class of a Munich school.

It is noticeable that the year and the age of the child are written on most of the collected drawings, if not by the children themselves, then by adults, though mostly in Münter's or Kandinsky's hand. Münter often adds written compliments or indicates individual graphic motifs. The drawings of the children were obviously granted the same esteem as the works of adults: "There is an unconscious, vast power in the child which manifests itself here and which places the work of children as high (and often much higher) than the work of adults," Kandinsky remarks in the almanac.[17]

The surviving collection testifies to the role of chance in the creation of many of the drawings and, at the same time, to the spontaneity with which they captured the fantasies and ideas of the children. Drawing paper, stationery, school notebooks, datebooks, pattern cards, paper napkins and postcards, everything that was at hand was used spontaneously for the fresh expressive inclinations of the children. There are even a number of works consisting of forms cut out of paper and glued to a base, which have a plastic effect and are thus closer to reality than what is only painted. Later, Münter herself often made this kind of collage, which she called a "glue picture." In addition to drawing with pencil and charcoal, the brush was also used in some of these children's drawings, in this way accentuating the joy in the colorful swath of movement. Color predominates in the painted pictures; the color of the surfaces is usually brilliant.

53 Child's drawing (Ella Reiss)

The motifs and themes of the children's drawings are mostly those of familiar domestic surroundings: house and garden, animals, horse and rider, flowers and vehicles, especially locomotives (fig. 53). The people who were closely associated with the children also became frequent subjects; emotional involvements were graphically portrayed. At the beginning of our century children were still largely uninfluenced by pictures from the media; their creative energies centered on the imitation of nature. Far from the adaptation of already formed images, children retained a direct relation to things in the world and correspondingly powerful directness of expression. Therefore, Kandinsky could write of the great fascination of the child who, dependent only on himself, makes his first acquaintance with things (for example, the spectacle of a candle).[18]

Drawings of practically all age groups are preserved in the collection established by Kandinsky and Münter, and they range in scope from the scribbling stage of little children to the quite impressive pictures of animals and people by twelve- and thirteen-year-olds. The best example of the latter is found in the four watercol- or drawings of the thirteen-year-old Lydia Wieber, which are reproduced in the almanac on a double page under the title *Sitting* (fig. 54); unfortunately, the origi- nals have not survived. The girl's name was entered by Kandinsky in the handwrit- ten table of contents for *Der Blau Reiter* almanac after "Van Gogh."[19] The drawings reproduced in the almanac will be discussed in greater detail later.

When it came to the graphic expressions of children, the high degree of imme- diacy may have fascinated Kandinsky and Münter. That which is already known or

54 Child's watercolor study in four parts (Lydia Wieber, age 13), *Sitting*, from *Der Blaue Reiter*

55 Child's drawing (Paulot Seddeler) **56** Child's drawing (Paulot Seddeler)

adapted from conventional styles of drawing has a relatively small place in the collection; rather, the act of comprehension through visual experience is graphically and concretely rendered. The particular ingenuity of children in formally conquering an object or a spatial situation on paper manifests itself.

The examples of the earliest phases of childhood graphic expression come from the four-year-old Paulot Seddeler: ladder forms, mandala figures and box people (figs. 55, 56). In their reduced simplicity, these can indeed be viewed as inspiration for the formal simplification in Kandinsky's transition to abstract painting. Distinct signs of simplification appear in Kandinsky's sketchbooks beginning in 1907–08. Some of the sketches reveal a summary figuration; the stroke abandons precision of rendering, with little attention still paid to detail (figs. 57, 58).

Through this kind of reduction, Kandinsky departs from the highly complex conventions of representation. At the same time, reduction means, most of all, a return to the simple line. For children at an early stage of development, line is the simplest method of seizing an object. Lines present a thing by its contour, its outer shell (figs. 59, 60). However, the line characterizes not only the outer form, but at the same time something of an object's essence—be it softness or sluggishness, or even hardness and vigor—in order to characterize it as a living thing or as a solid object. In this way the line not only imitates that which is outwardly visible, but it

57 Vasily Kandinsky, *Mountain with Domed Towers and Two Figures*, 1908–9

58 Vasily Kandinsky, *sheet of studies*, ca. 1909

also shows qualities of the depicted object's nature, as, for example, in the child's portrayal of a bird (fig. 60).

In one of Kandinsky's brush, pen and ink sketches from 1910–11 (fig. 61), the animal probably relates to the picture behind glass, *Fantasy Bird and Black Panther* (1911).[20] This brush, pen and ink composition, which relies entirely on contrast, shows in the upper left part of the picture an oval creature with a head and a distinctly marked bill—clearly a bird. Because of its featherless nakedness, the organic body created from the pure line evokes the impression of vulnerability and endangerment. A wolflike animal moves along the lower border: its erect tail, its black head and open jaws evoke a feeling of fear; the surrounding bristly, upright plant forms underscore the drama. This preliminary sketch demonstrates how Kandinsky achieves an intensification of expression from the power of the line and the accentuation of the black-white contrast. The linear forms become the vehicles of polar opposites in things that exist. Something similar can also be seen in a child's graphic language, in which certain linear constructions express primary emotions in stark contrast.[21]

A few of Kandinsky's sketches for paintings from 1910–12 (fig. 62) show an even greater renunciation of distinctness and individualization of form. The figures, reminiscent of the box people of young children (fig. 56), are, of course, still explainable as objects, but the message imparted is obscured through distortions of form and the ambiguous treatment of space.

 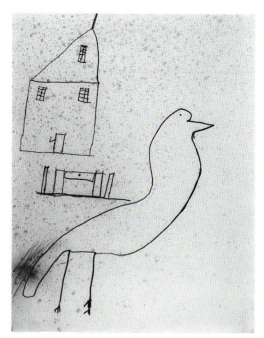

59 Child's drawing (Wolfgang) **60** Child's drawing (Elisabeth Busse)

The cultivation of the line is also very pronounced in Münter's work during this creative phase. In addition to drawing on the influences of French painting and graphics, and the inspiration of folk art,[22] she very well may have subjected her nieces' drawings to serious examination in order to achieve the plainness of style that is characteristic of many of the paintings of 1908–12. Nevertheless, whereas Kandinsky's line gains more of an identity on its own as an abstraction, Münter's pronounced contour drawing always signifies an object (fig. 63). Let it be noted here: Kandinsky's adaptation of the graphic vocabulary of children is fundamentally different from Münter's. Whereas Münter makes very direct use of childlike forms and motifs, Kandinsky uses them more to synthesize many artistic impressions that ultimately lead to a liberation from the concrete. Thus, he remarks in the autobiographical essay, "Reminiscences" (Rückblicke), published in June 1913:

> Only after many years of patient work, of strained thinking, of numerous careful attempts, of ever-developing ability to experience graphic forms in an unadulterated way and abstractly, to become ever more deeply engrossed in these immeasurable depths, I arrived at the graphic forms with which I work today (on which I work today) and those, as I hope, will develop much further.[23]

61 Vasily Kandinsky, *Wolflike Animal and Bird*, 1910–11

The free and unconventional spatial organization in the drawings of children was a particular inspiration for both artists. The spatial concept of some of Kandinsky's preliminary drawings in the sketchbooks of 1908–09 is laid out in stagelike layers, as in some of the drawings by children. The superimposition of two-dimensional planes, as in early medieval painting, involves a stacking, one behind the other, of concrete or scenic motifs. Of course compositional elements that create depth, such as diagonally drawn paths or mountain chains and hills leading into the background, do appear but the relationships are not developed with perspectival foreshortening. The lower edge of the picture often serves as a reference point for Kandinsky. The region of the sky is bounded by the upper edge (figs. 64, 65).

In some oil studies that have recently been discovered among Gabriele Münter's works, Münter's direct engagement with the "primitive" models becomes clear

62 Vasily Kandinsky, study for *Improvisation 7* (2nd version), 1910

63 Gabriele Münter, study for *Kandinsky at the Tea Table*, ca. 1910

64 Vasily Kandinsky, *Landscape with Female Form and Rider*, ca. 1907

65 Child's drawing (Josef Wechsler)

66 Child's drawing (Thomas Hermann)

67 Gabriele Münter, *Untitled*, copy after figure 66, 1914

(figs. 66, 67). These studies demonstrate the literal adoption of the spatial concepts from children's drawings. Depth is created as in comic strips with parallel spatial regions. A broad ground region makes the horizon, which is suggested in Münter's picture by means of a fence or a stream, appear only as a thin strip along the upper edge. The ground region can accommodate various motifs in its large expanse, for example, a path, a grazing animal, a streetlamp and trees. Nevertheless, these are all placed two dimensionally into the staggered spatial system, as in a "pop-up picture." Münter achieves depth by pointedly exaggerating the motifs of the middle

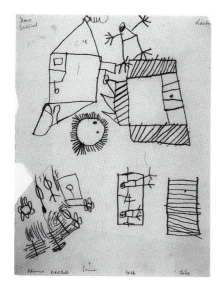

68 Child's drawing (anonymous) **69** Child's drawing (anonymous)

region, as compared with the children's drawing, but also by reducing the figures along the upper edge.

There are some examples in the collection of children's drawings that demonstrate the principle of "folding out," which is often used by children. For example, fences that serve to delineate a garden are two dimensionally folded outward, in order to make the spatial situation visible without problems in perspective portrayal (fig. 68). Everyday objects are drawn with great ingenuity—for example, a table with its legs slanting outward (fig. 69)—as if seen by children for the first time. In doing so, the child completely disregards the structural rules. According to Kandinsky, one of the reasons for the strong effect of children's drawing lies in this originality of conception:

> That which is practical and functional is foreign to the child because the child sees every object with unaccustomed eyes and still possesses the unclouded ability to perceive the object as such. (...) In this way the inner tone of the object spontaneously reveals itself without exception in every children's drawing.[24]

According to Kandinsky, seeing with "unaccustomed eyes"—in a way that seems faulty and awkward to us in the child's portrayal—imparts something unseen about the objects depicted. He calls this the "pure inner tone,"[25] something which, above and beyond the visible, we cannot objectively name and which we can perceive only through feeling. He explains his own conception of form in the same way in a letter to Münter from 1910, written before the publication of both relevant essays:

Now, as you know, I am altogether against hard, overly precise form which cannot exist "today" and altogether comes to a dead end. I have defined form very well and concisely in my brochure [the manuscript of a lecture presented to musicians and artists in Moscow on 9 October 1910]. Outwardly—delimitation; inwardly—outward expression of the inner. If you really feel what I mean by that (not philosophize, but simply understand, feel!) then you will also find the form. One must let the form influence itself and forget all of Picasso and Picassoisms.[26]

Accordingly, the form as such was not the objective of Kandinsky's artistic endeavors, but rather he sought the inner content of form: he states elsewhere, "direct building on feeling and the physical-psych. effect."[27]

An essential characteristic of children's drawing becomes evident in the variety of themes and their graphic transformation in the collected drawings: the absolute openness vis-à-vis everything emotional. For children the possibility of portraying the invisible is a matter of course; they give feelings visible existence. This peculiarity, of which Kandinsky was no doubt aware early on, may have been a fundamental factor in his attraction to children's drawings and in his reference to them. Many examples of the collection bring this to mind. One of the main themes is the human being. An especially pronounced sympathy for people intimately associated with children becomes apparent here: mother and father, siblings and close friends. Gestures of joy, of sadness, or of yearning for love and affection become very expressive through exaggerations and distortions of body parts. These gestures are transformed into a graphic language that expresses a spiritual life of which the child often is not conscious (fig. 70).

The collected drawings also reveal an intense emotional connection to animals, which early on are experienced by children as something essentially different than themselves. There are numerous pages with portrayals of animals. These at first have more to do with the "animal-like" itself, expressed, for example, through many legs, than they do with the distinction of individual animal types. In particular, horses can be seen in a number of drawings and they are usually drawn with a rider; they are even more often found in the child's immediate realm of experience.

The horse also plays an important role in Kandinsky's own memories of childhood.[28] As a vehicle for the expression of force and movement, the horse obtains a symbolic character in his oeuvre: "The horse carries the rider with force and speed. But the rider leads the horse."[29] Kandinsky's portrayals of horses are naturalistically constructed, for the most part, as in the various sketches for the cover of the almanac created in 1911 (fig. 71). These portrayals of horses were perhaps inspired by drawings of the brothers Niki and Oskar Zeh, which were meaningful enough to Kandinsky that he had asked the children's father to let him have them for an exhibition in Moscow.[30] During recent investigations in

70 Child's drawing (anonymous)

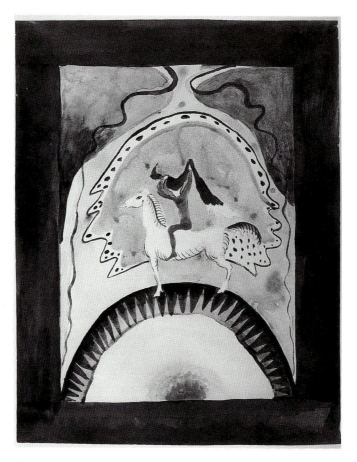

71 Vasily Kandinsky, study for the cover of *Der Blaue Reiter*, 1911

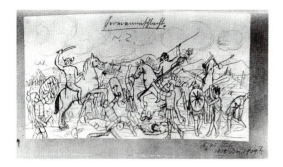

72 Child's drawing (Niki Zeh), *Teutonic Battle*, 1908–9

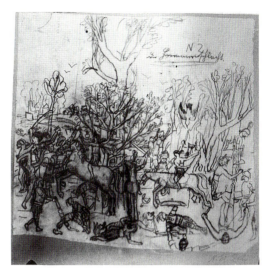

73 Child's drawing (Niki Zeh), *Teutonic Battle*, 1908–9

Münter's estate, photographic reproductions from that time, presumably of these drawings, were found with the signatures "N. Z." and "O. Z." They were inscribed by Münter with the full names and the respective dates 1908 and 1909. A wild tumult of riders and horses, infantry and equipment can be seen in the two works entitled *Teutonic Battle* (Germanenschlacht) (figs. 72, 73). The extremely lively renderings of horses, the rearing postures, and the pronounced realism of those almost personified figures, are striking. Nevertheless, it can be assumed that the "compositional form" of the pictures, in addition to the high quality of the drawing, especially fascinated Kandinsky. The reproduction of an elephant by Oskar Zeh is also preserved (see fig. 84), which, along with another preserved child's drawing of the same motif, could have inspired Kandinsky's picture *The Elephant*, created in 1909.

The house belongs to the immediate world surrounding the child, and, for this reason, it is portrayed in great variety in this collection of children's drawings. Its great frequency permits one to conclude that the notion "house" is enriched with the feeling of safety. As can be recognized in many drawings in the collection, the graphic rendering is tied to a formal schema: the front side is drawn head-on and is usually equipped with a door and windows; above this rises a gabled roof with a chimney issuing smoke. In this way, the symbol "house" as a totality evokes protection and warmth.

Münter occupied herself with the various types of houses portrayed by children in an entire series of oil studies. In copying single drawings of the collection she adopts all formal details from the respective model, including the coloring. A

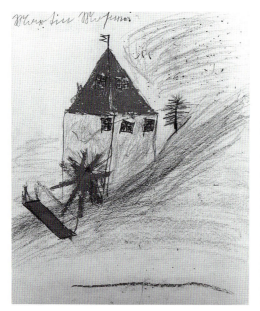

74 Child's colored drawing (Martin Mosner) **75** Gabriele Münter, *Untitled*, copy after figure 74, 1914

child's drawing of a mill on a stream (fig. 74) is emulated by Münter in all details down to the cloud formation, the spatial position of a building resting on a slope and a waterfall plunging before it (fig. 75). Whereas the child's first sketch still shows the house purely two dimensionally from the frontal point of view, the version executed later, by Münter, reveals attention to cubist construction. In a difficult artistic phase shortly before the beginning of World War I, when she lost confidence above all because of Kandinsky's unswerving strides ahead on the path to abstraction, Münter further oriented herself in the concrete. By delving into the spirit of the child's aesthetic perception of form, she hoped for inspiration for the independent continuation of her own oeuvre, apart from Kandinsky's.

Previous investigations have already made clear that, with regard to Kandinsky's graphic references to children's drawings, it cannot be a matter of concretely tracing specific formal similarities back to one child's drawing or another. Kandinsky's notions of form were complex, and his intuitive perception of form was too independently defined for him to need to borrow motifs. Rather, he reduced the works of children to their effective qualities, in order then to combine them and contrast them with other elements. Regarding his own creative production, he remarked:

I could never bring it upon myself to use a form that—in a logical way—did not arise in me purely from my feelings. I could not construct any forms, and it disgusts me when I see

76 Vasily Kandinsky, study for *With Sun*, 1911

such forms. All the forms which I ever needed came "spontaneously," they appeared complete before my eyes and it was only up to me to copy them, or they arose during my work, often surprising even me.[31]

In examining the preliminary sketch of 1911 (fig. 76), for the painting behind glass *With Sun*, individual principles become evident that essentially establish Kandinsky's affinity for children's draftsmanship. The preliminary sketch belongs to a larger group of pictures and is closely related not only to the picture behind glass, but also to the painting *Improvisation 21a*, also from 1911, and to the oil *Little Pleasures*, created in 1913. In this preliminary sketch, a planar, layered space contains various hills staggered, one on top of another, almost to the upper edge of the picture. As in a child's representation of space, this overlapping is not hard to translate as spatial recession. Numerous concrete symbols like people, houses and a boat are not presented plastically, but rather as planar elements into the system of distances and groupings. The pair of figures lying on the right is drawn around a base line according to the principle of folding back. To the left, simple formulas for

people can be recognized standing on the lower edge—an extended torso with an implied oval for a head, breaking out of the convention set by the remaining figures. A boat on the left edge of the picture with three stick figures, easily recognizable as rowers, moves upward and into the background; this movement is caused by the delimiting edge of the page. The domes and towers of both palaces, which are settled one on top of the other, have begun to totter and, thus, appear to be freed from material laws. The top of the uppermost citadel is abruptly truncated, an artistic measure that would be unthinkable for a child. The large sun after which the work is titled is supplied with long rays in a childlike manner and is placed like a cutout in the upper right corner of the drawing. The sun motif underscores the expression of relaxed cheerfulness and childlike innocence. Three riders create an antithesis by attempting to storm the castle that is situated at the top right. They awaken a mysterious element, as do the box figures in the left foreground, breaking up the unity of feeling; the castles that wobble above a steep drop-off augment this alternative spirit.

With regard to their content, the connotations of the individual motifs have been frequently debated and will not be further discussed here. As in the drawings of children, subjective conceptions are solidified here into symbolic forms through Kandinsky's highly concrete symbols. One's empirical knowledge of objects is overturned and transformed into its opposite: the hard becomes soft, buildings quiver, the laws of gravity are annulled. We are familiar with a similar tendency among the figures in the drawings of children (figs. 77, 78). Kandinsky conjures up the image of another world in which the objects, stripped of their materiality, have transformed themselves into something spiritual (see figs. 57, 58).

Vasily Kandinsky held throughout his life the strong impressions and images of his childhood in Russia, stored up in a prodigious "photographic memory." Many forms originated in this graphic memory, as he himself attests.[32] First impressions and images are also captured in the children's drawings he collected. These are original images, archetypal forms similar to those that every human being, regardless of cultural background, first perceives in early childhood and, therefore, feels with particular intensity and depth. Nevertheless, Kandinsky describes almost with sadness the loss of this original ability to experience anew: "the world gradually (. . .) loses its magic. One knows that trees cast shadows, that horses can run faster and automobiles even faster, that dogs bite, that the moon is far away, that the person in the mirror is not real."[33] The drawings of children, which express the more immediate impressions, thus become documents of a universal humanity. Finally, the universal in the artistic language of children is founded on this. That the search for a universal human value in his painting was essential for Kandinsky is evident from a statement he made to Will Grohmann, later his biographer: "And much later I left the Russian starting point and switched over to the universally human."[34]

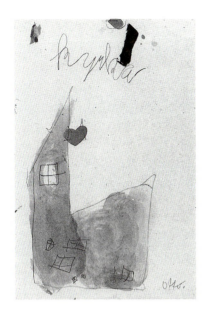

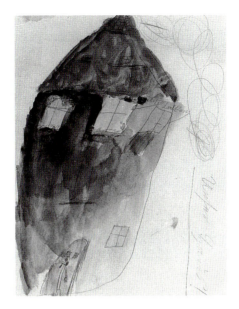

77 Child's watercolor (Otto)

78 Child's watercolor (Annemarie, Münter's niece)

One of Kandinsky's paintings may, in a certain way, illustrate with what striking force individual motifs become effective, independent of a particular time and space, and thus, universal. This is the image of the locomotive, frequently portrayed in children's drawings and adapted in several versions by Kandinsky. The picture *Locomotive near Murnau*, 1909 (fig. 79), is able to transcend the entire complex of conceptions, feelings and memories, symbolized in the picture by the rapidly moving train and a child waving. On the one hand, this complex is connected with the experience of parting and change; on the other, with home and remaining (represented by the static quality of the solidly built town).

The first spiritual experience of a situation as, so to speak, an original model, remains valid for subsequent experiences of this kind and is indelibly impressed on the memory. Kandinsky expresses this in his essay *On the Spiritual in Art* by describing, in an ontogenetic sense how, as a child, every human being has "a very intensive interest" in objects (for example, the light of a flame). "Only the customary objects have, in the case of a person of mediocre sensitivity, a very superficial effect. However, those which we encounter for the first time immediately make a spiritual impression on us. This is how the child perceives the world."[35] Adults have lost this experience; the only effect that objects still have on them is purely physical. Only through a higher development of the human being do "objects and creatures" recover their ability to evoke a psychic effect along with the physical; Kandinsky calls this their "inner sound."[36]

If, after these considerations, one now looks at the children's drawings chosen by Vasily Kandinsky and Franz Marc for reproduction in the almanac, then a

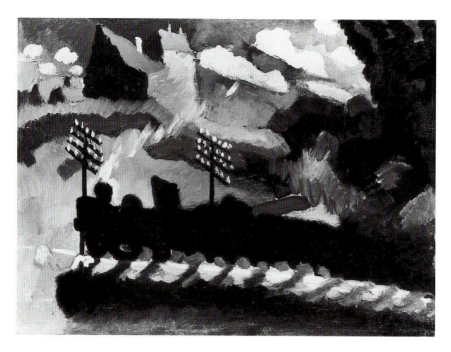

79 Vasily Kandinsky, *Locomotive near Murnau*, 1909

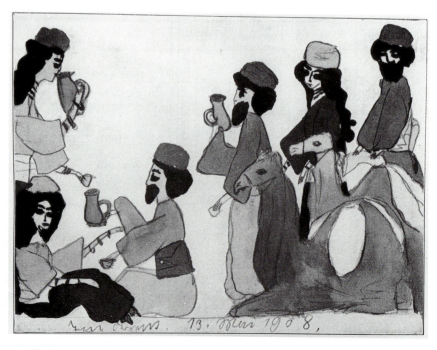

80 Child's watercolor study (Lydia Wieber), *Arabs*, from *Der Blaue Reiter*

contradiction remains, which can be clarified only with difficulty: not one of those early, awkward graphic expressions, whose force Kandinsky so vigorously emphasizes, can be found there. Very skillful or even conventional drawings by children (ones that seem as if made by adults for children) are reproduced there under the caption "child's drawing." Besides Lydia Wieber's four-part watercolor study *Sitting*, which was mentioned above and which exhibits a high degree of spiritual and psychological expression through both the pose and the rendering of the face, and the drawing *Arabs* (fig. 80), finished almost at the same time by the same girl, are two skillfully arranged full-page still lifes by children that follow Picasso's 1911 cubist picture *La femme à la Mandoline au Piano*. Both of two other pictures were "put together for a frieze by adults,"[37] as the editors state in the index of the almanac's reproductions. These other pictures show in narrow cartoons a farmyard with various animals, or in another case, the motif of the "old town" (figs. 81, 83). Because both reproductions carry the signatures N. Z. and O. Z., one can assume that the parents of the Zeh brothers cut out individual graphic motifs painted by their children and arranged them as a collage into the friezes portrayed in the almanac. Further pieces of the graphic material reproduced at that time

81 Children's drawing (Niki Zeh and Oskar Zeh), from *Der Blaue Reiter*

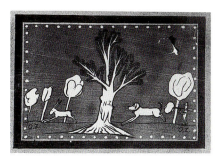

82 Children's drawings (Niki Zeh and Oskar Zeh)

83 Children's drawing (Niki Zeh and Oskar Zeh)

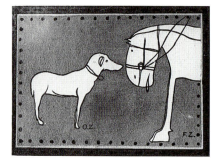

84 Children's drawings (Oskar Zeh and F. Zeh)

and similar collages by the Zeh brothers are still preserved in the archives of the Gabriele Münter- and Johannes Eichner-Stiftung (figs. 82, 84, 85).

But what might have prompted the editors to incorporate into the almanac this kind of children's art that has so little originality? Kandinsky expresses himself there in several places on the subject of the children's drawing. In his essay "On the Question of Form," he especially stresses a peculiarity of the children's drawing, the quality of the "compositional form": "Here I only want to stress one aspect of the good children's drawing which is important to us: the compositional aspect."[38] This "amazing quality" of compositional form, which Kandinsky also ascribes to folk art,[39] essentially develops, in analogy to music, as a "subordination of the individual elements to *one* sound."[40] The composition must lead the elements in one association: "This association can be conspicuously harmonic or conspicuously dissonant. A schematized or concealed theory of rhythm can be applied."[41] There is a kind of rhythmic arrangement that is revealed particularly by both friezes, but also by the watercolor study *Arabs*. This rhythmic arrangement, as well as the artistically skilled composition of both still lifes as they are portrayed in the almanac, enables the choice to appear under one uniform principle.

85 Child's drawings (anonymous), from *Der Blaue Reiter*

Kandinsky's comments in the almanac on "compositional form" touch one aspect which he viewed as absolutely characteristic of modern art: "The modern urge to reveal the purely compositional, to unveil the future laws of our great era, this is the force which compels the artists to strive on various paths to one goal."[42]

I would like to thank Ilse Holzinger, Managing Director of the Gabriele Münter- and Johannes Eichner-Stiftung, Munich, for her help in accessing the documentary material. All translations are by Andrew Ziarnik unless indicated differently.

1 Kandinsky to Münter, Moscow, 22 October 1910, Gabriele Münter- and Johannes Eichner-Stiftung (GMJE-St.), Munich. "Nun werden alle unsere 8 Münchner durch mich eingeladen mit 2 juryfreien Werken in der Dez.-Ausstellung 'Bubnowi Walet' (Karo-Bube) teilzunehmen."
2 Kandinsky to Münter, Moscow, 20 October 1910. GMJE-St. "Total von Moskau u. den Eindrücken hier verschlungen war."
3 Kandinsky to Münter, Moscow, 21 October 1910, GMJE-St.
4 Kandinsky to Münter, Odessa, 2 December 1910, GMJE-St. "Dass Isd. 2ten Salon macht, ist doch famos (. . .) Und nur recht energisch den Leuten nur 'neue' Kunst und recht nahe an die Nasen halten."
5 Kandinsky to Münter, Odessa, 4 December 1910, GMJE-St. "Gestern war Isd. hier. Wir haben Menge besprochen. Er bat mich, ein Vorwort für den katalog zu schreiben."
6 Konrad Roethel, *Das druckgraphische Werk*, nr. 81.

7 "Inhalt und Form," in *Soderzanie i forma*, in Salon 2 von Izdebsky. exh. cat. (Odessa 1910–11), 15 (trans. from the original). The essay also appears in Neue Künstler-Vereinigung München e. V. exh. cat. (Munich, 1910–11). "Herrlich is jenes Werk, dessen äußere Form ganz dem inneren gehalt entspricht (das ist wie das ewig nicht erreichbare Ideal). So ist die Form des Kunstwerks durch das Wesen der inneren Notwendigkeit bestimmt."

8 Nicoletta Misler and John E. Bowlt, "Der Primitivismus und die russische Avantgarde," in *Russische Avantgarde und Volkskunst*, exh. cat. (Baden-Baden, 1993), 15.

9 Vasily Kandinsky, *Der Blaue Reiter* (Rückblick), in Paul Vogt, *Der Blaue Reiter*, documentary appendix (Cologne, 1991), 104; reprint from: das Kunstblatt, XIV (Jahrgang, 1930), 57ff. "Die verderbliche Absonderunge der einen Kunst von der anderen, (...) der Kunst des Volks-, Kinderkunst, von der Ethnographie, die fest gebauten Mauern zwischen den in meinen Augen so verwandten, öfters identischen Erscheinungen, mit einem Wort, die synthetischen Beziehungen, ließen mir keine Ruhe."

10 Franz Marc, "Zwei Bilder," in *Der Blaue Reiter*, Franz Marc and Vasily Kandinsky, eds. Reprinted in a Documentary New Edition, ed. Klaus Lankheit (Munich 1994), 33. "Echtes bleibt stets neben Echtem bestehen, so verschieden auch sein Ausdruck sein mag."

11 Kandinsky to Münter, Moscow, 17 October 1910, GMJE-St.

12 Irina Boguslawskaja, "Volkskunst," in *Russische Avantgarde und Volkskunst*, 37 n. 8.

13 In the archives of the Gabriele Münter- und Johannes Eichner-Stiftung there is a postcard from A. Seddeler to Vasily Kandinsky from Moscow dated 27 July 1911. In this card Seddeler (presumably Niclolaj Seddeler's wife) informs Kandinsky that she intends to return to Munich with Paulot. In 1911 Paulot Seddeler was four years old, as can be determined from the signature of a drawing.

14 Originally from Ljubljana in Slovenia,

Anton Ažbé (1855–1905) had studied at the Wiener and the Münchner Akademie and founded his own drawing and painting school in Munich in 1891. Kandinsky was Ažbé's student from 1897 to 1899, before he went to study with Franz von Stuck at the Akademie.

15 Kandinsky to Franz Marc, in *Wassily Kandinsky / Franz Marc—Briefwechsel*, ed. Klaus Lankheit (Munich, 1983), 40ff. "Da bringen wir einen Ägypter neben einem kleinen Zeh, einen Chinesen neben Rousseau, ein Volksblatt neben Picasso u. drgl. noch viel mehr!"

16 See the children's drawing by Elfriede Schroeter, GMJE-St. KIZ 35. All of the children's drawings mentioned here are kept in the archives of the Gabriele Münter- und Johannes Eichner-Stiftung and are documented under "KIZ" inventory numbers. "Gruß an Tante Ella und Onkel Was. Kuß von Friedel."

17 Vasily Kandinsky, "Über die Formfrage," in *Der Blaue Reiter*, 169 n. 10. "Es ist eine unbewußte, enorme Kraft im Kinde, die sich hier äußert und die das Kunstwerk dem Werk der Erwachsenen gleich hoch (und oft viel höher) stellt."

18 Vasily Kandinsky, *Über das Geistige in der Kunst*, 10th ed. with an introduction by Max Bill (Bern, 1952), 59ff.

19 Watercolor studies by Lydia Wieber, in *Der Blaue Reiter*, 134 n. 10, 311; see also Siegrid Köllner, "Der Blaue Reiter und die vergleichende Kunstgeschichte," Ph.D. diss. (Karlsruhe, 1984), 62.

20 Erika Hanfstaengl, ed., *Wassily Kandinsky, Zeichnungen und Aquarelle*. Catalogue of the collection of the Städtische Galerie im Lenbachhaus (Munich, 1981), Nr. 165.

21 Hans-Günther Richter, *Die Kinderzeichnung, Entwicklung. Interpretation. Ästhetik* (Düsseldorf, 1987), 33.

22 Annegret Hoberg, "Gabriele Münter in München und Murnau," in *Gabriele Münter, 1877–1962, Retrospektive*, exh. cat. (Munich, 1992), 33ff.

23 Vasily Kandinsky, "Rückblicke," in *Der Sturm*, exh. cat. (Berlin, 1913; reprint, Bern, 1983), 20. "Erst nach vielen Jahren geduldiger Arbeit, angestrengten

Denkens, zahlreicher vorsichtiger Versuche, sich immer entwickelnder Fähigkeit, die malerischen Formen rein, abstrakt zu erleben, immer tiefer in diese unermeßlichen Tiefen sich zu vertiefen, kam ich zu den malerischen Formen, mit denen ich heute arbeite (an denen ich heute arbeite), und die, wie ich hoffen will, sich weiter entwickeln werden."

24 Vasily Kandinsky, "Über die Formfrage," in *Der Blaue Reiter*, 168 n. 10. "Das Praktisch-Zweckmäßige ist dem Kind fremd, da es jedes Ding mit ungewohnten Augen anschaut und noch die ungetrübte Fähigkeit besitzt, das Ding als solches aufzunehmen. (. . .) So entblößt sich in jeder Kinderzeichnung ohne Ausnahme der innere Klang des Gegenstandes von selbst."

25 Ibid., 161.

26 Kandinsky to Münter, Moscow, 26 October 1910, GMJE-St., page 2. "Nun, wie du weisst, bin ich überhaupt gegen harte, zu präzise Form, die 'heute' nicht sein kann u. auch überhaupt mit einer Sackgasse endet.
"Was Form ist, habe ich wirklich gut und knapp definiert in meiner Broschüre. Äußerlich—Abgrenzung; innerlich— äusserlicher Ausdruck des Inneren. Wenn du wirklich fühlst, was ich damit meine (nicht philosophieren, nur einfach verstehen, fühlen!) dann findest du auch die Form. Die Form muß man auf sich wirken lassen u. alle Picasso u. Picassore vergessen."

27 Kandinsky to Münter, Moscow, 3 October 1910, GMJE-St.

28 Kandinsky, "Rückblicke," 7 n. 22.

29 Ibid., 22. "Das Pferd trägt den Reiter mit Kraft und Schnelligkeit. Der Reiter führt aber das Pferd."

30 There is a letter dated 8 May 1911 from the architect August Zeh to Kandinsky, in which Zeh inquires about three children's drawings lent to Kandinsky and asks for information about an exhibition in Moscow. Presumably there were three Zeh brothers; besides Niki (born in 1900) and Oskar, who later became a sculptor and portrait artist, the initials F. Z. are also found on a collage. The parents apparently promoted their sons' graphic talent, and it received much attention, so that some eighty of their drawings were exhibited in the Galerie Brakl in Munich in April 1911. This exhibition is discussed in *Münchner Neueste Nachrichten*, 12 April 1911.

31 Kandinsky, "Rückblicke," 22 n. 10. "Nie konnte ich es über mich bringen, eine Form zu gebrauchen, die auf logischem Wege-nicht rein gefühlsmäßig in mir entstand. Ich konnte keine Formen ersinnen und es widert mich an, wenn ich solche Formen sehe. Alle Formen, die ich je brauchte, kamen 'von selbst', sie stellten sich fertig vor meine Augen und es blieb mir nur, sie zu kopieren, oder sie bildeten sich schon während der Arbeit, oft für mich selbst überraschend."

32 Kandinsky, "Rückblicke," 22 n. 10.

33 Kandinsky, *Über das Geistige in der Kunst*, 60 n. 10. "Allmählich wird die Welt (. . .) entzaubert. Man weiß, daß Bäume Schatten geben, daß Pferde schneller laufen können und Automobile noch schneller, daß Hunde beißen, daß der Mond weit ist, daß der Mensch im Spiegel kein echter ist."

34 Kandinsky to Will Grohmann, Weimar, 12 October 1924, Grohmann-Archiv, Staatsgalerie Stuttgart. "Und viel später verließ ich die russischen Ausgangspunkte und ging zu Allgemeinmenschlichem über."

35 Kandinsky, *Über das Geistige in der Kunst*, 59 n. 18. "Ein stark intensives Interesse;" "Nur die gewohnten Gegenstände wirken bei einem mittelmäßig empfindlichen Menschen ganz oberflächlich. Die aber die uns zum erstemal begegnen, üben sofort einen seelischen Eindruck auf uns aus. So empfindet die Welt das Kind."

36 Compare Felix Thürlemann, "Kandinsky's Theorie des 'inneren Klanges,'" in Felix Thürlemann, *Kandinsky über Kandinsky* (Bern, 1986), 115.

37 Kandinsky and Marc, eds., *Der Blaue Reiter*, 341 n. 10. "Von Erwachsenen für einen Fries zusammengestellt."

38 Kandinsky, "Über die Formfrage," 169 n. 24. "Hier will ich aber nur eine uns

wichtige Seite der guten Kinderzeich-
nung betonen: die kompositionelle."

39 Ibid., 169.

40 Ibid., 157. "Unterordnung der einelnen
Elemente *einem* Klang."

41 Ibid., 172. "Dieser Zusammenhang kann
auffallend harmonisch sein oder auffall-
end disharmonisch. Es kann hier eine

schematisierte Rhythmik angewendet
werden oder eine versteckte."

42 Ibid., 172. "Der unaufhaltsame Drang von
heute, das rein Kompositionelle zu offen-
baren, die künftigen Gesetze unserer
großen Epoche zu entschleiern, ist die
Kraft, die die Künstler auf verschiedenen
Wegen zu einem Ziele zu streben zwingt."

Paul Klee and Children's Art

Marcel Franciscono

With the possible exception of Jean Dubuffet, no artist has been more identi-fied with the art of children than has Paul Klee; certainly none has made more varied and persistent use of it. Throughout his career Klee's work exhibits many of the features commonly attributed to the drawings of very young children: scribbled forms; a diagrammatic simplicity of composition; and outline figures rendered in a primitive geometry, often only partial, sometimes reduced to mere sticks.[1] Until well after his death in 1940 Klee's critical reputation was col-ored by the claim, for better or worse, that his work also resembled the art of young children in its expression: in its playfulness, its insouciance of technique and—among his admirers—its childlike understanding of essential things.[2]

Before the mid-1920s Klee encouraged this last view by his public writings and by his diaries (which, in the surviving clear copy edited by Klee, were intended for publication).[3] Not until 1924, in a lecture he gave in Jena, did Klee finally react publicly to the misconceptions inherent in the association of his art with the art of children: "The tale of the infantilism of my drawings must have arisen from those linear formations in which I tried to unite the idea of an object—let's say a person—with a pure representation of the element of line."[4] Klee was, of course, right to point out the professional basis of his simplifications; but his explanation is disingenuous, for if, as has been argued, the misunderstanding arose from the inability of his critics to accept his principle of reduction,[5] the principle as Klee applied it was itself the cause of the problem. Reduction does not need to suggest naiveté, as the line drawings of Rodin and Matisse had already demonstrated. Klee laid himself open to the charge of infantilism, obtuse as it may have been, in part because his simplifications suggested, and were in fact influenced by, the work of children.[6]

Klee's interest in the art of children began at the climax of a long fascination on the part of artists and poets with the potentiality of children. The creative vitality of childhood had been discovered in the course of the eighteenth and nineteenth centuries, but it was the early modern search for an alternative to the imitation of nature that first gave license to the serious use of children's drawings. One can only wonder that they were taken over at all by artists, given that their forms were the products of a gross lack of skill, however admirable their expressive properties might be. But in fact the difficulty seems to have been less the formal awkwardness of joining the naive and unskilled work of children to that of trained artists than the practical one of risking public contempt, of laying oneself open to the charge of childishness or incompetence. As we know from Klee's own career, the latter danger was all too real; but in hindsight, at least, it seems to have been relatively easy for artists to accommodate the devices of children's drawings to their own art. They accomplished it not so much by ignoring the inevitable associations of children's art with naiveté as by making an effect of childlike directness one of the distinguishing marks of authentic personal vision. Klee shared the long-held appreciation of the untrained originality of children's art. In October 1902 he rediscovered some of his early childhood drawings in his parents' house in Bern, where he was then living. They were, he reported proudly, "among the most significant" he had made, "independent of the Italians and Netherlanders, full of style and naively observed."[7] To be attracted to the naiveté of children's drawings was by then a commonplace, but what it meant for Klee in practice was anything but conventional.

Attempts to return to an innocent vision had already been made at the beginning of the nineteenth century by the Nazarenes, who had hoped, in Hugh Honour's words, "to regain the lost paradise of childhood by recapturing a naive view of the brightness and beauty of nature."[8] But despite Honour's allusion to childhood, there was no question among the Nazarenes of recapturing the appearance of children's art; their return was rather to the "naiveté" of the fifteenth-century Italian "primitives." Formally, naiveté meant to them, as it did to artists for most of the nineteenth century, little more than bright local color, clear outlines and a relatively static and uncomplicated composition.

The Italian primitives were, indeed, admired for their presumed naiveté throughout the century. Thus in 1883 Camille Pissarro urged his son Lucien to pay particular attention to the Italians because they were "naive but knowing."[9] For Pissarro, as for the romantics, naiveté was a necessary component of artistic vision, a requisite for experiencing nature truly. But this no longer translated for him, as it had for earlier artists, into an archaism of form such as was represented by the art of the late Middle Ages and the early Renaissance. There are few antecedents in the visual arts for the distortions and simplifications of form that are embodied in Pissarro's conception of naiveté. At the beginning of the century

Philipp Otto Runge had expressed his sympathy with the nature of childhood in his paintings of children, and he had gone so far as to echo the Gospels by declaring that to achieve our best we had to become children again.[10] But the rigid forms and literalism of his pictures remain bound to a descriptive realism and have nothing to do with children's art per se. Pissarro's work in contrast marks a significant change in the notion of naiveté. His attempt at purity of expression is better compared to that of the romantic poets than to that of romantic painters. As in the youthful poems of Wordsworth, the idea of naiveté for Pissarro implies the creation of a personal style whose simplicity will make evident the artist's sincerity. If, despite this, we cannot find the schematic forms of children's art in Pissarro or the other impressionists, it is because, as in most of the art of the nineteenth century, the idea of naiveté had not yet been detached from the close observation of nature; but plainly the grounds for a separation already existed, as we know from the way the postimpressionists were able to tip the balance in impressionism towards subjectivity and the symbolic. The generation of post-impressionists and symbolists at the end of the century did not make the divorce final—the association of a certain simplicity of style and form with a direct and "honest" view into the nature of things remains active to the present day, in our continuing admiration, for example, of *art brut*. But with artists for whom personal vision mattered more than fidelity to nature, cohabitation, one might say, became a matter of choice rather than necessity. The symbolist movement freed artists to use whatever distortion might serve their purposes, including the distortions of children's art. By the same token, however, it also left them free to use children's art without any implication of naiveté at all.

This, in effect, is what Klee began by doing. He was not the first artist to borrow from children's art,[11] but he is the first to acknowledge it as a source of inspiration and the first for whom the dissociation of children's art and naiveté can be documented, even though, as we shall see, the separation in his work was not to be permanent.

Klee was preceded by the artists of Worpswede, who had developed a lively interest in the drawings of children by the turn of the century. In October 1900, Paula Modersohn-Becker noted that the painter Ottilie Reyländer, whose studio in Worpswede she was renting, contained a portfolio with drawings from her childhood. The discovery evidently made a strong enough impression to warrant her reporting it to Rainer Maria Rilke, to whom she mentions "a portfolio with highly original children's drawings."[12] Modersohn-Becker did not acknowledge the effect of such drawings on her own work, any more than she admitted borrowing from other artists, but the influence is unmistakable in at least one of her drawings.[13] The differences between that drawing and Klee's first essays in the genre are instructive, for they reveal a fundamental difference in attitude toward their sources. For Modersohn-Becker children's art is still prized conventionally for its innocence; that is, for its lack of inhibition and sincerity. Thus she advised Heinrich Vogeler to "keep what is deepest in you pure, those things

that we have in common with children, and with the birds, and with the flowers."[14] Moreover, her drawing has no professional value for her; it is nothing more than a private sketch, a humorous portrait of herself and her family drawn on a postcard for the amusement of her mother.

This is anything but what Klee had in mind in his first use of children's drawings. He was undoubtedly touched by their naiveté, but his admiration for that quality was overweighed by a more substantial consideration: the example children offered of an uncorrupted expressive capability. By the turn of the century belief in the superior creative instincts of children was all but universal among artists. We are told that in the 1890s the artists of the Vienna Secession, and especially Gustav Klimt, were enthusiastic about children's drawings, and even so conservative a figure as the classicizing sculptor Adolf von Hildebrand had proclaimed early childhood as the age in which "fantasy and the life of the eye are at their most vital."[15] Klee had expressed a similar sentiment as early as 1901, when he visited Italy to complete his artistic education: the "primal" talent of an eleven-year-old café singer in Rome, he had written, demonstrated to him that "talent doesn't need any experience of life; rather that in matters of feeling primitive feelings are the strongest."[16] Faith in the superior gifts of childhood in effect held out hope of succeeding in his search for originality.

We learn of Klee's first composition based on children's art from a letter to his fiancée, Lily, of 31 March 1905. There we read that Klee has just completed a drawing that he describes with some pride as of "two wretched children occupying themselves with dolls, no philosophy, no literature, only lines and forms, and done in a children's style; that is, as children would draw it. If I have not deceived myself about its worth, I will make an etching of it. It would be a first work in my new manner. . . ."[17] Klee seems eventually to have concluded that he had deceived himself, for the composition does not survive, and the etching was apparently never made. What does survive is a work in brush and watercolor behind glass (*Hinterglasbild*), dated October 1905, whose subject and general style plainly relate it to the failed drawing. This painting, *Girl with a Doll*, along with a watercolor companion on glass bearing the same date, *Paul and Fritz*, is drawn in a simplified style reminiscent in its general lack of modeling and its crudely rendered details of the drawings of young children (figs. 86, 87). The similarity of *Girl with a Doll* to such drawings had already been observed by Pierce, and Klee's letter substantiates the comparison.[18] Nothing could be further in intention from Modersohn-Becker's drawing. Not only did Klee not conceive it as a casual sketch—intended as it was for a print—but he invested it with particular significance for his development, hoping that it might be the start of a new phase in his career. And after the project failed he proceeded to use it in a way which at the time meant even more to him than etching: as a painting on glass, a medium he had adopted in 1905 in order to ease his transition from drawing to painting, in which he still felt uncertain.

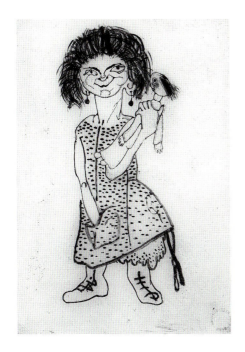

86 Paul Klee, *Girl with a Doll*, 1905

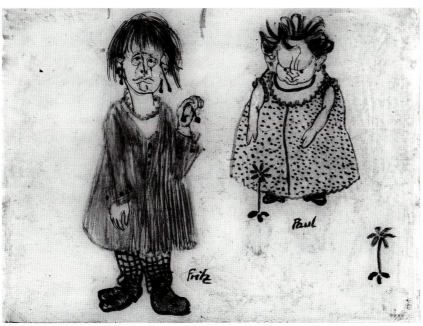

87 Paul Klee, *Paul and Fritz*, 1905

In their expressive character these two glass paintings of Klee's could not differ more from Modersohn-Becker's drawing. *Girl with a Doll* and *Paul and Fritz* are satiric in intent, *Paul and Fritz* in particular being a gentle dig at the contrast between Klee's personality and that of his close school friend Fritz Lotmar, a subject Klee had written about that year in his letters and diaries.[19] The doodled forms of the two works lend them an element of parody in which human personality—in the one case, Lotmar and Klee himself—is seen, as it were, through the eyes of children. There is little question here of evoking the innocence or naiveté of childhood, despite Klee's appreciation of his "naive" childhood drawings. His description of his failed composition with two children is worth quoting at length, for not only does it make his satiric intention unmistakable but it reveals the context of high art within which he perceived the drawings of children:

> That much of my work has turned out sorrowful and pensive has nothing to do with the place [Lily had complained that Klee needed to leave Bern] but with my character; yes, not even the above-mentioned children, who notwithstanding have almost breathed Spanish air, are such blissful creatures as one could assume from my boasting; in them, too, I could not disavow myself. They are girls playing a comedy in the role of mothers; it's the same old musty air my art will always breathe. Not that I couldn't be happy in some beautiful spot among beautiful people, but then I wouldn't have any need to create; I create *pour ne pas pleurer*, that is the first and final reason.[20]

One remark stands out above the others: the two girls "have almost breathed Spanish air." Klee is alluding to the general effect of looseness and facility he has achieved in his drawing (if we can judge by the two glass paintings). That March, when he described his picture to Lily, he had completed the last of his tightly etched "Inventions" on which he had labored for the previous year and a half, and he was consciously attempting to loosen his style. The models of freedom he admired most at the time were Velázquez, Goya and Klee's older contemporary Zuloaga. He planned to go to Spain, as we know from his March letter, and a few months later he announced that he had "come considerably closer to the Spanish masters Velázquez, Goya and Zuloaga, especially the first two."[21] Klee's reference to the Spanish air of his two girls locates the focus of this first use by him of children's art. For in keeping with the satiric content of the drawing, its stylistic freedom is associated in his mind with high art—the art of Spain—and not with the "innocent" source that was, ostensibly, in large part responsible for it. Whatever power children's drawings might have, it was, after all, severely limited; only in a trained and developed art could originality be fully displayed.

Indeed, if it were not for the subject matter of Klee's two works on glass, it would be hard to decide where their style originated.[22] Pierce shrewdly made the

connection between *Girl with a Doll* and children's art without benefit of Klee's letters, which had not yet been published; but the freedom and departure from academic convention of the two paintings are not greater than, or appreciably different from, those of other Klee works—chiefly drawings—of the period. Klee's composition with children and his two glass paintings were made at a time when scholarly interest in children's art was at its height. In the five years between 1901 and 1905, the number of items published on various aspects of the subject was almost triple what it had been in the previous fourteen; that is, since 1887 when Corrado Ricci's pioneering study, *L'arte dei bambini* (Children's art), first appeared.[23] This includes two major works in German published in the same year as Klee's glass paintings: Siegfried Levinstein's doctoral dissertation, *Kinderzeichnungen bis zum 14. Lebensjahr: Mit Parallelen aus der Urgeschichte und Völkerkunde* (Children's drawings through the 14th year of life: with parallels from prehistory and ethnology) (Leipzig), and Georg Kerschensteiner's *Die Entwickelung der zeichnerischen Begabung* (The Development of the gift of drawing) (Munich), each with hundreds of illustrations. Yet though Klee could not have avoided taking notice of all this, there is no evidence either in his writing or in his work that the notice he gave it was very serious. His glass paintings have almost nothing of the forms and details that had been singled out in the literature since the 1880s as distinctive of children's art.[24] For that matter, they have little in common stylistically with Klee's own childhood drawings: their free, "childlike" style is associated by Klee instead with the tradition of free execution that extended from the Spaniards through impressionism to the wash drawings of Rodin, which Klee had excitedly discovered in Italy, mistaking them at first for caricatures.

This becomes abundantly clear from his accounts. Soon after returning from Italy he decided that he would "probably have to come to the defense of impressionism, which I have so often instinctively affirmed in practice"; and when, in March 1905, he finished the last of his Inventions, he announced that he would begin working "in a completely new way, coming closer to impressionism."[25] Rodin, even more than the others—certainly more than his own or any other child's drawings—showed him the expressive possibilities of scrawls, pentimenti and loose and rapid sweeps of contour line.[26] Klee's understanding of children's art, in short, was facilitated by artists who were either already part of the modern movement in the freedom of their styles (the impressionists and Rodin) or else old masters (Velázquez and Goya) who had long been adopted by the modern movement as its forebears. It was through such art that Klee first came to see the possibilities of children's art for himself, not in its specific forms but in the general possibility it offered of a fresh and personal style.

For the next several years Klee's drawings continued to resemble children's drawings in their casual lines and extreme reduction of form. In a diary entry for January 1906 describing a dream he had had, Klee expressed his conviction that

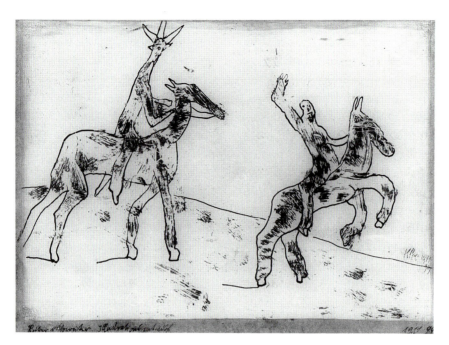

88 Paul Klee, *Rider and Outrider*, 1911

the direction of his art lay in a return to primal, childlike beginnings: "Dream. I flew home, where the beginning is. . . . If now a delegation came to me and bowed ceremoniously before the artist, pointing gratefully to his work, I would be only slightly surprised. For I was there where the beginning is. I was with my beloved Madame Primordial Cell [Urzelle]." This was the source, Klee added, of his fertility as an artist.[27] Werckmeister has pointed to the exceptional similarity in their continuous, rudimentary outlines between one of Klee's childhood drawings and a glass painting of 1911, *Rider and Outrider* (fig. 88).[28] Yet with one or two such exceptions—notwithstanding the poetic lines by Klee just quoted—it is not easy in the years 1905–11 to attribute such similarities to children's art rather than to, say, the continuing influence of Rodin or of folk art, which, Klee tells us, was the source of two other glass paintings of his from 1905.[29] In one respect only are resemblances to children's art more specific: in many of Klee's prints and drawings of 1905–11 forms are transparent, with hatched lines running across contours and objects cutting through each other (fig. 89). This is a regular feature in the drawings of very young children, and together with the extreme reduction and free execution of much of his work at the time, such transparency probably indicates that Klee continued to heed children's art. Yet here again a note of caution must be interjected: transparency has always been a feature of rapid or improvised sketches, whether from pentimenti or from artists' afterthoughts, and it is, besides, not notably present in Klee's own childhood drawings.[30]

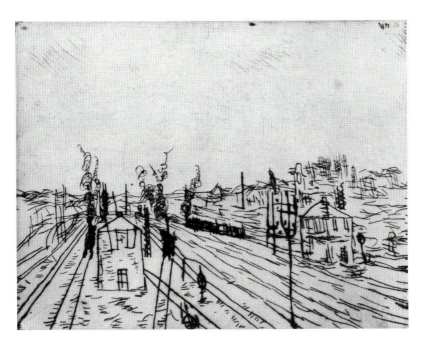

89 Paul Klee, *Railroad Station*, 1911

About Klee's pictures after 1911, however, there is little doubt. Although he never again expressly acknowledged the influence of children's art on a particular work, there is no mistaking its force on him from this time on.

In 1911 and early 1912 Klee entered the circle of avant-garde artists in Munich. He became friends with the founders of the Blaue Reiter and from the two Blaue Reiter exhibitions acquainted himself firsthand with French modernism. One result of this acquaintance was a seventeen-day trip to Paris—in April 1912—during which he familiarized himself with the spectrum of cubism from Picasso to Delaunay, Chagall and Le Fauconnier.[31] These encounters with radical modernism turned Klee's attention to the more schematic aspects of children's art. No doubt he could draw his own comparisons between modern abstraction and the symbolic work of children, but his awareness of their similarities was certainly heightened by the active interest in children's drawings taken by Kandinsky and Münter, who collected them avidly, requesting examples from friends and family alike. We do not know when they began their collection, but the earliest drawings preserved date from the 1890s, with most of the dated specimens falling between 1905 and 1918 and an especially large number from 1913.[32] These drawings added to the swelling number of published examples available to Klee.

The first clear evidence of Klee's new—or, rather, reconfirmed—interest in children's art is to be found in a series of drawings from 1912 based very probably

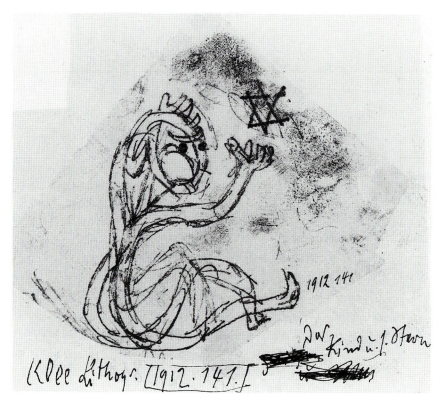

90 Paul Klee, *The Child and the Star*, 1912

on Goethe's *Faust*.[33] Although like most of his work until then they are only generically related to the work of children, their deliberate crudity, rare even for Klee, makes them the most extreme demonstration he had yet given of a return to primal beginnings. In one of them, *The Child and the Star* (Das Kind und der Stern, alternatively titled Das Kind und sein Stern in Klee's oeuvre catalogue), Klee adds a symbolic meaning to what in 1906, when he set down his "dream" of a return to primal beginnings, had alluded to style alone (fig. 90). Echoing Goethe, *The Child and the Star* is a symbolic representation of the genius of childhood and by extension, through its crude and schematic forms, an evocation of those primary marks of the human imagination that in Klee's view were the direct expression of inborn creative energies. But to this extent, at least, it is also a shift from the satirical thrust of his 1905 *Girl with a Doll* and *Paul and Fritz* and a return to the nineteenth-century celebration of naiveté and innocence. Was this simply because Klee was illustrating Goethe's own vision of childhood?

Klee's answer is equivocal. In his writing, his need to stake out a claim in the modern movement led him—perhaps inevitably—to emphasize the originality of children's art. Thus in his January 1912 review of the exhibitions of the Neue Kün-

stlervereinigung and Blaue Reiter for the Swiss journal *Die Alpen*, he places that art alongside primitive art and the drawings of the psychotic as examples to follow:

> For there are still primal beginnings in art, which one is more likely to find in ethnographic museums or at home in the nursery (don't laugh dear reader); children can do it too, and that is in no sense devastating for the latest efforts; on the contrary, there is positive wisdom in this state of affairs. The more helpless these children are, the more instructive is the art they offer us; for there is already a corruption here: when children begin to absorb developed works of art or even imitate them. Parallel phenomena are the drawings of the mentally ill....[34]

As Werckmeister has observed, the relatively "adult" drawings of the preteen-aged girl published by Kandinsky in *Der Blaue Reiter* meant little to Klee; only the pure, uninfluenced creative impulses of very young children had exemplary value.[35] In his actual work, however, it is the more conventional side of the child's vision, its naiveté and its consequent ability to reveal truths closed to others—complex and sophisticated in its implications, to be sure—that comes to the fore; and necessarily so, given the symbolic character from this time onward of Klee's borrowings from children's art. Klee was to some extent skeptical of the visionary atmosphere of the Blaue Reiter, and his work would retain an ironic tone substantially dependent on the employment of children's art; yet from then on the influence of the Munich circle would make itself felt in his ambiguous search for a spiritual reality, most apparent in the familiar "mystical" character of his mature work. Children's drawings, and the "childlike" look they could confer, would become a deliberate means of achieving what Klee was eventually to define (borrowing a symbolist slogan) as his aim of making the invisible visible.[36]

This is evident in a drawing of 1913, *Human Helplessness*, one of Klee's first attempts to organize pictures cubistically and—not by chance—one of his first to employ the schematic modes of children's art (fig. 91). Klee's return from his April 1912 visit to Paris had left him uneasy about cubism. He acknowledged the cubists' accomplishments but confessed that "much as I learned there, I nevertheless realize that *I* ought to explore less and work even harder than before on developing what is personal to me."[37] The geometrically reduced forms of *Human Helplessness* and the way they are tied together by simple lines defining triangular and trapezoidal fields have an evident basis in cubism. In the year before, Klee had cautiously tested cubism by subdividing his figures geometrically while still leaving backgrounds intact; now he extends cubist structure to the pictorial space as well. But cubism here has been put to a curious use. Taken as a whole, the picture is not much more complicated or naturalistic than what a young child might draw. Indeed, the coarse, schematic rendering of the forms; the large, undifferentiated circles used for eyes, nipples and navel; the limp, mannikin-like bodies; the placement of the figures in a

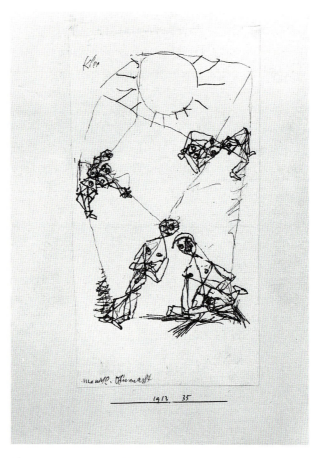

91 Paul Klee, *Human Helplessness*, 1913

way recalling the centrifugal, "exploded" perspective of children; and perhaps above all the attempt to render both space and a complex notion of relationship by a few schematic lines, all suggest that Klee was exploiting the simplicity and directness of children's art. *Human Helplessness* is not one of Klee's finest drawings; its form and construction are too rudimentary to compete with the best of his work. But its gaunt image of four wretchedly inept marionettes tied together by lines of fate under a dominating sun give it a raw immediacy not easily forgotten.

And yet how close is *Human Helplessness* to the art of children? Werckmeister has tentatively identified Kerschensteiner's published collection as a specific source for Klee's drawings of the time, citing "specimens of 'schematic' figure drawing by small children which seem rather similar to the diagonal cross schemes of figures that Klee applied in his drawings from 1912 onwards."[38] His suggestion is supported by the exploded perspective of *Human Helplessness* (though this is not

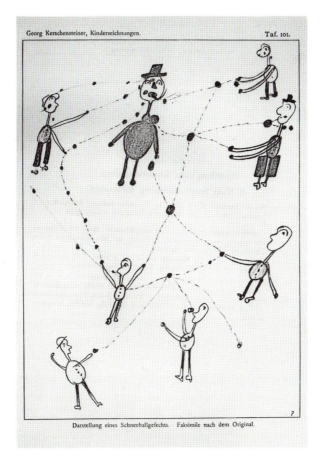

92 Child's drawing (anonymous), Plate 101, from Georg Kerschensteiner, *The Development of the Gift of Drawing* (Munich, 1905)

unique to the examples Kerschensteiner published) and even more by the lines that join the figures in their common fate. Among Kerschensteiner's reproductions is the drawing of a snowball fight in which the missiles are connected to the victims and their assailants by a series of lines forming triangular and diamond-shaped fields strikingly similar to those of *Human Helplessness* (fig. 92). The similarities of form and meaning in this linear scheme—the plights of the victims represented in both by lines of force—make Kerschensteiner Klee's likely source. But *Human Helplessness* is no attempt at elementarism such as Klee would defend in his Jena lecture of 1924. Despite its rudimentary scheme, Klee alters whatever children's drawings lie at the heart of the work. Very few of the drawings illustrated by Kerschensteiner have triangular forms ("diagonal cross schemes") of any sort at all; these are, in fact, generally rare in the drawings of children. Kerschensteiner himself observed that in his large sample of drawings from Munich schools the

human trunk was usually represented by young children as an oval.[39] If, as seems the case, Klee's triangular motif was influenced by certain illustrations in Kerschensteiner (though not the snowball fight), he chose it not because it was characteristic of children's drawings but because of its expressive qualities—its reduction of the figures to jointed puppets and its potential for expressing dynamism or activity—and because he could find comparable, if more complex, forms in cubism. As in his earlier work, children's art here essentially confirms what Klee had already found on the professional level.

Klee's cubist-inspired pictures sometimes attain the complexity of their French sources, but more often than not they are simplified, their marks more isolated. That is, they tend to represent things in themselves rather than forming interwoven parts of larger compositions as they do in French cubism. This is a matter of degree only, but it indicates a different way of working and of conceiving cubism. Cubist compositions tend to be developed from broad schematic arrangements that are then subdivided and elaborated with small details. Klee usually begins with a small figural or compositional motif, which is expanded into a picture by a process of accretion. This way of working is in effect the outgrowth of Klee's continuing interest in anecdote, narrative and caricature. It helps to explain why he could assimilate children's drawings to cubism: for their schemata, however abstract, are likewise meant to represent individual figures or things.

But this is only part of the answer. It does not explain why Klee should have bothered with children's art at all. Even granting that he found it impossible to assimilate cubism at once in its full complexity, why reduce it in such fashion as to suggest a particularly complicated example of children's doodling? It is no answer to fall back on Klee's words and say that he found the schematic drawings of young children "instructive." No doubt he saw in them what admirers had seen since the previous century: that they were highly expressive, that they were conceptual rather than imitative and that they were universal because all children drew more or less the same schemes at the same ages and because (for many writers) they resembled the art of primitive peoples and recapitulated the artistic evolution of the race.[40] But it can be argued that by accommodating children's drawings to cubism Klee lost precisely these characteristics. Was this, then, a failed compromise—an earnest but inevitably misguided attempt to get as close to the originals as any trained artist can? The answer seems evidently no. It is as impossible to recapture the original expressive effects of naive art as it is to recapture another artist's expression. Such borrowings are almost never attempts at imitation; unless in parody or direct emulation, they are inevitably transformed. Klee's borrowings from children's art are rarely, if ever, parodies; they are assimilated to his own style. Yet this is not to say that they do not carry with them something of the symbolic and expressive values of the originals. To begin with, his quotations from children's art insist on an identification between the universality of the child's schemata and

the universal claims of cubism. Within the Blaue Reiter, as elsewhere in the period, it was common to see cubism as a style that had uniquely returned art to its first principles of form. Thus Kandinsky, in his *Über das Geistige in der Kunst* (Concerning the spiritual in art), published in 1912, described cubism as a mathematical art and "a denuded [*entblösste*] construction." Roger Allard and Erwin von Busse, writing in *Der Blaue Reiter* almanac that same year, likewise conceived of cubism as an elemental art of order in which subject matter played a distinctly subordinate role. Klee himself, in a review of the second Blaue Reiter exhibition, joined them in seeing the radical new art as "the endeavors to treat the constructive side of form in an expressive manner."[41] But Klee's pictorial allusions to children's art also have a more evident expressive purpose: they serve, with the aid of his titles, to condense complex relationships and to display the fatefulness of his themes in a particularly naked and direct form. To a considerable degree such pictures as *Human Helplessness*, *Don Juan (Last Stage of Infatuation)*, *The Assailed*, or *The Hanged*, all from 1913, depend for a large part of their effect on the conventional belief in the power of the child's naive vision to reveal truths closed to more sophisticated perception. Yet what Klee offers he also takes away. The contrast between the seriousness of their subjects and their portentous titles on the one hand and the childlike inconsequentiality of their drawing on the other lends them a comic irony not unlike the irony bestowed by the use of children's art in Klee's glass paintings of 1905.[42] The result is Klee's characteristic tendency to present large and complex situations as if through a psychological and emotional reducing glass.

This effect is most striking in Klee's pictures of microcosms. *Small World*, an etching of 1914, is the first of Klee's many pictures in which a seemingly random collection of forms, objects and creatures is made to float in an undefined pictorial space so as to create a universe in miniature (fig. 93). The etching does not have the direct stylistic relationship to children's art we find in Klee's drawings of 1913, but it owes no small part of its character to the schemata of children. The idea for it was probably suggested by Kandinsky's apocalyptic scenes and swirling cosmic landscapes of 1912–14, but these have been brought down from the elevated plane on which Kandinsky usually conceived them. In its brevity, its rudimentary forms, its schematic renderings of plants and figures and its reduction of a complex realm to something approaching a diagram, it is instead a direct outgrowth of Klee's schematic drawings of 1913, and to that extent is still guided by the example of children's art.

The relationship of Klee's microcosms to children's art helps to explain one of Klee's best known but still elusive paintings, *Fish Magic* of 1925 (fig. 94). Based on a rejected landscape painting with a church from 1919–21, which Klee mounted in the center of his new painting and proceeded to overpaint, *Fish Magic* shows a collection of flowers, fish, vases, figures, heavenly bodies and abstract geometric forms floating in a nocturnal space around the caged image of a clock. By its simple

93 Paul Klee, *Small World*, 1914

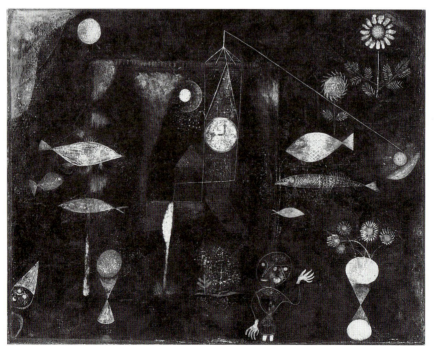

94 Paul Klee, *Fish Magic*, 1925

95 Paul Klee, *The Road from Unklaich to China*, 1920

outline forms it presents the picture of a universe at some preliminary stage of creation, when time has been set into motion but things have not yet been fully differentiated. It is the universe as a child-god might create it; Klee even includes the often-observed image drawn by young children of a head with a double face. The painting's objects—as various as suns, plants and people—are created from a narrowly restricted geometric vocabulary of cones, circles and arcs, rather as the variety of the real universe is created from the few building blocks of its particles. *Fish Magic* can be understood as a metaphor of creation, artistic as well as actual, in which the formal elements of art (simple contours and geometric planes) are equated with the ontogenetic beginnings of drawing, and these in turn with the elements of the universe itself.

In the late 1910s and early 1920s the simplicities of children's art came to have, if anything, even more attraction for Klee than they had had for him earlier. In such pictures as *The Road from Unklaich to China* of 1920, tightly organized structures yield to loose, ambulatory sequences of motifs resembling the discursive patterns of landscape drawings by young children (figs. 95, 96). Other works present evocative landscapes with simplified schemata for buildings, trees and people. It has been argued that during this period Klee tried to improve the sales of his work by giving them even more of the visionary, childlike properties admired by his reviewers.[43] But to forestall any notion we might have that this was nothing but a regret-

96 Child's drawing (anonymous)

table compromise with public taste, it is enough to recognize the ironic subversion introduced by their reductive elements. For although these contribute, along with Klee's visionary subjects and deeply affecting colors, to the "magical" quality of the works, they also call into question all pretense at revelation and cancel any suggestion of sentimentality; as with his microcosms, Klee's fairy tales are turned into comedy and even farce.

From the mid-1920s through the early 1930s Klee would refine his imagery until it bore little direct resemblance to the crude aspects of children's art he had borrowed earlier, though he would continue to employ rudimentary forms with various comic and ironic possibilities. The effects of spontaneity and sudden inspiration he had achieved earlier by his imitations of the art of children ran counter to the artistic climate in Germany at the time, which favored rationalized geometric abstraction. Perhaps even more important, Klee's own attempts to rationalize the process of design so that it could be imparted to his students in the Bauhaus were not conducive to these effects. These factors combined to produce in Klee's work a more deliberate, measured style. In 1931 Klee left the Bauhaus for a less demanding position in the academy in Düsseldorf, where he was not required to lecture, and the change brought with it a loosening of his style. In part this loosening seems to have been a reaction to the effort he increasingly complained of having to make for his Bauhaus lectures. In part it was the result of the threatening political climate in Germany, which for an artist as attuned to irony and caricature as Klee was, invited a more narrative response to events. Partly, too, it was an answer to

the dominance in French art—to which he had always been sensitive—of surrealism, with its emphasis on the expression of subconscious urges. But none of these caused him to return to the rude forms of children's art he had employed before the 1920s.

This changed for a brief and striking moment in 1935. In 1933, with the accession of Hitler to national power, Klee was forced to emigrate, and he returned to Switzerland to spend the rest of his life in Bern, where he had been raised. Practically, this meant a kind of exile; although he was not altogether cut off from the centers of modern art—thanks to occasional visits by other artists, including Picasso, and the information he could glean from art journals—he lost whatever community of sympathetic artists still existed in Germany, the security of a teaching position and, not least, the major market for his art, the last with obvious consequences for his financial security. All this seems to have led to a crisis of confidence—"crisis" being the term he himself used in a letter of February 1934 to one of his Swiss patrons, Richard Doetsch-Benziger. To his friend and spokesman Will Grohmann, Klee observed the following year that "my inventions don't fall over each other any more, but they haven't stopped, and I am venturing larger pictures despite my modest den."[44]

These expressions of uncertainty—fatigue might be the better word—are reflected in Klee's work of the mid-1930s. In 1934 he entered in his oeuvre catalogue less than half the number of pictures he had entered the year before. There is an especially sharp drop in his drawings, the medium requiring the least amount of preparation and space—a state of affairs that cannot therefore be entirely explained by the disruptions in his life or the fact that part of that year was taken up with preparation of a large retrospective in Bern. Moreover, his work of that year and the following tends to repeat itself, presenting some of the old, meticulous techniques he had employed in the Bauhaus, some of his old modes—the so-called magic squares, for instance—and even some old compositions.[45]

In 1935 Klee tried to rectify the situation by a drastic act of denial. A group of watercolors from that year, probably from the first half, present images of a new kind for him: rudimentary stick figures set within equally simple frameworks, whose stiffness and genuine simplicity, without complications or any particular subtlety of gesture, bring them closer in spirit to children's art than almost anything he had done before.[46] Throughout his career Klee had periodically sought to free himself from an overdeveloped or excessively finicky technique by a looser and less elaborate style. The stick figures of 1935 represent one of his periodic returns to the unmediated roots of his artistic impulses, in this case, as in 1905 and 1912, to a style powerfully evoking the drawings of young children. But unlike Klee's earlier essays in the primitive forms of children's art, these figures bear no formal resemblance of any sort to actual pictures by children, who rarely, if ever, draw people as a mere set of sticks. These exercises in basic form have their roots as

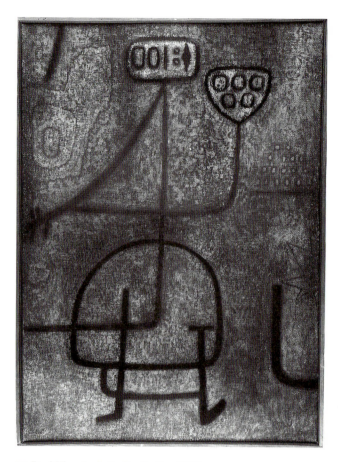

97 Paul Klee, *La belle Jardinière*, 1939

much in the elementary diagrams Klee devised for his Bauhaus lectures as they do in the art of children. They would seem to have been little more than experiments (one can hardly suppose that they would have satisfied Klee for long), but they have the historical importance of being Klee's first essays in what would develop in his final three years into the far more subtle stick-figure mode of such well-known paintings as *La belle Jardinière* (fig. 97), *Timpanist* and *Death and Fire*.

This is not the place to offer a detailed analysis of individual pictures from Klee's final years. For from 1937 to the first four months of 1940, when his illness made it no longer possible for him to work, they show an unprecedented consistency of approach that renders arbitrary for our subject any attempt to single out works for special treatment. Although Klee did not entirely abandon the use of modes, they tend now to merge, a strikingly bold outline style and a reduction of small details serving as the unifying features of his work. The late work as a whole owes an unmistakable debt to Picasso's so-called metamorphic or bone period of the late 1920s and early '30s, whose powerful influence hovers over much of it. Yet

98 Paul Klee, *A Walk with the Child*, 1940

it is symptomatic of the extent to which the notion of primal expression had by then been absorbed into the vocabulary of artists that Picasso's influence on Klee's late works results in a greater effect than ever of the simplicity and unmediated sensibility long associated with children's art (fig. 98). Picasso's simplified, grotesquely metamorphosing images have as their basis the surrealist fascination with the transforming powers of the subconscious and "automatic" drawing, which uses the technical means of realizing the transformation. Like Klee's late drawings, Picasso's bone period images are reduced to simple contours. But while Picasso, like the surrealists themselves, largely employs his means in the expression of desire, unchildlike in the variety of its erotic complications, Klee continues to exploit effects of naiveté, making use of the "unskilled" simplifications employed by children: roughly drawn triangles, circles and rectangles for heads and bodies; scribbles for hair; and in at least one instance—his 1939 drawing *Urchs Listening* (fig. 99)—evoking of his own childhood drawings, with their wavering contours and absence of volume.[47] But the strongest echo of children's art in Klee's late pictures is made finally by their subjects and general conception; for even when they are given the mythic forms of angels or deities, his figures are presented in the ordinary conditions of life, experiencing its small pleasures and its sufferings. With their circular eyes, their simple linear features and their expansive gestures, they

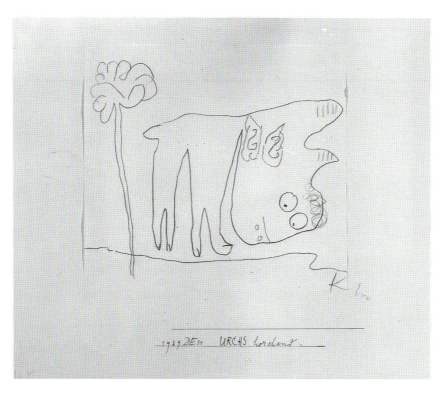

99 Paul Klee, *Urchs Listening*, 1939

respond with bemusement and (literally) wide-eyed innocence. By placing empha-
sis on ordinary human circumstances, Klee evokes one last time something of the
earnest and commonplace vision of children's drawings.

It is worth emphasizing once more that the intimations of metaphysical vision
in Klee's work—conveyed in large part by their schematic forms and simplifica-
tions, which suggest a newly reordered and hence newly revealed universe of peo-
ple and things—are not inherent in children's art but were the result rather of a
century-and-a-half-old assumption about the nature of children. Whatever is
expressed by Klee's pictures was, as it is in all trained art, the consequence of
sophisticated calculation. Yet paradoxically this itself may have been part of the
reason he was persistently tagged with the label childlike. It may be useful to
recall Dubuffet, with whom this essay began. Like Klee, Dubuffet also turned in
the 1940s to children's drawings as a means of cutting to the truth of ordinary
experience. Like Klee's, his paintings give a vivid new sense to the commonplace.
But Dubuffet returned much more radically than Klee to the forms of children's
art, and even today their effect, unlike Klee's, is startling. For Dubuffet's "revela-
tion" is not metaphysical—which is perhaps another way of saying that it is not
intended for prolonged contemplation—but rather of the elemental presence of

things: graffiti-like portraits reveal the psychic force of their subjects with almost comic violence, women stretching out in childlike forms on rectangles without perspective drop their babies in harsh images of birth. But in the final analysis it is just this harshness that prevents Dubuffet's work from being thought childlike: it is too brutal, too obviously tied to the surrealist poetics of the unconscious, with all its impulses and cruelty, to fit comfortably with notions of childhood's innocence. Klee's pictures, from any period, are not free of cruelty—we think of his helpless *bonshommes*, of his mocking images of people and even animals—but the cruelty is mitigated by his beautiful colors, by the elaborateness of his designs, and by his exquisite rendering of details. They seem innocent by comparison. Dubuffet's paintings exploit, not without a measure of truth, the pitiless aspect of children. Klee's delicate and poetic images give life to a more conventional and probably more fanciful conception of the inherent powers of childhood. But they also imply a richer and more hopeful conception of the child's imagination, and by extension of the human imagination as a whole.

1 The basic study of Klee's "childlike" forms is still James Smith Pierce, *Paul Klee and Primitive Art* (New York and London, 1976, a reprint of his Harvard dissertation of 1961), 72–84.

2 For public reaction to the "childlike" qualities in Klee's work, see O. K. Werckmeister, "The Issue of Childhood in the Art of Paul Klee," *Arts Magazine* 52, no. 1 (September 1977): 138–51.

3 Though it does not refer to the art of children per se, such is the effect of the often-quoted gnomic utterance Klee published in 1920, in the catalogue of his exhibition in the Galerie Goltz, Munich (*Der Ararat*, 2d special ed.), and again soon after as a preface to the monograph by Leopold Zahn, *Paul Klee: Leben, Werk, Geist* (Potsdam, 1920): "Diesseitig bin ich gar nicht fassbar. Denn ich wohne grad so gut bei den Toten, wie bei den Ungeborenen. Etwas näher dem Herzen der Schöpfung als üblich. Und noch lange nicht nahe genug." On the relevant entries in his diary, see Christian Geelhaar, "Journal intime oder Autobiographie? Über Paul Klees Tagebücher," in *Paul Klee: Das Frühwerk 1883–1922*, exh. cat., 12 December 1979–2 March 1980 (Munich: Städtische Galerie im Lenbachhaus), 255–56.

Klee had early on voiced his intention to use the diaries "as material for an autobiography." See Paul Klee, *Briefe an die Familie 1893–1940*, ed. Felix Klee, 2 vols. (Cologne, 1979), vol. 1: 413–14 (letter to Lily Stumpf, 16 April 1904). For Klee's editorial work on the diaries, see Geelhaar, "Journal intime?," 246–60.

4 "Die Sage von dem Infantilismus meiner Zeichnung muss ihren Ausgangspunkt bei jenen linearen Gebilden genommen haben, wo ich versuchte, eine gegenständliche Vorstellung, sagen wir einen Menschen, mit reiner Darstellung des linearen Elementes zu verbinden." Quoted in Werckmeister, "Childhod," 145. The entire speech is reprinted in Paul Klee, *Das bildnerische Denken*, ed. Jürg Spiller (Basel, 1956), 81–95. On the passage, see also Pierce, *Klee and Primitive Art*, 82.

5 Werckmeister, "Childhood," 144.

6 The defense of Klee's professionalism in the face of popular doubt continued to be made well into the 1950s, as can be seen from Ellen Marsh, "Paul Klee and the Art of Children: A Comparison of Their Creative Processes," *College Art Journal* 16, no. 2 (Winter 1957): 132–45. As recently as 1961, in his doctoral dissertation on Klee, Pierce could find fresh material in

the *similarities* between Klee's art and the drawings of children; the differences, in his view, having long been demonstrated (Pierce, *Klee and Primitive Art*, 82–83). Klee's Jena lecture may not have been the only place where he avoided the whole truth in order to defend his artistic skill. One of Klee's most ardent admirers, Hans-Friedrich Geist, an art teacher Klee had known since 1922, reported that in 1930 Klee insisted to him that one of the primary differences between his work and the drawings of children was that he began with a more or less indeterminate idea, which he then built upon to its final complexity, whereas the child began with the final idea and merely proceeded to illustrate it. Werckmeister has rightly warned against taking this report of their talks too seriously; but if Geist's account is accurate, Klee was misleading. In conversation with students at the Düsseldorf Academy, where he taught between leaving the Bauhaus in 1931 and his exile from Germany in 1933, Klee was more plausible, acknowledging what his works make apparent: that he often began with a specific subject in mind. (See Hans-Friedrich Geist, "Paul Klee und die Welt des Kindes," *Werk* 37, no. 6 [June 1950]: 186–92.) On Geist, see Werckmeister, "Childhood," 147. Klee's remarks in Düsseldorf are recorded in Petra Petitpierre, *Aus der Malklasse von Paul Klee* (Bern, 1957), 53: "Bei mir wachsen sie [Titel] mit dem Bilde oder kommen vorher oder nachher.—Da ist keine Regel."

7 Klee, *Briefe*, vol. 1: 273 (letter to Lily Stumpf, 3 October 1902).

8 Hugh Honour, *Romanticism* (New York, 1979), 314.

9 Letter of 9 December 1883: "Rappelle-toi que les primitifs sont nos maîtres parce qu'ils sont naïfs et savants." Camille Pissarro, *Correspondance de Camille Pissarro*, vol. 1, *1865–1885*, ed. Janine Bailly-Herzberg (Paris, 1980), 259.

10 Philipp Otto Runge, *Hinterlassene Schriften* (1840–41); reprinted in facsimile ed. (Göttingen, 1965), 7.

11 I exclude copies of children's art made for purposes of imitation or mockery, such as the drawings represented in a painting by the sixteenth-century Veronese painter Giovanni Francesco Caroto and in Ensor's etching *The Pisser* of 1887, or the parodic children's style of some of Feininger's early caricatures.

12 Paula Modersohn-Becker, *Paula Modersohn-Becker in Briefen und Tagebüchern*, eds. Günter Busch and Liselotte von Reinken (Frankfurt am Main, 1979), 236, 244. "... eine Mappe über höchst originellen Kinderzeichnungen" (letter to Rainer Maria Rilke, 12 November 1900). Not, as in the English edition, drawings *of* children. This is made abundantly clear by the context of the letter if not by the term *Kinderzeichnungen* itself. The other—diary—reference is correctly rendered in the English translation as: "a portfolio with her childhood drawings." (Cf. Paula Modersohn-Becker, *The Letters and Journals*, eds. Günter Busch and Liselotte von Reinken, trans. Arthur S. Wensinger and Carole Clew Hoey [New York, 1983], 200, 207.)

13 See especially her postcard drawing of 26 July 1903, ill. in Modersohn-Becker, *Letters and Journals*, 317. Its combination of flat, unarticulated forms, thick and rather crude outlines and careful details give it a resemblance to drawings by children of 8–14 years of age.

14 Letter from Paris, 12 April 1900, in Modersohn-Becker, *Letters and Journals*, 177.

15 L. W. Rochowanski, *Die Wiener Jugendkunst: Franz Cižek und seine Pflegestätte* (Vienna, 1946), 15-16; Adolf von Hildebrand, *Gesammelte Schriften zur Kunst*, ed. Henning Bock, Wissenschaftliche Abhandlungen der Arbeitsgemeinschaft für Forschung des Landes Nordrhein-Westfalen, vol. 39 (Cologne and Opladen, 1969), 254.

16 Paul Klee, *Tagebücher 1898–1918*, new critical edition, ed. Wolfgang Kersten (Stuttgart and Teufen, 1988), no. 323; Klee, *Briefe*, vol. 1: 183–84 (letter to Lily Stumpf, Rome, 13 November 1901).

17 Klee, *Briefe*, vol. 1: 492 (letter to Lily Stumpf). "Es gäbe eine erste Arbeit im neuen Sinn."

18 Pierce, *Klee and Primitive Art*, 75.

19 Klee, *Briefe*, vol. 1: 499–500 (letter to Lily Stumpf, 1 May 1905); Klee, *Tagebücher*, no. 592.

20 Klee, *Briefe*, vol. 1: 492 (letter to Lily Stumpf, 31 March 1905).

21 Klee, *Briefe*, vol. 1: 492, 508 (letter to Lily Stumpf, 15 June 1905).

22 The point can be illustrated by two comparisons to James Ensor made by Pierce in a different context (p. 81). The many tiny figures of Ensor's etching *Devil's Sabbath* (*Infernal Cortège*), 1887, have rude, simplified outlines and unarticulated bodies. If it could be shown that Ensor was in fact influenced in his etching by children's art, his would be a clear, early precedent for the kind of sophisticated separation of "crude" drawing from naiveté we find in Klee's glass paintings. But little in its style relates it specifically to children's art. That Ensor knew well enough what real children's work looked like can be seen from his etching of the same year, after Callot, *The Pisser*, where in self-mockery he draws children's graffiti along with a scrawled insult, "Ensor est un fou." (Ensor's two etchings are reproduced in Libby Tannenbaum, *James Ensor* [1951; reprint, New York: Museum of Modern Art, 1966], 63–64.) The roots of *Devil's Sabbath* are to be found, rather, in popular art and the tradition of Flemish grotesquerie; as in Klee's glass paintings, the effect of its "childish" forms is to intensify the sense of mockery.

23 Judging by the extensive bibliography in Georges Rouma, *Le langage graphique de l'enfant*, enlarged 2d ed. (Brussels, 1913).

24 The Second International Congress on the Teaching of Drawing was held the previous year in Bern, but no doubt because it was a meeting of *Fachmänner* concerned with debating and exhibiting the progress of drawing instruction in the lower schools, Klee has no mention of it. On the congress, see "Deuxième congrès international de l'enseignement du dessin à Berne 1904: Réglement de l'exposition du matériel de dessin et des modèles," *Blätter für den Zeichen- und gewerblichen Berufsunterricht. Organ des Verbandes zur Förderung des Zeichen- und gewerblichen Berufsunterrichts in der Schweiz* (St. Gallen), vol. 29, no. 2 (15 January 1904): 16; "Zweiter internationaler Kongress zur Förderung des Zeichenunterrichts in Bern vom 2.-6. August 1904," ibid., vol. 29, no. 16 (15 August 1904): 129–32; no. 17 (1 September 1904): 137-41; no. 18 (15 September 1904): 149–50; and "Der zweite internationale Zeichenunterrichtskongress in Bern," *Deutsche Blätter für Zeichen- und Kunst-Unterricht. Mitteilungen des Landesvereines Preussens für höhere Lehranstalten geprüfter Zeichenlehrer* (Bochum i. W.), vol. 9 (1904): 171–77.

25 Klee, *Briefe*, vol. 1: 244–45, 489.

26 On Rodin's influence, see Jürgen Glaesemer, *Paul Klee: Handzeichnungen I. Kindheit bis 1920* (Sammlungskataloge des Berner Kunstmuseums: Paul Klee, vol. 2), 118; Glaesemer, "Paul Klee: Die Kritik des Normalweibes. Form und Inhalt im Frühwerk," *Berner Kunstmitteilungen*, no. 131/132 (January–February 1972): 7–8; Marcel Franciscono, *Paul Klee: His Work and Thought* (Chicago: University of Chicago Press, 1991), 78–88.

27 Klee, *Tagebücher*, no. 748. On this passage, see Werckmeister, "Childhood," 141.

28 Werckmeister, "Childhood," 141.

29 *Lampoon Cat Licking Itself* (Brocard-Katze sich leckend) and *Garden Scene (Watering Cans, a Cat, a Red Chair) from Nature* (Gartenszene [Giesskannen, eine Katze, ein roter Stuhl] nach der Natur), both from October. They were, Klee tells us, inspired by the decoration of the traditional pottery of Langnau, Switzerland. See Klee, *Briefe*, vol. 1: 519, 520–21, with illustrations.

30 These are illustrated in Glaesemer, *Klee: Handzeichnungen I*, figs. 1–16.

31 For the Paris trip, see Klee, *Tagebücher*, nos. 910, 914.

32 The children's drawings have been preserved in the Gabriele Münter- und Johannes Eichner-Stiftung, Städtische Galerie im Lenbachhaus, Munich.

33 On these drawings, see M. Franciscono, "Paul Klee's Lithographic Drawings of 1912: Some Unsuspected Illustrations of 'Faust,'" *Pantheon* 41, no. 1 (January–

March 1983): 34–38.

34 Paul Klee, *Schriften, Rezensionen und Aufsätze*, ed. Christian Geelhaar (Cologne, 1976), 97.

35 Werckmeister, "Childhood," 141. The child is identified by Kandinsky in *Der Blaue Reiter* as Lydia Wieber ("Über die Formfrage," *Der Blaue Reiter*, ed. Klaus Lankheit [Munich, 1965], 169).

36 From his "Schöpferische Konfession," 1920, in Klee, *Schriften*, 118.

37 Letter of 19 May 1912 to Alfred Kubin, in *Paul Klee: Das Frühwerk 1883–1922*, 83.

38 Werckmeister, "Childhood," 142.

39 Georg Kerschensteiner, *Die Entwickelung der zeichnerischen Begabung* (Munich, 1905), 16.

40 See, e.g., Siegfried Levinstein's doctoral dissertation, "Kinderzeichnungen bis zum 14. Lebensjahr: Mit Parallelen aus der Urgeschichte und Völkerkunde" (Leipzig, 1905), 1–3 and ch. 6, with citations. See the early appreciation by the Italian painter Tommaso Minardi, writing in 1864: ". . . what would that first drawing . . . of the child be like? Certainly it would be not only of a loving act . . . but in the most simple style and of the truest character. . . . It would also be the most vividly expressive, since the less expressive, being felt less by him, could never by nature be chosen. And this painting would naturally be of a perfect unity of composition. Since the child's soul, completely involved in the sentiment of the loving image, would feel only that which is strictly connected with the expression of the image itself, all accessory matter would simply remain unobserved." Quoted from Joshua C. Taylor, ed., *Nineteenth-Century Art Theories* (Berkeley, 1987), 178–79. On the still earlier appreciation by the Swiss caricaturist Rodolphe Töpffer (1848) and the slightly later and even stronger praise in France by Chamfleury (1869), see Meyer Schapiro, "Courbet and Popular Imagery: An Essay on Realism and Naiveté," *Journal of the Warburg and Courtauld Institutes* 4, nos. 3–4 (1941): 173–80, and (for Töpffer) George Boas, *The Cult of Childhood*, Studies of the Warburg Institute, vol. 29: 79–81. See Boas

also for a concise history of the general idea that children resemble primitive peoples in their thought and recapitulate the evolution of the human race (pp. 60–67).

41 Vasily Kandinsky, *Über das Geistige in der Kunst*, 2d ed. (Munich, 1912), 35, 112; Roger Allard, "Die Kennzeichnungen der Erneuerung in der Malerei," *Der Blaue Reiter*, 79; E. von Busse, "Die Kompositionsmittel bei Robert Delaunay," *Der Blaue Reiter*, 97, 100–2; Klee, *Schriften*, 100 (review of March 1912).

42 These are all illustrated in *Paul Klee: Das Frühwerk 1883–1922*, 385–89; all but the last also in Glaesemer, *Klee: Handzeichnungen I*, figs. 490, 493, 494, along with others of a similar character from 1913.

43 O. K. Werckmeister, *The Making of Paul Klee's Career 1914–1920* (Chicago and London, 1989), 113–17. The pages are an expansion of the relevant sections in his "Childhood."

44 Karl Gutbrod, ed., *Lieber Freund, Künstler schreiben an Will Grohmann* (Cologne, 1968), 80: "Auf dem Gebiet, das mir zukommt, geht es nicht schlecht. Das Technische geht in mich über, die Erfindungen überstürzen sich nicht mehr, aber sie hören doch nicht auf, und ich wage grössere Formate trotz meiner bescheidenen Bude. . . ."

45 E.g., *Diana im Herbstwind*, 1934.142, which is based on a drawing of 1931; *Ruhende Sphinx*, 1934.210, a second version of a 1932 painting; *Der Schöpfer*, 1934.213, based on a drawing of 1930 and perhaps begun then; and *Dame Dämon*, 1935.115, a remake of a 1932 watercolor. All are in the Paul Klee-Stiftung, Bern.

46 The exact time in 1935 when Klee made these watercolors is unknown. One of them, *Nach Regeln zu pflanzen*, 1935.91, in the Paul Klee-Stiftung, bears an inscription to Marguerite Rupf, to whom he presented the work: "für Frau Marguerite Rupf, auf dass/wir wieder gesund werden/Weihnachten 1935." Klee was first stricken with scleroderma, the illness that would eventually kill him, in July or August of that year. It began with particular severity, forcing him to curtail his work sharply for over a year. In 1935

he entered only 148 works in his oeuvre catalogue, and the following year, at the height of his initial attack, the number dropped to 25. The inscription on this painting does not, of course, tell us when it was made, only when it was given as a gift, though it may be that these stick-figures were made during that attack. This might account for their rudimentary quality, but in fact it is unlikely that they were involved with his illness. As is well known, Klee did not necessarily enter works in his oeuvre catalogue in the strict order in which he finished them, usually waiting to enter them several at a time. This group of watercolors bears numbers in the nineties in Klee's catalogue, and if

we make the reasonable assumption that if he had not fallen ill he would have created at least as many works as he had in the previous, difficult year—217—and very probably more, these watercolors would in all likelihood fall into the first half of the year. There is the further consideration that pictures from that year with much higher catalogue numbers show nothing of this primitive simplicity.

47 E.g., Jürgen Glaesemer, *Paul Klee: Handzeichnungen III. 1937–1940* (Sammlungskataloge des Berner Kunstmuseums: Paul Klee, vol. 4), figs. 1–4, 19, 160, 606, 754. To the last, *Urchs Listening*, compare Glaesemer, *Klee: Handzeichnungen I*, figs. 11, 16.

The Issue of Childhood in Klee's Late Work

Josef Helfenstein

Paul Klee was, from the beginning of his artistic career, both theoretically and formally occupied with the notion of childhood. Not only is childhood a central pictorial theme of his work, but it is also related to Klee's artistic conception in a decisive way.[1] Tilman Osterwold viewed this engagement with childhood, which persists throughout Klee's oeuvre, as the "essence of the search for [his] own identity" as an artist.[2]

The meanings that Klee connected with the idea of childhood from 1933 to 1940 are particularly complex. These years represent a phase in Klee's life during which he saw his role as an artist called into question in relation to political events. It is conspicuous that Klee was intensively occupied with portrayals of childhood in 1932–33 and again in 1939–40. This essay will show that, in being so, Klee reacted to both an outer and an inner crisis: to the dangerously increasing gravity of political events in Germany and Europe as well as to the existential questioning of his artistic self that these events stimulated.

The novel thing about these pictures engaged with the idea of childhood in 1932 and 1933 is that they seem more than ever to relate to current events. Shortly before, in 1929, 1930 and 1931, Klee had attained the peak of his public success. By the end of his professorship at the Bauhaus in Dessau he was considered one of the most internationally esteemed artists in Germany. Large exhibitions surveying his work were opened on the occasion of his fiftieth birthday in the Alfred Flechtheim gallery in Berlin and the Neue Kunst Fides gallery in Dresden at the end of 1929 and at the beginning of 1930. At the same time, the first French monographs by Will Grohmann and René Crevel were published in Paris. Important Klee exhibitions opened across Germany and abroad in 1930 and 1931; among

Translated by Andrew R. Ziarnik

them, shows at the Museum of Modern Art in New York, the Kestner Society in Hannover and at the Düsseldorf Kunstverein. However, against the backdrop of the social developments in Germany, Klee's public successes at the time must have seemed precarious. The threatening economic and political changes that were to lead Germany to National Socialist dictatorship had already begun. In November 1929, the New York stock market crash had caused a deep worldwide depression, the lasting effects of which even Klee would soon feel. In 1932 depression and mass-unemployment reached their peak in Germany. On 30 January 1933, Hitler was elected chancellor. After this the repression of modern art and the art market was sanctioned by the state. Within a very short time, the intellectual and economic foundations in Germany were pulled out from under Klee's feet.

These upheavals are important for understanding Klee's engagement with the idea of childhood. Osterwold has shown how Klee reflected the political catastrophe connected with the rise of National Socialism and the fear of war "in the world of children."[3] Just as it did in 1932–33, the theme of childhood took on particular significance in Klee's work again in the last years of his life, after the start of World War II. At this time Klee equated childhood with war in some paintings and sequences of drawings.

This essay is not concerned with the investigation of an analogy between Klee's works and children's pictures or with the question of childhood as a formal characteristic of modern art. It is also not primarily concerned with the relationship of Klee's art to ideological aspects of the term "childhood" in art criticism—on the one hand innocence as an avant-garde stylistic ideal, or on the other childishness as a negative argument against modern art. This particular problem has been thoroughly discussed by Otto Karl Werckmeister in the most important contribution in the Klee literature to date with regard to this issue. Klee's occupation in his late work with drawings from his own childhood or with those of his son, is a topic that I will touch on only briefly at the conclusion of this essay. The focus of this essay is childhood as an intellectual concept and as an artistic theme in Klee's late work. The significance of this idea can be seen in Klee's use of childhood, either as a key to cryptic self-portrayal or as a graphic form in which a critique of his times and personal conviction are expressed (in indirect and enciphered form, of course, but intensely nevertheless).

The Drawings of 1932–33

As with many artists in Germany, Klee was deeply affected by the National Socialists' seizure of power in 1933. Like others who could expect only trouble from the new regime, Klee underestimated the direct consequences of this historical change, which included nothing short of an all-encompassing "rejection of avant garde cultural modernity" seething with hatred.[4] Nevertheless, Klee reacted to these outer changes with great intensity in his art.

Nineteen thirty-three was Klee's most productive year up to that point: he added a total of 482 works to his oeuvre catalogue, among these 314 drawings. Everything suggests that Klee reacted to the political events through this intense production.[5] This causal connection between the political change in Germany and Klee's greatly increased drafting activity is documented almost to the day in an often-quoted letter Klee wrote on 30 January 1933, the day Hitler became chancellor. In Klee's ironically dispassionate commentary on the political events, sent to his wife from Dessau, he mentioned that he had been experiencing a "mild fit of drafting madness" for the last few days.[6] The scope and uniformity of this cycle of more than two hundred sheets, of which the drawings discussed here are a part, was up to this point unique in Klee's work. The main part of the series was presumably created in March, April and May, and the remainder between May and the beginning of October 1933.[7] Extant documents do not allow a more precise dating.

It is conspicuous that Klee was particularly engaged with the theme of childhood in his drawings of 1933. Representations of children obviously belong to each of the pictorial themes with which Klee reflected the political events that called into question his artistic existence. In doing so, it seems as if he had fundamentally revised the idea of childhood. As a pictorial theme, childhood became an increasingly evident component of a growing pessimistic iconography in Klee's work of the 1930s.

Renewal of Discipline

By 1932 Klee had established a connection in his drawings between his idea of childhood and the explosive social changes that manifested themselves in the political radicalization of youths, their organization in paramilitary groups and in mass demonstrations. Klee commented on these events in pen and ink drawings such as *Parade of the Little Ones* (fig. 100), *Little Uproar* (1932.98) or *Big Man and Little People* (1932.105). In *Parade of the Little Ones* he was apparently alluding to the drawing *Bellicose Race* (1913.91), which had been published in 1913 in the journal *Der Sturm*. In contrast to the drawing of 1913, in which Klee had perhaps ironically portrayed the modernistic ideal of the artistic avant-garde, which included the art of children, primitive peoples and the mentally ill,[8] he now referred in the drawing of 1932 to contemporary historical events. This engagement intensified in 1933, and as regards the theme of childhood, it took on many layers with respect to content and iconography.

One of the most striking motifs around 1933 is the connection between childhood and training, between education and force. The first number of this cycle of pencil and oil crayon drawings registered in the oeuvre catalog refers to this connection. Its title, *Renewal of Discipline* (fig. 101), seems to suggest National Socialist methods of education. The figure of an adult built of planar polygons thrust into

100 Paul Klee, *Parade of the Little Ones*, 1932

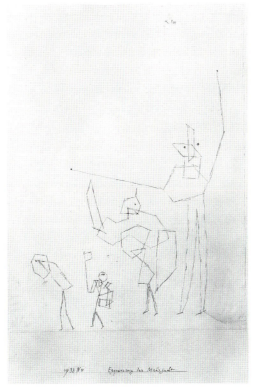

101 Paul Klee, *Renewal of Discipline*, 1933

each other directs three children to his right with arms that blend seamlessly into drumsticks. A pronounced discrepancy exists between the title, which unmistakably refers to contemporary politics, and the generalized abstract representation generated by a formal scheme; this contrast gives the work an ironic tinge. The sculptor Alexander Zschokke and Walter Kaesbach, the former director of the Düsseldorf Akademie, were presumably the first of Klee's contemporaries to see the drawings. Kaesbach reported on them in 1945 and 1948; it must have been these drawings to which he referred when he wrote:

> This cycle begins with one page composed of a few straight pencil strokes whose awkwardness, like a child's drawing, struck me as strange. I must admit that, after what we have suffered and learned from the German Revolution, this beginning exuded something comical, something that did not seem to be at all consistent with the gravity of the situation in which the artist found himself.[9]

Shortly thereafter (if one accepts the numbering of the oeuvre catalogue as the proper chronology) Klee again took up this theme in an extensive group of pencil and oil crayon drawings that are among the most striking of the series. Two adults and one child involved in conflicting exercises are portrayed in the drawing *Physical Exercise* (fig. 102). The child, who is spatially at the mercy of the adults because of his position in the middle, holds his arms straight up in the air, while the figure turned toward him on the right bends torso and arms downward. As the title suggests, the child is detained for gymnastic exercises. Klee repeats the theme of physical drills or the training of a child by adults in the drawings *Demonstration* (1933.107) and *Situps* (1933.108). The allusion to the infamous National Socialist "defense sports training" (*wehrsportliche Ertüchtigung*) of youths is unmistakable in this group of drawings.

Equally laden with double meanings are the drawings *Scene at the Pole* (fig. 103) and *A Child Is Measured* (fig. 104). In *Scene at the Pole* an ambiguous standing figure, which could be either a child or an animal, holds fast to a pole with outstretched arms. Meanwhile an adult on all fours kneels on the ground like one who is subjugated. A jug with curved handles stands on the floor to the left. This gives the event the appearance of an archaic, magical ritual. But here, too, the main theme seems to be the portrayal of a perversely ambivalent balance of power (psychological oppression and physical terror on the one hand, self-humiliation and admiration of the oppressor on the other). In the drawing *A Child Is Measured* two adults hold a long measuring instrument horizontally above two children. Whatever part of the child on the right is being measured is left unclear, but the handling itself of the grossly long measuring instrument just above the children's heads has a threatening, even violent quality.

The portrayal of violence against children, however, is unmistakable in the drawing *Difficult to Educate* (fig. 105). In this drawing an adult figure appears to

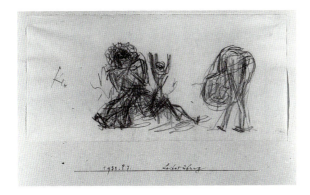

102 Paul Klee, *Physical Exercise*, 1933

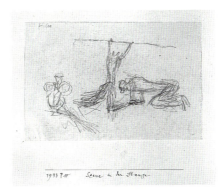

103 Paul Klee, *Scene at the Pole*, 1933

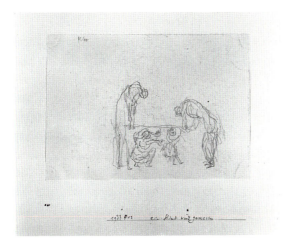

104 Paul Klee, *A Child Is Measured*, 1933

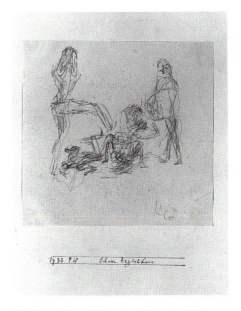

105 Paul Klee, *Difficult to Educate*, 1933

mistreat several children, kicking them as they lay before him on the ground. The figure on the right adds an enigmatic ambiguity to the event: although the figure is difficult to identify, a fool's cap and a drum suggest a clown. As in other portrayals, the drummer appears to be the leader or the inciter of the incident. It is conspicuous that the title and the images are not at all consistent with one another, but rather that the objectively neutral, ordinary title contrasts significantly with the drastic nature of the subject matter. In no other work of this year did Klee portray adult "instructive" violence against children so directly.

Childhood, *Training* and the "Taming Concept" against the Backdrop of German Domestic Policy

In another series of sheets Klee took up the same theme in a slightly altered way. In these, he took literally the original meaning of "training" (*Dressur*)—the breaking-in of animals by people—transferring emphasis from the adult-child relationship to the balance of power between human and animal. The most striking example of this is the oil crayon drawing *Training* (fig. 106). At the lower left Klee portrayed a human figure that, like an animal trainer, has control over a horned animal standing on its hind legs. The animal's head, with its eyes wide open, is pointed upward as if under hypnosis. On the one hand, the drama of the drawing lies in the explicitly portrayed act of training, in the physically inferior human teaching the animal the trick of walking upright on two legs. The event, which is as grotesque as it is threatening, is reflected in the style. The kinetic forms, the intensity and restlessness of the strokes reproduce exactly the provocative and diffusely threatening aspects of the imagery.[10] Some details in the expressive strokes are in this respect enlightening, such as the violence of the lines in the figure in the foreground as opposed to the animal. This difference in the quality of the lines indicates who has power over whom. The antagonism of the forces is likewise expressed in vigorously opposing diagonal movements: the human figure appears to be forcefully subjected to a movement from the lower left to the upper right; the animal, reeling over to the side, obeys the diagonal movement from the lower right to the upper left. This antagonism in the composition continues on into Klee's signature in the varied alignment of the letters.[11]

A few years earlier Klee had already expressly related these conceptions—the training of animals and children—which he put in such an ambivalent relationship to one another in 1933. In the pen and ink drawing entitled *Trained Child* (fig. 107), he portrayed an adult, with the arm movements of a dancer, instructing a child in a circus act. The drastic quality of the picture lies in the forced pose of the child who holds a ball with outstretched arms, just as in the familiar circus acts with ball-juggling animals.

Although it has not previously been remarked upon, the aspect of the drawing *Training* that is probably the most explosive lies in Klee's apparent reference to the political situation in Germany—a parallel that can seldom be shown so directly in Klee's work.[12] Klee's portrayal is like a commentary on that failed "taming concept" that nurtured the emergence of strategic power politics, which in turn led to the National Socialists' seizure of power. In order to explain this connection between Klee's symbolically cryptic portrayal and the political events of the day, it is neccessary to discuss briefly the preceding events.

For the first time, with the Reichstag elections of 31 July 1932 the National Socialists had become the strongest political party in Germany. Because the cen-

106 Paul Klee, *Training*, 1933 **107** Paul Klee, *Trained Child*, 1927

trist middle-class parties had suffered great losses, and the leftist parties (the Social Democrats and the Communists) were by all means to be kept from power, the leading middle-class politicians decided to let Hitler and the National Socialists share power without surrendering to them the most important positions of authority. Even Heinrich Brüning, the last internationally respected Chancellor of the Weimar Republic, who unexpectedly was fired by Reichspräsident von Hindenburg, faced the following decision in light of the National Socialists' victories: should he fight Hitler or serve him in an effort to "tame" him for Brüning's own purposes. Brüning, as well as his successor, Franz von Papen, the centrist politician who was more conservative than Brüning, decided on a course of rapprochement, namely to attempt a pragmatic collaboration and "taming" of Hitler.[13] The implementation of this taming concept, the attempt at roping in the National Socialists, and especially Hitler, must have seemed even more urgent from the leading conservative politicians' point of view, as the National Socialists' influence grew stronger and the street terror more visible.[14] Having in the meantime lost his power as chancellor, it was Von Papen who prevailed upon the elderly reichspräsident to accept Hitler's candidacy for chancellor. The transfer of power occurred on 30 January 1933, and Von Papen became vice chancellor. Because Von Papen, and not Hitler, could rely on Von Hindenburg's trust, Von Papen believed he could soon tame Hitler, or, as he called it, "push him in the corner."[15]

The taming concept of the last conservative, middle-class chancellors before the National Socialists' seizure of power was, by no means, a secret strategy; rather, the

daily press openly commented on this option. Klee knew all about it, as several letters to his wife, Lily, show. In a letter from 9 February 1933, Klee speaks frankly and condescendingly about "Hitler and his two tamers."[16] With the word "tamers" he undoubtedly refers to Vice Chancellor von Papen and Reichspräsident von Hindenberg, those two figures which the public most likely believed could keep a tight rein on Hitler.[17]

On the background of these circumstances, it seems likely that Klee's drawing *Training* refers to that fateful political constellation. Although the drawing can in no way be reduced to a political commentary, it contains one of Klee's most distinct opinions about the "German Revolution" as the seizure of power by the National Socialists was called at that time. Thus, Klee's discussion, which he had with Zschokke and Kaesbach after his dismissal from the Kunstakademie in Düsseldorf about the drawings created since March 1933, also gains new importance. It appears at least more understandable that Zschokke could later claim that Klee had portrayed the "German Revolution" in the drawings from 1933.[18] Zschokke saw "a kind of apocalyptic turmoil and noise" that reminded him of contemporary political events more in the style of drawing than in the subjects themselves. "The violence of the strokes" evoked for him "an almost physical malaise of brutality and feeling of the masses that placed the weeks gone by entirely before one's eyes."[19]

Infanticide and Artistic Self-Reflection

In another drawing from the cycle of 1933, Klee went a step further in the portrayal of violence against children. The oil crayon drawing *Infanticide* (fig. 108) refers to the biblical event of the infanticide of Bethlehem. In contrast to most portrayals of the event, Klee portrays only one mother. She appears to lean back in despair in an armchair, while a soldier armed with a spear and accompanied by a birdlike companion demands the child on her lap. The corpses of murdered children lie on the ground behind the chair.

Klee secularized the religious subject in his picture; the biblical allusion dominates the reference to the history of the times but it by no means negates this connection to contemporary events. At the same time the drawing is an extremely personal allegory, as Klee again and again compared his artistic production with real children. It is possible that the drawing *Infanticide* refers to this self-reflection on his activity as a creative artist, a well-documented theme in Klee's work.[20] Everything suggests that Klee in this historic moment established a direct connection between "infanticide" and the fact that his work was also physically threatened after the National Socialists' ascent. Details in the drawing, like the fact that Klee placed his signature directly over the corpses of the murdered children, support this interpretation.[21]

Klee's engagement with the theme of childhood in this critical phase of contemporary history shows in what a complex way he responded to historical events. Even

108 Paul Klee, *Infanticide*, 1933

the choice of the medium, the fact that he reacted to the historical upheavals with drawings, is hardly a coincidence. Klee selected the most intimate and private medium, hinting that the events affected him in a highly personal way. At the same time, however, this medium appeared to be far more appropriate for the subject than painting could have been; the rapidity and directness of reaction possible with pencil and oil crayon correspond to the accelerating course of historical events.

Like Picasso, Ernst, Beckmann or Kandinsky during these same years, Klee did not react in a literal way to external events as a history painter would. Klee's radically subjective reflection on current events and his historical pessimism parallel an attitude that manifested itself more and more among avant-garde artists of the 1930s, as in the increasingly pessimistic iconography of Ernst, Beckmann, Miró and Picasso, among others. Moreover, there is a connection between Klee's critique of contemporary culture and his historical pessimism, especially in his work between 1932 and 1940. Klee's reflections on history and on his own times are not literal but go "beyond the narrow bounds of history."[22]

Barbarism—Klee's Historical Pessimism

There are other interesting graphic themes within our context that are explosively powerful with regard to contemporary history. Klee drew upon these with renewed

109 Paul Klee, *Barbarian Boy*, 1933

strength in 1932 and, above all, in 1933, far more frequently than he had done in any other phase of his life. Among these are the themes of barbarism and slavery. Both terms appear noticeably often in the titles of his pictures, especially in those from 1933,[23] and these drawings belong to the extensive series in pencil and oil crayon with which Klee reacted to the contemporary historical situation.

Klee entitled one of these drawings *Barbarian Boy* (fig. 109). The subject's body, especially arms and legs, appears convulsively distorted, an impression strengthened by the irritating view of the observer (as if from below). The appearance and function of the object that the subject holds in his hands remain uncertain, but it suggests violence. It may possibly be a spear like the one in the drawing *Barbarian Soldier* (1933.145). The form culminates in irregular, violent hatchings with which Klee dissolved the outlines and purposely obscured the details of the body. In some places (right leg, parts of the arms) the dissolution of the form by means of the stroke of the drawing becomes especially evident, while the face appears downright deformed. The aggressive intensity of the gestures acquire in this case an inner convulsive power, as if Klee had intended a portrayal of ugliness. In any event, with the drawing *Barbarian Boy* he now referred explicitly to a cultural critique by linking the notion of the barbaric with childhood.

Klee's engagement with the themes "barbarism" and "slavery" expresses a profound historical pessimism. This point of view connects Klee to other German intellectuals of his period. Walter Benjamin was explicitly interested in Klee's art and directly drew from it ideas for his historical-philosophical theses.[24] He as well as Theodor W. Adorno understood barbarism in one respect to be the relapse in Hitler's Germany into totalitarian practices of domination, thought to have been obsolete; Benjamin and Adorno, as well as Klee, reacted to this relapse by emigrating. Like Klee, who had adopted a historically pessimistic view quite early, Adorno later understood barbarism to be much more than the relapse into fascist or other totalitarian dictatorships. Rather, after World War II, Adorno expressed a fundamentally pessimistic critique of modern civilization which he branded a "society moving towards barbarism."[25] In the drawings of 1933, Klee summed up history without stopping short at a superficial portrayal of contemporary events.[26] The force of the factual did not, however, lead to the dissolution of content, but rather Klee resorted to an illustrative drawing style and to a deepened engagement with pictorial themes central to his work, such as childhood, mythology, history, art, sexuality and death.

The Drawings of 1939–40

After Klee hastily emigrated from Germany in December 1933, signs of a crisis soon began to manifest themselves in his work and even in his letters. The outbreak of a grave illness followed in 1935 and led to the longest and most disruptive break to date in Klee's productivity. However, from 1937 on Klee seems to have adjusted himself to his illness, which eventually would lead to his death, in such a way that he could not only work again, but do so with rapidly increasing intensity. After the fateful year 1933, the years 1938, 1939 and 1940 became the most productive phase of Klee's career. These last three years of his life also brought the high point of Klee's engagement with the theme of childhood.

Childhood and War

The drawing *The Game Degenerates* (fig. 110) has a special meaning as the first numbered work of the year 1940, as is demonstrated by the special circumstances of Klee's entries in the oeuvre catalogue during his final year.[27] Together with the next drawing *Mummery* (Mummenschanz, 1940.2), it is the only drawing of this year that Klee dated on the page. The dating shows that Klee intentionally referred his production to the beginning of the year and that the first numbered works of this year had a special meaning for him.

In the drawing *The Game Degenerates* a group of children is represented, whose seemingly peaceful game is abruptly interrupted. On the left side in the

110 Paul Klee, *The Game Degenerates*, 1940

background a child juggles an object on its head like a circus artist, still evoking a peaceful situation.[28] However, the others seem to be transformed into an aggressive horde, which moves out of the picture to the right. The children, stylized as one-eyed, archaic monsters with slits for pupils, raise their fists into the air as if in a burst of mass psychosis. The ball game (two balls lie on the ground) seems to turn abruptly into a pogrom. The figure on the right, whose gloating expression differs from the deadly serious features of the others, is striking. Klee leaves us uncertain whether this is the leader of a group, or whether we are meant to see a contrast to the other children in the cautious, apparently ironic reserve of this figure.

A similar stylization of the archaic cyclops is found in the watercolor *Ostentatious Defense* (Protzige Wehr, 1935.55), the robotlike caricature of a warrior in medieval armor. Klee also used the motif of the one-eyed face in one of the last brush drawings created shortly before his death, entitled *For Intimidating* (fig. 131). The picture, which was carried out in great haste and in the primitive style of a child's drawing, shows a masklike face staving off harm.

The colored sheet *Children Play Attack* (fig. 111) was presumably created shortly after the drawing *The Game Degenerates*. Both pictures are closely related in their composition and content. The title unmistakably proves the event to be children's war games. A comparatively harmless preliminary stage is found in the late works of the year 1939. The page *Quarrel on the Playground* (Streit am Spielplatz, 1939.1213) is part of this. Shortly thereafter Klee varied the theme in the drawing *Incident in the Group* (Zwischenfall in der Gruppe, 1939.1230). However, the drawing *Group with the Fleeing Insulter* (Gruppe mit dem fliehenden Schimpfer, 1940.36) appears as a polar opposite to *The Game Degenerates*. This reversal of the event is expressed right down to the composition: the children play peacefully, whereas the insulter flees to the left.

111 Paul Klee, *Children Play Attack*, 1940

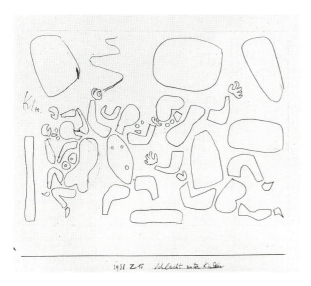

112 Paul Klee, *Battle among Children*, 1938

Klee had unmistakably combined the themes of childhood and war even before the outbreak of the war, as in the drawing *Battle among Children* (fig. 112). Here Klee synchronized his graphic style with the violent event he portrayed by presenting the three fighting figures broken into pieces corresponding to their body parts. The children are like marionettes, like toys, split up into various parts. An extra arm results from the style of unjoined body parts in the case of the fallen figure on the right. The figure that dominates the fight in the center of the picture is portrayed with triumphant facial features and raised whip. The female figure with the raised arm on the left appears to turn away from the event, fleeing. The playground has become a battleground. The aggressive dissonance is consistent with the content of the drawing right down to the method of representation.[29]

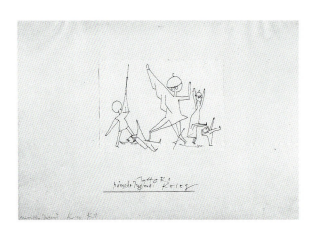

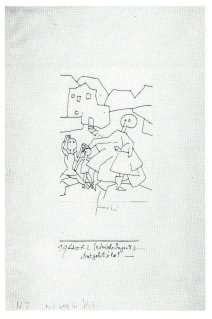

113 Paul Klee, *War* (from *Foolish Youth*), 1940

114 Paul Klee, *There Goes the Fun* (from *Foolish Youth*), 1940

Klee impressively formulated the identification of childhood with war in four drawings from 1940 which he grouped in a series called *Foolish Youth*. The four individual titles, *War* (fig. 113), *There Goes the Fun* (fig. 114), *Drunken Advance* (fig. 115) and *Encircling* (fig. 116) evoke a temporal course of events that follow one another with a military logic. The first drawing, *War*, portrays a group of five children occupied with war games. Three of them wear spiked helmets like the ones worn in the German army during World War I. The figure in the center, dominant in size and bearing, is positioned across from the smaller child on the left. The child lying between them, despite its position, repeats with its right arm the motion of the one standing over it. At the same time the drawing gives the impression that the prone child has been beaten down by the figure in the center and is going to be assaulted with kicks. The child on the left side of the picture shoulders a rifle that melds seamlessly with the figure's arm. Both the military pose and the rifle itself, with bayonet in place, show how serious the game is. On the right, two children boisterously practice goose-stepping. Even this scene has a double meaning: there is an unmistakable element of violence in the larger child's leg being aimed with dangerous directness at the face of the smaller child. With this repetition Klee strengthened the critical ambivalence between ruthless aggression and childlike exhuberance.[30]

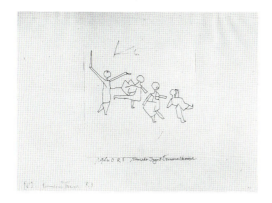

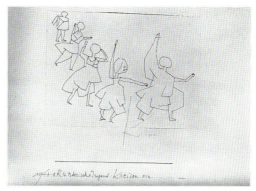

115 Paul Klee, *Drunken Advance* (from *Foolish Youth*), 1940

116 Paul Klee, *Encircling* (from *Foolish Youth*), 1940

The same contrast is expressed in the title of the third drawing of the series, *Drunken Advance*. The commander on the left side of the page seems to give orders for a marching exercise. He appears as if he were connected with an electric wire to the figure standing nearest him. The more the children advance in the commanded direction to the right, the more their marching movements resemble the grotesquely exaggerated movements of marionettes. The line that joins the two children on the left alludes to a fundamental conflict, the power relationship within the group. The "wire" is, in this case, an expression of a power relationship between the one on the left who drives the group on, and the children on the right carrying out his orders. By doing so, Klee illustrated the field of power laden with conflict between the individual and the group controlled by him. The signature is also an interesting indication of the pictorial content of the drawings in this group. It is hardly by chance that Klee placed his signature on each of the four pages in a conspicuous relationship to the leader of the group.[31] In the fourth composition in the series, *Encircling*, Klee unmistakably connected the drawing through its composition to that of *The Game Degenerates* and *Children Play Attack*.

Images of children engaging in military marching exercises, as in the series *Foolish Youth*, are not new in Klee's work. As early as 1937, Klee had already portrayed a goose-stepping boy, which in a rather detached way he had entitled *Little Mars* (1937.261). In the following year Klee took up the theme again. He now entitled the page *The Little Prussian* (fig. 117).[32] Here, too, Klee intentionally left open a direct contemporary-historical reference by using the historical generalization "Prussian." One also encounters the motif of the child practicing the goose step in other drawings of the last two years;[33] figures marching uniformly to the right are also found in the brush drawing *Comrades Wander* (Kameraden wandern, 1939.1115) as well.[34]

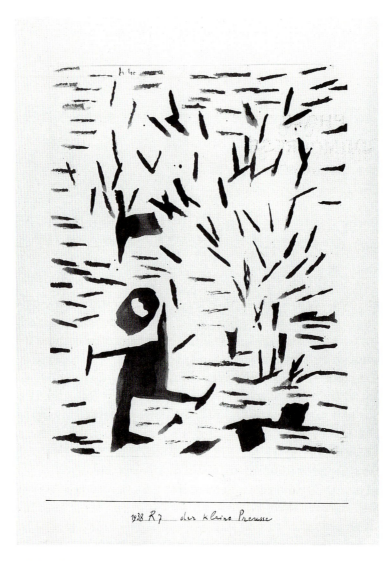

117 Paul Klee, *The Little Prussian*, 1938

The Questioning of Childhood as an Ideal of Avant-Garde Art

In his study "The Issue of Childhood in the Art of Paul Klee," O. K. Werckmeister demonstrated a new appraisal of childrens' art around 1929–30, and of the child-like as a stylistic ideal of avant-garde art in the art education literature, as well as in art criticism. On the backdrop of the social and economic changes in Germany, he diagnosed on the one hand the increased "politicizing of the art of children," and on the other the connection of Klee's art with a "new perception of the cruel nature of childhood."[35] In later contributions on this topic Werckmeister expanded further

the resulting thesis of his essay: that Klee had decisively revised his attitude toward the notion of childhood over the course of two decades.[36]

One can hardly dispute that Klee changed his attitude under the influence of the contemporary historical crisis. Even the assertion that he submitted his originally emphatic attraction to the art of children to a critical revision in the 1930s may be true. By contrast, the simplistic interpretation that Klee's conception of childhood in the 1930s corresponds to a negative reversal of his earlier idea, does not seem valid. In no way did Klee during the last three years, as is suggested, portray only the aggressive "ideal" that compares childhood with war.[37] In no other phase of his work did Klee occupy himself so intensively with the notion of childhood—in all its controversial multiplicity—as in his late work.

On the other hand, the pessimistic and belligerent conception of childhood is hardly new in his work either. At an early date Klee had already considered the negative aspects of childhood. In 1905 he wrote in a letter to his wife: "Children (. . .) are not such blessed creatures as one could assume from my high praises; here too I cannot give a false impression of myself and will never be able to do so."[38] Klee had expressed himself in a still more pointed manner in a letter from 1901. With frank aversion he told his fiancée, Lily Stumpf, about a children's class trip that was carried out with military discipline. The children's behavior is directly reflected in Klee's noticeably aggressive commentary:

> I saw more horrible than edifying things in these young faces and in these variously wretched forms and frames. (. . .) The children march (. . .) with little canton- and little Swiss flags, first the boys and then the girls, commanded by two women teachers. (. . .) Then "halt" is ordered, and the wriggling things, shoving each other, (. . .) were crammed into the (. . .) station shelter. (. . .) The children competed with each other and a nasty boy shamefully deceived his teacher. (. . .) The children pushed and trampled each other like a herd.[39]

Klee's account suggests a natural depravity in children, although their aggressiveness apparently can be traced to external factors: their oppression and the conformist pressures of the horde. Klee expressed himself similarly, although in this case referring to the events of war, in a letter from 6 February 1918, the period of his military service in Gersthofen. He indignantly told his wife about the war games of children, which his son Felix had vividly revealed to him during his furlough from the front.[40]

Ernst Kallai was the first critic who tried to demonstrate Klee's engagement with the new, negative conception of childhood, as Werckmeister has pointed out.[41] Walter Benjamin later adhered to Kallai's interpretation.[42] This "culturally antagonistic idea of childhood" was also adopted by other critics in connection with Klee, in that they, unlike Kallai, now used this as an argument against Klee.[43]

Based on the passages from the letters mentioned, but, above all, considering Klee's late drawings, Werckmeister's line of reasoning—that Klee devoted himself to this destructive conception of childhood in direct response to his critics—must at least be called into question.[44] The "culturally antagonistic" aspects of childhood, which are thematically dominant in Klee's late work, are based as much on empirical experiences from Klee's own discussion of and experiences with children, as they are on his generally pessimistic attitude concerning the political reasoning of people in general. Osterwold pointed out that with the theme "childhood and war" Klee also means a human spiritual conflict[45] that in no way requires real war as a model. Klee's famous, self-stylized note in his wartime diary, with which he had maintained his artistic renunciation of the world, also supports this presumption: "I have had this war inside myself for a long time. Therefore it does not concern me spiritually."[46]

In contrast to the emphatically positive opinion at the beginning of the avant-garde in Germany, the theme of childhood in the 1930s became for Klee the locus of a pessimistic engagement with war. His ambivalent conception of childhood is, however, significantly different from the biased affirmative, culturally antagonistic ideals of conservative critics around 1930. The corruption of children by the National Socialist dictatorship and the war, the sometimes overt cruelty of children, now becomes the metaphorical pretense for Klee's all-around pessimistic view of history and, indirectly, an expression of his decisive self-isolation as an artist.

The Child as Artist

The analogy between childhood and war is by no means the only aspect of the theme of childhood in Klee's late work. The range of meaning of this idea is revealed by studying Klee's other late pictures. One notion diametrically opposed to Klee's pessimistic conception of childhood, the notion of childhood as an idealization of the artist, can be traced even to his last drawings. The drawing *Close Work* (fig. 118), which may be a concealed self-portrait, is an example of this. In this drawing from his last year Klee portrayed the creativity of a child as a primeval state and as an ideal of artistic creativity. *Close Work* is like an illustration of that impassioned childlike artistic practice, described by Baudelaire in his essay "La morale du joujou," which "has at its disposal an intensity and faith which the later, conscious interaction with art can never return to."[47] The absorption of the child in his creative activity, neither forced nor weighed down by calculation, is like a mirror opposite to the radical introspection of the avant-garde artist in his apodictic renunciation of the world that Klee had caricatured in his self-portrait *Absorption* (Versunkenheit, 1919.75). The drawing *Music Student* (Musikschüler, 1940.77) and pictures in that Klee conjured up the peaceful side of childhood opposed to war are also examples of the many other uses of the theme in his late work.[48]

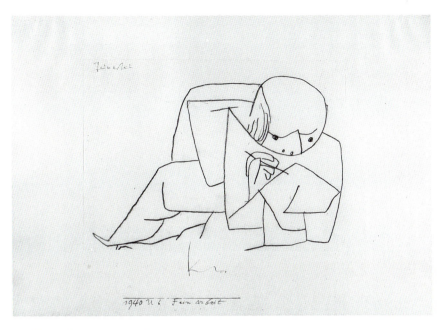

118 Paul Klee, *Close Work*, 1940

Klee repeatedly portrayed peaceful groups of children even at the end of 1939, as in *Group of Seven* (Gruppe zu sieben, 1939.1103), *Group of Eleven* (Gruppe zu elf, 1939.1129) and *Small Group out of the Crowd* (Kleine Gruppe aus der Menge, 1939.1129). The innocent, marveling expression on the faces of these children pressed tightly together in rows, heads softly leaning against each other, stands in the greatest contrast to Klee's stylization of children's faces as barbaric, one-eyed grotesques in *The Game Degenerates*.[49] Compared with static groups of children lined up on the surface, the composition *Group of Fools* (Narrengruppe, 1939.1140) brings a change. Here one encounters the connection of childhood and foolish exuberance, which Klee, in reference to the war, subsequently intensified to abysmal depths in the series *Foolish Youth*. In the first title note Klee had called the composition "darkened passion" (*verdüsterte Leid[en]schaft*).[50] He also made a variation on the same theme in a large format with the title *A Fool Finds Followers I* (Ein Narr macht Schule I, 1939.1239).

In the drawing *Mischief* (fig. 119) Klee united two concepts central to his work. In this case he portrayed two children who, like little acrobats, perform feats to the left and the right of a large figure. The child on the right hangs by his torso from a trapeze; the winglike, outstretched arm of the central figure functions as its support. The other child juggles a ladder, standing on one leg with right arm raised. The right arm of the main figure hangs down, touching the child's head. With its

119 Paul Klee, *Mischief*, 1940

statuesque, motionlessness and brooding facial expression, this central figure
stands in contrast to the children's liveliness, although it appears willing to allow
everything to happen to itself. Its monumental size, when compared with the chil-
dren, emphasizes this character of practical availability and, simultaneously, most
profound non-involvement. The outlines of the figure become vague in the lower
body, the legs merge into a kind of foundation, whose lines are aligned with the
lower corners of the sheet.

In the picture's central personage Klee portrayed a key metaphorical figure of
his pictorial repertoire: the type of the thinker who hermetically seals himself off
from the outside world. With this he presumably meant a type of artist, who, in
this case, is nuanced in his meaning by being tied into the depicted event. As a
total conception, *Mischief* defines Klee's idealized notion of the artist. The children
doing gymnastics and juggling embody "unregulated spontaneity,"[51] which was so
highly valued by Klee and other artists of the avant-garde, from the Blaue Reiter
to Surrealism. The main figure, whose ear appears like the mirror image of a ques-

120 Paul Klee, *Child as Hermit*, 1920

tion mark without its point, embodies the sign of reflection, which was decisive for Klee. The brooding, silent thinker in this case towers above the children without dominating them. In this way, *Mischief* is the counter-portrayal to the drawing *Wild Boys' Games* (Wilder Knaben Spiele, 1940.144), which presumably was created shortly before *Mischief*. In *Wild Boys' Games* the children have seized power and make their game of the helpless adult figure, as though flying a kite.[52]

A related association, that of childhood to the existence of the hermit, is already found in an oil painting from 1920 entitled *Child as Hermit* (fig. 120). In a fairy-tale garden landscape constructed of numerous architectural and botanical elements—in balance like the complementary red and green colors—the figure of a child appears in a doorlike opening on the right. The child's figure looks as though it could have been taken from a child's drawing. The masklike face with dark eye sockets, the long strands of hair and the skeletal arms and legs give the figure a ghostly quality. The artist accentuated the figure by including a stairlike path leading into the picture and up to the child's feet from the lower right. The green, red and white colors of the arrow-shaped path correspond to the colors of the child. Klee's depiction is ambiguous about whether the child wants to leave the hermit's dwelling. Unlike the drawing *Mischief*, in which the notions of childhood and the artist's withdrawal from life complement each other, the small oil-on-paper paint-

121 Paul Klee, *Itinerant Artist: A Poster*, 1940

ing *Child as Hermit* caricatures such a symbiosis. However, in both works—the late drawing created four months before his death in 1940, and his fairy-tale landscape from 1920—Klee joined the notions of childhood and radical isolation, both of which had a fundamental relevance to his artistic self-reflection.

In the color drawing *Itinerant Artist: A Poster* (fig. 121), created with brash, wide brushstrokes in March 1940, Klee took up the same theme, simultaneously varying and intensifying it. As the title suggests, the *Itinerant Artist* is a kind of self-declaration for Klee as an itinerant, in some sense homeless, artist. Here Klee united the notions of "childhood" and the "artist" reconciling them formally in the style of the little stick figure. The theme of the juggler, of the homeless "artiste" on the fringe of society, gives this work an additional symbolic dimension. For generations, jugglers and *saltimbinques* were considered by many artists as "heroes of failure."[53] Emigrating or fleeing people are among the pictorial motifs constantly

122 Felix Klee, *Untitled (Train)*, 1913

reappearing since 1933 in Klee's work; he connected these to his own experience of forced emigration. Nevertheless, although the old *artiste* embodies a familiar aspect of failure, Klee raised the myth of failure, of nomadic wandering and ostracism, to a metaphysical dimension through the linking of the *artiste*'s life and childhood.[54] The addendum to the title, "A Poster," emphasizes the programmatic character of the work. With it Klee expressly defines the drawing as an announcement directed at the public: the posterlike, simplified portrayal of the avant-garde artist's precarious position at this historical juncture.

Recourse to Children's Drawings

In comparison to his attitude during his time in Munich, Klee's relationship to children's drawings seems to have changed during the 1930s. In Munich, presumably even before Kubin, Kandinsky, Münter and Marc, Klee had discovered children's drawings and the "childlike style" as an ideal of the artistic avant-garde, with which it distanced itself from academic tradition. Klee's intensified engagement with his own childhood drawings also occurs around 1910.[55]

Despite the changed situation in the 1930s, there are also cases in Klee's late work in which he used children's drawings as models for his own drawings and paintings. An especially revealing example for this practice is the drawing by his son, Felix, from 1913 (fig. 122), which is mentioned numerous times in the literature on Klee. Klee took inspiration from it in no less than two drawings and two paintings in 1939. The drawing *Upward* (fig. 123) is the most similar to his son's drawing. In the title, however, Klee left it unclear that an alpine railway was meant with the rectangular, triangular and circular forms, as well as with the crossed lines to the right of center in the picture. A considerably more developed portrayal is found in the drawing *Railway Train* (fig. 124). Klee uses the same source for the motif in the paintings *Alpine Train* (fig. 125) and *Compulsion Toward the Mountain* (Zwang dem Berg, 1939.613).[56]

But otherwise, direct references to Klee's own childhood drawings or the drawings of his son are the exception in his late works. It is the case that Klee's

123 Paul Klee, *Upward*, 1939

124 Paul Klee, *Railway Train*, 1939

125 Paul Klee, *Alpine Train*, 1939

graphic oeuvre remained almost intact in his own possession throughout his career and that he seems to have made a practice of systematically recombining and recycling ideas. But in the years 1937 to 1940, when Klee showed signs of being sick, he increased his production in such a way that his drawing process took on more and more the quality of serial production. Thus, Klee increasingly turned away from his established method of returning to earlier compositions, with the countless possibilities for variation on a carefully calculated structure and instead he now worked much more directly.

Childhood and Primitive Style

Even as early as the turn of the century, during the course of the international aesthetic education movement and the interest in children's art, increasingly attention was paid to the relationship between children's drawings and the art of primitive peoples.[57] Thus, Alfred Lichtwark, who had been director of the Kunsthalle Hamburg since 1886 and was one of the pioneers of the aesthetic education movement in Germany at the end of the nineteenth century, could write in 1900: "We have recognized the relationship between the child's first attempts and those of primitive peoples."[58] This affinity to child art was then connected by Kandinsky and the other artists of the Blaue Reiter to the latest efforts of the avant-garde, and in the *Almanac* they elevated the relationship to a kind of program.

Klee also did not lay claim to the search for a "primitive style" for the first time in the 1930s, but rather he had done so since his artistic beginnings. Above all Klee time and again occupied himself with this in his journal entries, whereby he meant "primitive" not just in the ethnographic sense, but rather as a desired new

126 Paul Klee, *Childhood*, 1938

beginning of artistic development, as a "primeval beginning."[59] In a note in the recopied version of the journals dated to 1909 he defined "primitiveness" as "ultimate professional knowledge." Klee went to great pains, however, to make clear that his "primitiveness" was the result of the highest artistic discipline and, therefore, it was "the opposite of real primitiveness."[60] This "primitiveness" of childlike drawing is, of course, a model, but it must be transcended in a synthesis of childlike style and artistic calculation.

In 1938 Klee named a brush drawing done in royal red *Childhood* (fig. 126).[61] This work is especially enlightening with regard to his engagement with the notion of childhood. The title of this drawing signifies that there is a direct connection between intellectual conception and the style of painting typical of the late works. This connection will now be examined.

Klee used the word childhood only three times in titles for his pictures, and only once—in the brush drawing of 1938—without a modifying adjective. In the two earlier works in which he had used the word, he evoked with it a fairy-tale-like distant event with a mythological or religious undertone (*Childhood of Iris* [Kindheit der Iris, 1917.105] and *Childhood of the Chosen One* [Kindheit des Erwählten, 1930.186]). Whereas Klee created a romantic nature myth with the watercolor of 1917, he suggested a religious occurrence with the title *Childhood of the Chosen One*, an impression reinforced by the star in the upper left of the picture.

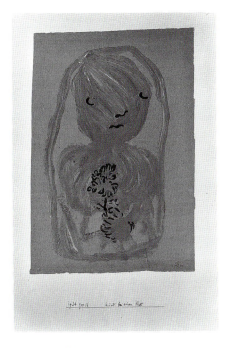

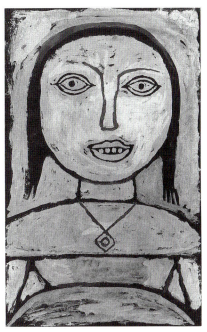

127 Paul Klee, *Child at a Party*, 1934 **128** Paul Klee, *Sick Girl*, 1937

The brush drawing *Childhood* of 1938 fundamentally distinguishes itself from such literary references that contribute substantially to the content of the pictures. The forms are rudimentary and abstract, no longer retaining any narrative function.[62] In the left half of the sheet the beginnings of the depiction of a plant or tree can be recognized, in the right half those of a childlike face. Above all, the primitive strokes of the brush and the paint material—the reddish-brown paste—contribute strikingly to the drawing's aesthetic effect. The raw brushwork and title strengthen the impression that, in this case, intellectual conception and graphic style have been harmonized. This is especially meaningful because the brush drawing is a typical example of Klee's late style of a concise language of linear forms.

A related tendency of synchronizing motif and style, statement and material, is found in colorful works like *Child at a Party* (fig. 127), *Sick Girl* (fig. 128) and *Moon-blond* (Mondblond, 1937.99). In these pictures it was still the case that Klee portrayed children in the style of children's drawings, as he often had earlier. In brush drawings created with a dense color paste, such as *Hungry Girl* (fig. 129), *Saluting Girl* (Salutierendes Mädchen, 1939.672), *Crazy Cook* (Tolle Köchin, 1939.797), *By the Blue Bush* (Beim blauen Busch, 1939.801), *Burnt Mask* (fig. 130) and *White-Brown Mask* (Weiss-braune Maske, 1939.806), Klee carried this primitive style a step further. In these portrayals of children or masks he achieved a convergence between childlike style and primitive aesthetic. Whether or not it was

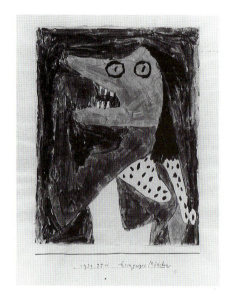

129 Paul Klee, *Hungry Girl*, 1939

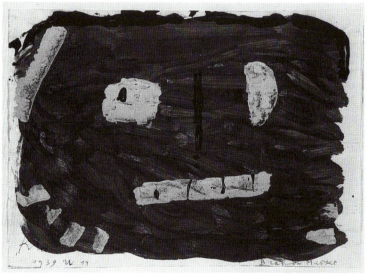

130 Paul Klee, *Burnt Mask*, 1939

intended, the primitivism of the style acts as an answer, and as a graphic equivalent, to the barbarism of contemporary history. In the watercolor drawing *For Intimidating* (fig. 131) already mentioned above, Klee appeared to address the reconciliation between the subject and the style of representation, between the archaic mask and a childlike primitive style of representation, as a subject—even in the title of the picture. In this way his idea of a convergence of appearance and idea[63] was also carried out in an artistically convincing way. Above all Klee's emphasis

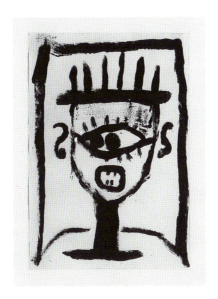

131 Paul Klee, *For Intimidating*, 1940

on the rather anti-aesthetic character of the material and on the coarse brush-stroke with which he manipulated the black paste was striking. On the other hand, Klee went a step further in the drawing *Childhood* by directly relating his notion of childhood to the creative act itself, the movement of his hand while painting and drawing. In this way Klee fundamentally connected his notion of childhood with his artistic conception.[64]

It is possible that precisely the characteristics of this drawing, the directness of the execution, the coarseness of the material and the omission of aesthetic calculation, indicate why Klee gave it this title, which had so much meaning for his artistic conception. The directness of this way of working and the renunciation of cultural tradition opened up new creative possibilities for Klee, which he passionately searched for in his work. And he directly connected precisely this manner of working with his notion of childhood. In this way, artistic style coincided with his notion of childhood in his late work, and Klee no longer needed to refer either formally or in a literary way to the theme of childhood or, as the case may be, to children's drawings.

1 Two scholars have published fundamental information on this theme: O. K. Werckmeister, "The Issue of Childhood in the Art of Paul Klee," *Arts Magazine, Special Issue Paul Klee* 52, no. 1 (1977): 138–51.

This contribution, which to date has been fundamental, appeared in revised form in Werckmeister's book *Versuche über Paul Klee* (Frankfurt am Main: 1981), 124ff. Tilman Osterwold dedicated a large exhi-

bition to this theme for the first time in 1979, accompanied by the publication *Paul Klee: Ein Kind träumt sich* (Stuttgart, 1979). Werckmeister took up the theme once again in the exhibition catalogue *Paul Klee in Exile, 1933–1940* (Himeji City: Museum of Art, 1985), 157ff.

2 Osterwold, *Paul Klee*, 6.

3 Ibid., 123 ["in der Welt des Kindes"]; see also p. 96.

4 Detlev J. K. Peukert, *Die Weimarer Republik. Krisenjahre der klassischen Moderne* (Frankfurt am Main, 1987), 166. "Absage an die kulturelle Modernität der Avantgarde."

5 Cf. Jürgen Glaesemer, *Paul Klee, Handzeichnungen II, 1921–1936* (Bern: Kunstmuseum, 1984), 343ff.; O. K. Werckmeister, "Von der Revolution zum Exil," in *Paul Klee: Leben und Werk*, exh. cat. (Bern: Kunstmuseum, 1987), 44ff.

6 Paul Klee, *Briefe an die Familie*, Band 2: 1907–1940, ed. Felix Klee (Cologne, 1979), 1225ff. "Gelinden Zeichenrappel."

7 Cf. Glaesemer, *Klee: Handzeichnungen II*, 343. I believe that the drawings' date of origin can be even more precisely determined. The brush drawing 1933.52 is entitled *It Stirs at the End of February*. It can be assumed that the title contains a reference to the date of origin, as is known from other examples: *The Wagon of Virtue (In Memory of October 5th, 1922)* (1922.123), *Feelings in May* (1926.103), *Rough Wind on May 8th* (1928.105), *May* (1933.284), *Still Life on Intercalary Day* (1940.233). From this it can be concluded that the pencil and oil crayon drawings starting with the number 1933.71 can at the earliest have been created beginning in March 1933. This stylistically and thematically closed cycle of drawings ends in the oeuvre catalogue with the number 1933.213. The next groups of drawings which Klee registered are the numbers 1933.222–33, 1933.268–73, 1933.313–52, 1933.359–69, 1933.387–90. The title of the small-format painting *May* also gives a point of reference for the date of origin. Accordingly, about 160 of the more than 200 drawings may have been created between March and May.

8 Cf. also Werckmeister, *Klee: Leben und Werk*, 34.

9 Cf. Alexander Zschokke, "Begegnung mit Paul Klee," in *DU, Schweizerische Monatszeitschrift* (October 1948): 27–28, 74ff. "Den Anfang dieses Zyklus bildet ein Blatt mit ein paar wenigen geraden Bleistiftstrichen, die, wie eine Kinderzeichnung, unbeholfen anmuteten. Ich muss gestehen, dass dieser Anfang—nachdem was man von der deutschen Revolution erlitten und erfahren hatte—etwas Komisches ausstrahlte und dem Ernst der Situation, in der der Künstler selbst war, keineswegs zu entsprechen schien." Zschokke had given a presumably identical radio lecture with the title "In Memory of Paul Klee" (Erinnerungen an Paul Klee) on 15 July 1945. Lily Klee responded to it extensively in a letter of 16 July 1945. She wrote: "It was also very interesting to me that you reminded me of that evening spent with us. Above all even I quite distinctly recall looking at those 200 pages (drawings) which you refer to as representations of the National Socialist Revolution." ["Sehr interessant war mir auch, dass Sie mir jenen bei uns verbrachten Abend mit Kaesbach wieder ins Gedächtnis riefen. Vor allem erinnere auch ich mich noch ganz deutlich an das Betrachten jener 200 Blätter (Zeichnungen) welche Sie als Schilderungen der nationalsozialistischen Revolution bezeichnen."] Felix Klee Estate Collection, Bern.

In 1933, the call was raised: "Self-discipline and (military) discipline must again return to cultural life" ["Selbstdisziplin und Mannszucht müssten im kulturellen Leben wieder einkehren"]; cf. Peter Ulrich Hein, *Die Brücke ins Geisterreich. Künstlerische Avantgarde zwischen Kulturkritik und Faschismus* (Reinbeck and Hamburg, 1992), 13 and 221.

10 Cf. also Glaesemer, *Klee: Handzeichnungen II*, 345ff.

11 Klee took up the theme once again in the same year in two oil crayon drawings. *Training of Rare Animals* (1933.317) reminds one of a circus act. As in *Training*, the contrast here between large and

small—here the human figure appears to be a child—contributes to the strange effect. In the drawing *Training Act "Duck Creek Bridge"* (1933.322) Klee caricatured the training process.

12 Werckmeister's general opinion, "none of the drawings (. . .) takes up openly National Socialist ideas, neither in subject nor title" ["keine der Zeichnungen (. . .) greift offen nationalsozialistische Themen auf, weder im Bild noch im Titel"] (Werckmeister, *Klee: Leben und Werk*, 43) is even less comprehensible the closer one examines the drawings of 1933. The fact that it is neither a matter of "anti-government caricatures" ["regierungsfeindliche Karikaturen"] (Ibid.) nor portrayals expressly referring to contemporary political events, does not mean, especially in 1933, that for Klee it was a question of "distancing his art in principle from visual actuality" ["seine Kunst von visueller Aktualituät zu entfernen"] (Ibid.).

13 Cf. Gotthard Jasper, *Die gescheiterte Zähmung. Wege zur Machtergreifung Hitlers 1930–1934* (Frankfurt am Main, 1986), 63ff.

14 Ibid., 100ff.

15 Ibid., 125; cf. also Peukert, *Die Weimarer Republik*, 255ff.

16 Paul Klee, *Briefe an die Familie*, Band 2, 1229.

17 That Klee was entirely aware of the imponderabilities and risks of this taming concept is, above all, shown in his letter to Lily of 30 January 1933, the day of Hitler's appointment as chancellor of the Reich. He wrote: "then there is the possibility that Hitler will slip away from Papen and then will derail him (. . .) one worries and tries to state one's opinion, however deplorable the whole German domestic political scene is and continues to be." ["dann besteht noch die Möglichkeit, dass Hitler dem Papen entgleitet und dann entgleisen wird (. . .) man macht sich doch seine Gedanken, und versucht Stellung zu nehmen, so jammerbar der ganze Schauplatz deutscher Innenpolitik ist und bleibt."] Ibid., 1225.

18 Cf. note 12; Zschokke, "Begegnung mit Klee," 74ff.; cf. also Werckmeister, *Klee: Leben und Werk*, 43.

19 Cf. Zschokke, "Begegnung mit Klee," 76. ["eine Art von apokalyptischem Getöse und Lärm;" "Die Heftigkeit der Striche;" "ein fast körperliches Unbehagen von Brutalität und Massengefühl, dass einem die verflossenen Wochen voll vor Augen standen."]

20 The clearest evidence in his late work is probably Klee's letter to his son, Felix, from 29 December 1939, in which he speaks of his drawings as "children." Klee, *Briefe an die Familie*, Band 2, 1295.

21 For more on Klee's conception of artistic work as a process of birth, and his habit of referring to his works as children, see Josef Helfenstein, "Das Spätwerk als 'Vermächtnis.' Klees Schaffen im Todesjahr," in *Paul Klee: Das Schaffen im Todesjahr*, exh. cat. (Bern: Kunstmuseum, 1990), 64; Gregor Wedekind, "Geschlecht und Autonomie: Über die allmähliche Verfertigung der Abstraktion aus dem Geist des Mannes bei Paul Klee," in Susanne Deicher, ed., *Die weibliche und die männliche Linie. Das imaginäre Geschlecht der modernen Kunst von Klimt bis Mondrian* (Berlin, 1993), 90.

22 Cf. also Stefan Germer, "Le Répertoire des Souvenirs. Zur Reflexion des Historischen bei Manet," in *Edouard Manet, Augenblicke der Geschichte*, eds. Manfred Fath and Stefan Germer, exh. cat. (Mannheim: Kunsthalle, 1992–93), 40. "Über den engen Rahmen der Historie hinaus."

23 *Barbarian General* (1932.1); *Barbarian Victim* (1932.12); *Music Slave* (1933.136); *Barbarian Soldier* (1933.145); *Slave* (1933.174); *Chained Slave* (1933.182); *House Slave* (1933.183); *Barbarian Boy* (1933.188).

24 Cf. O. K. Werckmeister, "Walter Benjamin, Paul Klee und der Engel der Geschichte," in Werckmeister, *Versuche über Klee*, 98ff.

25 Theodor W. Adorno, *Ästhetische Theorie* (Frankfurt am Main, 1971), 373. "[Auf] Barbarei sich hinbewegende Gesellschaft."

26 Cf. Werner Spies, *Kontinent Picasso: Ausgewählte Aufsätze aus zwei Jahrhun-*

derten (Munich, 1988), 59.

27 Helfenstein, *"Das Spätwerk,"* 69ff.

28 In drawings created presumably shortly beforehand like *Group of Children* (1939.11005) and *At Bajazzo* (1939.1125) one likewise finds the motif of the child juggling a ball like an acrobat.

29 Cf. Osterwold, *Paul Klee*, 212ff.; and Werckmeister, *Klee in Exile*, 159.

30 For more on the series *Foolish Youth*, see Werckmeister, *Klee in Exile*, 159ff.

31 Cf. also Wolfgang Kersten, *Paul Klee: Übermut: Allegorie der künstlerischen Existenz* (Frankfurt am Main, 1990), 38: "Thus the signature of the artist itself becomes a visible portrayal of forces bellicosely raging forward." ["So wird die Signatur des Künstlers selbst zu einer Verbildlichung kriegerisch vorwärtsstürmender Kräfte."] For general information on the series *Foolish Youth* or on the relationship between signature and figurative portrayal, see ibid., 47ff.

32 Cf. Osterwold, *Paul Klee*, 138ff.

33 For example, *Next in Sight* (1939.1037).

34 Jürgen Glaesemer, *Paul Klee: Die farbigen Werke im Kunstmuseum Bern* (Bern: Kunstmuseum, 1976), no. 238.

35 Werckmeister, *Versuche über Klee*, 160ff. "Politisierung der kindlichen Kunst;" "neue, grausam-naturhafte Konzeption der Kindheit."

36 Ibid. and Werckmeister, *Klee: Leben und Werk.*

37 Werckmeister, *Klee in Exile*, 159.

38 Letter of 31 March 1905 in Klee, *Briefe an die Familie*, Band 1, 492 ["Die Kinder (. . .) sind nicht so selige Geschöpfe, wie man nach meinen Anpreisungen annehmen könnte; auch hier könnte ich mich nicht verleugnen und werde mich nie verleugnen können"]; cf. also Osterwold, *Paul Klee*, 102.

39 Letter of 6 August 1901 ["Schon auf diesen jungen Gesichtern und in diesen vielfach jämmerlichen Gestalten und Gestellen las ich mehr abscheuliche als erbauliche Dinge (. . .) Die Kinder marschieren (. . .) mit Kantons- und Schweizerfähnchen, zuerst die Buben und dann die Mädchen, kommandiert von zwei Lehrerinnen (. . .) Da hiess es 'halt',

und das zappelnde, einander stossende (. . .) Zeug wurde in die (. . .) Stationshütte gepfercht (. . .) Die Kinder stritten sich um den Rang und ein böser Bube überlistete seine Lehrerin in schändlichster Weise (. . .) Die Kinder drängten und traten sich wie eine Herde;" cf. also Osterwold, *Paul Klee*, 180.

40 "Felix wrote me extensively about the procession day [of the school]. Apparently it was no go again with instruction, and so they spent their time playing wild war games, which I am not exactly delighted about." ["Felix schrieb mir ausführlich über den Umzugstag [der Schule]. Es war scheints wieder nichts mit dem Unterricht, und da haben sie ihre Zeit mit wilden Kriegsspielen zugebracht, für die ich nicht gerade begeistert bin."] In Klee, *Briefe an die Familie*, Band 2, 903.

41 Werckmeister, *Versuche über Klee*, 162.

42 Ibid., 176 n. 120.

43 Ibid., 163. "Kulturfeindliche Idee der Kindheit."

44 "Already in what Kallai and Geist had written about him back in 1929 and 1930, Klee could read about children as aggressive, destructive, animal-like creatures. When his admirer Geist turned National Socialist in 1934, Klee was able, as he surely did, to study a book-length account of what the ideal of childhood could mean to the regime which the year before had condemned his own 'mad, childish daubings.' In his last three years, Klee depicted just the kind of aggressive ideal of childhood, to which Kallai and Geist had been subscribing." In Werckmeister, *Klee in Exile*, 159.

45 Osterwold, *Paul Klee*, 139.

46 Paul Klee, *Tagebücher 1894–1918*, Textkritische Neuedition, ed. Wolfgang Kersten (Bern: Paul-Klee-Stiftung, 1988), no. 952. "Ich habe diesen Krieg in mir längst gehabt. Daher geht er mich innerlich nichts an."

47 Cf. Werner Spies, *Rosarot vor Miami, Ausflüge zu Kunst und Künstlern unseres Jahrhunderts* (Munich, 1989), 98; Charles Baudelaire, "Vom Sozialismus zum Supranationalismus, Edgar Allan Poe, 1847–1857," *Sämtliche Werke/Briefe,*

Band 2 (Munich, 1983), 199. "Über die Intensität und Gläubigkeit verfügt, zu der der spätere, bewusste Umgang mit Kunst nie mehr zurückfinden könne."

48 Cf. also *Formerly Three United* (1940.95) from the Eidola-series; cf. Stefan Frey and Josef Helfenstein, eds., *Paul Klee, Verzeichnis der Werke des Jahres 1940* (Bern: Paul-Klee-Stiftung, 1991), 81.

49 For more on the groups of figures in Klee's late works, see also Glaesemer, *Paul Klee: Handzeichnungen III: 1937–1940* (Bern, 1979), 43.

50 Cf. Ibid., fig. 307.

51 Werckmeister, *Versuche über Klee*, 124.

52 Frey and Helfenstein, eds., *Klee, Verzeichnis der Werke*, 105.

53 Jean Starobinsky, *Porträt des Künstlers als Gaukler: Drei Essays* (Frankfurt am Main, 1985), 64.

54 In the drawings *Street Musician* (1940.306) and *Arlecchino* (1940.307) Klee soon was again occupied with this theme.

55 Jürgen Glaesemer, *Paul Klee: Handzeichnungen I: Kindheit bis 1920* (Bern, 1973), 12, 182. The assertion made by Wolfgang Kersten and Osamu Okuda in the most recent Klee literature, that Klee occupied himself with children's drawings for the first time in the wake of the *Blaue Reiter* "in an effort to keep up with the avant-garde" ["im Bemühen, mit der Avant-garde Schritt zu halten"], does not withstand an even somewhat diligent reconstruction of the historical circumstances (Wolfgang Kersten and Osamu Okuda, *Paul Klee: Im Zeichen der Teilung*, exh. cat. [Düsseldorf: Kunstsammlung Nordrhein-Westfalen, 1995], 35). Even the statement that Klee introduced "a seemingly childlike style into his artistic production parallel to the graphic and accountant-like processing of childhood" ["einen scheinbar kindlichen Stil in seine Kunstproduktion parallel zur bildnerischen und buchhalterischen Aufarbeitung der Kindheit"] and to the editing of [his] journal (Ibid.) appears to originate in ideological simplification. As is known, Klee had already occupied himself with this considerably earlier, as the letter to

his fiancée Lily Stumpf of 31 March 1905, among others, proves. Moreover, Werckmeister had already pointed out this letter (Werckmeister, *Versuche über Klee*, 134).

56 Cf. also Osterwold, *Paul Klee*, picture, 82ff., and Werckmeister in *Paul Klee: Das Schaffen im Todesjahr*, 45ff.

57 Jessica Boissel, "Quand les enfants se mirent à dessiner. 1880–1914: Un fragment de l'histoire des idées," *Les Cahiers du Musée national d'art moderne, Centre Georges Pompidou*, no. 31 (1990), 30. For more on the concept of "primitivism" in relation to children's drawing see the excellent unpublished essay by Martin Heller, "Zur Kunst der gebrannten Kinder: 'Kindlicher' Primitivismus zwischen 1939 und 1960," typed manuscript (Basel: 1985), 9ff. I thank the author for the chance to look at it.

58 Cited after Boissel, "Quand les enfants," 30 n. 77. "Wir haben die Verwandtschaft der ersten Versuche des Kindes mit denen der primitiven Menschen erkannt."

59 "I want to be reborn, [I do] not [want] to know anything about Europe, nothing at all. [I do not] want to know any authors, [I want] to be completely dull; almost primeval." ["wie neugeboren will ich sein, nichts wissen von Europa, gar nichts. Keine Dichter kennen, ganz schwunglos sein; fast Ursprung."] Klee, *Tagebücher*, no. 425.

60 Klee, *Tagebücher*, no. 857. A later remark of Klee's about drawing as a fundamental artistic activity, although it cannot be precisely substantiated, is consistent with this credo:

"So let us for the time being remain with the most primitive style, the line. In past ages of the peoples, when writing and drawing coincide, the line is the given element. Even our children usually begin with it; one day they discover the phenomenon of the movable point, and one can hardly imagine with what enthusiasm. Next, the pencil moves wherever it pleases with the greatest liberty.

"However, in observing the first works, the discovery is made at the same time that the paths that have been traversed

now stand permanently written. Now, children who are pleased by the chaotic naturally are not artists, but other children will soon progress to a certain order. The criticism of the written paths begins. The chaos of the first game submits to an initial regularity. The freedom of the line's direction yields to the expected end result; work with just a few lines now cautiously begins. One remains primitive. But, nevertheless, one cannot very well persist with primitiveness. A method of enriching the poor end result will have to be discovered without destroying or blotting out the clearly arranged, simple design."

["Bleiben wir also vorläufig beim primitivisten Mittel, bei der Linie. In Vorzeiten der Völker, wo Schreiben und Zeichnen noch zusammenfällt, ist sie das gegebene Element. Auch unsere Kinder beginnen meist damit; sie entdecken eines Tages das Phänomen des beweglichen Punktes, und man kann sich kaum mehr vorstellen, mit welcher Begeisterung. Mit grösster Ungebundenheit bewegt sich zunächst der Stift, wohin es gefällt.

"Beim Betrachten der ersten Werke wird aber auch zugleich die Entdeckung gemacht, dass die begangenen Wege nun fast geschrieben stehen. Kinder, die nun Freude am Chaotischen behalten, sind natürlich keine Bildner, aber andere Kinder werden bald zu einer gewissen Ordnung fortschreiten. Die Kritik der beschriebenen Gänge setzt ein. Die Chaotik des ersten Spiels weicht einer anfänglichen Gesetzmässigkeit. Die Freiheit der Linienführung unterwirft sich der zu erwartenden Endwirkung, vorsichtshalber beginnt nun ein Wirken mit ganz wenigen Linien. Man bleibt primitiv. Aber bei der Primitivität kann man doch nicht gut verharren. Man wird einen Modus entdecken müssen, das armselige Endergebnis zu bereichern, ohne die übersichtlich-einfache Anlage zu zerstören, verwischen."]

In this case it is possibly a question of the undated text of a lecture. In Klee, *Das bildnerische Denken*, ed. and rev. by Jürg Spiller (Basel/Stuttgart, 1971), 103.

61 Cf. Glaesemer, *Klee: Handzeichnung III*, no. 120.

62 An interesting, still concrete preliminary stage of *Childhood* can be found in 1937 in colored drawings like *Julie* (1937.237), *Child Ph.* (1937.238) or *Rita* (1937.239).

63 Cf. Werckmeister, *Klee: Leben und Werk*, 46; Kersten and Okuda, *Klee: Im Zeichen der Teilung*, 208.

64 Klee's position appears in this respect more radical than that of Picasso, who wanted to put childlike perception in the service of another vision: cf. Werner Spies, *Picasso: Die Welt der Kinder* (Munich: 1994), 11. But even Picasso, like Klee, used portrayals of children in order to push forward to a "cultural primitivism." (Ibid, 12).

From Primitivist Phylogeny
to Formalist Ontogeny

Roger Fry and Children's Drawings

Richard Shiff

Psychology of Education (Some Commonplaces)

Two commonplace beliefs: to become an adult, a child must master various modes of instrumental communication, learning the meanings his or her society attaches to certain aural and visual configurations, to words and images; to become an artist, an adult must revert to the child's mode of primitive sensation. There is education in both instances. Just as the child learns to behave like an adult, the adult artist, no longer a child, must learn to perceive like one. In accord with such beliefs, William James's *Principles of Psychology* defines artistic education by way of a "formalist" distinction between ordinary vision and its artistic (childlike) counterpart:

> The whole education of the artist consists in his learning to see the presented signs as well as the represented things. No matter what the field of view means, he sees it also as it *feels*—that is, as a collection of patches of color bounded by lines...The ordinary man's attention passes over them to their import; the artist's turns back and dwells upon them for their own sake.[1]

James suggests that artists are able to disengage from practical life ("what the field of view means"), attending to form in an immediate experience of its physicality (seeing the field "as it feels"). Such direct sensation elicits and liberates the artist's emotions. The ambiguity of James's verb "to feel" must come into play whether intended or not: what an artist "feels" is both sensation and emotion, generated both externally and internally.

James's *Principles of Psychology*, first published in 1890 and for several decades the most widely circulated study of its kind, appears near the beginning of the period dominated by formalist conceptions of art; the 1960s mark that era's end. In the United States, Clement Greenberg's writings had by then become the

preeminent formalist paradigm, and the years to follow were to witness a concerted resistance and reaction to his views. In England, however, and to a certain extent in America as well, it was Roger Fry (1866–1934), rather than Greenberg, who set the ultimate standard for formalist criticism.[2] The very fact that Fry belonged to the artistic generation of Vasily Kandinsky (1866–1944), Henri Matisse (1869–1954) and the somewhat younger Pablo Picasso (1881–1973) distinguished his position from Greenberg's. As the contemporary of these pioneering modernists and a fellow painter, Fry had to adjust and readjust his eyes to their individual developments and achievements, whereas Greenberg, born more than forty years later in 1909, regarded work by this same group of artists as the already established tradition of European modernism.

Fry's formalism relies on the problematic distinction articulated by James, as well as by many others of the time: on the one hand, there is the appearance or feel things have when experienced under the least prejudicial circumstances, as in the case of artistic vision; on the other hand, there is the meaning those very same things assume when regarded as means to an end or within a delimiting interpretive context, as in "ordinary," instrumental vision. Fry identified specifically "artistic" content with states of emotion communicated directly by visual design. Whatever meanings other interpreters might derive from subject matter, theme or allegory were of only secondary concern to this formalist critic. Such thematic elements would require a viewer's application of educated intellect, often to be followed by a practical moral judgment appropriate to either the artist's or the viewer's cultural tradition, whereas appreciation of elements of design required nothing more or less than keen attention and aesthetic sensitivity. Formalists believed that the aesthetic sense was an innate human faculty, not a product of rarefied, elitist culture. Formalism was universalist and democratic. Because sensitivity to form was entirely natural, it was characteristic of children—inborn.

Formalist principles shape many early twentieth-century theories of art, education, psychology and social development. Wherever these related disciplinary concerns converge into a coherent pattern—as they do in Fry's various discussions of children's art and education—the fluid principles of formalism crystallize, becoming all the more evident. Formalism is very much the implicit topic of Fry's fundamental "Essay in Aesthetics" of 1909. There he brought his understanding of a child's perception and mentality to bear on the question of how art should appear and how it should be created. As an essential bit of evidence, he figured the child into his account. But perhaps it would be more accurate to say that Fry depended on a preexisting figure *of* the child—the child as constituting a certain literary or rhetorical figure and locus of a grand cultural mythology, a point of condensation for many of the concepts and structures that were enabling European society to negotiate its own modernity. Such a process of negotiation began with the early industrial revolution and was still very much in operation during Fry's lifetime.

Let me leave aside for the moment Fry's conception of the child, in order to consider one of the central claims he made in his 1909 essay. He explains how an artist's vision can produce feelings in others:

> When the artist passes from pure sensations to emotions aroused by means of sensations, he uses natural forms which, in themselves, are calculated to move our emotions, and he presents these in such a manner that the forms themselves generate in us emotional states, based upon the fundamental necessities of our physical and physiological nature. The artist's attitude to natural form is, therefore, infinitely various according to the emotions he wishes to arouse.[3]

By Fry's early conception of formalist practice, the artist manipulates lines, shapes, colors, textures and other visual elements so as to express emotions—not only his or her own emotions, but those that can be felt also by a public. This emotional expression is communicative and perhaps even collaborative since it depends on the sympathetic participation of the receptive observer, a viewer "touched" by common responses to physiological stimuli. According to Fry, form in a work of art can communicate more directly and to a greater number of people than can any particular code of subject matter.

By this account, formalist practice involves acquisition of skills followed by a directed application; artists do not find their universalizing form unconsciously or passively, but consciously organize formal elements within a context or frame. For the storyteller, one of Fry's figures of comparison, the framing structure is temporal. The storyteller presents a tale so as to announce its beginning and end, within which the narrative and even the phrasing develop a certain rhythm. The painter, however, frames materially, containing an image and organizing its parts within the fixed space of a rectangular format. Analogously, viewers psychologically "frame" what they see, and the framing determines their response. This type of "framing" actually competes with the formalist kind. Fry notes that people react to observations in "actual life" (that is, outside the privileged realm of art) by allowing practical concerns and specific psychological investments to guide and censor their perception. When viewing a busy street, a person cannot scan its contents impartially but will, for instance, "recognize an acquaintance, and wonder why he looks so dejected this morning." In this case, the observer's concerned response is guided by the psychological frame that distinguishes friends from strangers. But, Fry states, if one scans the same view as reflected within the arbitrary borders of a mirror, "it is easier to abstract [oneself] completely, and look upon the changing scene as a whole. . . The frame of the mirror makes its surface into a very rudimentary work of art [which will be] separated from actual life by the absence of [one's own] responsive action."[4]

Notice that Fry here regards the mirror primarily as a device for framing; it detaches an image from its worldly context, converting it to pictorial matter for

the free play of imagination. The mirror does not reproduce the familiar conditions of practical life but transforms them, as if to raise them to the level of universal art or poetry, if only minimally.[5] Accordingly, Fry would contrast the formalist artist's expressive enterprise (in which a special kind of "framing" precludes practical concerns) to the academic or illustrative artist's aim of capturing a given illusionistic effect (within a psychological "frame" of expectations and conventions). Nevertheless, Fry adds that the two purposes—emotional expression and illusionistic depiction—need not exclude each other. The critic aimed to draw attention to expression, not discredit depiction.[6]

We see formalism in Fry's position of 1909, but the name was not yet his; his privileged terms were "emotion" and "expression" rather than "form."[7] His "Essay in Aesthetics" presented form as but a means to an end, the expression or conveyance of emotion. To my knowledge, Fry's initial use of the term "formalism" came eight years later in "Children's Drawings," an essay of 1917 on art education. There many of the critic's previous thoughts on both form and children confront his ideas regarding primitives, who are the "children" of social evolution.[8]

Fry already used the example of children's drawings at a crucial point in his "Essay in Aesthetics" to suggest that they revealed the natural alliance between art and the psychic and emotional engagement of "imaginative life," which was to be opposed to the "actual life" of practical interests:

> That the graphic arts are the expression of the imaginative life rather than a copy of actual life might be guessed from observing children. Children, if left to themselves, never..."draw from nature," but express, with a delightful freedom and sincerity, the mental images which make up their own imaginative lives.[9]

Elsewhere Fry noted that children's imagery becomes all the more artistic or "decorative" whenever they draw within a "clearly bounded" surface, that is to say, within a frame.[10] So children—whom Fry assumed were thoroughly natural beings, at least when "left to themselves"—appear to respond innately to the specifically artistic medium, drawing expressively and with concern for design when faced with a traditional rectilinear format.

In thus asserting that children's artistic practice was natural, sincere and, to use a term Fry adopted from Kant and German idealist theories of art, *disinterested*, detached from utilitarian considerations, the critic was following late nineteenth-century beliefs regarding the psychology of the child and related theories of the importance of imaginative play for human development.[11] Detached and disinterested, artistic expression seemed an activity of play. But Fry's "Essay in Aesthetics" also suggested, in a somewhat contradictory fashion, that artists manipulated form with the aim of moving viewers in a determined way ("forms . . . calculated to move our emotions"). To conceive artistic activity in this manner

directs it toward an end, giving it a kind of utilitarian interest. Yet any such purpose quickly recedes, especially in Fry's later essays, whenever the critic relates modern art to children's art. It is as if Fry's reflections on the child kept entering into his conception of artistic expression, leading him to preserve its disinterestedness, keeping it a matter of free play. Adults act with self-conscious purpose. Children play. Is the artist more like the adult or like the child?

Among Fry's contemporaries, the constellation of concerns that marks so much of his criticism—disinterestedness, emotional expression, creative art, children, play—was quite pervasive (as, perhaps, it still is today). The central concepts appeared in tandem and inflected one another in writings generated through several different disciplines. As evidence of the commonplace character of the associations, consider this observation by a late nineteenth-century French reviewer of studies in child psychology: "If disinterest were the sole feature of esthetic emotion, we might say the child is more of an artist than the adult, and it is certainly the child who plays more"—disinterestedness, emotion, art, children, play.[12] Levels of irony can be detected in this reviewer's simple deduction, related to the modern suspicion that playful, expressive art is intellectually shallow. Not unlike the insane or the socially deviant, the child (in modern conception) shares so many of the psychological features of the adult artist that old distinctions become unstable and new questions arise: Are expressively liberated artists responsible to the needs of conventional society? What social purpose can an individual's artistic activity serve if it amounts to no more than disinterested play, idle child's play?

Fry's use of the child as a model for free artistic expressiveness, and hence as a kind of mirroring alter ego for the artist, entailed a problematic consideration related to these "modern" questions. For it was possible that, when understood as a part of human development, children's "disinterested" formal play might not be entirely liberated and disinterested after all. Such play might instead have important utilitarian "interest" of its own in facilitating the passage from child to adult, for play with objects and materials might well be necessary to the normal development of adult perceptual and motor skills. Analogies could easily be found at an early stage of growth, when the infant's seemingly idiosyncratic babble amounts to an impersonal training of tongue and ear necessary for speech, and its aimless scribbling prepares for purposeful specializations of the hand.[13] In the developmental context, babbling and scribbling constitute play that can readily be regarded as work—a self-discipline of the growing child that ultimately benefits the larger social order. For society depends on the transformation of unskilled children into physically competent adults.

Would eye and mind require training, just like tongue and hand, in order that imaginative "vision" start to operate? Psychologists of the late nineteenth century observed that infants gradually begin to distinguish a framed mirror image from its corresponding reality. At a certain age this allows them to substitute an "illu-

sion of the ideal" (analogous to Fry's mirroring and framing of form) for an antecedent "illusion of the real"; before that moment of passage no question of disinterested or idealized form can arise.[14] This understanding of the child's mentality in terms of distinct stages, which was common to Fry's contemporaries, prompts a series of questions that bear on a formalist sense of art: When in the course of development is the child's inborn expressiveness and mental liberation first manifested in a manner an art critic is able to recognize? Surely not at birth, for the differentiated modes of human expression appear only as the organism interacts with its environment in a timely fashion, actualizing prescheduled stages of cognitive development; such growth continues even through adolescence.[15] At what point, then, does the child become a "child" (and not an infant)? Is this the moment when art enters the frame? Does the child need to be nurtured, and perhaps even taught, to develop the relatively individualized kinds of expression adults recognize as artistic?[16] Does such expressiveness allow the child to be a "child," or does possession of it actually constitute adult mentality, complete with a mature imaginative capacity? In the final analysis, the gestures Fry took as evidence of children's expressiveness, signs of their "delightful freedom and sincerity," might constitute a pattern of exercise for the rigors of adult social life, exercises any child would practice and repeat when living under conditions of normal human socialization.

Such thoughts remove the modernist romance from children's art by making it appear both biologically and culturally programmed. Fry does not seem to have attended much to his contemporaries' empirical and statistical studies of child development, and he avoided the notion that a universal genetic code, perhaps modified by forces of evolution, might be determining at what age and in what manner a child would draw a line.[17] As I have suggested, he was engaged instead with a cultural mythology. Along with many others of his time, he compared children to racial primitives as if seduced by a certain Lamarckian analogy: just as contemporary social and racial groups who live in a primitive state correspond to Europeans who lived at an earlier stage of collective human history, and just as these primitives appear to be phylogenetic "children" among the world's races, so the European child is an ontogenetic "primitive," an undeveloped being within its own race. Biologists had argued that the human embryo and the growing infant and child passed through developmental stages corresponding to the history of Homo sapiens and even of the entire animal kingdom, millennia of genetic and reactive change being compressed into the time frame of a single organism. They called this a "recapitulation" theory, using the slogan "ontogeny recapitulates phylogeny."[18] Ontogenetically—that is, in its own development—the racially advanced child "recapitulates" all previous stages of phylogenetic evolution, including that represented by the present-day primitive, man still living in the wild (more or less).[19]

It was entirely characteristic for members of Fry's generation (Heinrich Wölfflin, for instance) to classify the styles and techniques of individuals, workshops,

national schools or historical periods in terms of developmental sequences. To do so in the case of the child artist could not have been more natural. Fry compared the child to the unspoiled primitive or uncivilized "savage,"[20] not only on grounds of a charming lack of sophistication and capacity for wonder, but also because both child and primitive persisted in depicting mental images rather than imitating the appearance of direct vision:

> Precisely the same phenomenon occurs in primitive art [as in children's art]; the symbols for concepts gradually take on more and more of the likeness to appearances, but the mode of approach remains even in comparatively advanced periods the same. The artist does not seek to transfer a visual sensation to paper, but to express a mental image which is colored by his conceptual habits.[21]

Fry made this pronouncement in a short essay of 1910, "Bushman Paintings." African Bushmen—a racially distinct, "primitive" people whose art, strangely enough, had a sophisticated appearance unseen in work by European children— became the exception to prove Fry's rule. To those intrigued by recapitulation theory, African Bushmen exemplified a group whose intellectual, social and technological levels corresponded to some putative, remote stage of European development; the rapidly vanishing Bushman society could be regarded as a root of the human genealogical tree from which modern Europeans grew into one of the uppermost branches. Faced with clear evidence that Bushmen, unlike most other "savage" peoples, had superb powers of illusionistic visualization, Fry needed to account for their special kind of artistic primitiveness, which hardly looked "primitive." He argued that the remarkably detailed Paleolithic renderings found at Altamira were appropriate comparative material. Like the Altamira cave painters, Bushman artists were actually at a more primitive level in psychic evolution than typical "primitives": "They appear to have been at a stage of intellectual development where concepts were not so clearly grasped as to have begun to interfere with perception, and where therefore the retinal image passed into a clear memory picture with scarcely any intervening mental process."[22] Bushman painters thus had the rare capacity to apply accomplished illusionistic rendering under conditions of utter naiveté.

For the most part, Fry used the category "primitive art" to refer to any works perceived as products of an individual or a society at an early stage of its own proper development, whether that history was already known or could be projected by analogy with other histories. Among the producers of primitive art, he included "savage" peoples such as the African Negro and the still more primitive Bushman. As I have noted, the latter case remained problematic since Bushman art exhibited such strong "retinal" or illusionistic qualities that Fry could not fit it to the primitive stereotype nor claim that it resembled children's art; yet, in recognition of

principles of evolutionary social development, he had to judge it "primitive." Like his contemporaries, Fry tended to regard primitive cultures as developmental markers or evidence, but without histories of their own; they did not necessarily change their ways over time or evolve into cultures of another kind (this attitude allowed Fry's generation to decontextualize objects of tribal art, collecting them for the sake of "timeless" aesthetic qualities). As "primitives," Fry also included certain types who had a recognized claim to (European) history: the many initiators of the living traditions of modern Western art—Egyptians, archaic Greeks, anonymous Byzantine masters, and the group of remarkably inventive painters known collectively as "Italian Primitives" (Giotto was the most frequently invoked representative). Whereas succeeding generations of Italians mastered the fictive illusion of appearances, the "Primitives" instead revealed something more purely expressive, "the charm of dramatic sincerity and naturalness."[23]

In 1913 Fry's intellectual ally Clive Bell offered a succinct definition of primitive art in terms of three essential characteristics: "absence of [illusionistic] representation, absence of technical swagger, sublimely impressive form."[24] By this standard, Byzantine, Romanesque and Islamic art fell under the rubric of the primitive. Regarding the case of medieval Islamic art, Fry himself wrote of "a new dramatic expressiveness unhindered by the artist's ignorance of actual [representational] form."[25] This coupling of "ignorance" and "expressiveness" is precisely what Fry and others admired in children: "The majority of [children] are more or less artists until they begin to be taught Art [that is, a set of approved techniques for rendering "actual form"]. It is also true that most savages are artists."[26]

It would be wrong to suggest that Fry's or Bell's formulations were innovative. During the late nineteenth and early twentieth centuries, comparisons between the child and the primitive appeared so frequently within so many disciplines as to assume a quality of gratuitousness. The strong impact of such associations on art theory and criticism is at least loosely connected with the fact that much of the published evidence for biological recapitulation was pictorial. Illustrations to scientific tracts showed human embryos at various stages memorably juxtaposed with the embryos of mammals, reptiles or even fish. The emphasis was on formal similarities. In addition, there were impressionistic comparisons of researchers' own infants photographed in postures resembling those of animals—not only primates, but even the family cat (fig. 132).[27] Readily represented, this seemingly advanced kind of scientific morphology was so accessible to rational understanding that writers, including art critics and educators, could not resist drawing their own innocent analogies with respect to the phylogenetically primitive adult (the "savage") and the ontogenetically primitive child.[28] If nothing more, such comparison served to indicate one's membership in a community of informed intellectuals. A network of ideological factors linked to colonialism supported the early twentieth-century discourse of the primitive, but this is also a case of intel-

132 Recapitulatory acts. Comparative study of movements of babies and animals from S. S. Buckman, "Human Babies: Some of Their Characters," *Proceedings of the Cotteswald National Field Club* 13 (1899), as reproduced in Stephen Jay Gould, *Ontogeny and Phylogeny*

lectual mass seduction (often prompted by pictures) and an ensuing intellectual fashion.

Analogies between primitives' art and children's art became contentious only when they led to unexpected judgments of aesthetic value. This was so in 1920 when Fry developed his thoughts on tribal African sculpture. Africans, he claimed, possessed the "power to create expressive form . . . not only in a higher degree than we [British and Europeans] at this moment, but than we as a nation have ever possessed it."[29] Ever? Had the maturation of Anglo-Saxons from out of their own primitive, pan-European medievalism been such a process of expressive degeneration? To comprehend Fry's provocative negativity in this instance, it becomes necessary to add two variables to his cultural calculus: his ideas on education (already broached) and his attitude toward industry.[30]

A number of underlying social themes shaped much of Fry's art criticism: the superiority of primitive production, the unhappy consequences of modern industrialization, the importance of a psychology of education. This configuration of concerns was not at all unusual; it was shared, for instance, by Fry's American contemporary John Dewey, a more systematic thinker on both art and education. Dewey believed that African fetishes were "fine art" as much as "useful or technological art" because their "anonymous artist[s] lived and experienced so fully during the process of production." With industrialization, the technological and the aesthetic diverged, and society lost its primitive emotional intensity, "so much of production [having] become a postponed living and so much of consumption a superimposed enjoyment of the fruits of the labor of others."[31] These were compelling reasons to lament society's "phylogenetic" development from primitive arts and crafts to modern industry.

In 1901, writing onc of his first extended essays, Fry referred to Giotto, the Italian Primitive, as if he had been something of a precocious child with respect to Raphael, whose painting marked the transition to a fully modern technique of illusionism. From the developmental perspective of the history of European art, it seemed that the phylogenetically "young" Giotto required little adult correction by those of Raphael's generation. Fry wrote that despite traces of "a certain archaism" in much of Giotto's late work, "there is scarcely anything. . .Raphael would have had to alter."[32] This primitive "child" would have had little to learn from his developmentally more mature descendants. In 1917, with the publication of "Children's Drawings," Fry shifted the developmental perspective, offering a new classification and, in effect, an explanation of the situation: Giotto was actually not a primitive but a "formalist."[33] In the space of a paragraph in his modest essay "Children's Drawings," Fry reoriented the traditional sense of primitivism in art. For most critics, the concept of the primitive, especially as applied to the question of aesthetics, had been flexible enough to accommodate both Giotto and anonymous African sculptors. For Fry, at least after 1917, this would no longer be the case. The use of the concept of the primitive in art criticism would be radically restricted and refined by considerations of social evolution and "form."

Education of Producer and Consumer

Fry's argument in "Children's Drawings" was inspired by the work of Marion Richardson (1892–1946). Richardson, who knew Fry's sister Margery, taught art at Dudley Girls' High School in the "Black Country" of industrial Midlands, England. In February 1917, after an unsuccessful interview in London for an inspectorate, she stopped at the Omega Workshops, Fry's studio-gallery of decorative art and interior design. The encounter proved significant for both parties.

Under Fry's direction, and with the participation of many of his friends, especially Vanessa Bell and Duncan Grant, Omega had been open for business since

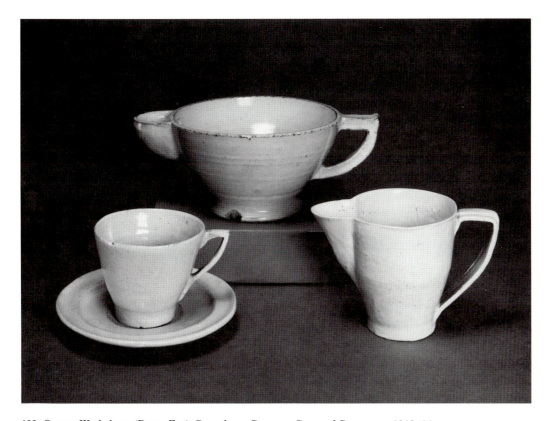

133 Omega Workshops (Roger Fry), *Sauceboat, Creamer, Cup and Saucer*, ca. 1913–14

July 1913. Fry organized the Workshops to provide "real works of art" in the form of "objects for common life," an alternative to mass production. With the exception of some ceramics and earthenware, Omega products were crafted through subcontract with skilled artisans or commercial suppliers, then painted or otherwise finished by Fry and his artist colleagues, who were committed not "to spoil the expressive quality of their work by sand-papering it down to a shop finish."[34] Indeed, when Fry himself threw pots the results were unusually rough. Marketing this primitivizing directness, Omega sold sets of his tableware fabricated from molds that preserved all the "expressive" irregularities—every last nick, pit and finger mark in the surface (fig. 133). In all Workshops products, Fry proposed to "substitut[e] wherever possible the directly expressive quality of the artist's handling for the deadness of mechanical reproduction." The signs of such expression did not necessarily indicate a particular mood or thought, but the directness and spontaneity of the hand itself, a varying human touch as opposed to the absolute regularity of a machine. Fry offered this justification for the unrefined appearance of Omega pottery:

[Commercially manufactured] cups and saucers are reduced by machine turning to a dead mechanical exactitude and uniformity. Pottery is essentially a form of sculpture, and its surface should express directly the artist's sensibility both of proportion and surface. The Omega pottery is made on the wheel by artists...[and] therefore presents, as scarcely any modern pottery does, this expressive character.[35]

Expressive artistry is individualized, yet it need not be authored: in accord with the nature of cooperative workshop practice, Fry insisted that his own and all other Omega products should remain unsigned, anonymous. They were identified only by the Omega mark. Omega products were also designed to be relatively inexpensive. Fry thus conceived of Omega's collective output as suitable competition for trademarked but otherwise anonymous industrial production, an antidote to the "scientific commercialism" that so deadened modern life. Moreover, through anonymity Fry was eliciting comparison with the art that many believed best represented a spirited human engagement; this was the work of primitives, those "nameless savages" with "crude instruments [who] pondered delightedly over the possibilities of [their] craft."[36] In the European imagination, anonymity and selfless collectivity were often regarded as constitutive features of primitive society, giving it a utopian quality.

Children, as we know, were among the residents of Fry's extended world of "primitive" sensibility. Schoolteacher Richardson's visit to Omega came at a particularly propitious moment since Fry had just mounted an exhibition of drawings by artists' children (up to age twelve) (fig. 134), including works by his own son and daughter. When Richardson showed Fry drawings by her pupils, he decided immediately to add a selection of them to the current exhibition, and, beyond that, to use their example in an attempt to spur the Minister of Education to reform the national art program (fig. 135).[37] Like many artists, Fry was extremely critical of customary art education, asserting that "the untaught child's work has artistic value," but "ordinary teaching destroy[s] completely the children's peculiar gifts of representation and design."[38] Fry thought it especially remarkable that Richardson's older pupils had been able to retain many of the qualities that young, untrained children exhibit when they draw.[39] Had their native primitivism been allowed to grow with them? If so, into what did it develop? In a letter to Margery concerning Richardson's work, Fry concluded: "[Children's art] is real primitive art, not the greatest or purest kind of art, but real art, which is more than can be said of almost anything else we turn out nowadays...[Marion Richardson] has found out how to *educate* and not to teach."[40]

To educate but not to teach. As a critic concerned with preserving the organicism and spontaneity of the human hand in an economy of machine-tooled and mass-produced objects (what "we turn out nowadays"), Fry often discussed art in opposition to industry. He was accustomed to citing "'South Kensington' principles"

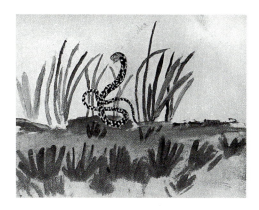

134 Child's drawing (David John, son of Augustus John), *A Snake*, in Roger Fry, "Children's Drawings," *Burlington Magazine* 30 (June 1917)

135 Child's drawing (pupil of Marion Richardson), *A Black Country Landscape*, in Roger Fry, "Children's Drawings," *Burlington Magazine* 30 (June 1917)

as the enemy, referring to the official schooling directed toward industrial and applied arts as well as toward the training of teachers of art.[41] William Morris and the Arts and Crafts movement had set principles for reform with which Fry sympathized (but which he did not necessarily follow); a central theme was the integration of artist and craftsman, invention and execution, within the nurturing society of a workshop.[42] What Fry called "real art"—primitivistic in its emotional directness—would be fostered by an *educational* process occurring in an uninhibiting environment, whether communal studio (like Omega) or a classroom in which the teacher (like Richardson) imposed a minimum of hierarchical constraint. In contrast, much official *teaching* merely furthered the topical aims of commercial manufacture, converting art, design or decoration into useful secondary services.[43] Fry's distinction between educating and teaching amounted to this: to educate is to lead forward so that moral, intellectual and aesthetic development can proceed on an individual basis; to teach is merely to impart standardized skills.

The pedagogical question had acquired urgency during the nineteenth century because European and American public education (in art as elsewhere) was designed not only to "educate" but also to "teach"; that is, it prepared children for their eventual roles as various kinds of skilled workers and "scientific" professionals in an industrial economy.[44] Instruction in drawing may well have been conceived to bring art to industry, but the systematic nature of that instruction threatened to transform art into industry; specific manual and vocational skills would be developed in preference to a less tangible creativity and capacity for aesthetic appreciation. As if to counteract expected objections, a highly systematic turn-of-the-century program in drawing for "manual occupations" insisted that "the most methodical course is compatible with the greatest freedom" (fig. 136).[45] Such allusions to freedom in the face of constraint rehearse a traditional philosophical

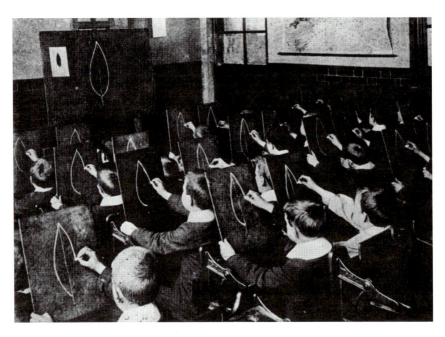

136 Boys practicing freearm drawing. Illustration to Joseph Vaughan, *Nelson's New Drawing Course: Drawing, Design, and Manual Occupations (Teacher's Manual, Stage 1)* (London, 1902)

argument (one needs an order within which to innovate). Ideologically, however, this is to assign to art two opposing social functions, with liberated aesthetic choice somehow being conceived as an aspect of the "art" of disciplined mass industry. What kind of product results? Perhaps a single consumer item designed to be mass-marketed in many different colors. Choice of color becomes the signifier of aesthetic "freedom," appearing deceptively as a superficial mask on an imposed necessity, the standardization of the product.

Fry's contemporaries associated manual skills with the demands put on a working class, and aesthetic sensitivity with the prerogatives of a leisure class. Fry himself sought creative ways to transcend this division. It is not irrelevant that he described his beloved African sculptors as profiting from "endless leisure."[46] The racist implications of attributing leisure to native peoples cannot be ignored (although leisure is not the same as idleness).[47] Fry, however, often had specific economic issues in mind when he referred to Africans; in this case, he was suggesting a comparison not of races but of modes of social organization, including European socialism. For the sake of artistic creativity, Fry wanted to preserve a haven of leisure in his own society (a release from useful, gainful employment), something he thought many Africans enjoyed because nature supplemented by a bit of human labor readily supplied their basic material needs: "In fortunately

placed savage societies, where the sheer necessities of life are easily obtained, the opportunity for creating [decorative artifacts] or works of art during the long leisure hours is shared by almost every member of society."[48] Fry's view of Africa may have been fantasy, but it allowed him to link the happy life of the primitive to what socialism was promising: "The Great State aims at human freedom; essentially, it is an organization for leisure—out of which art grows."[49] With no rebuke intended, Fry characterized those who become artists as "anarchist by nature [and] intransigeants [who] ask to be fed and clothed without contributing their share."[50] Fry himself was much more artist and anarchist than socialist; socialism, he argued, should it succeed in providing leisure, might do well to tolerate artists, whose existence it would foster, if only as a marginal by-product.[51]

Distinctions between a working class and a leisure class could not be fixed since, ideally, the middle class worked not only for a livelihood but also, ultimately, to enjoy leisure.[52] The rhetoric of educators often suggested that aesthetics was not the disinterested first consideration it was to philosophers, but instead a utilitarian and even commercial concern that should be subordinated to industry. In lists of the social benefits of art, the pure aesthetic sometimes appeared as if an afterthought. A rather typical program for art education, published in 1912, argued that drawing "becomes a tool with which to think. . .Elementary representation is of direct industrial, scientific, and aesthetic importance."[53] Why, last but not least, acquire an aesthetic sense? It was often implied that the aesthetic became useful for appreciating with a finer taste the products of commercialism. Along with the production of artifacts, taste itself, disseminated through mass education, was being commodified.

To be more specific on this point: Fry understood that the industrial revolution and the rise of newly moneyed classes put pressure on whatever claim aesthetic concerns had to disinterestedness. As plutocracy (status by wealth) replaced aristocracy (status by lineage) the aesthetic acquired an oddly enhanced kind of utilitarian value; it functioned ever more obviously as a symbol of prestige and social rank for the self-made, mobile classes of the affluent. Fry's views on such matters—expressed especially in essays on socialism and commercialization—resembled those of Thorstein Veblen's celebrated *Theory of the Leisure Class*, to which Fry occasionally made specific reference.[54] Veblen called attention to an evaluative "canon of conspicuous waste," which applied to both consumer goods and works of art; an item produced expensively by hand would afford its owner more status than a better functioning or more durable machined version, which had the ironic social disadvantage of being "within the pecuniary reach" of the average person (hence, no prestige value). Under such conditions, what might become of education in aesthetics? Veblen had an answer for the advancing "leisure class": "The appreciation of those evidences of honorific crudeness to which hand-wrought goods owe their superior worth and charm in the eyes of well-bred people . . . requires training [in] what

may be called the physiognomy of goods."[55] To assure itself of its identity, the leisure class needed to acquire the proper kind of material possessions; and for the where-withal to make the choices, it needed a course in art appreciation.

In its own manner—perhaps against the grain—Fry's Omega Workshops provided remedial adult education for both producers and consumers. Omega exhibited a selection of finely crafted objects and would fabricate unique items to order, in response to an individual's decorative needs. And it was at Omega that Fry displayed drawings by children, a lesson in the art of individual aesthetic expression, directed toward the grown-ups. His brief preface to the Omega Workshops catalogue (1914) became a primitivist manifesto for prospective buyers, soliciting them to share in a "joy in creation" like that experienced through objects "made by a negro savage of the Congo." Fry contrasted industrialism's lamentable profit motive to Omega's aesthetic and emotional interests:

> Modern factory products were made almost entirely for gain, no other joy than that of money making entered into their creation [and so they] can communicate no disinterested delight…[But Omega artists] try to keep the spontaneous freshness of primitive or peasant work while satisfying the needs and expressing the feelings of modern cultivated man.[56]

As if in evidence of its own principle of putting aesthetic delight before profit, Omega was bankrupt by 1920, despite a number of marketing successes over the years.

Early twentieth-century proposals for children's training in art reflect the complex role of the aesthetic in modern society by bringing three concerns into convergence: the economic value of efficient design for industry, the social and personal advantages of exercising good taste (including the symbolic value accruing to those recognized as having the leisure necessary to acquire taste to begin with), and—sometimes, it seems, last—the human or moral value inhering in creativity and sincere emotional expression. Witness this statement, which appears to slight the third factor in the equation: "Art and industry, closely related in actual life, are also united in education. Schools that have accepted the industrial arts point of view are bound to bring about improved public taste and an improved product at the same time."[57] If the primary ideal was to improve the quality of industrial manufacture, education would also strive to improve "taste" so that the relation of producer to consumer would be symbiotic, with the consumer demanding precisely those tasteful objects of quality that a creative and sensitized industry would already be inclined to provide.[58] Yet, for the sake of *individual* creativity, Fry himself resisted the "industrial arts point of view," which he linked to excessive commercialism, manipulative advertising, and an unfortunate domination of culture and society by a philistine plutocracy.[59]

Middle-class consumption of affordable decorative objects was a significant feature of the new industrial economy, and this required a workforce of artist-arti-

sans able to design and produce items efficiently and in quantity, whether by hand or by machine. As Fry stated, "it was gradually discovered to be worth while [economically] to produce immense quantities of objects at very low prices."[60] Aesthetic sensitivities and manual skills initiated at an early age through training in the arts of line and color were expected to result in the adult performance of mechanical and technical rendering essential to manufacturing, architecture, advertising and many other developing fields. At the higher levels of public education, industrial arts students (workers and certain professionals) and fine arts students (leisure-class consumers and a few future artists) could be segregated. Art education for the younger children, however, would logically assume a universal program since the fundamental principles of design underlying proper production in, as well as consumption of, both art and industry derived from the very same formal orders. The artist and educator Arthur Wesley Dow—who, like Fry, stressed the importance of formal design as opposed to illusionistic representation—introduced his *Theory and Practice of Teaching Art*, stating: "Even from the economic side, that education is deficient which leaves one unable to judge of form and color when he is constantly required to use such judgment."[61]

So the philosophical crux remained: how to treat the younger children, the beginners, some of whom were destined to be painters and others, engineers. Should they be "educated" (nurtured in their individual development) or "taught" (provided with techniques and skills related to specific problems and tasks)? At one point Fry suggested that "drawing in the sense of the more or less accurate representation of objects" would probably benefit all children, with the ironic exception of those few "who showed special artistic aptitude"—training in art for everyone but the prospective artists.[62] And thinking in 1917 (the year of "Children's Drawings") about the example of Paul Cézanne, Fry mused: "In a world where everyone else is being perpetually educated [Fry might have said 'taught'] the artist remains ineducable—where others are shaped, he grows."[63]

Growing Artists

Like the Fry of "An Essay in Aesthetics" and "Bushman Paintings," Marion Richardson believed that the art children created derived naturally from their delight in representing their mental images. Young children already possessed the beneficial capacity to imagine and invent; good education had only to promote this potential, letting it grow into adulthood. In her classroom, Richardson wrote, "the stress must never be on skill; all we can do is to encourage [the child] to find the very fullest. . . form of expression, so that the picture on his paper shall more and more nearly come to match the one that he has in his mind."[64] Richardson strove to stimulate the child's mind by offering a verbal account of a scene or object, which replaced any live model to be observed. She provoked the imaginations of her

pupils, their powers of subjective visualization, not their "objective" vision.[65] Fry described her method as if in appreciation of a visual poetry: "Miss Richardson's chief effort seems to be to train the children's power of fixing mental images and trusting to them implicitly so that their drawings are almost literal renderings of inner visions."[66]

Richardson's teaching thus had an important result she may never have consciously articulated, one with implications for early twentieth-century art theory: the students concentrated on the emerging image they themselves caused to appear on the paper before them. Instead of straining to observe and record a fixed model with ever more accuracy by established means, they delighted in unforeseeable formal aspects. Rather than tasks to be accomplished, their renderings became a process of discovery and even "play," as well as a kind of self-revelation and self-fulfillment. Indeed, this was very much the way Fry thought of individual "expression" in art: whereas drawing a picture would give material reality to the play of imagination, the realization of a formal order would stimulate the imagination to further expressive activity. Artistic expression was self-motivating. In Richardson's classroom the standard of artistic excellence derived not only from the strength of each child's immediate feelings but also from the specificity of aesthetic qualities the child could perceive in her own unique work that was being produced at the moment. In this sense, the actions of Richardson's pupils were in sympathy with the thinking of Henri Matisse, a contemporary whom Fry very much admired:

> I cannot distinguish between the feeling I have of life and the way I translate it. Expression...is in the entire arrangement of my picture: the position occupied by solid bodies, the empty spaces surrounding them, the proportional relationships—everything plays its part...If I take a piece of paper of a given size, my drawing there will have an essential relationship to this format.[67]

For Matisse—writing in 1908, shortly before Fry's "An Essay in Aesthetics"—art was always immediate in its expression, specific to feelings of a lived moment and to the materials at hand. In his drawing *Girl with Tulips* (fig. 137), he repeatedly adjusted the contours of the arms, as well as the position of the densely rendered head (which contrasts with the graphic void on axis at the bottom), as he responded to the particularity of the given rectangle. The material format inspired aspects of the expressive representation.

The example of Matisse's practice touched off one of Fry's early discussions of child and primitive, foreshadowing "Children's Drawings"; this was the catalogue introduction for the first of Fry's two innovative exhibitions of post-impressionist painting (1910 and 1912). Observing the radical extent of Matisse's "search for an abstract harmony of line [and his search] for rhythm," Fry wrote that the

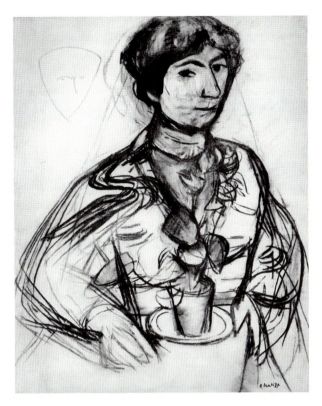

137 Henri Matisse, *Girl with Tulips (Jeanne Vaderin)*, 1910

painter "deprive[d] the figure of all appearance to nature. The general effect of his pictures is that of a return to primitive, even perhaps . . . barbaric, art."[68] Given Fry's reference to "return," he might well have added, in the spirit of his day, that Matisse's artistic ontogeny was recapitulating art history's phylogeny, albeit in reverse order (so much easier for his readers that the critic never attempted the formulation).

In this "post-impressionist" essay, as elsewhere, Fry compared primitive art to child art since both set out to represent an emotionally expressive mental image. Their expressiveness (the primitive's and the child's) would gradually be threatened by one and the same type of development, a technological and intellectual progress that in the case of the modern child would be linked to ethical and aesthetic consequences of the industrial economy. Fry argued that the cultivation of disinterested expression was usually diverted by the exercise of skills suited to the market for illusionistic representation. Resistance to such a situation originated with a society's committed artists, despite their many opportunities for easy success in the marketplace, always a temptation. Fry's thinking passes from primitive to child and back again:

Like the work of the primitive artist, the pictures children draw are often extraordinarily expressive. But what delights them is to find they are acquiring more and more skill in producing a deceptive likeness of the object itself... [Analogously, in] the development of primitive art... there comes a point when the accumulations of an increasing skill in mere representation begin to destroy the expressiveness of the design, and then, though a large section of the public continues to applaud, the [true] artist grows uneasy... [In response] he is prepared to subordinate consciously his power of representing... to the expressiveness of his whole design.[69]

Here Fry is imagining the good primitive (perhaps a Giotto) who resists his own increasing representational skill and turns back to formal design as his primary interest and exercise. Acting like a modern post-impressionist, this good primitive sacrifices representational detail in order to develop and realize the "entire arrangement of [his] picture" (Matisse), the "expressiveness of his whole design" (Fry).

Such is the essence of Fry's formalism in 1910, constructed as moral allegory and phylogenetic denouement. I have already suggested that by 1917, when Fry composed "Children's Drawings," Giotto was neither the good racial primitive (childlike in his rudimentary level of intellectual and social development) nor the good Italian Primitive (unspoiled progenitor of advanced Western culture); instead, he had become the good formalist, an early version of Matisse. Fry wrote: "I should like for the time being to apply the word primitive not so much to a period in time as to a particular psychological attitude... I do not count Cimabue or Giotto as primitives." What was this primitive "psychological attitude" that now excluded most of the early Italians? A true primitive is like a child, Fry intimated, and "is intensely moved by events and objects... his art is the direct expression of his wonder and delight in them."[70]

Indeed, one might associate wonder with primitives by the very fact they seemed to be "children" within the evolutionary family. More specifically, according to theories of primitive mentality, the concentrated wondrous response derived from the fact that objects at hand satisfied primitives' desires; commonplace things of everyday encounter offered immediate gratification rather than serving as instrumental means to distant ends. Hence, the characterization of primitives, and also children, as animistic and fetishistic—the most ordinary things possessed qualities that stimulated their fantasy life and met its consequent demands.[71] Because primitives or children invest their emotional interest in things close at hand, they remain (Fry implied) unself-conscious, unreflective, and undeliberative. And from within this blissful psychic state they produce spontaneous orders of beautiful "rhythmical form." Such engaged distraction and absorption, which Fry regarded as closely related to aesthetic disinterest, generates its own peculiar disadvantage. The animistic and fetishistic delight in objects, so characteristic of primitive and child artists, renders them susceptible to the apparent magic of skill-

ful naturalistic illusion, the kind of representation academic artists create once they undergo conventional training. Having entertained this thought in 1910, Fry gave his formulation a somewhat different cast in 1917:

> Children's art, like that of primitive races, the modern negro for instance, is singularly at the mercy of outside influences. Native races that produce almost unconsciously the most beautiful and tasteful work will throw them aside to make bad copies of the vilest products of modern European industrialism, so little does their work result from any clear self-conscious principle.[72]

Notice that Fry's argument keeps switching back and forth between child and primitive, caught up in a vicious circle; the one habitually invoked the other. The characteristics of both must be regarded as projections stimulated by the modern European's sense of his own place in culture, history and evolutionary development. In their capacity as artists, primitive and child were undone by similar temptations and psychological weaknesses—in effect, by susceptibility to influence and authority. Inhibiting influences and repressive authorities were the enemies of Fry's own libertarian inclinations. So from the perspective of the self-expressive artist, Fry's own perspective, it seemed that a modernist "indifference to representation" (to be associated with Matisse's pictorial liberties) had been leading viewers back to a sympathetic appreciation of primitive art and decoration as much as to children's drawings.[73] Yet Fry discovered a real difference between child and primitive: whereas primitives retain their primitive mentality, the child can grow into a formalist. This is to be inferred from Fry's introduction of the designation "Formalist" in "Children's Drawings," where it marks the possibility of a critical distinction: "[Like the primitive,] the Formalist may be moved deeply by the contemplation of events and objects, but"—the essential qualification—"there comes a certain moment when his expression is no longer related entirely to that emotion, but is dominated by a passionate feeling about form."[74] By definition, then, the formalist's "passionate feeling about form" preempts or displaces emotions associated with the specific character of an event or object, no matter what its utilitarian, symbolic or psychological significance.

When Matisse claimed "expression [develops] in the entire arrangement of my picture," he was already indicating—inadvertently, one would think—that such a "formalist" mode generates a measure of detachment even as it accommodates intimate expression and "passionate feeling." To produce the kind of artistic picture Matisse and Fry championed entails distance from an originary situation of wonder, or from an external object of delight. The artwork and its object—whether live model, fetishized artifact or figment of imagination—must diverge from the very start. Striving to realize and express immediate feeling by means of the picture itself, the artist is removed from any concrete, "primitive" connection to ordi-

nary things of intimate human attachment. Instead of being engaged with a pre-existing "real" environment, the artist becomes implicated in representation. Here "representation" is both the artist's fictive construction and the picture's constructed form, which assumes its own specific materiality.

To comprehend what the formalist attitude involves in practice, we must imagine a *transference* of wonder and emotion from one place to another, from the physical object or model represented (or its mental substitute), to the material work of art in its own emerging form. Eventually, as this perceptual and psychological transference becomes increasingly familiar and recognized as desirable, it assumes the quality of an evolutionary fact, no longer contingent in the opinion of artist, critic or scholar, but appearing inevitable and natural. The transference becomes a piece of human society's phylogenetic inheritance and an accepted feature of art's irreversible history.

Fry seems to have regarded such reorientation of imaginative attention and aesthetic sensibility as both psychologically and historically definitive: human art and culture could have evolved no other way. This understanding left the critic's "formalist" artists quite free to fixate on their medium, despite the aim of personalized emotion. With expression located in created form (not in the animism of external objects), manipulation of the medium could become its own end, a new skill and a new "object" for art. Along with the characteristic critical positions that support it, this kind of formalist practice has often been labeled "modernist," especially when the implications extend beyond the individual. An illustrative case is the criticism of William Seitz, who, with regard to abstract expressionist art in 1953, conceived a general cultural evolution proceeding through the exercise of form:

> The painters' and sculptors' empathic identification with materials, technical processes and structure is a symbolic function of the entire personality... The continually changing, unpredictable, uncoerced creative experience is not only *expressive* of cultural orientation but is also *productive* of the richest cultural values.[75]

For Seitz as modernist, as for Matisse and for Richardson's pupils, art becomes a cognitive and cultural feedback loop; the formal means facilitate expression but, more than that, they encourage, and perhaps even determine, what is to be felt and expressed. The medium creates the human subjectivities that express themselves through that very same medium. Its potential for freedom is their potential for freedom.

There are further consequences to the identification of a formalist attitude. Ontogenetic development of creative individuals within modern society, who grow from gifted children into practicing formalist artists, might seem to confirm a phylogenetic order of mentalities from animism and fetishism to an abstracted and

expressive symbolism (both linguistic and pictorial). Given such evolution, a particular history of twentieth-century art can be conceived, one that privileges pure abstraction as an expressive mode with the greatest potential for feedback and hence as a self-sustaining developmental advance. Abstraction responds most directly and freely to the artist and, reciprocally, is the least dependent on external circumstances, including (so Fry thought) the demands of mass industrial economy. For the "modernist," then, abstraction facilitates the discovery and exercise of a proper culture. When art historians focus resolutely on the importance of form and the medium, the practices of Fry and Clement Greenberg, both deeply informed by complex social values, appear to move in tandem toward abstract art, despite the two critics' many points of divergence along the way.[76]

Fry's distinction between primitive and formalist illuminates the degraded position of academic artists in a surprising manner. Because true primitives supposedly lack the self-consciousness necessary to effect a formalist transference of their own wonder and attention, they continue to respond, either in wonder or pragmatically, to what physical things do and fail to engage the form of things in detached isolation. According to Fry, the primitive's "modern descendant" becomes not the formalist (as one might have imagined) but the academic painter, because the academic remains fixed upon representing identifiable objects.[77] Like the primitive fetishist, he never sees form in its psychologically isolated purity, independent of the functioning object or the being that possesses it. Yet the academic can be no primitive, unless a debased one; having gained control of a magical illusionism, he loses all possibility of primitive wonder. In psychic limbo, then, he lacks both wonder and form. The academic's experience becomes strictly technological, even routine; he merely learns to apply skills to preassigned productivist functions. Children, by Fry's account, have a chance of faring better than such trained professional artists if only they preserve their expressiveness when passing into adulthood. Individuals who live "in our modern self-conscious civilization" cannot expect to retain an unself-conscious "primitive attitude...the surprise and shock, the intimacy and sharpness of notation, the *imprévu* quality of primitive art."[78] But what can keep growing nevertheless is the passion for form.[79]

"Children's Drawings" implies that all individuals have the potential to grow into, and be "educated" into, good formalists—to be passionate about form, expressive through it, moved by it. Fry made his point explicit in a subsequent essay, "Teaching Art" (1919):

It is...much more difficult for the civilized man to become an artist [yet] his art is altogether richer and more complete than that of savages and children. The problem for Art teaching, then, must be how to preserve and develop the individual reaction to vision during the time when the child is also receiving the accumulated experience of mankind, and so enable at least a few of them to pass from being child-artists to being civilized artists.[80]

Educator Marion Richardson, in Fry's estimation, knew how to guide growing children toward this noble passage.

Devolution of the Hand

> Whatever is "gauche" about the left hand is indispensable to an advanced culture; it keeps us in touch with man's venerable past, with a time when he was not over-skillful.[81]

Henri Focillon, son of a reproductive engraver (an artist of mass production), thus linked the left hand, regressively but beneficially, to humankind's phylogenetic history. Whatever else it might signify, by the time Focillon published his statement—in 1936, two years after Fry's death and sixteen years after the Omega Workshops died—idiosyncratic artistic handwork had become emblematic of resistance to a culture gone thoroughly technological.[82] If the right hand was learned and skillful and could compete with the machine as well as run it, the left hand retained a primitive and childlike and seemingly more expressive mode of marking. So much the better for its atavistic cultural value.

It remains to consider certain aspects of Fry's attitude toward technology. To be sure, some of his younger contemporaries considered the technological question paramount. It is possible that Fry's theme of loss of childhood expressiveness was merely figuring—that is, serving as a metonymical displacement or substitution for—a grand technological problem, one that involved conditions of global social change, the transformations associated with industrialization. In broadly Marxist terms of work, leisure and class formation, Clement Greenberg would recognize this problem as the historical ground for his critical evaluations: "Proletariat and petty bourgeois...did not win the leisure and comfort necessary for the enjoyment of the city's traditional culture...[In the kitsch produced for them] the methods of industrialism displace the handicrafts."[83] To Fry, perhaps the matter seemed more manageable when conceived locally, with history collapsed into the few years of childhood development. The social and psychological effects of increasing mechanization, which led to an economy of mass production and consumption, would somehow be addressed by considering strategies for instructing young children in drawing.

Recall what Fry believed regarding children of industrialized society: they suffered the fate of native peoples living in societies evolving toward the organized state; attention to their own ever increasing skill at refined construction and illusionistic depiction gradually supplanted their wondrous delight in primitive forms of experience, such as the simple touching and manipulating of objects, or the direct observation and repetition of formal harmonies of line and color. These immediate, autotelic experiences were phylogenetically primitive for the "savage," ontogenetically primitive for the child. Acquiring a measure of technology, most children abandoned artistic anarchy and idiosyncrasy to join the utilitarian herd.

In Fry's modern society, philistine plutocrats ruled the cultural scene as they did the economy, and machine perfection occluded craft sensibility. If unspoiled primitive society and its corresponding psychology represented in some senses an ideal antidote to the ills of industrial society, the untrained child embodied the last vestige of this desirable "primitive attitude."

To extend such figured analogies is to discover yet another "last vestige," a bodily organ Fry hoped would never devolve into something merely vestigial. This was, of course, the hand. So much of what Fry valued concentrated itself in a hand quivering with sensation, excitation, intense engagement. Perhaps his emotional kind of formalism can seem only an obtuse and ineffectual resistance to what from our own perspective appears inevitable, we post-industrialists whose technology may well have passed from hand to machine only to pass further, from machine to microchip. In a sense, Fry was resisting the future by admiring the most personalized studio practices. Like John Ruskin before him and Martin Heidegger after him, he had a passion for the working of hands as well as for the forms they created. He called the artist's individual touch "handwriting," a mark-making that could be self-expressive while yet sharing a vision of a world outside.[84]

The term "handwriting" implied comparison between figuring letters (writing) and figuring depictions (drawing or painting). Such analogy was doubly apt. In the first place, it followed increasingly common English word usage, which Fry regarded as parallel to use of the French term for a painter's characteristic brushwork, *écriture* (more "literally," both writing and handwriting).[85] In the second place, Fry's extension of the term to the visual arts agreed with prevailing notions of handwriting itself, not only among professional graphologists (who specialized in identifying and analyzing uses of the pen, a kind of connoisseurship), but also among Fry's associates who were concerned to preserve a fine art of writing by hand.[86] Although the mechanical typewriter was developed when Fry was a child, he grew up without it; and for many in his society penmanship remained both a fine and a practical art.

Perhaps the art of handwriting, as both practical and aesthetic, is better denoted as a "craft"; Poet Laureate Robert Bridges conceived it so in his 1926 essay "English Handwriting." Bridges aimed to promote competent instruction in modern cursive, taking account of the requirements of legibility (utility), speed (economy), and beauty (aesthetics).[87] During the early twentieth century, there was extensive debate over the compatibility of these three considerations when training the hand, as well as highly detailed studies of the human mechanics of it all, both psychologies and physiologies of handwriting.[88]

Cursive is a "running hand," designed for speed. Bridges discussed the craft of cursive in a manner that suggests analogies with the art of drawing as it would be conceived by a formalist. He evoked a certain spontaneous, unself-conscious creativity that the cursive entailed. Each letter, being joined to its neighbors, had to

be reshaped or adjusted by the hand according to its immediate situation in a word, its "chance environment" and specificity (one thinks of Matisse adjusting his hand and its figure to the found dimensions of a paper or canvas surface and preferring not to transfer images to new formats).[89] Bridges describes the situation of handwriting with phrases he borrows from the discourse of biological evolution—"chance environment," "adaptation to environment." Having borrowed it, he places the latter phrase within quotation marks of his own: "This 'adaptation to environment' provokes originality and is thus the main cause of the individual characteristics and beauties...of any cursive."[90] In other words, use of the cursive—developed for speed, and therefore for economy in the industry of writing—leads to individuality and beauty, but inadvertently, unself-consciously. Here a necessary pattern of "adaptation to environment" produces a happy evolutionary outcome, perhaps like that of a modern child who, despite the unavoidable regularizing effects of schooling, develops into an adult without losing (possibly even gaining) sensitivity to form and capacity for spontaneous invention.

Bridges recognized that self-conscious hands, although legible enough, were unlikely to write beautifully, so he chose to illustrate his study with "chance specimen[s]." Having asked friends to supply exemplary pieces of handwriting, in many instances he published their casual accompanying notes in place of their consciously belabored submissions (fig. 138). The aesthetics of a sample had to be judged independently of its linguistic message, the utilitarian factor (just as formal evaluation of painting had to ignore depiction). To this end Bridges offered a device that recalls the formalism of Fry's "Essay in Aesthetics": "If any one should wish to investigate for himself this quality of beauty independently of other considerations, he would do well to look at the writings in a mirror. When seen backwards the words lose the distraction of their significations and appear as pure forms." Since formal evaluation, with or without the mirror, presents difficulties, Bridges left the matter "in the hands of our critic."[91] He enlisted as expert his old friend Roger Fry.

Contributing "artistic comment," Fry referred to the same unconscious spontaneity that Bridges invoked. He found cursive writing aesthetically superior to either print or calligraphic script because its individual letters and ligatures had a much greater capacity to adapt "to the varying situations in which the accidents of spelling place them." Beauty was born in "those unconscious variations which create the rhythmic phrase by the modification of its elements." Here, as formal terminologies converge, Fry's "rhythmic" phrasing, a product of handwriting, belongs to the signifier, not the signified; it is a set of visible markings and their associated kinesthetic and tactile sensations, not a set of discrete letters to be collected into words, heard audibly or imaginatively, constituting coherent semantic or poetic units. Only as the writer is "liberated" from and "no longer conscious" of the utilitarian concern for forming individual letters, do "the more organic and richer

139 Sample of handwriting by Gerard Manley Hopkins. Illustration to Robert Bridges, "English Handwriting," *S.P.E. Tract No. XXIII, English Handwriting* (Oxford, 1926)

138 Sample of handwriting by Roger Fry. Illustration to Robert Bridges, "English Handwriting," *S.P.E. Tract No. XXIII, English Handwriting* (Oxford, 1926)

rhythmic systems occur" (fig. 139).[92] This freedom creates the beauty of handwriting. Like Fry, Marion Richardson, who in 1935 published an instruction manual of her own, advocated "free cursive writing [that] employs only easy [natural] movements of the hand and arm." She wished "to teach a swift and simple running hand...which will grow as [a child] grows into something that is increasingly his own...[The child will learn] to write without self-consciousness."[93]

With such technique the form of writing would seem, especially to the individual writer, to derive from the body and its sensations, rather than to follow an external standard of imitation. As both Richardson and Fry conceived it, the craft of handwriting would grow with its practitioner, becoming a vehicle for self-realization. Thus, the somewhat hidden social, even political, value of handwriting in Fry's estimation: "It is the only exercise in the graphic arts undertaken habitually by ordinary men...letters are formed by them with the same certainty and unconscious freedom as the artist alone attains to with regard to other forms." Representing individualization and democratization of the aesthetic, handwriting became art for Everyman. Because "ordinary" people practice handwriting without being self-conscious about it (at least ordinarily, unless asked to provide specimens), this craft "gradually allow[s] deliberate aesthetic predilections to pass into unconscious manual habits."[94] Fry was suggesting that for those who have artistic

aptitude—and, like children, even ordinary people possess it—the natural selectiveness of the eye, its unconscious attraction to certain formal relationships, transfers immediately to the characteristically rhythmic cursive of the hand.

One of the remarkable things about Richardson was that she succeeded in teaching "ordinary" children, those having neither privileged home environments nor special talents.[95] Under favorable social and psychological conditions, aesthetic excellence could be found, then, in three areas of performance, two of them quite "ordinary": in children's drawings, in adults' handwriting and, extraordinarily, in artists' formalism. Fry's thoughts on handwriting corresponded to his view of painting: just as cursive becomes expressive aesthetically only when it transcends the need to render a preconceived and rigidly conventionalized set of forms (the individual letters), so painting develops an emotionally powerful formalism only when it disregards any practical concern for representation or for conventional depiction of specific objects. Richardson's pedagogical technique had the advantage that it imposed no particular visual model on her drawing students; they worked unself-consciously from their imaginative predilections in the way that an adult might allow idiosyncrasy to run through his handwriting. The political appeal of these considerations lay in their inversion of a common allegorical sense of education or teaching: education as socialization in the form of discipline, training, control—in short, as docility, a quality industrialists might want to foster in either colonized primitives or laboring-class children. With training such as that given by Richardson, the aim was to liberate the hand (an equally common allegory) rather than constrain it, and to enable rather than mold. Such instruction, although it transmuted a natural primitive expressiveness into skills (drawing skill in the one instance, legible handwriting in the other) could no longer be viewed as emblematic of control or organization, nor as a metaphor of regularized socialization for the industrial economy.

Handwriting had its science (graphology) and also a technology of sorts (penmanship). With his concern for the hand, Fry naturally reflected on the hand's tools; and, not surprisingly, he preferred the expressiveness of the simpler and older ones, as if in support of primitive economy instead of mass industrialism. Submitting samples of his own writing to Bridges, he complained of having executed them with a modern fountain pen, "a beastly instrument. One can only write decently with a quill or at least a pen that keeps some of the qualities of a quill."[96] The advantage of the fountain pen, as Fry himself admitted, was its convenience and efficiency; those features he accepted.[97] Its disadvantage, stated clearly by writing master Alfred Fairbank, was its regularity, a stroke of unvarying width.[98] The fountain pen, like a machine, seemed to distance the hand from the studied complexities and spontaneous irregularities of its own functioning; it made writing economical but (relatively) inorganic and hence limited in visual and tactile expression.

A pen of any kind, however, brought the hand sufficiently close to its paper support to register physical quirks and limitations that might characterize the

author. One could decipher idiosyncratic handwriting by becoming familiar with its particular patterns of irregularity and also by interpreting the linguistic context, for not all combinations of letters were possible. Bridges himself had argued that writing by hand, as opposed to typing with a machine, did not presuppose absolute differentiation of individual letters, the discrete signs of the normalized representational code. In many cursives "n" and "u" looked quite the same, an obvious impracticality; whereas, in principle, mechanical script eliminated all such graphological ambiguities as well as superfluities.

Scholars have often regarded the typewriter as among the most paradigmatic instruments of the machine age, perhaps because it so reduces the indexical or traceable use of the author's or copyist's hand (like the camera, however, this writing machine leaves indications of its own physical identity, which can in turn be associated with its user-owner). The typewriter's advantage for mass communication lies in its removal of certain expressive idiosyncrasies—creative ligatures, individualized paraphs, irregularities of size and spacing—which may have little if anything to do with the consciously intended meaning of a text.[99] In representing its content without marked formal interference or supplement, the typewritten message becomes the antithesis of the child's drawing or primitive's design. Yet one could argue that the universal principles critics and scholars often perceived in both children's and primitives' art would likewise qualify these signifying practices as socially instrumental and without individuating personality. What matters, of course, is the context of the comparison. By Fry's reasoning, a child would be less expressive than a formalist painter, more expressive than a typist. The difference becomes most evident when one considers that the typewritten message lacks precisely those conventional visual signs of sincerity, which, as if by both cultural definition and a natural order, children's unregulated markings display. Hence the belief, still strong today, that personal correspondence should never be typed, let alone laser-printed.[100] Barring dadaist or concretist subversion of the machine, if personal expression were to appear in typewriting, it would do so linguistically, not graphically. Of course, producers of typewriters offer models having variant typefaces, thereby appealing to a consumer need to express—or, actually, to acquire—individual identity and "taste." Industry can readily accommodate a society that values "expression."

In his essay *Art and Commerce* of 1926, the year of his "Reflections on Handwriting," Fry consolidated his thoughts concerning work by modern machine as opposed to primitive instrument: "[Machinery's] effect is to substitute an ideal exactitude for a felt approximation. Wherever the machine enters, the nervous tremor of the creator disappears." Fry made this argument relentlessly. Even the potter's wheel, he claimed, a simple machine from antiquity, eliminated a certain degree of creative sensibility by regularizing the craft: although the vertical section of the pot, its contour or profile, continued to express an immediacy of touch

and judgment, the horizontal section became, invariantly, a perfect circle. This move toward mechanization was ominous, for it was also a move toward devaluation of the primitivistic "fabrication by hand of all the minor objects of daily use." According to Fry, such handwork was the traditional, tacit means "to develop any latent aesthetic sense which a man possesses."[101] At times it seemed that the only vehicle remaining to make modern practical life expressive for "ordinary" people was handwriting. Beware of fountain pens and, above all, typewriters.

In 1932 Fry responded to a popular account of modern art and design by Joseph Edwin Barton, who, along with many others, was optimistic about developing "personality" in machine production.[102] Fry lamented the commercial failure of his Omega Workshops, an enterprise "too far ahead of [its] time," which had been dedicated to modernizing craft for an age dominated by machined goods. With his familiar call for expressive handwork applied to "the needs of everyday life," he repeated his example of the somewhat detrimental effect the potter's wheel had had on the history of the hand, its social phylogenesis.[103] Fry tolerated the most primitive of ceramic work for its utter lack of mechanism (recall the crudeness of his own pottery), just as he appreciated artistically mediocre drawings by Richardson's pupils so long as they were expressively sincere, that is, without any rigid or mechanistic application of schooled technique. His evaluation might be translated into a moral principle, the same in life as in art: it is better to be sincere than accomplished. Fry did not necessarily fear an organic or even automatistic integration of hand and tool or body and machine—why would such a state not appeal to both artist and craftsman? He had a more particular worry that within an industrialized economy the balance would shift toward mindless mechanical instrumentality; ever more efficient machines would displace the sensitive body rather than supplement or merge with it as it performed. Human performance would cease to be characterized by the kind of aesthetic feedback Matisse's formalist practice exemplified.

In coming to terms with Barton's optimism, Fry noted that a specifically technological and utilitarian aesthetic was being applied: Barton believed that an object acquired beauty whenever it functioned efficiently and flawlessly. Fry's reader is left to imagine (correctly or not) that Barton would prefer the machined pot to the crude one, the fountain pen to the quill, the indisputable proof to the intellectual provocation. In his rebuttal, Fry observed that Barton's examples of beautiful modern design were all machines "made for attaining speed"—locomotives, automobiles, ocean liners. These cases should be regarded as exceptional since no one could deny taking aesthetic pleasure in the streamlining that expressed such objects' function, just as swift and powerful leopards seemed to everyone more beautiful than pigs, although both animals functioned perfectly. Even without reference to his related interest in handwriting, Fry's counterexample to the automobiles and ocean liners was particularly significant: "Should we ever stare in admiration at the lovely lines

of a typewriter?" His deprecating answer was intended to distinguish aesthetics from technics: "We might, if we knew something of its mechanism [which has been] adapted for the most complicated functions, but this would be a purely intellectual admiration, not at all an aesthetic one." Indeed, the typewriter (especially in the days before its streamlined encasement) could hardly inspire aesthetic wonder since Fry regarded it as one of those machines that removed aesthetic sensibility from a common daily activity: writing. Like the fountain pen but to exponentially greater effect, the typewriter distanced the hand from its proper manner of figuration, regularizing its rhythms and strokes. Given the operation of this writing machine, Fry could only insist on there being "a real antagonism between sensibility and mechanism . . . Mechanical mass production [however perfected] will not of itself supply us with a positive artistic result."[104] Typically, Fry distinguishes "sincere," "expressive," individualized performance from its mass equivalent. For him, the substitution amounted to a loss because the material product no longer reflected the producer, nor did the process add anything to the preexisting conception. The act of typewriting converted the writer-typist into a mere instrument, just as strict academic procedures for painting did the same to the painter.

It seems Fry feared that the evolution of machine technology was inducing irreversible phylogenetic changes in society, manifested as an exaggeration or acceleration of certain ontogenetic changes in the developing individual. No need to counter that throughout history each generation of adults had lost a measure of its own childhood expressiveness; Fry recognized this. But his romantic-modernist position asserted that the loss was never so acute and final as in the era of industrial economy. The ordinary citizen found it increasingly difficult to locate vehicles for personal expression as well as to maintain "touch with man's venerable past, with a time when he was not over-skillful," as Focillon put it in 1936. For the adult worker or professional, this "past" without overbearing technology was both the individual's childhood and modern society's primitive prehistory. Having no grand political or social theory, Fry looked to remedy modern social ills through children's education, the exercise of simple crafts like handwriting, and the celebration of liberated artistic sensibility, wherever it might be found. "Sensibility," he wrote, "corresponds to our desire for variety, multiplicity, chance, the unforeseeable."[105]

Fry figured his social and political critique through the problem of aesthetic sensibility as he and his contemporaries conceived it, with aesthetic development, or perhaps devolution, paralleling a history of social change. When he practiced formal analysis of a work, Fry sought an ideal, unique order that might come about for both artist and viewer without its having been consciously predetermined by the creator. The real target of his perennial attack was neither technology nor machines but standardization, any regularity that resulted from the imposition of rule. Indeed, this was the substance of Fry's distinction between teaching and educating: the one leads to standardization; the other fosters individuality.

As something of a libertarian, Fry would "educate" the children by letting them draw as they felt, autonomously "moved by events and objects" (no rulers or straight edges required).[106] If, growing into adults, few would ever experience the freedom of formalist artists, these ordinary people were at least still likely to be writing their cursive rhythmically and with expressive hands. To the extent that Fry encouraged such practice—an economic left-handedness—he attempted a modest bit of social engineering.

To establish a discursive context for Roger Fry's thoughts on children's art, I have called on academic and critical studies available to him, citing both British and American (and, to a lesser extent, French) publications on children and education. In Britain and the United States the same sets of issues were debated, and most of the relevant publications had editions in both countries. Fry had strong professional ties to the United States, serving briefly as curator of paintings at the Metropolitan Museum, New York (1906–7). Although a connoisseur of Italian Renaissance painting, he became better known for promoting modern French art. He was fluent in French, traveled in France often, and resided there at times. He was also in contact with German scholars and critics, but had difficulty with the German language. I thank Katy Siegel for expert assistance in researching this essay. Translations, unless otherwise noted, are mine.

experience of "plastic images" into a corresponding "art of words" (38).

Although Fry's writings provide a generally accepted model for the "classic" formalist approach to art, he is by no means the only candidate for this honor; in addition to Wölfflin, the art historian Aloïs Riegl (1858–1905), the theorist Konrad Fiedler (1841–95), and Fiedler's associate the sculptor and theorist Adolf von Hildebrand (1847–1921) have often been noted as influential initiators. Scholars also commonly cite John Ruskin (*Elements of Drawing*, 1857) and Charles Baudelaire ("Le peintre de la vie moderne," 1863) because they emphasized the artist's childlike capacity to perceive relationships of form and color independent of representational signification (endless debate has followed concerning belief in the "innocent eye," a notion neither Ruskin nor Baudelaire accepted without substantial qualification). Stéphane Mallarmé, French symbolist poetry and the art criticism of Maurice Denis represent somewhat more immediate sources for formalist principles (Fry translated Denis's 1907 essay on Cézanne and once referred to much of his own work as an "elaboration of its principles"; Roger Fry, "The Double Nature of Painting" [1933], ed. and trans. Pamela Diamand, *Apollo* 89 [May 1969]: 365). On the development of formalism, see Edgar Wind, *Art and Anarchy* (New York, 1965); Michael Podro, *The Manifold in Perception* (Oxford, 1972); Philippe Junod, *Transparence et opacité* (Lausanne, 1976); Margaret Olin, *Forms of Representation in Aloïs Riegl's Theory of Art* (University Park, Pa., 1992);

1 William James, *The Principles of Psychology*, 3 vols. (Cambridge, Mass., 1981 [1890]), 2:874–75 (original emphasis). James added an astute observation: no final distinction between the essential object and its sign or visual appearance can be made, since the reality of the object is nothing other than a special instance of its appearance—namely, that object seen under "normal" conditions.

2 Cf. Herbert Read, "Farewell to Formalism," *Art News* 51 (June–August 1952): 36–39. Read's primary example of formalist art criticism is Roger Fry, and of formalist art history, Fry's contemporary Heinrich Wölfflin (1864–1945). To replace formalist analysis of discrete visual elements, Read advocates a "symbolic interpretation" that would translate holistic

and, for an early critique with emphasis on sociological issues, M. M. Bakhtin and P. N. Medvedev, *The Formal Method in Literary Scholarship*, trans. Albert J. Wehrle (Cambridge, Mass., 1985 [1928]), esp. 41–53. Aside from pictorial "formalism," the term is most often associated with early twentieth-century Russian literary theory (see Victor Erlich, *Russian Formalism* [New Haven, 1981]) and with the Anglo-American "New Criticism" stemming from the work of I. A. Richards (*Principles of Literary Criticism* [London, 1924]). On issues surrounding Fry's formalist critical practice, see also Jacqueline V. Falkenheim, *Roger Fry and the Beginnings of Formalist Art Criticism* (Ann Arbor, 1980); Richard Shiff, *Cézanne and the End of Impressionism* (Chicago, 1984), 55–69, 142–61; Shiff, "Painting, Writing, Handwriting: Roger Fry and Paul Cézanne," in Roger Fry, *Cézanne: A Study of His Development* (Chicago, 1989), xi–xxvi; Mark Roskill, *Klee, Kandinsky, and the Thought of Their Time* (Urbana, Ill., 1992), 1–27; Christopher Reed, *A Roger Fry Reader* (Chicago, 1996).

3 Roger Fry, "An Essay in Aesthetics" [1909], *Vision and Design* (New York, 1956 [1920]), 37–38.

4 Fry, "An Essay in Aesthetics," 19–20. Clement Greenberg would likewise focus on a choice between "exploiting the practical meanings of objects" and "savoring their appearance"; the distinction is for him (as also for Fry, as discussed below) linked to consequences of industrialization and the rise of bourgeois society ("Towards a Newer Laocoon" [1940], *Clement Greenberg: The Collected Essays and Criticism*, ed. John O'Brian, 4 vols. [Chicago, 1986–93], 1:27). On the common analogy and discursive interplay of imaginary psychological frames and physical picture frames, cf. Gregory Bateson, "A Theory of Play and Fantasy" (1954–55), *Steps to an Ecology of Mind* (New York, 1972), 177–93.

5 Cf. the later Clement Greenberg on the conditions of "painting," which can be satisfied minimally by a framed or material-

ly delimited surface: "A stretched or tacked-up [unpainted] canvas already exists as a picture—though not necessarily as a successful one" ("After Abstract Expressionism" [1962], *Collected Essays*, 4:131–32).

6 Fry, "An Essay in Aesthetics," 38. Concerning the autonomy of pictorial form, see also Roger Fry, "The Allied Artists," *The Nation* 13 (2 August 1913): 677 (on emotional expression in both Kandinsky's landscapes and his "abstract visual signs"); "Mr. MacColl and Drawing," *Burlington Magazine* 35 (August 1919): 85; "Retrospect" [1920], *Vision and Design*, 294–96 (on Fry's notion of formal expressiveness in relation to Clive Bell's), 300–302; *The Artist and Psycho-Analysis* (London, 1924), 16; "Some Questions in Aesthetics," *Transformations* (Garden City, N.Y., 1956 [1926]), 27–31. Fry's later writings emphasize that nearly all works of art combine elements of verisimilitude and illusion with elements of abstract design, eliciting emotions "aroused by actual life" along with emotions "peculiar to esthetic apprehension" (Roger Fry, "An Early Introduction" [1921], in *Stéphane Mallarmé, Poems*, trans. Roger Fry, ed. Charles Mauron [London, 1936], 295). Cf. also Roger Fry, *Henri-Matisse* (London, 1930); Fry, "The Double Nature of Painting," 365–66. On shifts in formalist theory, cf. Christopher Reed, "Through Formalism: Feminism and Virginia Woolf's Relation to Bloomsbury Aesthetics," *Twentieth Century Literature* 38 (Spring 1992): 23–25. For an assessment of Fry's thinking at each stage of his career, see Reed, *A Roger Fry Reader*.

7 At a still earlier date, Fry's analysis of the Avignon *Pietà* indicates his penchant for evaluating art in terms of emotional expression conveyed through form; Roger Fry, "The Exhibition of French Primitives, Part II," *Burlington Magazine* 5 (July 1904): 379. By his own estimation, however, Fry's 1901 essay on Giotto lacked this incipient "formalism"; republishing it in 1920, the critic added an introductory note, disclaiming any implication that "the value of [Giotto's] form for us is

bound up with recognition of the dramatic idea [as opposed to] our reaction to pure form" ("Giotto" [1901], *Vision and Design*, 131).

8 Roger Fry, "Children's Drawings," *Burlington Magazine* 30 (June 1917): 225–31. Jacqueline V. Falkenheim suggested to me that this essay was the probable location of Fry's first use of the term "formalist," although she did not address the question in her *Roger Fry and the Beginnings of Formalist Art Criticism*. Use of the term "formalist," of course, does not in itself indicate use of a set of concepts that might constitute a theory of "formalism."

9 Fry, "An Essay in Aesthetics," 20. Cf. Karl Groos, *The Play of Man*, trans. Elizabeth L. Baldwin (New York, 1901; orig. German ed., 1899), 316: "[Children] object to drawing from Nature . . . The child's model is commonly a mental image."

10 Roger Fry, "Bushman Paintings," *Burlington Magazine* 16 (March 1910): 335 n. 3.

11 For Fry's use of the term "disinterested," see his "An Essay in Aesthetics," 29; "The Artist in the Great State," in Frances Evelyn Warwick et al., eds., *Socialism and the Great State* (New York, 1912), 253; and *The Artist and Psycho-Analysis*, 18. ("The Artist in the Great State" is better known from its republication as "Art and Socialism," *Vision and Design*, 55–78, to which Fry added several new paragraphs [70–73]). Cf. also Roger Fry, "The New Movement in Art in its Relation to Life," *Burlington Magazine* 31 (October 1917): 167 ("the complete detachment of the artistic vision from the values imposed on vision by every-day life").

12 Francis Paulhan, "L'art chez l'enfant," *Revue philosophique* 28 (1889): 601. The theory of human play derived from Friedrich Schiller and, more immediately, Herbert Spencer; around the turn of the century, it was promoted also by the influential American evolutionist and educational psychologist G. Stanley Hall.

13 Karl Groos, *The Play of Animals*, trans. Elizabeth L. Baldwin (New York, 1898; orig. German ed., 1896), 7: "The most important elementary forms of

play . . . are not [disinterested] imitative repetitions, but rather preparatory efforts." Groos, *The Play of Man*, 31–32: "The child's first voice practice consists in screaming . . . More important than crying are the babbling, chattering, and gurgling of infants . . . Without this playful practice he could not become master of his voice." Marion Richardson, *Writing and Writing Patterns, Teacher's Book* (London, 1935), 3: "Childish scribble [and its] rhythmic pattern movements are the natural preparation for handwriting, just as prattle is the natural preparation for speech." Cf. also Marion Richardson, *Art and the Child* (London, 1948), 55. Discussion of Richardson's work follows in the text.

14 Bernard Perez, "L'art chez l'enfant: Le dessin," *Revue philosophique* 25 (1888): 281. Perez's major work on early development, *Les trois premières années de l'enfant* (Paris, 1878), was widely cited and available in English translation. His "illusion of the ideal" corresponds not only to Fry's detached framing of form but to Lacan's stage of the "imaginary"; see Jacques Lacan, "The Mirror Stage as Formative of the Function of the I as Revealed in Psychoanalytic Experience" [1949], "The Function and Field of Speech and Language in Psychoanalysis" [1953], *Ecrits: A Selection*, trans. Alan Sheridan (New York, 1977), 1–7, 30–113. When, with the acquisition of language, the child enters Lacan's "symbolic" stage and becomes a subject of signification, it also enters Fry's world of "practical life," configured by a network of objects of intention, investment and desire.

15 For a far-reaching version of the theory, see Jean Piaget, *Biology and Knowledge*, trans. Beatrix Walsh (Chicago, 1971), 21–23. Piaget's position developed from his research conducted during the 1920s.

16 On the relation of nurture to the biological development of normal human modes of expression, cf. Roger Shattuck, *The Forbidden Experiment: The Story of the Wild Boy of Aveyron* (New York, 1980); the "forbidden experiment" would deprive a child of nurture in order to determine whether "there is any such thing as human nature

apart from culture and individual heredity" (41).

17 For an example of a statistical study, see R. B. Ballard, "What London Children Like to Draw," *Journal of Experimental Pedagogy and Training College Record* 1 (1911–12): 185–97.

18 Cf. James Mark Baldwin, *Mental Development in the Child and the Race* (New York, 1968 [1894]), 1–33. Ontogenetic "recapitulation" was associated primarily with the German evolutionist Ernst Haeckel (1834–1919); extremely appealing to the imagination yet inconclusively demonstrated and gradually abandoned by biologists, recapitulation theory eventually also became unacceptable politically because of its appropriation by Nazism. Concerning its influence on theories of racial difference, child development and primary education during Fry's lifetime, see Stephen Jay Gould, *Ontogeny and Phylogeny* (Cambridge, Mass., 1977), 126–55. For an assessment of the fate of recapitulation theory among biologists, see also Nicolas Rasmussen, "The Decline of Recapitulationism in Early Twentieth-Century Biology: Disciplinary Conflict and Consensus on the Battleground of Theory," *Journal of the History of Biology* 24 (Spring 1991): 51–89.

When philosophers, psychologists and anthropologists drew analogies between children's and primitives' art, such comparisons were usually marked by an ambivalence concerning the value of the primitives' work. This ambivalence needs to be set into the context of European cultural and economic colonization of Africa and the Western hemisphere (for a sense of the issues, cf. the discursive analysis in Homi K. Bhabha, "The Other Question— The Stereotype and Colonial Discourse," *Screen* 24 [November–December 1983]: 18–36; or the political analysis in Abdul R. JanMohamed, "The Economy of Manichean Allegory: The Function of Racial Difference in Colonialist Literature," *Critical Inquiry* 12 [Autumn 1985]: 59–87). Comparisons between the mentalities of children and native peoples served, consciously or not, to justify

paternalism on the part of Europeans. On the dissemination of a neo-Lamarckian theory of evolution, with the nonwhite, "childlike" races regarded as having failed to evolve as much as the white, see Peter J. Bowler, *Evolution: The History of an Idea* (Berkeley, 1984), 282–88. Like young children, nonwhites were judged unsuited for modern industry because they lacked the discipline needed to work by the clock (David Muschinske, "The Nonwhite as Child: G. Stanley Hall on the Education of Nonwhite Peoples," *Journal of the History of the Behavioral Sciences* 13 [1977]: 331). Nevertheless, to those who romanticized the freedom and spontaneity of the child, this characteristic of the primitive had its desirable aspect. The problematic nature of the analogy between child and primitive in the early years of the twentieth century can be discerned in the ambivalence of conclusions reached by James Sully, *Studies of Childhood* (New York, 1903 [1895]), 385: "The art of children is a thing by itself, and must not straight away be classed with the rude art of the untrained adult. As adult, the latter has knowledge and technical resources above those of the little child; and these points of superiority show themselves, for example, in the fine delineation of animal forms by Africans and others. At the same time, after allowing for these differences, it is, I think, incontestable that a number of characteristic traits in children's drawings are reflected in those of untutored savages." For a similar expression of ambivalence, see Groos, *The Play of Man*, 317.

19 Cf. G. Stanley Hall et al., *Aspects of Child Life and Education* (Boston, 1907), ix: "The child is older than the adult in the sense that its traits existed earlier in the world than those that characterize the mature man or woman." Hall describes one of his essays as recording a "spontaneous development [in children's play] that seemed to the writer an idyl of recapitulation" (vi).

20 The term "savage," which Fry used interchangeably with "primitive" when referring to nonliterate peoples, connoted lack

of material civilization and an early stage of evolutionary social development but not necessarily aggressiveness, violence or moral inferiority. Applied to humans, Fry's use of "savage" parallels the French "sauvage" (as in Claude Lévi-Strauss, *La pensée sauvage*) and does not elide with the same term as applied to animals—fierce, wild, untamed, undomesticated (cf. the use in John Dewey, "Interpretation of Savage Mind," *The Psychological Review* 9 [May 1902]: 217–30). Since, on the contrary, readers today assume this reductive elision, a contemporary such as Marianna Torgovnick winces at Fry's language: "[His] term 'savages' speaks for itself, the implications of wildness tallying oddly with the sensitivity attributed to the [African] artist" (*Gone Primitive: Savage Intellects, Modern Lives* [Chicago, 1990], 90). Torgovnick's reading is either naive or willfully decontextualizing; it ignores the lexical nuances characteristic of Fry's moment, which cannot so easily be shown to have been either more or less racist than our own.

21 Fry, "Bushman Paintings," 334. Cf. Roger Fry, *Last Lectures* [1933–34] (London, 1939), 51–52. Maurice Denis also characterized the primitive's representations as guided by mental images ("De la gaucherie des primitifs" [1904], *Théories, 1890–1910: Du symbolisme et de Gauguin vers un nouvel ordre classique* [Paris, 1920], 174–77). Denis referred to his argument in a note to his essay on Cézanne, which Fry translated and published in *Burlington Magazine* a month before "Bushman Paintings" appeared in the same journal (Maurice Denis, "Cézanne, II," *Burlington Magazine* 16 [February 1910]: 275).

22 Fry, "Bushman Paintings," 337. Fry's essay was a commentary on copies published in M. Helen Tongue, *Bushman Paintings* (Oxford, 1909). Regarding conceptual features of representation that characterize a primitive stage of development as well as children's art, Fry cited Emanuel Loewy as authority. Loewy used the primitive's and child's "mental image" as a convenient explanatory fiction, defin-

ing it rather mysteriously as a "metamorphosed" version of "the pictures that reality presents to the eye" (*The Rendering of Nature in Early Greek Art*, trans. John Fothergill [London, 1907; orig. German ed., 1900], 18). It seems that such normative retinal pictures would have to correspond to whatever manner of rendering was already regarded as properly "perceptual" by adult Europeans, leaving uninvestigated the possible influence of Europeans' own mental images on any assessment of their, and the others', perception. Fry himself accepted Bushman painting as "retinal" and regarded it relevant to a current attempt by impressionists "to get back to that ultra-primitive directness of vision . . . to de-conceptualize art"; he concluded that contemporary painters had "a choice before [them] of whether [they] will *think* form like the early artists of the European races or merely *see* it like the Bushmen" (338; original emphasis). This may be as close as Fry ever came to a theory of the innocent eye. Concerning the significance of debates over mental image and actual vision for the course of art history, see E. H. Gombrich, *Art and Illusion* (Princeton, 1961), 9–30. For a brief critique of theories that oppose mental images to actual vision, see Rudolf Arnheim, *Art and Visual Perception* (Berkeley, 1974), 164–67; here one might also consult William James (see above, note 1). For a recent detailed analysis of children's drawings by a follower of Arnheim, see Claire Golomb, *The Child's Creation of a Pictorial World* (Berkeley, 1992). Recent anthropological study, linking local cultural standards and patterns of education to varying degrees of illusion found in children's art within both "primitive" and industrialized societies, dispels any sense of universal development toward representation: "Representation is not the necessary consequence of picture making for children" (Alexander Alland, Jr., *Playing with Form: Children Learn to Draw in Six Cultures* [New York, 1983], 16).

23 Fry, "Retrospect," 300.

24 Clive Bell, "Post-Impressionism and Aes-

thetics," *Burlington Magazine* 12 (January 1913): 228.

25 Roger Fry, "The Munich Exhibition of Mohammedan Art, I," *Burlington Magazine* 17 (August 1910): 284.

26 Roger Fry, "Teaching Art," *Atheneum* 93 (12 September 1919): 887. Childlike naiveté and expressive "ignorance" of proper representation (to the benefit of form) are also precisely what Fry admired in Cézanne (*Cézanne: A Study of His Development*, 46), as had other critics before him, such as Félicien Fagus: "In front of nature, [Cézanne] becomes a child . . . His nudes are never academic studies . . . what [marvelous] ignorance!" ("Quarante tableaux de Cézanne," *La revue blanche* 20 [1 September 1899]: 627).

27 I owe the example of the cat (from S. S. Buckman, "Human Babies" [1899]) to an illustration in Gould, *Ontogeny and Phylogeny*, 138.

28 Two typical instances: "Only artists and educated people of extraordinary sensibility and some savages and children feel the significance of form so acutely that they know how things look" (Clive Bell, *Art* [New York, 1958 (1913)], 62). "In early stages the child, like the savage, prefers to draw animal and human forms" (Laura L. Plaisted, *Handwork and its Place in Early Education* [Oxford, 1913], 120). Plaisted's educational program shows the influence of biological recapitulation theory, mediated in part by John Dewey; see her chapter "Reproduction of Primitive Industries," 133–40.

29 Fry, "Negro Sculpture" [1920], *Vision and Design*, 100. Fry later claimed that African sculptors' intense spiritualism, unmatched by Europeans, led to their singleminded pursuit of the "energy of the inner life which manifests itself in certain forms and rhythms," that is, in expressive aesthetic abstraction ("Negro Art" [1933], *Last Lectures*, 76). Fry often singled out the British for aesthetic failing: "As a nation [we] are in the habit of treating our emotions, especially our aesthetic emotions, with a certain levity" (Roger Fry, "The French Group," in *Second Post-Impressionist Exhibition*, exh. cat. [London, Grafton Galleries, 1912], 17). Like many of his contemporaries, Fry collected "primitive" art, including tribal objects from Africa and Oceania and diverse examples of European peasant pottery; see Christopher Reed, "The Fry Collection at the Courtauld Institute Galleries," *Burlington Magazine* 132 (November 1990): 772.

30 A third variable would be Fry's thoughts on class relations, although these are implicit in his discussions of industrialization and plutocracy. When Fry noted the superiority of medieval British pottery ("of all the arts the most intimately connected with life"), he attributed the degenerate quality of later examples to "the profound division between the culture of the people and the upper classes which the renaissance effected" ("The Art of Pottery in England," *Burlington Magazine* 24 [March 1914]: 330, 335).

31 John Dewey, *Art as Experience* (New York, 1934), 26–27. Dewey debated some of Fry's more "formalist" points (86–90).

32 Fry, "Giotto," 173–74.

33 Fry, "Children's Drawings" [1917], 226. See also above, note 7.

34 Roger Fry, *Omega Workshops Ltd, Artist Decorators*, catalogue (London, n.d. [1914]), 3–4. On Omega's division of labor, between the crafting of furniture and its "coloring and final decoration," see Anonymous [Roger Fry], *Omega Workshops Ltd, Artist Decorators*, prospectus (London, n.d. [1913]), n.p. [3]. For Fry's authorship and the dating of these texts, see Judith Collins, *The Omega Workshops* (Chicago, 1984), 53, 97–98. Isabelle Anscombe dates the catalogue c. 1915 rather than 1914 (*Omega and After: Bloomsbury and the Decorative Arts* [London, 1981], 170).

35 Fry, Omega Workshops prospectus, 3; Omega Workshops catalogue, 10. See also Carol Hogben et al., *British Art and Design 1900–1960*, exh. cat., Victoria and Albert Museum (London, 1983), 57; Collins, *The Omega Workshops*, 99–101. During Fry's lifetime, critics and theorists repeatedly used the pot to exemplify an

object both aesthetic and utilitarian, individualized and quotidian, refined and crude (cf. Fry's own essay "The Art of Pottery in England"). For some the pot revealed in a single object the gap between (Fry's) categories of emotional and practical interest; for others it offered an opportunity to grasp what lay beyond (or within) this apparent antinomy. For a succinct account of the issues (in terms of opposing notions of the pot as developed by Georg Simmel [1911] and Ernst Bloch [1918]), see Theodor W. Adorno, "The Handle, the Pot, and Early Experience" [1965], *Notes to Literature*, ed. Rolf Tiedemann, trans. Shierry Weber Nicholsen, 2 vols. (New York, 1991–92), 2:211–19. Adorno criticizes Simmel for maintaining the antithesis of utility and beauty, arguing that as a result "aesthetics becomes aestheticizing" (214). This is a charge to which Fry as a theorist might be susceptible, although Omega in *practice* sought to escape it.

36 See Fry, "Negro Sculpture," 100 ("nameless savages"); Omega Workshops catalogue, 3 ("crude instruments . . ."), 10 ("scientific commercialism").

37 Fry mentions the relevant events in letters to Pamela Fry, his daughter (7 March 1917), to Rose Vildrac, wife of his friend the *unanimiste* poet Charles Vildrac (4 April 1917), and to Margery Fry (2 or 3 May 1917). He had previously expressed his desire for an exhibition of children's drawings in a letter to the artist Simon Bussy (28 December 1913). After Fry's 1917 exhibition of works by Marion Richardson's pupils, he held a second show of their art in 1919, also at Omega (letter to Vanessa Bell, 22 February 1919). See Denys Sutton, ed., *Letters of Roger Fry*, 2 vols. (New York, 1972), 2:376, 405–6, 408, 409–10, 447; Virginia Woolf, *Roger Fry: A Biography* (London, 1940), 206; Collins, *The Omega Workshops*, 144–45, 170. Collins (145) notes with curiosity that in writing to Pamela, Fry distinguished the work of artists' children from that of Richardson's pupils, remarking that the latter group would "never come to being [adult] artists." Richard-

son's own account of her interaction with Fry is without much detail (*Art and the Child*, 30–32). Recalling their first meeting at Omega, she writes that the drawings already on display "were all by young and surely very brilliant children. The Dudley drawings were by ordinary children of all ages. My courage ebbed and flowed" (31). On his part, Fry described Richardson's students as "quite average children of lower middle-class parents in a black-country town" ("Children's Drawings," *Burlington Magazine* 44 [January 1924]: 36). It should be noted that Richardson's Dudley School pupils were not only lower middle-class but female, although neither she nor Fry seem to have been concerned that training in art either encourage or discourage differentiation by gender. This is consistent with Fry's and Richardson's desire to keep training in art independent of vocational and professional aims, which would tend to be gender-specific. Journals of education, however, studied the implications of gender difference at great length; see, e.g., Cyril Burt and Robert C. Moore, "The Mental Differences between the Sexes," *Journal of Experimental Pedagogy and Training College Record* 1 (1911–12): 273–84, 355–88.

38 Fry, "Children's Drawings" [1917], 225. Cf. Fry, "Teaching Art," 887; and "Art and the State" [1924], *Transformations*, 61: "The average child has extraordinary inventiveness in design and the average adult none whatever . . . in between these two states there occurs the process known as art teaching. Is this a causal relation or not?" For similar thoughts (by "formalists") on the destructiveness of conventional teaching, see Wassily Kandinsky, "On the Problem of Form," *The Blaue Reiter Almanac*, trans. Henning Falkenstein (New York, 1974; orig. German ed., 1912), 174; Adolf [von] Hildebrand, *The Problem of Form*, trans. Max Meyer and Robert Morris Ogden (New York, 1907; orig. German ed., 1893), 121–22.

39 Cf. Richardson, *Art and the Child*, 32. See also Roger Fry, *Exhibition of Sketches by M. Larionow and drawings by the girls of*

the *Dudley High School* (London, Omega Workshops Ltd., 1919), n.p. ("no falling off [in expressiveness] was visible up to the ages of 16 and 17 when [Richardson's pupils] left school"); and Roger Fry, "Children's Drawings at the County Hall," *New Statesman and Nation*, 24 June 1933, 844–45.

40 Letter to Margery Fry, 2 or 3 May 1917, *Letters of Roger Fry*, 2:410 (original emphasis). Cf. Fry, "Teaching Art," 887 ("Could an Art teacher not teach anything at all, but educate the native powers of perception and visualization?"); "Children's Drawings" [1924], 36 ("[Richardson] has found how not to teach and yet to inspire").

41 Fry, "Children's Drawings" [1924], 36.

42 Cf. Fry, Omega Workshops prospectus, 1. Concerning the history of policy debates over the formation and use of the "South Kensington" collections (which became the Victoria and Albert Museum) and over the training of designers and art teachers at the Royal College of Art and its predecessor institutions, see Stuart Macdonald, *The History and Philosophy of Art Education* (London, 1970); Hogben, *British Art and Design 1900–1960*, xiii–xvi; Peter Stansky, *Redesigning the World: William Morris, the 1880s, and the Arts and Crafts* (Princeton, 1985), 21–29; Christopher Fraylint, *The Royal College of Art* (London, 1987). For an example of the debates, see Fry's old friend C. R. Ashbee, *Should We Stop Teaching Art* (London, 1911). Central issues were what role historical models should play and how systematically instruction in drawing should be conducted. Ashbee solicited teachers "to get the child to invent methods of expression of its own" (6). On the Arts and Crafts movement and Omega, see also S. K. Tillyard, *The Impact of Modernism 1900–1920: Early Modernism and the Arts and Crafts Movement in Edwardian England* (London, 1988), 47–70.

43 Cf. John Ruskin, *"A Joy For Ever"* [1880], in E. T. Cook and Alexander Wedderburn, eds., *The Works of John Ruskin*, 39 vols. (London, 1903–10), 16:121: "Whatever

people can teach each other to do, they will estimate, and ought to estimate, only as common industry."

44 For a simple account of early twentieth-century thinking on the relative merits of training in "fine arts" and "industrial arts," see William G. Whitford, *An Introduction to Art Education* (New York, 1929); on the (possibly false) question of whether to promote free expression or acquisition of skills in the classroom, see John Dewey, "Individuality and Experience" [1926], in Albert C. Barnes, ed., *Art and Education* (Merion, Pa., 1954), 32–40.

45 Joseph Vaughan, *Nelson's New Drawing Course: Drawing, Design, and Manual Occupations, Stage 1* (London, 1902), 46.

46 Fry, "Negro Sculpture," 102. Cf. Henry Balfour's reference to the Bushman artist's need of leisure, in his preface to Tongue, *Bushman Paintings*, 10.

47 On the inappropriateness of evaluating primitives' "power of continued hard work," cf. Dewey, "Interpretation of Savage Mind," 225–26.

48 Roger Fry, *Art and Commerce* (London, 1926), 9.

49 Fry, "The Artist in the Great State," 271. On the designation "The Great State," cf. H. G. Wells, "The Past and the Great State," in Warwick, et al., eds., *Socialism and the Great State*, 32: "We propose to use the term The Great State to express [an] ideal of a social system . . . world-wide in its interests and outlook . . . a system of great individual freedom with a universal understanding among its citizens of a collective thought and purpose."

50 Roger Fry, "Art in a Socialism," *Burlington Magazine* 29 (April 1916): 36–37. Fry's reference to anarchism evokes the writings of Peter Kropotkin, especially *La conquête du pain* (Paris, 1892), which appeared as *The Conquest of Bread* in London editions of 1906 and 1913. Kropotkin, who lived in London from 1886 to 1917, praised the art teachings of Ruskin and William Morris for their social orientation. Like Fry, he linked artistic development to the availability of leisure within a nurturing, egalitarian society devoid of material want; see

P. Kropotkin, *The Conquest of Bread* (London, 1906), 153–54. I am unaware of any direct references to Kropotkin's anarchism on the part of Fry, whose arguments were ultimately weighted toward establishing a place for committed "professional" artists in society, as opposed to Kropotkin's interest in fostering the practice of art by all citizens (although that too was one of Fry's concerns, as evidenced by his attitude toward handwriting, discussed below in the text).

51 Fry, "The Artist in the Great State," 251, 269–72. Politically, Fry, who was raised as a Quaker, was individualist, anarchist (in his generalized sense), egalitarian and internationalist; he reacted against all nationalism, especially in view of the politics of World War I and its aftermath: "I see at present no end to the vicious circle of nationalism except the complete submergence of European civilization" (letter to Robert Bridges, 4 March 1921, *Letters of Roger Fry*, 2:504).

52 Cf. Wells, "The Past and the Great State," 37: "The Great State [would be] without any specific labor class."

53 Walter Sargent, *Fine and Industrial Arts in Elementary Schools* (Boston, 1912), 5, 7.

54 Cf. Fry, "The Artist in the Great State," 264–66; Fry, *Art and Commerce*, 8–9 (where Veblen is cited); Roger Fry, "Higher Commercialism in Art," *Nation and Atheneum* 42 (19 November 1927): 276–77; Roger Fry, "The Arts of Painting and Sculpture," in William Rose, ed., *An Outline of Modern Knowledge* (London, 1931), 913–14 (where Veblen is cited). See also Fry, "Culture and Snobbism" [1926], *Transformations*, 74–88 (discussing the social symbolism of art in relation to opposing groups of cultural conservatives and modish snobs, neither of which engages art aesthetically).

55 Thorstein Veblen, *The Theory of the Leisure Class* (New York, 1912 [1899]), 159–60. Compare the type of book intended to inform the consumer's exercise of taste, such as Margaret H. Bulley, *Have You Good Taste? A Guide to the Appreciation of the Lesser Arts* (London, 1933).

Bulley was a friend of both Fry and Marion Richardson.

56 Fry, Omega Workshops catalogue, 3–4.

57 Leon Loyal Winslow, *Art and Industrial Arts: A Handbook for Elementary Teachers* (Albany, 1922), 10.

58 Arthur Wesley Dow advocated education in art to lead "the majority to desire finer form . . . in things for daily use" (*The Theory and Practice of Teaching Art* [New York, 1912 (1908)], 1 [original emphasis]).

59 Fry, "The Artist in the Great State," 251–72.

60 Fry, *Art and Commerce*, 16.

61 Dow, *The Theory and Practice of Teaching Art*, 1.

62 Fry, "Art and the State," 61–62.

63 Roger Fry, "'Paul Cézanne' by Ambroise Vollard: Paris, 1915," *Burlington Magazine* 31 (August 1917): 52–53.

64 Richardson, *Art and the Child*, 58. Cf. Walter Sargent and Elizabeth E. Miller, *How Children Learn to Draw* (Boston, 1916), 244–45: "[Small children] proceed to draw out of their heads, influenced only in part by the object before them. When it first became our custom as teachers to 'allow' them to draw from their imaginations, it was probably rather a matter of resignation to the inevitable than of principle on our part . . . With older children it is different. Their perceptions have developed to a point where they reject any representation which does not conform in some degree to actual appearances." This is, of course, what Fry regretted.

65 Richardson, *Art and the Child*, 14–17, 41.

66 Fry, "Children's Drawings" [1917], 231.

67 Henri Matisse, "Notes d'un peintre" [1908], *Ecrits et propos sur l'art*, ed. Dominique Fourcade (Paris, 1972), 42–43. On the context for Matisse's statement, see Roger Benjamin, *Matisse's "Notes of a Painter": Criticism, Theory, and Context, 1891–1908* (Ann Arbor, 1987). I have discussed the correspondence between the views of Matisse and Fry, with emphasis on Matisse, in "Imitation of Matisse," Caroline Turner and Roger Benjamin, eds., *Matisse* (Brisbane, 1995), 41–51.

68 Anonymous [Roger Fry and Desmond

MacCarthy], "The Post-Impressionists," *Manet and the Post-Impressionists*, exh. cat., Grafton Galleries (London, 1910), 11. Fry had some initial doubts about Matisse's art but by 1911 could say, "I am now become completely Matissiste"; see his letter to Simon Bussy, 22 May 1911, *Letters of Roger Fry*, 1:348. Bussy was a mutual friend of Fry and Matisse.

69 Fry and MacCarthy, "The Post-Impressionists," 12. Echoes can be found in Clement Greenberg's analysis of Willem de Kooning: "There is a deliberate renunciation of [the painter's] will in so far as it makes itself felt as skill" ("Review of an Exhibition of Willem de Kooning" [1948], *Collected Essays*, 2:229).

70 Fry, "Children's Drawings" [1917], 226. Never entirely consistent throughout his writings, Fry did not necessarily exclude from primitive art the kind of conscious expressive intention characterizing formalism: "The distorted features [of primitive sculpture] are no accident, they are designed to produce a particular effect on the spectator" ("The Arts of Painting and Sculpture" [1931], 919).

71 Cf. Dewey, "Interpretation of Savage Mind," 222; Lucien Lévy-Bruhl, *How Natives Think*, trans. Lilian A. Clare (London, 1926; orig. French ed., 1910), 36. On animist and fetishist attitudes in children, see G. Harold Ellis, "Fetichism [*sic*] in Children," *Pedagogical Seminary* 9 (June 1902): 205–20.

72 Fry, "Children's Drawings" [1917], 226. On African artists who "accept our cheapest illusionist art with humble enthusiasm," cf. Fry, "Negro Sculpture," 103.

73 Fry, "The New Movement in Art in Its Relation to Life," 167.

74 Fry, "Children's Drawings" [1917], 226. Despite the crucial importance of Fry's definition of "formalist" for his evaluative system, the word itself never became a mainstay of his critical vocabulary, as "primitive" was already and "sensibility" would be in later years.

75 William Seitz, "Spirit, Time and 'Abstract Expressionism,'" *Magazine of Art* 46 (February 1953): 86–87 (original emphasis). Seitz's inclusion of the term "uncoerced"

suggests a sensitivity to the cold war politics of the time. Cf. also Meyer Schapiro, "The Liberating Quality of Avant-garde Art," *Art News* 56 (Summer 1957): 36–42.

76 Cf. Clement Greenberg's statement concerning the development of arts of abstraction: "The avant-garde poet or artist . . . turns out to be imitating . . . the disciplines and processes of art and literature themselves . . . In turning his attention away from subject matter of common experience [and, as Fry would say, from childhood's "wonder and delight in objects"], the poet or artist turns it upon the medium of his own craft" ("Avant-Garde and Kitsch" [1939], *Collected Essays*, 1:8–9). According to Dwight Macdonald, Greenberg's "Avant-Garde and Kitsch" developed out of the observation that "native tribesmen," like the proletariat, do not respond to Picasso but to gaudy picture postcards; see Diana Trilling, "An Interview with Dwight Macdonald," in William Phillips, ed., *Partisan Review: The 50th Anniversary Edition* (New York, 1985), 319. Greenberg lacked Fry's fundamental concern for emotional expression; Fry lacked Greenberg's fully articulated sense of the social significance of abstraction, which resisted the alienating effects of bourgeois realism in art. When Greenberg argued that the bourgeoisie (not to mention primitives or the proletariat) habitually chose illusionism over abstraction, he effectively reformulated in (phylogenetic) Marxist terms Fry's (ontogenetic) account of the developing child, a human mirror of industrialism's progressive abandonment of idiosyncratic expression for the market rewards of skilled and standardized representation (cf. Greenberg, "Towards a Newer Laocoon," *Collected Essays*, 1:23–38). On matters related to the centrality of the medium for modernist practice, see Richard Shiff, "Performing an Appearance: On the Surface of Abstract Expressionism," in Michael Auping, ed., *Abstract Expressionism: The Critical Developments* (New York, 1987), 94–123.

77 Fry, "Children's Drawings" [1917], 226. The foremost exception to this division

between knowledgeable, self-conscious formalist and naive, unself-conscious primitive was Cézanne, Fry's most privileged modern master; Cézanne seemed able to achieve the most effective formal structure without consciously intending to do so. Cf. Fry and MacCarthy, "The Post-Impressionists," 10 (note, incidentally, that in this essay Fry allowed exceptional primitives a certain capacity for self-consciousness); Fry, *Cézanne: A Study of His Development*, 27, 46, 51, 56, 63; Shiff, *Cézanne and the End of Impressionism*, 142–52; Shiff, "Performing an Appearance," 106–9.

78 Fry, "Children's Drawings" [1917], 226.

79 For one of Fry's attempts to describe how the passionate response to formal relations operates and feels to the artist, see his "The Artist's Vision" [1919], *Vision and Design*, 51–52.

80 Fry, "Teaching Art," 887–88. Fry's reference to the child's "receiving the accumulated experience of mankind" represents still another way in which ontogeny would recapitulate phylogeny. Fry had presented the basic argument of "Teaching Art" in highly condensed form earlier the same year (February 1919) in his introduction to the Omega catalogue *Exhibition of Sketches by M. Larionow and drawings by the girls of the Dudley High School*.

81 Henri Focillon, "In Praise of Hands" [1936], trans. S. L. Faison, Jr., in *The Life of Forms in Art*, trans. Charles Beecher Hogan and George Kubler (New York, 1948), 67.

82 In Europe and America substantial segments of pretechnological culture were not replaced by machine technology until the first decades of the twentieth century, later than might often be supposed; see Albert Borgmann, *Technology and the Character of Contemporary Life* (Chicago, 1984), 40–48. From his postwar perspective, Siegfried Giedion identified the interwar period, 1918–39, as "the time of full mechanization" (*Mechanization Takes Command* [Oxford, 1948], 41–44). Focillon's sense of the aesthetics of hand versus machine was, by the 1930s, entirely

conventional; cf. the nineteenth-century art theorist and educator Ernest Chesneau, an admirer of Ruskin: "Imperfections contribute to give [the handwork] individuality—as it were, a soul. The product of the machine is lifeless and cold; the work of man is living, like man himself" (*The Education of the Artist*, trans. Clara Bell [London, 1886; orig. French ed., 1880], 257).

83 Greenberg, "Avant-Garde and Kitsch," *Collected Essays*, 1:12–13; cf. also "The Plight of Our Culture" (1953), *Collected Essays*, 3:122–52.

84 See, e.g., Fry, "Giotto," 175; *Cézanne: A Study of His Development*, 44. Fry used the term "handwriting" to discuss not only genuine "expression" but also the repetitious technical "performance" he associated with commercialization of painting ("Higher Commercialism in Art," 276).

85 See Roger Fry, "Words Wanted in Connexion with Art," in Logan Pearsall Smith, *S. P. E. [Society for Pure English] Tract No. XXXI, Needed Words* (Oxford, 1928), 331. In the first paragraph of "In Praise of Hands," Focillon reflected on his own hands at work, alluding to all three senses of *écriture* (writing, handwriting, expressive marking): man's hands impose on thought "une forme, un contour et, dans l'écriture même, un style" (*Vie des formes suivi de Eloge de la main* [Paris, 1970], 103).

86 Research in graphology was extensive during Fry's lifetime; see, e.g., Ludwig Klages, *Handschrift und Charakter* (Leipzig, 1917); Robert Saudek, *The Psychology of Handwriting* (London, 1925).

87 Robert Bridges, "English Handwriting," in *S. P. E. Tract No. XXIII, English Handwriting* (Oxford, 1926), 71–76. Handwriting was the professional concern of Bridges's wife; see M. Monica Bridges, *A New Handwriting for Teachers* (Oxford, 1898).

88 See, e.g., M. Bridges, *A New Handwriting for Teachers*; Saudek, *The Psychology of Handwriting*, 56–126; and, on calligraphy, Edward Johnston, *Writing and Illuminating, and Lettering* (London, 1906). Studies

of the physiology of typewriting were conducted in the same spirit; see, e.g., William Frederick Book, "The Psychology of Skill with Special Reference to Its Acquisition in Typewriting" [1908], in Howard Gardner and Judith Kreiger Gardner, eds., *The Psychology of Skill: Three Studies* (New York, 1973), 7–188.

89 Matisse, "Notes d'un peintre," 43. See also Kandinsky's remarks concerning the formal effect of irregular typographies used for punctuation marks in ordinary printed text, or the effect of the most ordinary letters once they are divorced from their conventional function ("On the Problem of Form," 165–68).

90 Bridges, "English Handwriting," 74. See also Robert Bridges, "General Remarks," in *S. P. E. Tract No. XXVIII, English Handwriting* (Oxford, 1927), 228–29.

91 Bridges, "English Handwriting," 75–77.

92 Roger Fry, "Reflections on Handwriting," in *S. P. E. Tract No. XXIII, English Handwriting* (Oxford, 1926), 86–88. I find no indication in Fry's various writings that he distinguished in any systematic way between things "unconscious" and things "unself-conscious" (concerning Fry's views on Freudian analysis, see *The Artist and Psycho-Analysis*). Of all the samples Bridges provided, Fry regarded as best Gerard Manley Hopkins's, where "the forms of letters are so freely varied according to their position relative to other letters" (90)—clearly, a case of artistic liberation (fig. 139). In making his artistic judgments, Fry admitted it would be difficult to "exclude those [graphological] intuitions of character which we get from handwriting and confine [himself] to the problem of rhythm" (letter to Robert Bridges, 20 January 1926, *Letters of Roger Fry*, 2:590).

93 Richardson, *Writing and Writing Patterns*, Teacher's Book, 3, 16–17.

94 Fry, "Reflections on Handwriting," 91.

95 Richardson, *Art and the Child*, 31; Fry, "Children's Drawings" [1924], 36.

96 Fry, letter to Robert Bridges, 18 December 1925, *Letters of Roger Fry*, 2:588. Fry also mentions his use of a stylograph, an early type of ballpoint, convenient but

even less agreeable than the fountain pen. For later generations, with quills outmoded, the relevant distinction indeed came to be between fine fountain pens and mass-produced ballpoints; see Roland Barthes, "An Almost Obsessive Relation to Writing Instruments" [1973], in *The Grain of the Voice: Interviews 1962–1980*, trans. Linda Coverdale (New York, 1985), 178. Barthes associated pens in general with autonomous creativity and the typewriter with commercial directives (179). He also set the issue into the broadest historical perspective: "Manual writing, long impersonal (during Antiquity and the Middle Ages), began to be individualized in the Renaissance, dawn of the modern period; but today . . . the personality of writing is fading out"; Roland Barthes, "That Old Thing, Art . . . ," in *The Responsibility of Forms*, trans. Richard Howard (New York, 1985), 201.

97 Fry, letter to Robert Bridges, 20 January 1926, *Letters of Roger Fry*, 2:590. Compare Kandinsky's contemporaneous allusion to a modern sense of technical economy: "Of the various kinds of etching, *drypoint* is used by preference today because it harmonizes especially well with the present day atmosphere of haste, and because it possesses the incisive character of precision" (Wassily Kandinsky, *Point and Line to Plane*, trans. Howard Dearstyne and Hilla Rebay [New York, 1947; orig. German ed., 1926], 48).

98 Alfred J. Fairbank, "Penmanship," in *S. P. E. Tract No. XXVIII, English Handwriting*, 242.

99 Bridges, "English Handwriting," 73–74; "General Remarks," 227–29. With the progress of technology, the typewriter evolved toward less and less "expression." Whereas purely mechanical models registered differences in the touch of the operator, later electrical models regularized that factor, making it adjustable not to immediate physical pressure, but rather to the predetermined setting of a gauge; and recent electronic models are still more removed from physicality.

100 Compare Martin Heidegger's attitude

toward the typewriter, which has become a common academic topos. See, e.g., Friedrich Kittler, "Gramophone, Film, Typewriter," trans. Dorothea von Mücke, *October* 41 (Summer 1987): 113–14; Jacques Derrida, "*Geschlecht* II: Heidegger's Hand," in John Sallis, ed., *Deconstruction and Philosophy: The Texts of Jacques Derrida* (Chicago, 1987), 178–80; Michael E. Zimmerman, *Heidegger's Confrontation with Modernity: Technology, Politics, Art* (Bloomington, Ind., 1990), 205–6. The relevant Heidegger text is *Parmenides*: "Man himself acts through the hand . . . In the time of the first dominance of the typewriter, a letter written on this machine still stood for a breach of good manners . . . Mechanical writing . . . conceals the handwriting and thereby the character. The typewriter makes everyone look the same" (*Parmenides* [1942–43], trans. André Schuwer and Richard Rojcewicz [Bloomington, Ind., 1992], 80–81). Such statements have a broadly allegorical meaning for Heidegger, related to his speculation on the alienation of modern society from the fundamental conditions of human existence: "In handwriting the relation of Being to

man, namely the word, is inscribed in beings themselves . . . In the typewriter we find the irruption of the mechanism in the realm of the word . . . [The typewriter] withdraws from man the essential rank of the hand, without man's experiencing this withdrawal appropriately and recognizing that it has transformed the relation of Being to his essence" (85).

101 Fry, *Art and Commerce*, 17–18. Cf. Fry, "The Artist in the Great State," 268: "disastrous . . . so-called improvements whereby decoration, the whole value of which consists in its expressive power, is multiplied indefinitely by machinery."

102 Cf. J. E. Barton, *Purpose and Admiration: A Lay Study of the Visual Arts* (London, 1932), 222–23: "Personality of a kind, and undoubtedly of a sensitive kind, informs this amalgamation of modern mechanistic design and the modern civilized outlook. The admission of mechanism to the sphere of craft and art is forcing us to keep our eyes open."

103 Roger Fry, "Sensibility versus Mechanism," *The Listener*, 6 April 1932, 497–98.

104 Ibid.

105 Fry, "Sensibility" [1933], *Last Lectures*, 28.

106 Cf. Fry, "Children's Drawings" [1917], 226.

Miró and Children's Drawings

Dora Vallier

All authors who have concerned themselves with the work of Miró have evoked children's drawings. The most insightful among them have broadened the question by observing that Miró "arrives at the suggestion of primitive writing, of prehistoric paintings, of exotic or archaic arts, of graffiti."[1] This statement is so evident that it has never prompted any discussion or analysis. Associating the painting of Miró with the drawing of children on the one hand, and on the other with the primitive arts in general, raises fundamental problems with multiple implications. The juxtaposition parallels the highly personalized expression of a painter with anonymous artistic productions; it contrasts an achievement of aesthetic order with plastic activities that take place outside of the aesthetic act. It seems a clear contradiction, yet the evidence is undeniable.

In establishing a relationship between Miró's painting and these diverse forms of artistic activity, one evokes the sources of art, the unknown that gives birth to the creative gesture, the mystery so dear to the romantics. If there is a domain where this level of creativity presents itself most clearly, it is when a child draws. It is not by chance that since Freud the study of children's drawings has taken a great leap forward. The unconscious guides the child's hand. When we say that the painting of Miró makes us think of children's drawings, we are actually speaking about the role of the unconscious. This is why the comparison is not at all contradictory. But now the question shifts: How is the unconscious revealed in children's drawings? How does it present itself in the work of Miró?

Translated by Erika Pistorius-Stamper

Creation in the Child

It is well known that drawing is a spontaneous activity for a child—a game, an escape, and at the same time the discovery of a total freedom that allows the expression of his desires as well as the deliverance from his fears. Hence the importance of drawing as a diagnostic tool for child psychoanalysts and its role in the general education of children during their first years of school. Yet these two areas of investigation, although at the center of interest provoked today by children's drawings and holding an important place in those specialties, only indirectly bear on the subject we have chosen to address here. We will thus leave them aside and concern ourselves only with better defining the creative gesture of the child for the purpose of comparing it to that of Miró.

Through the gesture of the child who draws, creation reveals itself in a pure state—a "poetic" state *par excellence* in the Greek etymological sense, in which the act of making is more important than the result. To paint or to draw is for the child a self-sufficient activity. It is first of all a movement of the hand that meets a surface and leaves a mark; that mark, in turn, can attract the movement of the hand in one direction or in another, guiding it toward this or that form or even bringing forth an exteriorization of an inner sensation, a nameless phantasm that will suddenly appear. In this way the material trace prompts the emergence of the unconscious and becomes at that very moment a source of jubilation. To paint is a pleasure for the child. The simple line and, even more, color exercise a fascination on him which can extend to physical excitation: so the child looks for direct contact with the colored material, he abandons the brush to paint with his fingers.

This deep taste for creativity diminishes little by little. The trace of the brush tends to retain the perception of the exterior world, which, within the next few years, is still represented according to the inner vision: often, while drawing, the child tells stories made up as he goes along in relation to the graphic representation. Then comes the moment when the child takes the reality around him as his model. Specialists situate this transformation around the age of seven or eight. The child then initiates himself in a technique that permits him to arrive at realistic figuration, more or less awkward, indeed, but conforming to a conventional system of drawing. The stage of pure creation definitively ends for the child.

Creation in Miró: His Own Testimony

We are fortunate that Miró explained his method of work at length on various occasions. He wrote without reserve, providing much detail. Was it because he knew how much he differed from other painters? He has revealed to us what we could not have known had he been less outspoken. Certainly the reading of his

works would have allowed us to formulate some hypotheses, but never would we have been certain about his method for ambushing the unconscious; never could we have imagined the great effort that the professional painter must make in order to recapture the innocence of creation which characterizes the child: "I am in need of great solitude in order to paint because painting, my painting requires an enormous tension. I must be at home to put myself in the best working conditions. I need a physical impulse in order to paint."[2]

Miró even prepared himself physically to serve as the vehicle of his painting: "I eat little, I listen to music, I read—almost exclusively poetry, I take walks in the country . . . I look at the sea, the trees, the birds. And this way of spending my days with myself, in silence, allows me to maintain the tension which is necessary for me to produce paintings."[3]

Thus Miró aimed at a concentration on his sensibilities rather than merely on his thoughts, and he succeeded. "Once I find myself in the ecstasy of work, my painting overflows. I start a drawing and I could end up doing ten, fifteen. They follow in a series emerging one from the other. At that moment I take a canvas, the first one on hand and I put down what is going on in me."[4]

The unconscious takes its free course. And this is the birth of a painting:

I always start a painting after receiving a shock from something material, as for example the texture of a canvas, of the material itself formed by this texture, or through something that triggers itself within me without my knowing why. It is what Rimbaud calls "the spark." . . . This trigger goes off in me when I am in a café or anywhere far from home. I then take the first scrap of paper that I come across, and when there is no paper around, I will even use a pack of cigarettes in my haste to note what I feel.[5]

Elsewhere, Miró has said:

I always work on a vast number of things at the same time. And even in different media: painting, engraving, lithography, sculpture, ceramics. The material and the tool dictate to me a technique, a means of infusing life into an object. If I attack a wood block with a chisel this puts me into a certain state of mind. If I attack a lithographic stone with a brush, or a copper plate with a burin, I experience different states of mind. The encounter of the tool with the material produces an impact which is something alive.[6]

In this description he insists on his unique manner of working, adding details that demonstrate the degree to which he has excluded the intervention of the will, to the point where the trace of his gesture depends not on him but rather on the sensation he experiences upon contact with the material: "If I attack a shiny copper plate, I am in a different state of mind than if I have to confront the dull wood. The shininess and the dullness do not inspire me to create the same forms."[7]

He went still further in 1977, when he was eighty-four years old: "Now I work very often with my fingers: I dip my fingers into the paint, into the lithographic inks. . . . This inclination to paint with the fingers increases every day."[8] At the end of this same interview came this intimate and even more revealing confession: "The time when I work the most is very early in the morning around four o'clock. I work the most without working. In my bed. Between four and seven I am completely absorbed by my work. Then I fall asleep again between seven and eight. It is almost always like this."[9]

Who does not know, since Freud, that sleep liberates the unconscious? Miró watched for the margin between wakefulness and sleep in order to insert his painting there. Here we can see how far he consciously strove to capture messages of the unconscious.

Resemblances

It is clear that each time Miró set out to work, he initiated the basic conditions of pure creation that exist in the natural state of the child. He listened to the unconscious about which he spoke only in metaphor—it is the "spark," the "trigger," the "shock." He looked for the excitement provoked by the contact with the material and, intent on submitting to its fascination, he pursued the tracks left behind by this encounter; because he has created, as much as is possible, a spontaneity of the same nature as that of a child, unavoidably what enters into his work are his own desires, his own phantasms. It is therefore not surprising that he ends up with signs common to children's drawings: the sun with radiating beams, the moon, the stars, which one comes across continually in his work, but also multiform personages (elaborated versions of the "stick-figure," which is one of the most widely used tools of interpretation in the psychological study of children's drawings).

Needless to say this common repertory also belongs to the primordial symbolism of mankind exhibited since prehistoric time in the different primitive arts. The unconscious is actually a language that possesses its own structures—as Lacan, among others, has repeatedly pointed out. If these structures emerge at the level of signs in the work of Miró, they establish themselves at the level of the signifier along with the painterly gesture. Stimulated by the simple contact with the material, the brush inscribes a fluid or an interrupted line; it imprints a rhythm. The color, sometimes applied with the tip of the brush, goes in pursuit of itself to form curved lines that seem to respond only to the pleasure of psycho-motor activity; or the color spreads freely, drifts, stands out, becomes a daub, a splash.

From this first stage of creation Miró has seized upon the resources of the unconscious, and remarkably he succeeds in continuing to draw on them throughout his working process and beyond, all the way to the title. Indeed Miró is one of the only modern painters who liked to confer long and extravagant titles on his

paintings: *The Wings of the Bird Touch the Moon to Reach the Stars*; *Woman Hypnotized by Twilight Rays Striking the Plain*; *The Star Rises, the Birds Fly, People Dance*. This pecularity to which Miró has accustomed us, has been considered a tribute to poetry and nothing more. In fact, it denotes the very deep links that this painter maintains with the world of childhood. When a child draws, he tells a story; even if it is not legible in his drawing, it exists for him.

What did Miró say? "I find my titles gradually as I work, as I link one thing to another on my canvas. Once I have found the title, I live in its atmosphere. The title becomes for me a hundred percent reality in the same way that a model, a reclining woman for example, is for another painter. For me, the title is an exact reality."[10] A statement of foremost importance, which, beyond its relevance to the parallel with children's drawings, concerns an area still very little studied—the relationship between language and image. One understands the importance of this experience for Miró when one knows, thanks to psychological studies, that a literary essay becomes richer and more subtle when, some time before being written, it has been preceded by its graphic illustration, because graphic illustration requires of the child an effort and a much more personal adaptation.[11]

Thus Miró not only drew on the unconscious but on the entire process of creation as it exists in the child. At the same time one cannot fail also to note the differences between Miró's work and that of a child.

Differences

If the act of painting rested for Miró on an acquired spontaneity, this spontaneity is at the same time under control. While the child's plastic realization is fast, reflecting the immediacy of the gesture, for Miró the realization came slowly, much more slowly than one would think: "There are always many years between the beginning of one of my paintings, its act of execution and its realization. It often happens that I return to a painting years and years after its initial drawing. Sometimes even ten years; this is common for me. During all this time it sleeps in my studio until the day when, suddenly I see something in it."[12]

Far from being an instantaneous expression, as it is for a child, the painting of Miró is an accumulation of spontaneous gestures that condensed into the image; he multiplied formal allusions, exploited the sensual, unconscious flow of line for the purpose of erotic symbolism, and at the same time proceeded by the association of ideas to the grafting of forms and to elliptical reminders of the real. These are all operations alien to the plastic activity of the child.

As for materials, Miró could work with just about anything; he could even dip his fingers into the color and paint. But he never lost sight of a painting as a totality that must cohere, a concept that the young child misses completely. In a word, Miró did not forget for a single moment that he was a painter, and if he returned in

his own way to the creative activity of the child, it was for the purpose of reaching profound sources and bending them to his own purposes without ever imitating the child's creative process. The child's drawing never served as a model for him (as it happens to have done for Paul Klee), but a signal that creation in its pure form exists and that it is a necessary goal. In Miró's studio in Majorca, aside from his own works, there was nothing on the walls at a given moment except the drawing of a child.[13] It was a way of marking the direction.

Miró's Attitude Toward His Own Childhood Drawings

In 1959, during a long interview with Miró (later published in the journal *Cahiers d'Art*), I showed him a book with some drawings that he had done in 1901, at the age of eight (figs. 140, 141). He was not expecting this. He had a surprised smile looking at one of these drawings, which depicted a closed umbrella with tips at the top of each fold, a capricious detail. The drawing made him recall his earliest paintings: "It is true, one finds here things which interested me later on." Then, with a mischievous air, he added: "Even this fish that I painted as a child resembles that of the *Still Life* in the Basel Museum." Finally, now serious after this exchange, he concluded: "The older I get and the more I master the medium, the more I return to my earliest experiences. I think that at the end of my life I will rediscover all the force of my childhood."[14] This was a premonition. In the 1960s and 1970s Miró came closer and closer to the creative gesture of a child (figs. 142–45).

Conclusion

If it is evident that Miró's interest in the unconscious dates back to his encounter with the surrealists, it is also clear that he was never an orthodox surrealist himself. He never came to terms with the plastic orientations of surrealism, yet he broadened its formal vocabulary more than anybody else. This is a fact that deserves particular attention in the framework of this study.

Under the influence of automatic writing, recourse to the unconscious became a goal for Miró; but he pursued this goal in the constant exercise of the technical knowledge he possessed as a painter. Convinced of the importance of his craft he declared: "I have been able to make use of the surrealist lesson because I already had a foundation in plasticity."[15] This foundation in plasticity is generally thought of as a biographical detail without importance. In my opinion, however, the uncommon character of this foundation had prepared Miró to receive the surrealist message, without knowing it.

From the first hour he had, in effect, received a training that reoriented his attention from the exterior world toward the interior one. It happened at the beginning of his career in Barcelona:

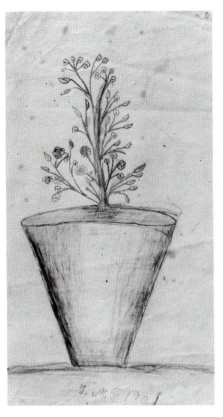

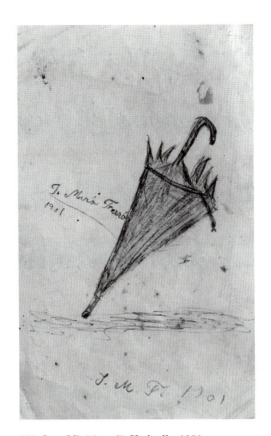

140 Joan Miró (age 8), *Flower Pot with Flowers*, 1901

141 Joan Miró (age 8), *Umbrella*, 1901

142 Child's drawing (anonymous, age 5), *Gesture drawing*

143 Child's drawing (anonymous, age 4), *Gesture drawing*

144 Joan Miró, *Mediterranean Landscape*, 1930

145 Joan Miró, *La Manucure évaporée*, 1975

I was fortunate to be the student of a teacher like Galí. He had a school of painting which I attended when I was about sixteen. His conception of teaching art was very original. He proceeded in the following way: he made us touch an object while our eyes were closed and then he asked us to draw its form according to the sense of touch.... It was a great discipline.[16]

It was a discipline that nullified the rational approach in favor of the imaginary, an apprenticeship in art from its inner side, a clear call of the unconscious, not formulated as such but already destined to deepen plastic realization. It is this discipline that surrealism brought to the surface in Miró. The elaboration of this unique creative process would be its direct consequence, with the pure creation of early childhood as its model.

1 Jacques Dupin, *Miró* (Lausanne: Editions Rencontre, 1969).

2 Dora Vallier, *L'intérieur de l'art*. (Interviews with Braque, Léger, Villon, Miró and Brancusi published during their lifetimes in *Cahiers d'Art*, Paris). (Paris: Editions du Seuil, 1982 and 1986), 127.

3 Ibid.

4 Ibid.

5 Ibid., 128.

6 Miró, *Je travaille comme un jardinier*. Propos recueillis par Y. Taillandier. (Paris: Editions XXe Siècle-Hazan, 1962), 23.

7 Ibid.

8 Georges Raillard, *Ceci est la couleur de mes rêves* (interview with Miró) (Paris: Editions du Seuil, 1977), 46.

9 Ibid., 24.

10 Miró, *Je travaille comme un jardinier*, 22.

11 Marie-Claire Debienne, *Le dessin chez l'enfant* (Paris: PUF, 1968 and 1976), 95.

12 Vallier, *L'intérieur de l'art*, 130.

13 Raillard, *Ceci est la couleur de mes rêves*, 130.

14 Vallier, *L'intérieur de l'art*, 143–44.

15 Ibid., 138.

16 Ibid., 139.

The Infant in the Adult

Joan Miró and the Infantile Image

Christopher Green

In 1929 Michel Leiris ended a short piece in the periodical *Documents* thus: "It is not so easy to re-discover the freshness of infancy...even less easy than learning English."[1] Leiris's observation makes two points that will surface recurrently here. First, that the "rediscovery" of "infancy" is highly attractive; it is the rediscovery of "freshness." Second, that it is difficult.

At the time of Leiris's remark, the Catalan painter Joan Miró, who was spending at least half his working life in Paris, had just enjoyed the success of a sell-out exhibition of paintings at the Right Bank Parisian Galerie Georges Bernheim.[2] He was among the most successful of the surrealists around André Breton. At the same time, he was one of the artists most celebrated in *Documents* and he had been for half a decade a close friend of Leiris.

Documents and Leiris are both indissolubly associated with the phenomenon of "primitivism" in France in the 1920s and 1930s. Indeed, Leiris was in the process of becoming one of the new anthropologists produced by the teaching of Marcel Mauss at the Institut d'ethnologie in Paris. Over the whole of the period from the mid to late 1920s into the late 1930s, Miró's painting was, as we shall see, consistently aligned with "infancy," either in the sense of the infancy of "man" or in the sense of the infancy of the individual. "Primitivism" and infantilism were closely aligned. Another point to which we shall return here is the trope of the "primitive-as-child" and "child-as-primitive." Both the attractions and the difficulties of "rediscovery" revolve around this conflation of the child and the so-called primitive. However positive and anti-racist the stance of a figure like Leiris, it is, of course, a notion fraught with derogatory colonial and racist connotations.

The attractions of child art as a model for avant-garde art in the early twentieth century went with two factors: first, the enormous increase in interest from the late nineteenth century in the child and in child art across Europe from the

direction of educational theory and psychology, and second, the long post-Enlightenment tradition of the child as the model for the artist, or more broadly for the ideal human being.

The romantic equation between genius and "childhood regained," founded on Jean-Jacques Rousseau's idealized belief in the innocent "freedom" of the child, still retained force into this century. The increased interest among educationalists and psychologists in the child and specifically in child art was not necessarily connected with this tradition, or at least with the Rousseau-esque belief in unalloyed innocence and its romantic counterpart, although it is clearly significant that Jean Piaget's crucial research in child psychology in the 1920s was carried out at the Institut J. J. Rousseau. Piaget's work was on the developmental aspects of child psychology as a whole. It was not on child art and, although he referred to work on the subject, he did not use child art as a source of evidence. His conclusions, however, above all in *Le Langage et la pensée chez l'enfant* of 1923 and *La Représentation du monde chez l'enfant* of 1926 were so profound in their implications and so influential in Europe by the end of the 1920s, that they certainly affected the way that child art was understood from that time on. His studies were the culmination of an intense burst of activity in child psychology that had produced, before 1914, a steady flow of major publications on child art: in Germany above all Siegfried Levinstein's doctoral dissertation and the work of Georg Kerschensteiner; in France most significantly G.-H. Luquet's *Les Dessins d'un enfant, étude psychologique*, which was respectfully used and acknowledged by Piaget and to which I shall return. These publications were packed with illustrations of child art, so that it was no longer necessary to build one's own collection, although artists, including Miró and his surrealist companion André Masson, did keep at least some of the drawings of their children.[3]

It is in this context that the representation generally of the artist as child in the later 1920s and the 1930s must be seen, and especially the near automatic tendency for critics at the time to apply to Miró, as to Paul Klee, the epithet childlike. This was, in fact, a widespread tendency, but I shall confine myself here to just three instances. First, Georges Limbour (writer and friend of both Miró and Masson from their rue Blomet days) commented in *Documents* on Klee, as if Rousseau's romantic ideal of innocence is an attainable reality both for the child and for Klee. "While not pushing the analogy too far, one recalls," he writes, "certain childhood drawings, which are unencumbered by any consideration capable of obstructing the trajectory of their imagination. . . ."[4] Miró was to acknowledge the role of Klee in the move that took him into the "dream paintings" of the mid-1920s (fig. 146), something of which Limbour was no doubt aware.

Second, there is the German critic Carl Einstein's article on Miró in *Documents*, in which he explicitly relates to child art Miró's move into the simple sign-making of the "dream paintings." He writes of "the starry songs of children," and

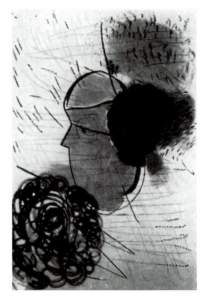

146 Joan Miró, *Painting*, 1925

147 Joan Miró, *Head*, 1930

then, underlining the strength of the notion of the child-as-primitive, goes further to associate Miró's most recent work—the collages, constructions and "anti-paintings" of 1929–30 (figs. 147, 148)—with the "primitive" in general and above all the prehistoric. Miró's notorious "assassination of painting" becomes, as an attack on sophistication, a return to origins. "Miró," Einstein writes, "has renounced this time the charm of his old palette. This is the defeat of virtuosity. Intuition rises. Mark of an expanded freedom. Prehistoric simplicity. . . . The end rejoins the beginning."[5]

This pairing of a process of renunciation, of stripping away, with a return to origins is a notion that receives especially elaborate expression in the third of my instances, the article that Leiris devoted to Miró in *Documents*. Leiris begins this piece with a remarkable evocation of the Oriental meditative process whereby every detail of a garden or landscape is systematically thought away, until there is only a "void" (*le vide*). He seems to have in mind specific paintings by Miró, where there is indeed a strong sense of void. As the article develops, it becomes clear that Leiris uses this metaphor, which becomes a metaphor for Miró's creative process altogether, as a fable of the loss of civilized knowledge and the regaining of innocence. He writes:

> It can seem...bizarre to speak of asceticism [as with the mystic] in relation to Miró. The burlesque appearance of his canvases, the astonishing joy they release seem so many denials of this way of seeing. All the same, if one looks at them hard, one can see that the artist has achieved a void in himself...in order to rediscover an infancy, at once so serious and so

212 Christopher Green

148 Joan Miró, *Painting*, 1930

comical, shot through with a mythology so primitive, founded on the metonymy of stones, plants, animals, a little like the stories of savage peoples, where all the elements of the globe encounter such unlikely transformations.[6]

Leiris does not merely conflate the child and the "primitive" or "savage." He writes of a return to childhood which is equally a return to magic: to the beginnings, it is implied, of art. For both Leiris and Einstein, the child analogy takes as its inevitable corollary, more fundamentally than the "primitive," the prehistoric. When in 1931 Georges Hugnet published his first article on Miró in *Cahiers d'Art* and called it "Joan Miró ou l'enfance de l'art," his title pulled tight a whole network of connotations, but most tellingly those associated with childhood, prehistory and origins.[7] At its most basic, the metaphor of the artist as child became, in the case of Miró, the metaphor of the modern artist as *first* artist.

My introduction of the topic of Miró and the childlike cannot be complete without a consideration of intention. Is the childlike in Miró's work something he intended? Or, most important, is such an intention something that has to be established? At certain points in this essay, it should be clear that such an intention is indeed a probability, but my emphasis here is on the fact that the metaphor of the "first artist"—of the artist-as-child or prehistoric man—was a key component in the actual ways in which Miró and his art *were* seen. It is, therefore, far more important to demonstrate the existence of a context for the *reception* of such a metaphor than to demonstrate intention. My aim is to explore the condition of

receptivity for the metaphor of the artist as child in relation to the work of Miró during the 1920s and 1930s. Such a condition of receptivity was, no doubt, variable and changing (between individuals and from year to year), but it was a necessary given behind the effectiveness at any time of the metaphor. My concern above all is with the beliefs, assumptions, ideas and rationalizations about children, children's art and the origins of art that made for this receptivity to Miró's persistent prehistoric and infantile image. And this is a receptivity, of course, as much to be inferred in Miró as his audience, whatever might have been his intentions.

If Leiris could find in Miró a special talent for the rediscovery of "the freshness of infancy," it is worth remembering that, for him, such a rediscovery was not easy. Leiris had good reason for speaking of the difficulties, because, certainly over the previous fifteen years, one of the dominant themes in French-speaking child psychology and educational theory had been the impossibility of bridging the gap between adulthood and childhood and the width of the gap. This was a theme tied closely to discussions of the so-called primitive, and especially of "primitive mentality."

Within the Enlightenment tradition, there is a recognizable continuity in the approach to the education of the child that connects Rousseau's *Emile*, from 1762, with, say Viollet-le-Duc's instructive novel of 1879, *Histoire d'un dessinateur*. Basically, an *epistemological* function is given to drawing. It is presented as a way of progressively learning about the world, and the accent is on the preservation into adulthood of an infantile innocence of vision so as to retain the clear objectivity that is assumed to go with it. From such innocence and objectivity will come a true grasp of the "real," it is suggested, and this is something that can continue undistorted and fundamentally unchanged into adulthood.

In the 1920s, Jean Piaget's early books challenged the very ground of such beliefs. Piaget set out to demonstrate that the structure of thought in childhood and thus the way children know or represent the world is clearly distinct from adult thought and, further, that the thinking of children is characterized by its "egocentricity," the very reverse of objectivity. His meticulous program of questioning and observing children led him to conclude that "egocentric thinking" was especially dominant between the ages of three and seven, that it was found to a lesser degree between seven and eleven, finally giving way to logical thought after the age of eleven. Crucial, he argued, to the development into adult thought—logical thought—was socialization, for a growing awareness of others indicated a growing capacity to separate subject from object, the necessary basis for logical thinking. He was well aware of Freudian methodology and theory, and the parallels with Freudian notions of ego-formation and the acquisition of the "reality principle" are clear enough.[8] For Piaget, childhood was a "pre-logical" state, a time of rampant subjectivity during which the child could not separate him- or herself as subject from his or her surroundings. As a result, the laws of child thought were in most respects

different from those of adult thought. The distance between child and adult was the distance between the very structures of two mentalities.

In his study of 1926, *La Représentation du monde chez l'enfant*, Piaget drew a parallel between his work on children and a particular antecedent in ethnology. He acknowledged how much he had learned from "the analysis of primitive mentality, and in particular, from the memorable works of Monsieur Lévy-Bruhl. Without doubt," he continued, "at every step we shall encounter analogies between the child and the primitive."[9] He went on to insist that the case of the "primitive" should be put aside so as to focus without distraction on the case of "the child in its own right," but the fact is that his notion of child thought does relate in many respects to Lévy-Bruhl's highly influential notion of "primitive mentality," as first set out in 1910 in his *Fonctions mentales dans les sociétés inférieures*, and as expanded, without fundamental change, in the more crisply titled *La Mentalité primitive* of 1922.

Lévy-Bruhl's use of the term "les sociétés inférieures" seems to suggest a simple evolutionary view of "primitive mentality" in relation to "civilized mentality," a continuity between them. It is a term that indelibly underlines the pervasiveness of a colonial "mentality" in Europe in the first decades of this century (the ground, of course, for the conflation of the child with the "primitive"). Yet, in fact, Lévy-Bruhl aimed to arrive at broad conclusions about "man" as a whole by the exploration of "primitive mentality," and he rejected the evolutionary model. Indeed, the rejection of the evolutionary model was his starting point, something he makes absolutely clear in the introduction to *Les Fonctions mentales* in 1910. He presents his study as a direct challenge to the evolutionism of Herbert Spencer, with its assumption that there is a continuous development from the simple to the complex in the maturing process of human mentality, an evolution traceable in the development from "primitive" to "civilized" thinking and beliefs; and he sets his study specifically against the adaptation of this evolutionary model to the analysis of myth and magic in "primitive societies" by the anthropologists of the English School, notably M.E.B. Tylor and Frazer (author of *The Golden Bough*).[10]

In the first place, Lévy-Bruhl does not accept that "primitive" thought is simpler than "civilized" thought, and so he problematizes the term "primitive."[11] In the second place, as Lévy-Bruhl saw it, the attempt to explain animistic beliefs and magic as simpler logics based on the false perception of reality (the argument put forward especially by Frazer) might have been plausible but was fundamentally misconceived, since it started with a European model of the mechanism of thought that was then tendentiously applied to the evidence.[12] The evidence, Lévy-Bruhl contended, demonstrated that the essentials of logical thought were entirely missing from the thinking of the "primitives."

For Lévy-Bruhl, it followed that if a society had fundamentally different institutions and customs, its way of thinking (its mentality) was fundamentally differ-

ent too.[13] The major difference here was between the logical and something else, and the keys to understanding that something else were mysticism—the belief that everything possessed spirit or life—and magic.

In the case of magic, Lévy-Bruhl focused on a particular aspect: the "illogical" notion of causation required by the belief that two demonstrably unconnected things are causally connected, that, say, in an instance recorded from Northern Australia, a portrait of Queen Victoria *caused* misfortune.[14] In such instances, Lévy-Bruhl stressed, things can be associated causally when they are both in different places and contiguous in time. This was not to be understood merely as faulty logic (feebleness of mind) or, following Frazer, as logic erroneously based on "associations of ideas"; it was to be understood in terms of what he called "the law of participation." This was no less than the basic principle of "primitive mentality." According to this law, anything could "participate" in anything else at any time, anywhere. The force of something here could be simultaneously partaken of somewhere else. "Primitive mentality" simply ignored the logician's fundamental rule of "non-contradiction," the rule by which two objects cannot occupy the same space at the same time. "I would say," Lévy-Bruhl writes, "that, in the collective representations of primitive mentality, objects, beings, phenomena, can be, in a way incomprehensible to us, at once themselves and other than themselves. In a way no less incomprehensible, they emit and receive forces, virtues, qualities, mystical actions, which are felt to be outside them, without ceasing to be what they are."[15] It was he who first coined the term "pre-logical" for those modes of connection between things that follow the "law of participation" rather than the laws of logic.[16] He adds, incidentally, that the "primitive" is not incapable of logical judgment and action, and uses such judgments consistently in life.[17] His point is that, though this is so, "primitive mentality" can accept contradiction.

Lévy-Bruhl vehemently rejected the tendency to call "primitive mentality" infantile, but there can be no doubt that his stress on the *structural* differences between "mentalities" and on the centrality of the distinction between "pre-logical" and "logical" thought does connect with Piaget's structural differentiation between the "egocentric thought" of the child and the logic of adult thought.[18] Much in Piaget's characterization of "egocentric thought" echoes, at times explicitly, Lévy-Bruhl's "primitive mentality," however much he, too, as we have seen, wanted to avoid facile parallels.

In child thought (especially between three and seven) Piaget found, as in "primitive mentality," a systematic resistance to the logic of causality, and he found, furthermore, that this was manifested in the child's habitual obedience to "the law of participation," its capacity either mystically to invest things with spirit, or to believe itself a force in the world that makes things happen magically: to believe itself perhaps the agency that makes the sun get up in the morning and walk across the sky.[19] Infantile mysticism and magic are crucial factors in "egocen-

tric thinking." Another factor, also crucial to "primitive mentality," is what Piaget called "syncretic thinking": that is, the linking of things by analogy. For both Piaget and Lévy-Bruhl, it was often syncretically that "the law of participation" acted.[20] One thing was experienced as analogous to another; the link thus made, they either partook in each other's force or became one and the same. Then too, Piaget observed in children, as Lévy-Bruhl did in "primitives," a belief in a mystical and magic world so final that any and all contrary evidence was simply ignored.[21]

The connected cases of Piaget and Lévy-Bruhl, along with the theory of "mentalities," together show just how effectively arguments from at least two highly influential directions widened the distance between notions of adulthood and of childhood, and so exposed to serious question the Rousseau-esque ideal of the child as model for the man. G.-H. Luquet has been mentioned already as a child psychologist acknowledged by Piaget.[22] It was above all Luquet who, in French theories about child and "primitive" art brought out the relationship between them as one between mentalities; and it was Luquet too who most influentially made the connection between the child and the prehistoric "artist." As Piaget saw clearly enough, Luquet's work on child art accentuated the gap between child and adult and corroborated his generalizations about logic in adult thought and about the pre-logical in the "egocentric thinking" of the child. Before I turn to Luquet, however, it is necessary to mention one further factor that Piaget considered demonstrative of "egocentric thinking" and Lévy-Bruhl of "primitive mentality." As an aspect of a mentality that gave such scope to mysticism and magic, it might seem surprising: it is realism.

Piaget opened *La Représentation du monde chez l'enfant* with a section on "Le Réalisme enfantin," and here he made a key distinction between objectivity and realism. Objectivity, he explains, is the basis of logical thought. It starts with the recognition of the subjective in things and thus of the necessity that judgments be detached from the self; it enables the mind to think in categories that go beyond immediate sense experience: abstract categories. "Realism, on the contrary," he writes, "consists in ignoring the existence of the self, and consequently, in taking one's own perspective as immediately objective, and absolute. Realism is, therefore, the anthropological illusion, it is essentialism."[23] With the egocentric, infantile confusion between self and world goes an absolute emphasis on things as they are seen from the single perspective of the subject.

The question of realism was what most concerned Luquet in his analysis not only of child art but of "primitive" and of prehistoric art too. The heroine of Luquet's early book *Dessins d'un enfant*, published in 1913, was Simone, his own daughter (fig. 149). The book takes her as a special case by which to look more closely at children's art in developmental terms. Previous studies, like Levinstein's, had not taken careful account of age and had focused on drawings of particular motifs by different children. Luquet allowed Simone to choose her own motifs and

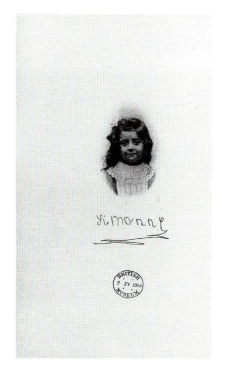

149 Photograph of Simone [Luquet], with the signature "Simone," from G.-H. Luquet, *Les Dessins d'un enfant, étude psychologique* (Paris, 1913)

150 Child's drawing (Simone Luquet), Plate I, from G.-H. Luquet, *Les Dessins d'un enfant, étude psychologique* (Paris, 1913)

draw as she wanted and then meticulously recorded her drawings in sequence, numbering each one and giving the age, to the day, when it was done—for instance, "3, 3 (10)" for three years, three months and ten days (fig. 150). The accent on preserving as far as possible the child's own volition and on exact sequential recording anticipates Piaget's "clinical method."[24]

Luquet's project might have been developmental, but one of his major conclusions suggested nonetheless a clear typological distinction between the drawings of adults and those of children, one that anticipates Piaget's distinction between adult and child mentalities. It was in the making of this distinction that the question of realism figured so prominently.

Simone, declared Luquet, like all children, was always a realist. She was only satisfied when she thought she had achieved "resemblance" and completeness. In her case, he recorded three stages: first, up to around four years, when the "realist" impulse was obscured by lack of skill (*maladresse*); second, from around four years, when the elements of child realism were increasingly clear; and third, beginning as the child approached six years, when child realism began gradually to give way to adult realism. His stages parallel but do not quite overlap with Piaget's, who iden-

tified, as has been seen, three to seven as the key phase of "egocentric thinking." This is how Luquet makes the distinction between child and adult realism:

> For the adult, a drawing must be a kind of photograph of the object: it must reproduce all the details and only those details visible from where the object is perceived and in the form they take from that view-point...According to the child's conception, on the contrary, drawing, to achieve resemblance, must contain all the details of the object, all its logical elements, even those that are invisible either from the view-point from which it is envisaged or from any view-point, and otherwise must give each of these details its characteristic form, that which exemplarity demands.[25]

For adult realism he used the term "visual realism"; for child realism, in 1913, he used the term "logical realism," which by the 1920s, in response to Piaget's stress on the non-logical in child thought, had become "intellectual realism."[26]

The characteristics he isolated as those of infantile "intellectual" or "logical realism" are mostly to be seen in a page of drawings of home done by Simone at 4 years, 7 months (fig. 151). They included the consistent use of "exemplary" viewpoints—full faces for the heads of people, for instance, or bird's-eye for rooms, furniture and so on; the juxtaposition of parts or items usually obscured from a particular viewpoint (the chairs around the table seem as if they are unobstructed, for instance); and transparency, the exposure of the insides of things (rooms seen through the roof, for instance). The child draws, concluded Luquet, what it *knows* from seeing, not what it sees from a particular vantage-point. There is a curious symmetry between his child/adult distinction and the distinctions made at this time (around 1912–13) between cubism, often called a "conceptual: realism," and naturalism (a parallel apparently unnoticed by Luquet).[27] As in Lévy-Bruhl's and Piaget's theories of "mentality," what is clear is the absolute structural character of the distinction. Child drawing is the visible face of the world seen and constructed by a mentality foreign to ours.

Throughout *Dessins d'un enfant*, Luquet remarked on the similarities, as he saw it, between child, "primitive" and prehistoric art (they were all demonstrations of "logical realism"), and he had published on cave art in these terms in 1910. During the 1920s and later, it was to be these three together, under the reductive heading "primitive art" that most concerned him. He brings them together particularly influentially in *L'Art primitif*, published in 1930 in the popularizing series "Encyclopédie Scientifique." He had already, in 1926, made an elaborate attempt to apply certain of his observations in the case of Simone to a major problem in the study of prehistoric art, the problem of origins.[28] A shorter version of the 1926 argument was included in *L'Art primitif*. It indissolubly fused current understanding of the infantile and the prehistoric around the deeply suggestive image of "the first artist."

151 Child's drawing (Simone Luquet), Plate XXXVI, from G.-H. Luquet, *Les Dessins d'un enfant, étude psychologique* (Paris, 1913)

152 Child's drawing ("Jean L"), Page 35, from G.-H. Luquet, *L'Art primitif* (Paris, 1930)

Luquet opened *L'Art primitif* with a chapter titled "La Genèse de l'art figuré." Here he announced that his study of child art had established that figuration was not something learned by imitating a child's elder, but that every child, on its own, "invents for itself figurative drawing as if it were the first artist."[29] He goes on to claim that what can be observed of how this discovery takes place in the child is to be observed also, in all its essentials, in what is known of the preludes to figurative art in the earliest known art of the caves, that of the Aurignacian period, between 25,000 and 16,000 B.C. His method is to apply what he has learned from Simone to the enormously expanded information about cave art revealed by the major discoveries of the early twentieth century, those of western Spain, including Altamira, and of the Dordogne. The archaeologists Abbé Breuil and Obermaier were among his sources.[30] The analogy made between the child and the prehistoric man as "first artist" is easily summed up by looking at the earliest of Simone's drawings published in *Dessins d'un enfant* (fig. 150) alongside the early drawings of a child dubbed by Luquet "Jean L" published in *L'Art primitif* (fig. 152).

From such instances as these, Luquet concludes that children discover figurative art accidentally. They start simply by making marks on paper, without any

depictive intent, and then "see" resemblances, which they later imitate with depictive intent and develop into signs. Thus, at 3 years, 4 months, Simone makes a scribble, which she subsequently identifies, by resemblance, as a whip and a horse, while "Jean L," without, as the caption tells us, any representational intent, makes his own squiggles (at between 3 years, 6 months, and 3 years, 9 months), which he subsequently identifies as a windmill, a whip, a bird, a balloon or a cane, and so on. This, says Luquet in 1926, is precisely how figurative art is "invented" by Aurignacian man, and he points to cases, on the one hand, of apparently purposeless mark-making (palmprints, finger-tracings, etc.), and, on the other, of images apparently suggested by natural accidents of form, most famously, a galloping wild boar at Altamira that uses the form of a very slight boss on the cave wall. For both child and Aurignacian man, two capacities—the capacity to see resemblances and the capacity to grasp the effectiveness of directed industry—allowed first the discovery of figurative images and then the development of figurative art.[31] Whatever we may think now of so simple a conflation of the child and prehistoric man in the figure of the "first artist," a personnage who returns in the infancy of every individual, it was a widely influential one by the early 1930s in France. Luquet, generally, was believed.

If we are to return to the case of Joan Miró and to the question of the infantile and the image of the "first artist" as they are condensed into his paintings of the 1920s and 1930s, a problem must be confronted. It will have become clear that the dominant pictures of child mentality and child art constructed in this period effectively polarized the states of adult and child. Luquet leaves the unmistakable inference that the ways a child and an adult see cannot mesh in any sense and that it is simply impossible to regain the state of undirected unknowing that exists as a given in each child's discovery of figurative art. This hardly provides the ground for any kind of receptivity to the metaphor of Miró-as-child or Miró-as-first-man/first-artist. The question is how could this metaphor have had such force, even in the milieu of the surrealists and of *Documents*, where the work of Piaget and Luquet was well known? How could regression become an attractive and a possible aspiration?

That it was, in fact, a possible aspiration is actually built into the theory of mentalities and Luquet's conclusions on child art. The possibility is acknowledged, as I have already suggested, in Lévy-Bruhl's realization that a prelogical "primitive mentality" can and does coexist with the logical (which is engaged on a practical, everyday level for problem solving).[32] Luquet's acknowledgment of the possibility is altogether more graphic, in the literal sense of that word. His introduction to *Dessins d'un enfant* includes a page of graffiti figures transcribed from the walls of various French towns (fig. 153). For him, they show that the spontaneous drawings of untutored adults in urban France share basic characteristics with child

153 Street graffiti, Plate XVIII, from G.-H. Luquet, *Les Dessins d'un enfant, étude psychologique* (Paris, 1913)

drawing. In this case, he picked out the attachments of limbs directly to heads, a trait typical of child drawings at an early age. The adult can and does see the world as a child, so long as he has not been taught learned skills and the techniques remain crude. Famously, Brassaï elaborated on Luquet's finding in the joint number 3–4 of the surrealist-backed periodical *Minotaure* at the end of 1933, with his short piece, "Du Mur des cavernes au mur d'usine," publishing for the first time the photographs he had begun to take of urban graffiti along with a test that used these images to bring together modern industrial man with prehistoric man (fig. 154). Brassaï's text begins: "Everything is a question of optics. Living analogies make vertiginous connections across the ages by the simple elimination of the factor time. In the light of ethnography, great age becomes first youth, the stone age is a state of mind, and it is the vision of a child that brings to the fragments of flint, the brilliance of life."[33] Significantly, the photograph of a graffiti face placed between the columns of text is a classic instance of chance configurations visibly generating an image by resemblance, the image seemingly suggested by chipped and bored holes in the wall and perhaps by random scribblings. Brassaï records the invention of art relived in adulthood. "In 1933," he writes, "a couple of steps from the Opéra, signs like those of the caves of the Dordogne . . . pour out onto the walls."[34] The distance traveled, between childhood and adulthood, between the caves and 1933, is unimaginable, but it can be traveled every day, and not just by artists. There may be a structural divide between "mentalities," but it is not unbridgeable.

Still more to the point, from the very outset the theory of "mentalities" itself, with its insistence on difference, was in various ways challenged by the ethnologist who, by the late 1920s, had become the dominant figure in the formation of the new French profession of ethnology, Michel Leiris's teacher, mentor of many in the *Documents* circle, Marcel Mauss. For Mauss, the study of totemic thinking, magical practices and the institutions of giving and receiving in non-European societies suggested deep structural *similarities* between the thought and behavior of "primitive" and "civilized" peoples, similarities that further undermined the very notion of the primitive.[35] It was from this new ethnological perspective, so very different from that offered by Lévy-Bruhl, that Georges Bataille wrote a memorable review of Luquet's *L'Art primitif* in the penultimate number of *Documents* in 1930, of which Bataille himself was editor. Bataille's review was placed immediately before his own presentation of seven reproductions of Miró's most recent work, all of them "anti-paintings" of 1930. The works reproduced included the huge, wall-size *Head* now in Grenoble (fig. 147), where the resemblance between the profile head, apparently half scribbled out, and Luquet's graffiti profiles may not be merely fortuitous.

Bataille accepted without qualification Luquet's theory of the origins of art: the starting point in purposeless mark-making with palms or finger, or in the scrib-

DU MUR DES CAVERNES AU MUR D'USINE

par BRASSAÏ

Tout est une question d'optique. Des analogies vivantes établissent des rapprochements vertigineux à travers les âges par simple élimination du facteur temps. A la lumière de l'ethnographie, l'antiquité devient prime jeunesse, l'âge de la pierre un état d'esprit, et c'est la compréhension de l'enfance qui apporte aux éclats de silex, l'éclat de la vie.

Les graffiti suivants ont été recueillis à Paris même au hasard de quelques promenades. En 1933, et à deux pas de l'Opéra, des signes semblables à ceux des grottes de la Dordogne, de la Vallée du Nil ou de l'Euphrate, surgissent sur les murs. La même angoisse qui a labouré d'un monde chaotique de gravures les parois des cavernes, trace aujourd'hui des dessins autour du mot « Défense » le premier que l'enfant déchiffre sur les murs.

Le curieux qui explore cette flore précoce cherche en vain à y retrouver le baroque des dessins d'enfant. Du papier au mur, du surveillé à l'anonyme, le caractère de l'expression change. Le frétillement de la fantaisie cède le pas à l'envoûtement. C'est la réinvestiture du mot « charmant » dans son sens original.

Comme la pierre est dure ! Comme les instruments sont rudimentaires ! Qu'importe ! Il ne s'agit plus de jouer mais de maîtriser la frénésie de l'inconscient. Ces signes succincts ne sont rien moins que l'origine de l'écriture, ces animaux, ces monstres, ces démons, ces héros, ces dieux phalliques, rien moins que les éléments de la mythologie. S'élever à la poésie ou s'engouffrer dans la trivialité n'a plus de sens en cette région où les lois de la gravitation ne sont plus en vigueur. Etrange région des « mères », chère à Faust, où tout est en formation, transformation, déformation, tout en restant immobile, où les créatures existantes et possibles contiennent inertes, toute l'énergie subversive de l'atome. Et c'est parce qu'il est projeté

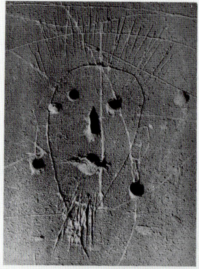

à la surface par une violente lame de fond que le graffite devient en matière d'art un précieux outil d'investigation.

Aux chefs-d'œuvre, pesants et mûrs fruits de l'esprit, qui recèlent en eux tant de sève que la branche qui les porte se dessèche et se brise, seule une imagination créatrice peut reconnaître dans la cicatrice le sceau du secret de leur naissance. Les graffiti nous font assister avec la joie sensuelle du voyeur, à l'épanouissement et à la fécondation de la fleur, le fruit jaillit, un fruit minuscule et sauvage qui porte encore l'or des pollens, au milieu des pétales.

Ce qu'on décèle sous la transparence cristalline de la spontanéité est ici une fonction vivante, aussi impérieuse, aussi irraisonnée que la respiration ou le sommeil. Or quelle que soit la dissemblance entre les œuvres d'art, seule la marque innée de cette fonction atteste leur authenticité. C'est elle qui classe.

L'art bâtard des rues mal famées, qui n'arrive même pas à effleurer notre curiosité, si éphémère qu'une intempérie, une couche de peinture efface sa trace, devient un critérium de valeur. Sa loi est formelle, elle renverse tous les canons laborieusement établis de l'esthétique.

La beauté n'est pas l'objet de la création, elle en est la récompense. Son apparition, souvent tardive, annonce seulement que l'équilibre, rompu entre l'homme et la nature, est une fois de plus reconquis par l'art. Que reste-t-il des œuvres contemporaines après cette confrontation ?

Que ce qui, sous des apparences trompeuses, ne contient pas autant de vérité, n'est pas autant une nécessité physiologique, ne se tient pas dans les limites d'une discipline aussi austère qu'un graffite, soit rejeté comme une non-valeur.

BRASSAÏ

154 Brassaï, *Graffiti Head*, as published in *Minotaure*, no. 3–4 (Paris, 12 December 1933), 6

blings of the three-year-old, the role of accidental shapes on cave walls, development by purposive imitation, etc. As we shall see, he gave the theory a particular slant of special relevance to Miró, but broadly he had no quarrels with it. His quarrel was most of all with the comprehensiveness of Luquet's analogy between child and prehistoric art and the assumption that followed from it that prehistoric art at its most "primitive" was, like child art, realist in the "intellectual" rather than "visual" sense. He deeply distrusted the tendency in Luquet to conflate ontogenetic with phylogenetic evolution (i.e., the evolution of the individual with that of the species), and he especially distrusted the decision to use the development of figuration in child drawing as the model for understanding the development of prehistoric art. In his view, the question of development was distinct from that of origins. If prehistoric man started with an exclusively "intellectual" realism, how, Bataille asked, could Luquet explain the coexistence, even in the Auragnacian epoch, of both "intellectual" and "visual" realism on the walls of caves? For Bataille, this revealed the ability in the case of Aurignacian man to choose *between* modes immediately after the discovery of figurative art. And he noted that "intellectual realism" of a usually rudimentary kind seemed to be reserved for the human figure, while "visual realism" of an often astonishing acuity was reserved for animals. Such willful oscillation between modes or visions was, of course, out of the reach of children.[36]

The juxtaposition of Bataille on Luquet and Bataille on Miró clearly encouraged particular expectations of the "anti-paintings" by Miró reproduced in *Documents*, not merely of the Grenoble *Head* but also of those that were less immediately legible in figurative terms. All seven of the works reproduced in *Documents* are captioned simply "Peinture," including the large painting comprising three colored blobs now in Houston (fig. 148). It too is wall size, and no distinct depictive image is defined. The canvas has been left open to the spectator to "find" his own figuration. We have, as it were, three blobs waiting for the moment of recognition by resemblance. Among the "dream paintings," between 1924 and 1927, Miró had produced many such pictures, which combined an apparent randomness of mark-making (usually more linear) with an openness to signification (fig. 146), though he often completed the process of recognition by resemblance for the spectator by supplying a title. Especially striking was the series of eleven pictures known as the *Circus Horse* pictures, produced in 1927. They were all carefully enlarged from pencil drawings where Miró seems simply to have allowed his hand to move without depictive intent, so they do, in fact, literally represent that initial stage in the invention of figurative signs when undirected mark-making triggers recognition by resemblance. One of the *Circus Horse* pictures and especially the sketch for it (fig. 155) may even specifically connect with a particular scribble by Simone (fig. 150), where, as we have seen, the comparable swing and dip of the line led the little girl, like Miró, to "see" a whip and a horse.[37] Again, the similarity

155 Joan Miró, *Study for Circus Horse*,
1926–27

between these cases may not be merely fortuitous, and whether or not it is, such a reading in terms of the reliving of the child's moment as, once again, the "first artist," is irresistibly invited.

Overt links between Miró's work and child art were, in fact, many and various, and they did not only involve the reliving of origins. On the one hand, there was the conspicuous parading of the lack of skill (something obviously intended to be related more to very young children in Luquet's first phase of "failed realism," or *réalisme manqué*, than to Aurignacian man). And, on the other hand, there was the incorporation of the features of "intellectual realism." The *Circus Horse* paintings of 1927, the "anti-paintings" of 1930 and many of the collages, constructions and "painting-objects" of 1929–31 are clear enough instances of conspicuous lack of skill, and Miró was to continue to produce aggressively unskilled images for the rest of his career. At the same time, it is interesting to note how, when he helped with the "chronology" assembled by *Documents* in 1929, he left the impression (obviously with intent) that, from his earliest training as an artist, he lacked all technical aptitude. From 1929, Miró actively helped construct a reputation for himself of innate *maladresse*.[38]

As to his engagement with an unmistakable "intellectual realism" the most obvious and elaborate instances are the teeming anecdotal pictures of 1924–25, above all *The Tilled Field, The Harlequin's Carnival* and *The Hunter (Catalan Landscape)* (fig. 156). Everything is there: the compulsive need, commented on by Luquet, for itemized detail, the use of exemplary viewpoints, juxtapositions, hinging,

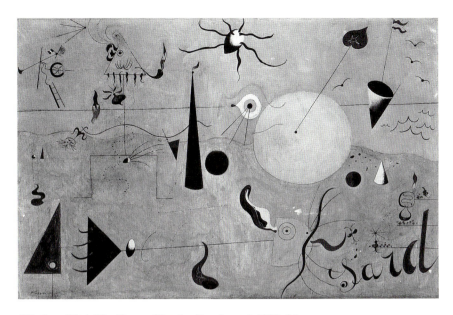

156 Joan Miró, *The Hunter (Catalan Landscape)*, 1923–24

transparency (the hunter's heart and the sardine's intestine are both made visible). The stick-figure schema and the copybook lettering of "sard" instantly activate the child art connection. And there are many and various ways in which Miró's work could be read, not merely in terms of Luquet's "intellectual realism" but of Piaget's characterization of "egocentric thinking." It ignores the contradictory (the sardine has a rabbit's ear and whiskers) which, as Piaget demonstrated, is characteristic of children's art. It is often syncretic (the triangles that denote boat and gun, the flames of gun and heart, and the sun-as-spider all establish chains of analogy). And when words become an integral part of images, they often confuse the relation between things and names, a confusion typical, according to Piaget, of child thought, in which the name is assumed to be actually a part of the thing.[39]

The connections are manifold, but it is important to realize that intentionality is not the condition for making these connections. The point is that Miró's paintings could be and were easily read as manifestations of the infantile, of "intellectual realism," of "egocentric thinking" and of the moment of the child-as-"first painter." The conditions of receptivity to such readings were very much in place. In these images one could readily find a representation of Miró as child and "first painter," along with a statement of widely shared aspirations to return not merely to earlier stages of development but to origins, to the "mentalities" that Piaget was in the process of describing in such detail and analyzing in such depth.

All that Miró produced between 1924 and 1939 (and indeed later) stands in some relation, more or less explicit, to the discourse of the child and of origins, but

there was a period when that relationship was especially strong and, opened up by contemporary readings of the pictures, especially deep: the period of the campaign to "assassinate painting." It is probable that the famous phrase "the assassination of painting" was actually first used by Miró around 1925, but I refer here specifically to the years when the campaign was fuelled by Miró's own published statements and those of the critics he himself briefed, that is, between the end of 1928 and 1933, the period of *Documents* and the first numbers of *Minotaure*. Leiris's metaphor for Miró's working process of stripping away knowledge to arrive at the "void" of infancy went with the presentation of Miró's "assassination of painting" as a return to origins, as an attempt to begin again by reliving the moment of the "first painter." It is above all in the collages, the "painting-objects" and the "anti-paintings" of 1929–33 that Miró's work makes explicit the regressive ideal.

There is a further factor held in common by the "anti-paintings" reproduced with Bataille's review of Luquet and his article on Miró in 1930: aggression. It was not the reliving of the moment of discovery in the experience of the "first painter" that Bataille stressed in his brief commentary on Miró; it was the destructive aspect of "assassination." "Finally," he writes, "as Miró himself claims that he wishes 'to assassinate painting,' the process of decomposition has been pushed to such a point that there remain nothing more than a few formless marks on the lid of the box of spells (or on the tomb-stone . . .)." All that is left are "the traces of some inconceivable disaster."[40] There are certainly "anti-paintings" among those Bataille reproduced that can be read in terms as much of "remains" as of beginnings—one such is the Houston *Painting* (fig. 148)—and the profile of *Head* (fig. 147) is both invaded by stains and blotches and literally crossed out. Bataille gave a new slant to Luquet's theory of the origins of art in the review that he juxtaposed with this statement, a slant that followed from a new stress on the *destructive* aspect. Bataille picked out Luquet's admission that the impulse to mark the paper on the part of the child or to leave finger-tracings and scratchings on walls, in the case of the graffiti artist and Auragnacian man, came of a vandalistic desire to leave a personal sign. He argued that in the invention and development of figurative art the desire, as he put it, "sadistically" to destroy was the inevitable complement to the desire to create. Both the child and the adult needed to impose themselves on things by altering them. The process of alteration was initially one of destruction. The paper or the wall was vandalized by marking, and only then was there recognition by resemblance. Indeed, Bataille contended that even the process of developing figurative signs by repetition was essentially destructive, since it proceeded in a series of deformations, or, as he put it, "a series of destructions." This was so even where the progression was away from the merely approximate toward the more "like," toward greater "resemblance." At the moment of origin Bataille found not merely random openness but destruction. Once again, he invoked the image of the child, but this time the image of "children who break everything" (*des "enfants*

brise-tout"). Transgression was at the beginning of art. The first word the child learned to decipher when it began to draw on walls was, according to Bataille, *défendu* (forbidden).[41]

Yet there is a further inference to be drawn from Bataille's article. It is that, for him, since it was only the adult who could choose between the vision of the child and the adult, it was more the model of prehistoric man than that of the child which was appropriate to Miró, and, perhaps, most appropriate of all, was the model of the graffiti artist, the adult in modern society whose *maladresse* and whose transgressive vandalism combined to preserve access to origins. Certainly, more often than not, Miró brought together in his use of signs features from *different* stages in the development of child art as recorded by Luquet, or even both adult and child features. In the Grenoble *Head*, the random markings suggest early child drawing, but the profile suggests a much later style. *Maladresse* and the merger of modes or the features of different infantile stages are typical, according to Luquet, of adult graffiti. Miró's "assassination of painting" in terms of origins could, it is clear, be read in terms of infantilism, but was perhaps most appropriately read as a distinctly and recognizably adult regression, in which the vandalism of its dada-esque attack on art could play a major part.

If the writings of Piaget were relatively marginal to the formation specifically of surrealist attitudes in the 1920s, those of Lévy-Bruhl, Mauss and (to a much less extent) Luquet were relatively central. Yet there was one additional writer whose role in surrealism and in the dissident surrealism of *Documents* was formative and who also tackled the categories of the "primitive" and the infantile in proximity to one another. This was Sigmund Freud. He did so in two major texts: *Totem and Taboo* of 1913, and *Civilization and its Discontents* of 1930, precisely the moment of Miró's "anti-paintings."[42]

For Freud, there was no difficulty at all in conceiving of regression from adulthood into the infantile, and in *Civilization and its Discontents* he tackled the question of the distance between the two head-on. "In mental life," he declared, "nothing which has formed can perish." His confident belief was that "everything is somehow preserved and that in suitable circumstances (when, for instance, regression goes back far enough) it can be brought to life."[43] He went so far as to visualize the mind as a city in which everything that was ever built in every stage of its existence continued to exist alongside the buildings that still stood. Distinguishing mind from body, he concluded: "Only in the mind is such a preservation of all the earlier stages alongside of the final form possible."[44]

But, of course, for Freud, regression was not to be thought of as the key to the rediscovery of something that could be called "innocent," something worthy of the epithet of "freshness," which Michel Leiris and so many others attached to infancy. Regression, alongside inhibited development, was for Freud the key to neurosis.

In *Totem and Taboo* Freud added to the derogatory, fundamentally colonial/paternal image of the primitive-as-child the equally derogatory image of the primitive as model for the understanding of the European neurotic. For him, the operation of taboo in totemic religions was an illuminating parallel for the operation of taboo in obsessive neurosis, and the parallel was valid because, for him, the development of "man" from "animism" through "religion" to "science" was to be seen as closely parallel with that of the individual from infancy through adolescence to adulthood. Freud maintained the conflation of the ontogenetic and the phylogenetic set aside by Lévy-Bruhl and still more insistently by Mauss and Bataille.[45] But at the same time he stressed the possibility of regression.

From such a perspective, the conspicuous infantilism of Miró's art might have seemed the mark, not of revelatory force, but of neurosis (with all its connotations of regression). Miró, the infantile artist working in European society, might have appeared closer to the obsessive neurotic than to the "savage" (and Miró's reputation for orderliness in his studio practice and for reticence in his social relations could encourage such a view). Yet, the image of the infant-as-primitive constructed by Freud was not wholly negative. He argued in *Totem and Taboo* that the magical aspect of thinking in "primitives" and infants went with an "unshakable confidence in the possibility of controlling the world." He wrote of "the omnipotence of thoughts," echoing Piaget's observation that "egocentric thinking" ignores the distinction between thought and "reality," subject and object. This Freud called "sexualized thinking": thought directed by desire. He believed it to be characteristic of the "animistic" stage in human development and of the "narcissistic" stage in that of the individual. If regression usually went with neurosis and the repression of desire, there was, Freud contended, one category of regression in which "the omnipotence of thoughts" was fully retained in "civilized" adulthood and in which neurosis might be escaped: art. He might have considered art no more than the embodiment of fantasy, but still he allowed it a positive role. "In only one field of our civilization," he writes, "has the omnipotence of thoughts been retained, and that is the field of art. Only in art does it still happen that a man who is consumed by desires performs something resembling the accomplishment of those desires and that what he does in play produces emotional effects—thanks to artistic illusion—just as though it were something real. People speak with justice of the 'magic of art' and compare artists to magicians."[46]

When Michel Leiris described Miró's practice as stripping the world away until it became a "void," he ended with an image of an art that had returned to "infancy" and "the stories of savage peoples," where one thing can metamorphose into another. He ended with the "omnipotence of thought": magic. The same image of a process of unlearning that ends in regression and revelation is found earlier in 1929 in an article that Carl Einstein published in *Documents* about Miró's close friend André Masson. It is an article that anticipates both Leiris on Miró and Einstein himself on

Miró, writing in 1930, as we saw at the start of this essay, about "the defeat of virtuosity" and "prehistoric simplicity." Einstein too envisages a process by which the artist "eliminates" and "forgets" the world of "objects" in the "manner of a religious adept." This is, he declares, the route to the discovery and animation of "the mythological layers" of consciousness, and crucial to it is the fact that "the regressive type arrives at infantile forms." Indeed, he concludes, that one can speak of "a *duplicate child*"; a second childhood to be encountered in adulthood.[47]

A year later, Freud himself was to turn to precisely this image of the mystical trance state as a possible route to the attainment of a positive rather than negative kind of regression. In *Civilization and its Discontents*, Freud wrote of a "friend" who had assured him "that through the practice of Yoga, by withdrawing from the world, by fixing the attention on bodily functions and by peculiar methods of breathing, one can in fact evoke new sensations and coenaesthesias in oneself, which he regards as regressions to primordial states of mind which have long ago been overlaid. He sees in them a physiological base, as it were, of much of the wisdom of mysticism."[48]

The Freudian perspective on Miró's infantilism allowed space for both an idealized notion of the child state as one of unrepressed desire and an idealized notion of the primordial in early infancy as one of origins. It enhanced rather than dulled both the attractions of the "mystical" and the "magical" in such works as *Hunter (Catalan Landscape)*, and of the "first artist" in such works as *Head* and the Houston *Painting*.

It seems appropriate to end not with Miró alone but with us and our predecessors: with the spectator in relation to the infantilism of Miró's images.

A major irony brought out by Piaget's analysis of child "realism" as a function of "egocentric thought" is that with the failure to be aware of the self went an equivalent failure, as we have seen, to separate the world from the self. Everything in the world becomes an extension of the self, and lives and moves as such (hence the omnipotence of thought).[49] Miró's public stress on the anonymity of his work carried the inference, of course, that he was aware of no self behind it, and yet at the same time offered it up as entirely permeated with his own subjectivity.[50] To invite the epithet of the infantile was to invite the total integration of Miró as subject with the image (from a Freudian as well as a Piagetian viewpoint). Yet there was a complication, because the image was offered *to* the spectator, another subject, and the more the image is open, the more the spectator is allowed to go through the process of recognition by resemblance for themselves, the more the image leaves a space for that other subject (us) to occupy.

Above all in the emptiest of the "anti-paintings," in the most "primordial" of Miró's regressions to the point of origin, it is in the end the spectator who is invited to see as the child and the "first man." Miró not only holds up to himself the chance of regression; he holds it up to us as well.

1 Michel Leiris, "Fox Movietone Follies of 1929," *Documents* 7 (1929), 388.

2 1–15 May 1928, Galerie Georges Bernheim et cie.

3 A drawing by Miró's daughter Dolores survives in the Musée National d'Art Moderne, Paris. It was a gift from Miró to Vasily Kandinsky.

4 Georges Limbour, "Paul Klee," *Documents* 1 (1929), 53–54.

5 Carl Einstein, "Joan Miró (Papiers collés à la galerie Pierre)," *Documents* 4 (1930), 243.

6 Michel Leiris, "Miró," *Documents* 4 (1929), 263–64.

7 Georges Hugnet, "Joan Miró ou l'enfance de l'art," *Cahiers d'Art* 7/8 (1931), 335–40. Shortly before this, Carl Einstein titled an article on Jean Arp in *Documents*, "L'Enfance néolithique" (*Documents* [1930], 35–43).

8 Piaget often mentions Freud, as does Claparède in his preface to Jean Piaget, *Le Langage et la pensée chez l'enfant* (Paris: Delachaux et Niestlé, 1923). The analogy between Freud's diagnostic methods and Piaget's stress on "letting children talk," while encouraging spontaneity, is clear. Significantly, Piaget himself aligns what he calls the "egocentric thinking" of children (and especially their belief in magic) with the Freudian notion of narcissism, though he notes that in his findings the longevity of the stage of "egocentric thinking" in children does not precisely correlate with Freud's focus on early infancy. See Jean Piaget, *La Représentation du monde chez l'enfant* (Paris: F. Alcan, 1926), 138–39. The first to discuss Piaget seriously in relation to surrealism in France was Jennifer Mundy. She too observes the connection between his and Lévy-Bruhl's ideas. See Jennifer Mundy, "Biomorphism," Ph.D. diss. (Courtauld Institute, University of London, 1986), 200–202.

9 Ibid., 69.

10 See Lucien Lévy-Bruhl, *Les Fonctions mentales dans les sociétés inférieurs* (Paris, 1910), 5–10.

11 Ibid., 12.

12 Ibid., 5–19.

13 "La série de faits sociaux sont solidaires les unes des autres, et elles se conditionnent réciproquement. Un type de société défini, qui a ses institutions et ses moeurs propres, aura donc aussi, nécessairement, sa mentalité propre." Ibid., 19.

14 Ibid., 70–72. For a more comprehensive discussion of causality in "primitive mentality," see Lucien Lévy-Bruhl, *La Mentalité primitive* (Paris, 1922), 43–93.

15 Ibid., 77.

16 For Lévy-Bruhl "primitive mentality" could be called "mystique" if the focus was on "le contenu des représentations," and "prélogique" if it was on "les liasons." See Ibid., 78.

17 Lévy-Bruhl stressed the point that the "prélogique" was not the "anti-logique." In simple, practical terms the "primitive" is demonstrably capable, he argues, of judging and acting causally. The point is that the contradictory is not evaded, as it is in "notre pensée." See Ibid., 78–79.

18 For an introductory account of the structural character of Piaget's thought and especially his stress on the assimilatory constructive character of the subject's knowledge of "reality," see John H. Flavell, *The Developmental Psychology of Jean Piaget* (Princeton, N.J., 1963), 67.

19 For Piaget on animism and magic, and on the child's belief in its power to make the sun and moon move, see Piaget, *La Représentation du monde*, 117–18 and 211–20.

20 For Lévy-Bruhl on the tendency for "prelogical" thought to assume that the joining by analogy of two things is to make them one, see Lévy-Bruhl, *Les Fonctions mentales*, 135. For Piaget on the syncretic nature of "egocentric thinking," see Piaget, *Le Langage et la pensée*, 242.

21 For Lévy-Bruhl on the refusal of contrary evidence against the action of magic in "primitive mentality," see Ibid., 61–62. Piaget's central argument that "la pensée egocentrique" was incapable of objectivity underpinned the same point in relation to the child's belief in magical action. This is especially clear in *La Représentation du monde*.

22 Piaget specifically refers to Luquet's

notion of "réalisme logique" or "réalisme intellectuel" in Piaget, *Le Langage et la pensée*, 237–39, and *La Représentation du monde*, 48.

23 Piaget, *La Représentation du monde*, 4.

24 In his preface to *Le Langage et la pensée chez l'enfant*, Claparède notes the origins of this aspect of Piaget's method in his zoological formation. See Piaget, *Le Langage et la pensée*, x–xxi.

25 G.-H. Luquet, *Les Dessins d'un enfant, étude psychologique* (Paris, 1913), 186.

26 This is already the case in 1926. See G.-H. Luquet, *L'Art et la religion des hommes fossiles* (Paris, 1926).

27 I have discussed this in the context of notions of the rational and logical as applied to cubism in Christopher Green, *Juan Gris* (Stuttgart, New Haven and London: The Whitechapel Art Gallery in association with Gerd Hatje and Yale University Press, 1992), 35.

28 Luquet, *L'Art et la religion*.

29 G.-H. Luquet, *L'Art primitif* (Paris, 1930), 11.

30 Luquet dedicated his book *L'Art et la religion des hommes fossiles* to the archaeologist Marcellin Boule, acknowledging his *Les Hommes fossiles* for its contribution to understanding "the physical constitution of our more remote ancestors." In the preface to his book Luquet also acknowledged both Abbé Breuil and Obermaier. See Jean Luquet, *The Art and Religion of Fossil Man*, trans. J. Townsend Russel, Jr. (New Haven and London, 1930), xiii–xiv.

31 Ibid., 114–18; and Luquet, *L'Art primitif*, 11–60.

32 See Lévy-Bruhl, *Les Fonctions mentales*, 112.

33 Brassaï, "Du Mur des cavernes au mur d'usine," *Minotaure*, no. 3–4 (12 December 1933), 6.

34 Ibid.

35 For Mauss, see Marcel Mauss, *Sociologie et Anthropologie*, with an introduction by Claude Lévi-Strauss (Paris, 1966). Lévi-Strauss's introduction has been translated as *Introduction to the Work of Marcel Mauss* (London, 1987). Also see Jean Cazeneuve, *Sociologie de Marcel Mauss* (Paris, 1968).

36 Georges Bataille, "L'Art primitif," *Documents* 7 (1930), 389–97.

37 This sketch, Fundació Joan Miró no. 684, is preparatory to Dupin no. 209. Recognition by resemblance led Miró to another idea besides that of the circus horse, *Man Reading* (Dupin no. 210), for which he added a head and a sheet of paper. The sketch for the latter appears on the following facing page in the same sketchbook (Fundació Joan Miró no. 685), the basic configuration from no. 684 being exactly repeated by following the indentations on the page by the pencil pressing through.

38 Miró is quoted describing himself as "un phénomène de maladresse," especially in drawing: "Suis coloriste, mais pour la forme une nullité. Je n'arrive pas à distinguer une ligne droite d'une courbe." In the short biography that introduces Leiris, "Miró," 263.

39 A good instance in Miró of the fusion of name and thing is the poem-painting *Un Oiseau pousuit une abeille et la baisse* of 1925 (Dupin no. 161), where the words describing the flight of the bee also depict it. In chapter II of *La Représentation du monde chez l'enfant*, Piaget demonstrates that at the age of 5–6 years children think of names as the properties of things. See Piaget, *La Représentation du monde*, 39.

40 G[eorges] B[ataille], "Joan Miró: Peintures récentes," *Documents* 7 (1930), 399.

41 Bataille, "Joan Miró," 389–90.

42 *Civilization and its Discontents* was translated into French the year of its publication, 1930; *Totem and Taboo* was translated in 1924. See Elisabeth Roudinesco, *La Bataille de cent ans: Histoire de la psychanalyse en France* (Paris, 1982), vol. 1: 178–79. The speed with which *Civilization and its Discontents* made an impact, at least in the milieu of *Documents*, is manifest in Bataille's review of Luquet's *L'Art primitif* in no. 7, toward the end of 1930, since his argument concerning destructiveness and aggression in the child (what he describes as "instincts *libidineux*," which are essentially "*sadiques*") clearly springs from Freud's

argument in this text concerning the aggressive instinct.

43 Sigmund Freud, *Civilization and its Discontents* (1930); reprinted in *Civilization, Society, and Religion* (London: The Pelican Freud Library, 1985), 256.

44 Ibid., 259.

45 The clearest statement by Freud of the parallel between the phylogenetic and the ontogenetic processes of evolution is in Sigmund Freud, *Totem and Taboo* (1913); reprinted in *The Origins of Religion* (London: The Pelican Freud Library, 1985), 148.

46 Ibid., 148–49.

47 Carl Einstein, "André Masson, étude ethnologique," *Documents* 2 (1929), 100. It is clear that his argument concerning the "totemic" and the phenomenon of "projection" in Masson's use of animal imagery draws heavily on *Totem and Taboo*.

48 Freud, *Civilization and its Discontents*, 260.

49 "En bref, il semble que . . . tout le contenu de la conscience enfantine soit primitivement projeté dans le réel (dans les choses et en autrui), ce qui équivaut à une absence complète de soi." Piaget, *La Représentation du monde*, 112. Interestingly, Piaget goes further to consider this observation in terms of the Freudian theory of projection, explicitly acknowledging *Totem and Taboo*; see 233–34.

50 Miró is clearest on this question in his reply to Tériade in *Minotaure* 3/4 (December 1933), 18: "Il m'est difficile de parler de ma peinture, car elle est toujours née dans un état d'hallucination, provoqué par un choc quelconque, objectif ou subjectif, et duquel je suis entièrement irresponsable."

Magic Figures

Jorn, Cobra and Children's Drawings

Troels Andersen

"Viewed as art, drawings by children have neither a history nor historical possibilities for development. They are created every minute of the day—without connection to each other and without influencing each other. They go through a development without knowledge and without awareness and disappear again. The child's art is not culture, but rather growth. Its purposelessness makes it true art."[1] Aksel Jørgensen, painter and professor at the Copenhagen Academy of Art, characterized children's drawings in this way in 1945. Jørgensen, who as artist and teacher constructed pictures in a strictly analytical way—in a combination of perspective composition and geometrical division of the surface of the picture—nevertheless had a surprisingly sure eye for the special qualities of children's drawings. In 1940, possibly even earlier, Jørgensen also made presentations of children's drawings in his weekly lectures for the students of the Art Academy; pointedly, he did so on the same high plane that he presented analyses of the most important works of classical European painting.

In 1940 he wrote the following in a commentary on the drawing of an eight-year-old girl:

> The child is not restrained or encumbered by psychological knowledge, and no one demands that she should subordinate her natural urge to develop to that kind of knowledge. The child stands alone in the midst of the world and perceives everything that occurs around her with her eyes alone and without reflection. Deep in concentration, forgetting the entire environment, she lives in and with whatever captivates her attention. The child has no clear concept of the physical existence of the world, and therefore lives according to her own thinking. Movements interest a child only in direct gestures that she can perceive

Translated by Andrew R. Ziarnik

with the eye and in which she can find a meaning and a context; and when these movements please her, she uses what we call art to communicate her joys and troubles. The figures in this picture develop freely without influence from any side. At the same time the picture derives a spatial content from the rotating movements of the eye. The individuality of the single figures blossoms within this total rhythm of movement without disturbing the total experience.[2]

In his analyses, Aksel Jørgensen did not just show the compositional features by which children's drawings are bound to the general compositional laws. He described, above all, the essence of children's drawing.

Just like the artist, the child also possesses the special ability that the artist retained—or, stated more precisely, the child has not yet lost this ability—namely: to enclose himself within his experience. In the child's pictures, this intensive experience comes forth as the magical power which pours out from the figural plane of the individual form.[3]

Aksel Jørgensen maintains that this magical power links children's drawing to the abstract in art.

One of his students at the Copenhagen Art Academy was his namesake, the painter Asger Jørgensen, who later became known as Asger Jorn. Jorn was trained as an elementary school teacher and, though he never practiced as such, he had gained for himself pedagogical insight into the subject of drawing (fig. 157). In 1937 he worked as Le Corbusier's assistant, enlarging three children's drawings to monumental formats in Le Corbusier's pavilion for the World Exhibition in Paris. In collaboration with a French master painter, Jorn transferred drawings about the noisy traffic of the city and rural harvest scenes to panels several square meters in size (fig. 158). The drawing of the urban world was a purely linear portrayal of the chaos of the street that stylistically anticipated the later works of Jean Dubuffet. The other drawings were just as reflective, but nevertheless lacked this immediate expression.

Asger Jorn held the same view as his much older colleague, Aksel Jørgensen, about the creative abilities of the child and the accentuation of the magical power of children's drawing. Children's drawings became a natural and essential source of inspiration for the group of artists that came together around the art periodical *Helhesten* immediately after the occupation of Denmark in 1940. The driving force for the art periodical came from Asger Jorn and his painter-colleagues Carl-Henning Pedersen, Ejler Bille, and Egill Jacobsen. One of their coworkers was the child-pedagogue Jens Sigsgaard, the author of the children's book *Paul Is Alone in the World*,[4] which became world-famous after the war and was translated into many languages. Jens Sigsgaard was also director of the Association of Kindergartens, in which capacity he had plenty of opportunity to collect children's drawings. He gave many

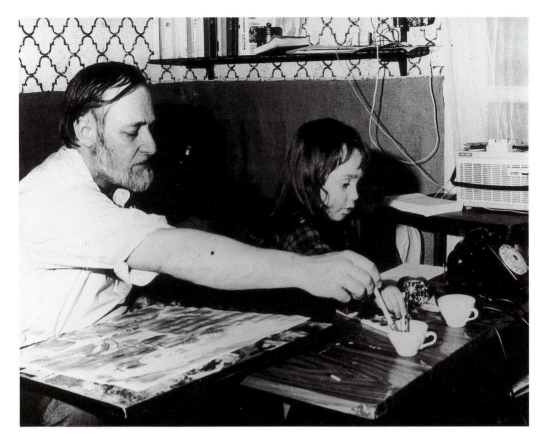

157 Asger Jorn with the daughter of Jean Weber. Photograph by Jean Weber, Paris, 1968

of these to Asger Jorn, who carefully preserved them to the end of his life. Sigsgaard wrote articles about children's drawings and their verbal expressions in *Helhesten*. The journal often included original lithographs by Danish artists, and, in the last number from 1944, a series of children's drawings was lithographed and published in just the same way as the adult artists' lithographs (fig. 159).

During the war Jorn was able to study children's language as well as the child's graphic world of perception by watching his first son growing up. Jorn liked to draw, often together with his children. On one drawing from 1944 he recorded a series of expressions from the vocabulary of children, such as *didi*, *tita*, *tito*, *palipiti*, and so on. He used some of these kinds of words as titles for his pictures. At the end of 1944 a large Copenhagen daily paper, *Politiken*, organized a children's drawing contest with a subsequent exhibition in the city's Kunstindustrimuseum. The purpose of this contest was to publish a children's book illustrated with drawings by children. But even before the opening of the exhibition, *Helhesten* announced its position on the subject of the child's drawing.

158 Children's drawings (anonymous), enlarged by Asger Jorn for the *Pavillon des temps nouveaux*, designed by Le Corbusier for the 1937 Exposition Universelle in Paris

Jorn distinguished very precisely between the artistic creations of adults and the childlike use of a drawing as a means of expression. At the end of 1944 he painted, together with a number of artists of the *Helhesten* group (among others, Bille, Pedersen, Henry Heerup, Else Alfelt), the decoration of the Copenhagen kindergarten that his son attended. This work came about after the group had organized a collective project for a competition to decorate another children's institution, which, however, did not work out. The group summarized its position in connection with the competition as follows:

> This project came out of a true joy for colors and forms and the completely free fantasy of the imagination. In our experience this dreaming, playful quality is one of the most meaningful assets of the child—an excellent quality that, unfortunately, most adults have lost. In an age in which the rational demands on children and adults are so overwhelming and dominant, our pedagogical effort aims to support and nourish this enormously valuable side of the child's spirit by creating an environment where this ability to fantasize and feel can grow and blossom.

The decoration was not supposed to be "a picture to look at," nor was it supposed "to serve as an advertisement for the functions which had already been fulfilled from the start: the children's possibilities for play and occupation in sunny and healthy surroundings."[5] The pictures were intended to address themselves directly to the children.

159 Children's lithographs (anonymous), reproduced in *Helhesten* 5–6 (Copenhagen, 1944)

This was the view of children's drawings that Danish "spontaneous-abstract" painting carried out from the isolation of the war years. When Jorn established contact with Czechoslovak artists in 1947, he discovered in the periodical *Blok* an interest in children's drawings related to his conception. *Blok* was able to attract a number of writers and artists during the short freedom of Czechoslovakia from 1946 to 1948. It presented children's art on the same level as modern art. Like the last number of *Helhesten*, the March 1947 edition of *Blok* also centered on drawings and texts by children.

When the association "Cobra" was founded in Paris in 1948, one of Jorn's first actions was to invite the Dutch members Appel, Corneille and Constant to Copenhagen. In Copenhagen, Constant and Corneille visited the kindergarten that had been decorated a few years earlier by the *Helhesten* group, and each of those artists was allowed to add a panel. The children's drawing was a liberating element for all three Dutch artists. Karel Appel's most important work, *Questioning Children*, was one of the greatest expressions of this inspiration. The picture is the result of the impressions that the children in the ruins of Europe made on him during his railroad trip to Copenhagen.

In the years 1948 to 1950 Jorn also occupied himself in a theoretical way with the relationship between the artistic expression of the child and the creative work of adults. In an article entitled "L'enfant adulte et l'adulte enfantin,"[6] he warned against transferring the expression of the child onto the work of adults and he distanced himself from consciously "naïve" creations.

After the collapse of Cobra in 1952, Jorn returned to his occupation with the creative work of children—at least once, in any event, on a larger scale. In 1954 he settled in the small Ligurian town of Albisola, populated by ceramics artists. There, together with one of the town's ceramics firms, he organized an experiment in 1955 in which the children of the town were to decorate over a hundred ceramic bowls. This happened in the course of his efforts to continue the group cooperation of European artists on the basis of Cobra ideas, but now the group was called "Mouvement pour un Bauhaus imaginiste." Some of the children's ceramic works were reproduced in his brochure "Structure et changement" with the subtitle "Sur le rôle de l'intelligence dans la création artistique." In 1957 the brochure was incorporated into his book *Pour la forme*. The main part of the text does not address children's drawings. Nevertheless, Jorn stresses on the book jacket that the decorative abilities of preschool children far surpass the decorative sense of adults. In his conscious and clear distinction between the fundamental aesthetic questions as they are posed in conscious creative work and in the unimpeded abilities of children, Jorn did not maintain the same position as his teacher at the Art Academy, Aksel Jørgensen. Nevertheless, both pursued one purpose: to develop in artistic work the same qualities that are found in children's drawings.

1 Aksel Jørgensen, *Kunst i skolen* (Copenhagen, 1945), 7. "Borns tegninger som kunst har ingen historie og er uden historiske udviklingsmuligheder. De opstar hvert minut pa dagen, uden forbindelse med hinanden, uden pavirkning af hinanden. Uden viden og kundskaber gennemløber de en udvikling og forsvinder. Barnets kunst er en vækst og ingen dannelse. Deres formalsloshed betegner dem som ren kunst."

2 Aksel Jørgensen, *Vor Ungdom*, vol. 62 (Copenhagen, 1940), 260. "Barnet star uden hæmning og uden belastning af psykologisk kundskab, og ingen kræver, at det skal indordne sin naturlige udfoldelsestrang under denne, barnet star alene midt i verden, og uden refleksioner sanser det med sine øjne alt, hvad der sker omkring det, og lever i dyb forglemmelse af alt andet, med i det som i øjeblikket har fanget dets interesse. Barnet har ingen klar forstæsle af verdens fysik, of lever derfor pa sine sanser. Hvad der interesserer et barn af bevægelse, er den direkte gestus, som dets øje kan folge og

finde mening og sammenhæng i; og foler det glæde over disse bevægelser, opstar det meddelelsesmiddel om dets glæder og sorger, som vi kalder kunst. Uden tryk fra nogen af siderne, udfolder figurerne sig frit pa dette billede. Folgende øjets cirkulerende bevægelse far det tillige et rumligt indhold, og indenfor denne samlede bevægelsesrytme udfolder de enkelte figurer deres individualitet uden at bryde helhedsoplevelsen."

3 Ibid., 262. "Ligesom kunstneren ejer barnet, eller rettere sagt barnet har endnu ikke mistet, den evne som kunstneren har bevaret: at lukke sig helt ind i sin oplevelse. I barnets billeder viser denne intense oplevelse sig i den magiske fraft, som udstrømmer fra den enkelte skikkelses figuromrade."

4 Jens Sigsgaard, *Palle alene i verden* (Copenhagen: Gyldendalske Bog Handel, 1942).

5 Ms. 1944, The Royal Library, Copenhagen; quoted in Troels Andersen, *Asger Jorn, En biografi, arene 1914–1953* (Copenhagen, 1994), 108. "Dette projekt

er udformet paa grundlag af en ren farve-
og formglæde og fantasiens helt frie
buleren i erkendelse af, at denne drøm-
mende, legende evne er et af barnets
betydningsfuldeste aktiver, et aktiv, som
de fleste voksne desvaerre har mistet. Vor
padagogiske stræben gar ud pa, i en tid,
hvor de rationelle krav til barnet og det
voksne mennske dominerer overvældende,

at støtte og nære denne uhyre værdifulde
side af barnets sjæleliv ved at skabe
omgivelser, hvor denne fantasiens og
følelsens evene kan vokse og blomstre."

6 Jorn's essay, "L'Enfant adulte et l'adulte
enfantine" is an unpublished manuscript
from 1949 or 1950 in the Jorn Archive at
the Kunstmuseum, Silkeborg, Denmark.

From Wonder to Blunder

The Child Is Mother to the Man

John Carlin

In the late nineteenth and early twentieth centuries intelligent people from all disciplines and origins seemed obsessed with going outside of themselves and the culture into which they were born. The great journeys of the eighteenth century that mapped the world and colonized it for profit and comfort were followed in the nineteenth century by great intellectual journeys that effectively colonized the insane, the primitive, the debased and the intoxicated in much the same way. Within this overall conquest of the unknown and adoption of otherness into the vocabulary of European thought, the category of the child has a unique place. The child is the unknown within ourselves. Interest in the condition of childness represents an overall desire to retreat into a more innocent state untainted by the bad habits and values of the civilized mind. In general, the cult of the child runs parallel with that of Nature and with the great quest of people born in the industrial revolution to recover the very thing they had joyously conquered: a direct, dangerous, primitive relationship to the natural world and their own bodies. This movement was called romantic for a reason. It was predicated on the recovery of a presumed paradise lost of natural innocence. And the history of this idea runs from the great romantic poets like Wordsworth to their true heirs—not poets, but philosophers and theorists, like Freud who popularized the notion that the child is father to the man.

Now, the way in which William Wordsworth and his followers made great art from this simple idea is of interest. They did not do so in a casual or innocent way at all. Their use of the idea of the child was pure metaphor in the most sophisticated and advanced sense of the term. The child to Wordsworth was not the equivalent of Coleridge's opium, a device to derange elegant thought into seductive, decadent patterns that left the structure largely unchanged. Wordsworth's trips to the Lake Country and into his own past were truly profound and helped permanently change the shape of European art. This is relevant in the context of visual

art for two reasons. First, Wordsworth defines his own perceptions in largely visual terms. Second, for that reason, the poet's language provides a vocabulary for understanding the conceptual dimension in visual awareness that parallels the less obvious philosophy that informs the work of visual artists struggling with the issues of personal growth and visual perspective.

Prior to Wordsworth, the origin of the metaphoric use of the child as someone who enjoys a privileged relationship with nature is often traced to Rousseau's *Emile*. The great French writer of the age of enlightenment proclaimed "childhood is the sleep of reason."[1] The education of Emile that Rousseau prescribed led the child from such sleep to a mature, enlightened point of view. But to later writers, the sleep itself was a more seductive idea than the education. The critic Tony Tanner puts it succinctly in his book *The Reign of Wonder*, "Rousseau aimed at producing the philosopher out of the child by slow and careful supervision. For Wordsworth the child already *is* the philosopher."[2]

Perhaps the finest single example of Wordsworth's use of the child as metaphor is in "Ode: Intimations of Immortality from Recollections in Early Childhood." The epigraph to the poem begins with the now-famous quotation

> The Child is father of the Man;
> And I could wish my days to be
> Bound to each by natural piety.[3]

Wordsworth's own description of how the experience of his own childhood relates to the "Ode" perfectly describes not only the lost paradise of innocent experience that he sought to regain, but also the importance of visual perception in those memories.

> I was often unable to think of external things as having external existence, and I communed with all that I saw as something not apart from, but inherent in, my own immaterial nature. Many times while going to school have I grasped at a wall or a tree to recall myself from this abyss of idealism to the reality. At that time I was afraid of such processes. In later periods of life I have deplored, as we have all reason to do, a subjugation of an opposite character, and have rejoiced over the remembrances, as is expressed in the lines "obstinate questionings," etc. To that dreamlike vividness and splendour which invest objects of sight in childhood, everyone, I believe, if he would look back, could bear testimony. . . . [4]

The "Ode" begins with a simple declaration of how Wordsworth's maturity has caused the loss of wonder:

> There was a time when meadow, grove, and stream,
> The earth and every common sight,
> To me did seem

Apparelled in celestial light.
The glory and the freshness of a dream.
It is not now as it hath been of yore;—
Turn wheresoe'er I may,
By night or day,
The things which I have seen I now can see no more.[5]

The poem goes on through the first four stanzas to eloquently state the sense of loss the poet feels. This ends with the remarkable phrase:

The Pansy at my feet
Doth the same tale repeat
Whither is fled the visionary gleam?
Where is it now, the glory and the dream?

The fifth stanza begins the second section by reflecting upon the nature of the loss described in the first four stanzas: "Our birth is but a sleep and a forgetting. . . ." The poet also describes how maturity, like "a prison-house," begins to divorce the man from the boy's delight. The sixth stanza continues the prison metaphor by stating that the "homely Nurse" of culture makes "her Foster-child, her Inmate Man,/Forget the glories he hath known. . . ." This section ends with a direct celebration of the child, whose diminutive exterior belies the immensity of his philosophic soul. For Wordsworth this loss of oneness with nature begins the mortality of that soul. This is a profound reversal of the traditional sense that maturity was the positive mandate of civilization. Where two thousand years of Western thought proclaimed that experience developed the soul to a higher state of existence, Wordsworth in this seemingly simple reflection upon his own childhood perceptions changed the course of modern thought.

Perhaps the most interesting thing about the "Ode" is not just the basic premise I have so far outlined, but the complex, deliberately ambivalent way in which it is resolved. On a superficial level, the "Ode" simply states the issue of loss and establishes the symbolic role of the child as philosopher. But Wordsworth's ultimate impressions run deeper. The "Ode" ends with a complex acceptance of inevitable loss and with the understanding that an embrace of such loss prepares one for the sense of mortality that is the curse of human consciousness. This resolution is not through philosophy, but through art. The poem re-creates in its form and novel use of the metaphors of childhood and nature an epitaph for childhood lost that is intended to and often succeeds in keeping the kernel of that childhood experience alive.

The penultimate stanza of the "Ode" is one of the great moments in Western literature:

Though nothing can bring back the hour
Of splendour in the grass, of glory in the flower;
We will grieve not, rather find
Strength in what remains behind;
In the primal sympathy
Which having been must ever be;
In the soothing thoughts that spring
Out of human suffering;
In the faith that looks through death,
In the years that bring the philosophic mind.

The poet goes on in the final, eleventh, stanza to explicitly state the consolation that adult experience can bring to the inevitable loss of the primal relation to nature—that moment when one cannot perceive external things to be external to oneself. The final two lines, "To me the meanest flower that blows can give/Thoughts that do often lie too deep for tears," illustrate that the suffering caused by the pansy at the poet's feet at the end of the fourth stanza, forcing recognition of lost time, can be reclaimed by the act of the poet's art. The paradox here is carefully, rather than joyously, resolved by understanding that the flower of art may not replace the splendor of nature, but it is the consolation prize of human existence with which we must survive.

The importance of Wordsworth's work to this volume and analysis of visual art is that he used the experience of the child to unbridle the limitation of his adult mind, but did not literally use the product of the child's hand in his own work. The modernists took the romantics' use of the child as a metaphor for pure vision to its logical conclusion by using it to undermine the form of traditional art and not just the content. While Wordsworth wrote about the child, artists like Picasso, Kandinsky, Klee and Miró literally used the formal structure of children's drawings to take them to a place that their sophisticated, educated minds had trouble reaching. To put it simply, Wordsworth longed for the lost wonder of childhood but could not accept the actual blunder of childlike expression. There is an important distinction here that helps set romantic ideas apart from modern ideas. In the latter period artists became fascinated with the idea of mistakes, of things apparently wrong. These mistakes were transformed from the margins of art and experience into the center, much as Freud took dreams from the unconscious sleeping mind and placed them at the forefront of conscious analysis. The difference here is telling and helps define why so much modern art continues to appear deliberately bad. In this context it becomes clear that these blunders are the physical tools by which the overly mannered habits of the civilized adult mind are revolutionized.

Prior to the twentieth century, the art closest to this type of literal use of the formal derangement of childish "bad" art can be found in caricature. The debased

humor and disregard for propriety that inform cartooning was almost immediately found fascinating and championed by a wide variety of artists throughout the nineteenth century. It is notable that the French symbolist poet Charles Baudelaire transformed the "meanest flower that blows" in Wordsworth's "Ode" into "Flowers of Evil." To understand this phenomenon, contrast two seminal artists who began to incorporate cartoon elements into their work when mass printmaking began to make caricature available to the middle and lower classes. Perhaps the first significant artist to do so was William Hogarth. He absorbed everything around him into a sophisticated rhetoric of visual techniques that he adapted to a theatrical model, both in terms of storytelling and spatial relations. This made his work immensely popular. Hogarth's "finished" work, like Wordsworth's, makes almost no use of any formal technique that one could consider naive, primitive or childlike. IIowever, his treatises on art such as *The Analysis of Beauty* reproduce some very childlike drawings to show the origins and simple popular appeal of cartooning. With a stretch, one can see elements of that in the deep structure of Hogarth's work when his elegance and formal sophistication give way to vulgar humor, popular sentiments and crowd-pleasing sensationalism. In this sense Hogarth is the father of the modern cartoon in terms of narrative storytelling through simplified graphic symbols.

But it is William Blake who truly began to use cartoon elements in a radical fashion that was invested in the style of his work and not just its content. Perhaps Blake is just an anomaly in the history of European art, but his literal fusion of innocence and experience can be seen to pave the way for much of what was later called modernism. Blake started from much the same perspective as Wordsworth and the other romantics. He felt the growing decadence of Western art in a palpable way. He felt that its experiences had become inauthentic and inappropriate for the world in which he lived. Rather than trying to render this world in a realistic way, based upon the careful reproduction of the material objects through which modern society manifested itself, Blake chose to discover and represent a new form of spirituality that he saw nascent in the world around him. Blake's rejection of the physical nature sought by Wordsworth or the sordid reality of contemporary London rendered by Hogarth or Charles Dickens, led his art closest to what others in the nineteenth and twentieth centuries would find most profound and sustaining about the otherness of nontraditional forms of art and thought.

In much the same way, Blake's poetry avoids the rhetorical sophistication of Wordsworth and later romantic poets. Just as Blake's visual imagery can be seen as a form of cartooning, his poetry can be seen as something preliterate, almost primitive, in its direct, seemingly unadorned use of language and figures of speech. In particular, his *Songs of Innocence and Experience* are literally "songs" not "odes" or "sonnets." Blake deliberately created a new type of expression that was populist and at the same time adopted the style of simple, childlike expression; he did not

just use such ideas merely as metaphors. To be fair, one could argue that the style of Wordsworth's poetry was radically unadorned in comparison to his predecessors Milton and Pope and even his peers Byron and Keats. However, Blake certainly embraced the simplicity of modern colloquial rhetoric in a far more radical way than Wordsworth ever did.

Within American art of the nineteenth century similar tendencies can be found. Wordsworth's naturalism and his equation of the child with nature are paralleled to some degree in the philosophy of Emerson and in Walt Whitman's poetry. And again we can see a radical difference between the use of the child as a metaphor for pure unadorned vision and as a radical tool for restructuring the language of communication. In some ways Whitman perfectly synthesizes Wordsworth's rhetorical sophistication with Blake's use and understanding of the raw power of "primitive" visionary expression.

What is particularly interesting about Whitman's work in the context of a discussion of visual art is the degree to which his work deliberately constructs pictures from language. And the manner in which he does so defines much of the power and innovation in his work. Earlier we saw how Wordsworth described a vision of nature that was lost and partially regained through the poetic imagination. We also saw that Wordsworth used language to build a monument to lost visual experience. Where Whitman goes beyond Wordsworth is in taking the ambivalent ending to the "Ode" discussed above and making that a principal of how he actually made his art and not just how he described it metaphorically.

Whitman does not describe stable objects in nature as a substitute in art for what has been lost in experience. He literally dematerializes language to re-create the lost experience in art. Simply put, his use of style is more like that of impressionists such as Monet wherein the sense of nature is re-created through the limitations of artistic expression rather than by merely copying their appearance in paint. This is more than simply a sense of subjectivity that one can find in Wordsworth and great romantic painters of his era such as Turner or Constable.

The most succinct expression of Whitman's philosophy with regard to the concept of the innocent eye is in a poem written in 1855 that begins,

> There was a child went forth every day,
> And the first object he looked upon and received with
> wonder or pity or love or dread, that object he became.... [6]

For Whitman the beauty of childhood vision perfectly echoes Wordsworth's remarks about not perceiving external things as external in his comment on the "Ode." At first glance Whitman's version of this observation appears both derivative and less skillful. However, if one will grant that Whitman's apparent lack of skill is just another type of skill, then interesting observations ensue. To make this point in a

careful way, allow me to explicate what is perhaps his most successful work, "Crossing Brooklyn Ferry," written at roughly the same time.[7]

The poem is not about the literal crossing of the East River, which separates Manhattan from Brooklyn. Instead it is a poem about how the crossing between two states is "forever held in solution" by the poetic process. Emerson anticipated this sense: "the quality of the imagination is to flow and not to freeze. . . . For all symbols are fluxional, all language is vehicular and transitive, and is good, as ferries . . . are. . . ."[8] The radical aspect of Whitman's poem is to use the metaphor of the ferry not to connect two different places, but to affirm their relation to each other. Just as Wordsworth's "Ode" is about dealing with the poet's awareness of his distance from an earlier, more perfect state of being, Whitman's poem is about crossing, which he sees as more important than actually getting anywhere. There is an obvious lesson here for the sophisticated reader. The crossing is a kind of perpetual looking that finds meaning in process rather than in any concrete result.

There is no better illustration of this than in the third section of the poem. The celebrated image of the seagulls circling above the poet's head dramatically represents an object of perception in terms of its effect within atmospheric space, as color and motion, rather than as a fixed, concrete reality. The relevant passage reads:

> I too many and many a time cross'd the river of old,
> Watched the Twelfth-month sea-gulls, saw them high in the air
> floating with motionless wings, oscillating their bodies,
> Saw how glistening yellow lit up part of their bodies and
> left the rest in strong shadow,
> Saw the slow-wheeling circles and the gradual edging toward the south,
> Saw the reflection of the summer sun in the water,
> Had my eyes dazzled by the shimmering track of beams. . . .

Whitman's way of depicting a natural phenomenon has become so commonplace that it is hard to see how he created an entirely new mode of representation in American art. The poet goes on to describe a longer series of visual details in an ambiguous phantasmic manner. This reaches its apex in a bizarre image of the poet leaning over the side of the boat and observing the reflection of his face replaced by a halo created by the aura of light that surrounds it. The idea that images are created by an infusion of light rather than by their corporeal root continues with the poet's recognition that the objects of his gaze are in fact not objects but merely the atmosphere in which they bathe. Whitman "look'd on the haze on the hills," and not the hills themselves much as his contemporary Emily Dickinson wrote of the amber that "flits" between the mountain and the sky:

The Mountain-at a given distance-
In Amber-lies-
Approached-the Amber flits-a little-
And that's-the Skies-[9]

The significance of these proto-impressionistic images is not merely their relative novelty, but their integral importance to the poet's overall vision. This mode of figuration allowed Whitman to blend the apparently incongruous split between his desire to express the spirit of things and their outward appearance. The poet's attempt to cross rather than link these tendencies extends to a larger series of intentional oppositions in his poem. These range from the initial dichotomy between the "I" and "you" within the poem's fictional present tense to the poet's obsession with fusing the past and future, which is expressed best in the startlingly confident line that ends the first section of the poem: "And you that shall cross from shore to shore years hence are more to me, and more in my meditations, than you might suppose."

The third section recasts these oppositions into concrete poetic imagery by isolating purely visual imagery and making it visionary. This is how Whitman fulfills his own description of the poem, in section two, as a "well-join'd scheme" in which "every one [is] disintegrated yet part of the scheme." He does so by spiritualizing, or as he says "disintegrating" matter to the extent that it appears to evaporate:

On the neighboring shore the fires from the foundry chimneys
 burning high and glaringly into the night,
Casting their flicker of black contrasted with wild red and yellow light
 over the tops of houses and down into the clefts of streets.

In this visionary scene Whitman cleverly returns to the curious yellow patches, which he moves from the seagulls in the beginning of this section to the housetops at the end. He does so both to provide formal symmetry and to imply the unity of particular things beyond their limited material form. This latter point is the underlying theme of the poem as a whole. The final line makes this clear:

You furnish your parts toward eternity
Great or small, you furnish your parts toward the soul.

The central third section, framed by the yellow patches on the gulls and housetops, masterfully represents an impressionistic scene of expressive intensity and absolute formal control. Whitman plays upon the oscillating circles of the gulls and their variants throughout the poem, just as a painter establishes deliberate echoes between shapes and forms abstracted from representational imagery. From these

"slow-wheeling circles" we are led to the "centrifugal spokes of light" haloing the poet's head in the water, from there to the curl of the ship's sails near the shore: "the round masts" and "the sunning motion of the hulls." In the latter phrase there is a literal echo between gull and hull. From the ships we are led to the flying flags, then from the flags to the "wake left by the passage" and the lapping of the waves as evening falls and light grows more dim toward the shore. Finally we are left with the chimney fires casting their flickering light "down into the clefts of streets." The "well-join'd scheme" of the poem subliminally makes itself one with the well-joined scheme of nature.

Immediately after Whitman's triumphant projection of the correspondence between word and thing in the third section, the poem collapses into an awareness of that transparency as a trick. In another line omitted in later versions of the poem Whitman fears, "would not people laugh at me?" This originally followed the most difficult passage in the poem, the last three lines of the fifth section:

> I too had been struck from the float forever held in solution,
> I too had receiv'd identity by my body,
> That I was I knew was of my body, and what I should be
> I knew I should be of my body.

This begins the dark undersong that turns "Crossing Brooklyn Ferry" from Whitman's early optimism concerning the power of art to transcend. For instance in "Song of Myself" he makes the ultimate romantic proclamation:

> Dazzling and tremendous how quick the sun-rise would kill me,
> If I could not now and always send sun-rise out of me....[10]

From the shocking revelation that his identity is of his body and not his art in the third section of the poem, Whitman goes on to what is perhaps the central passage in American poetry:

> It is not upon you alone the dark patches fall,
> The dark threw its patches down upon me also,
> The best I had done seem'd to me blank and suspicious,
> My great thoughts as I supposed them, were they not in reality meagre?[11]

Whitman's transition from the transparency at the poem's beginning to this tragic blankness at its center follows the transition in Emerson's "Nature" from the early "transparent eyeball" to the idea that the "ruin or the blank that we see when we look at nature, is in our own eye."[12]

But Whitman does not end his poem where Emerson and Wordsworth left their ruminations. In spite of the apparent contradiction between the civilized mind and

unmediated nature, Whitman continues to rely upon art to "ferry" between nature and imagination. This can be merely by decree as in the ending of "When Lilacs Last in the Dooryard Bloom'd" where Whitman finds his poetry perfectly "twined" with the forces of nature: "Lilac and star and bird twined with the chant of my soul/There in the fragrant pines and cedars dusk and dim."[13] Or, Whitman's "twining" of the signs of nature and the imagination can be part of a complex rhetorical strategy, a virtual allegory of reading, as in the ending of "Crossing Brooklyn Ferry."

The obvious clue is the way Whitman subtly fuses the question of his identity with that of the reader. In this fashion the song of the self becomes the song of a song. Its meaning does not come about in the relation of images to things, but in the relation of images to each other. Whitman's most startling trick in this regard is the transubstantial self. The crossing at the heart of this poem is in part Whitman literally fusing his concrete identity with the incorporeal identity of his readers. This is made particularly evident in the next section, in which Whitman jumps down the reader's throat with all the cunning he can muster:

> Closer yet I approach you,
> What thought you have of me now, I had as much of you—
> I laid my stores in advance,
> I consider'd long and seriously of you before you were born.
> Who was to know what should come home to me?
> Who knows but I am enjoying this?
> Who knows, for all the distance, but I am as good as
> looking at you now, for all you cannot see me?[14]

By displacing the question of identity from his self to that of his readers, Whitman finds a new way to make the opacity transparent without violating the unavoidable materiality of both nature and language. He writes in line 97 that this, ". . . fuses me into you now, and pours my meaning into you."[15] In the next line Whitman cleverly literalizes this fusion by changing from first to third person pronouns. At this point, "we" replaces "I" and "you." This concludes the middle section of the poem and sets up a repetition of earlier imagery in the final section.

Here the poet allows himself a celebratory incantation. He no longer describes objects in nature or his/our relation to them, but commands:

> Flow on, river! flow with the flood-tide, and ebb with the ebb-tide!
> Frolic on. . . .
> Cross from shore to shore, countless crowds of passengers!
> Stand up tall masts of Mannahatts! stand up, beautiful hills of Brooklyn!
> Throb, baffled and curious brain! throw out questions and answers!
> Suspend here and everywhere, eternal float of solution!

But in Whitman's hyperbolic repetition of waves, sunset, masts, hills, etc., something profound has changed. The images have lost whatever referentiality they once had and have become obvious poetic signs manipulated and joined by the poet to suit his overall scheme in a somewhat clichéd manner. Perhaps this is just part of the "eternal float of solution" first mentioned in line 62 and now repeated in line 107. What first was a recognition of limits, the boundaries of an adult ego defining human perceptions in a narrow and prescriptive way, is transformed into an incandescent acceptance of those limits. Indeed we find a recognition that these limits, rather than binding the artist, link him with the general level of existence, the "well join'd scheme" as he described it.

In the final twelve lines of the poem Whitman asserts the incongruity of his observations and, at the same time, the necessity of this result. By asserting "you necessary film, continue to envelop the soul," Whitman acknowledges that although his art cannot penetrate the surface, in fact no art can. His poem succeeds without transcendence precisely because he makes the limits of perception coextensive with the limits of form. Furthermore, he plainly states those limits without falling back upon a leap of faith to unite poetic form with the external world.

Whitman's "necessary film" is both the surface of the body and the indefinite aura that surrounds the skin like the spokes of light around the reflection of the poet's head in sections three and nine. The second reflection ends the poem by going beyond the poet's own portrait to form one of humanity:

> You have waited, you always wait, you dumb, beautiful ministers,
> We receive you with free sense at last, and are insatiate henceforward,
> We use you, and do not cast you aside—we plant you permanently within us,
> We fathom you not—we love you—there is perfection in you also,
> You furnish your parts toward eternity,
> Great or small, you furnish your parts toward the soul.

Here the world of things, the "dumb, beautiful ministers," are planted "permanently within us." Note that apostrophes are suppressed in the final lines to indicate that these things are now seen as particular and not universal. The final line, "Great or small, you furnish your parts toward the soul," deliberately echoes the final line of the sixth section and thereby links the "great or small" among things to the "great and small" of our own behavior:

> Saw many I loved in the streets or ferry-boat or public assembly, yet
> never told them a word,
> Lived the same life with the rest, the same old laughing, gnawing, sleeping,
> Play'd the part that still looks back on the actor or actress
> The same old role, the role that is what we make of it, as great as we like,
> Or as small as we like, or both great and small.

This passage follows Whitman's initial recovery from the painful falling into the "dark patches" that struck him from the "the float forever held in solution" in the first section of the poem. This "great and small" begins the fusion of "I" and "you" that makes this poem the most modern expression of self in nineteenth-century American art. By speaking to and for us Whitman creates in his poetry what other poets of his time only referred to, at best.

The "necessary film" which "envelops all" puts the poet back into the solution. He sees that the separation between things is only a product of the human mind, which discriminates to make its own sense out of things, and not the inherent sense of things themselves. The final "great or small" shows that by the poet's finer discriminations he can, as he writes elsewhere, "know the earth's words and use them more than audible words."

"Crossing Brooklyn Ferry" is Whitman's most successful poem because it perfectly fuses its representational imagery with its conceptual design. In this respect the poem is not about crossing the East River, or even about the crossing between the poet and his readers. It sets up these, among many other types of crossings, only to hold them in solution. In this poem the ferry never gets where it is going, but the poet does. He shows us that meaning lies between, not in, things. By doing so he literally recovers part of the lost wonder of things that earlier artists like Wordsworth simply proclaimed.

"Crossing Brooklyn Ferry" demonstrates the strategy by which many modern artists have made art of the greatest sophistication from seemingly simple child-like experiences and materials. Just as Whitman has been misread as a simple "primitive" poet whose greatest claim to fame is as precursor to the sloppy spontaneous spoken word poetry of the Beat era, many contemporary artists have suffered from a confusion between childish and childlike. The former is a state of arrested development. The later may be part of a conceptual strategy that makes obvious certain unavoidable realities of life that the artist then places within an overall conceptual process. This process often has allegorical overtones that can make a subtle change of context into a profound statement about modern life. In this light it is not a leap, but a logical step, from Whitman to American artists in the postmodern era who have similarly embraced primitivism, popular culture and childlike wonder with equal enthusiasm and intelligence.

If Whitman is the aboriginal American artist who combined impressionistic techniques with conceptual sophistication, then Mark Twain is the archetypal pop artist masquerading complex tales about language and representation as stories written by and for children. *The Adventures of Huckleberry Finn* is not just an entertaining chapter in American literature. It is one of the most profound works of art in our culture and appropriate to the topic at hand because it literally purports to be written by a young boy. Where Whitman saw language in terms of visual perception, Twain is obsessed with the sound of language. His book is an ode to

dialect. He states in an explanatory note that preceeds the novel: "In this book a number of dialects are used...The shadings have not been done in a haphazard fashion, or by guesswork....I make this explanation for the reason that without it many readers would suppose that all these characters were trying to talk alike and not succeeding." The text is crisscrossed with difficult ways to say simple things that in the end become simple ways to say difficult things.

It would be comparatively easy to leap from Huck and Big Jim's trip up the Mississippi to Jack Kerouac and Neal Cassidy crossing America a century later *On the Road*. But I am not convinced that the embrace of childlike wandering and ranting by the Beats represents an advanced or profound use of the experience of the child in American art. Yet the Beats certainly represented something happening in American culture at mid-century. If nothing else, they elevated youth culture and the idea of the "teen" (as opposed to the "child") to the forefront of art and society. Similarly one can see the rise of other simple art forms like cartoons, rock music and TV as a weird backlash against the overly complex character of modern life. At their best, the Beats represent the end of romanticism and the beginning of postmodernism in American art. Their aimless drifting across the country, their own minds and, in the case of Burroughs, language itself, can be seen as either sloppy or profound depending upon one's point of view. From my perspective, the Beats have little to teach us in terms of art that cannot be learned from Whitman. The Beats are more fascinating in terms of sociology and how our culture as a whole began to embrace and celebrate apparent childish behavior. Prior to mid-century, Americans seemed to pass directly from childhood to maturity. Now perpetual adolescence rules.

It is interesting to apply the simple history I have sketched above directly to the iconography of the child and the use of childlike gestures in twentieth-century American painting. The first appearance of the child as icon is in the so-called Ashcan School. Here one finds sentimental portraits of street urchins and other children isolated and alone but possessing their own identities, unlike most children found in previous American art who are part of family portraits or used as archetypes. By mid-century, abstract artists began elevating the effect of child's play, as opposed to the idea itself, into the picture. Doodles, caricatures, graffiti and other "bad" or nonrepresentational devices became a virtual laboratory for how to create a new language of visual communication that was not overly reliant upon the identification between image and object. This was the beginning of the "my child could do that" era of gestural abstraction. We now know not only that a child could not produce art of this nature, but that its very childishness was a deliberate and profound conceptual gesture, often more significant than the actual gestures in paint. However, much of this art was produced in the service of romantic ideas. It was about self-expression and as such a potentially old-fashioned form of representation. The next generation of painters went in a slightly different direction.

The pop artists echoed the childishness of the Beats and the childlike gestures of the abstract expressionists, but the major point of difference is that artists like Warhol and Lichtenstein directly manipulated signs of childhood that already existed in the mass media rather than mediating objects of their own experience. What makes this particularly interesting is that this shift from personal to collective memory was representative of a general transformation in American culture in the early 1960s.

Artists in a wide variety of media began to see innocence and experience in terms of the manipulation of signs existing in society rather than as an outgrowth of phenomenological awareness. For this generation there is no nature, as figured by Wordsworth or Whitman, to be lost. They, too, have lost their childhoods, of course, but what has been lost can no longer be equated with a pure natural landscape; rather, they create a different way of existing in the signscape into which current generations of artists were born. We are doomed to existence in the funhouse of culture. Our lost innocence is that of simple, stupid expression: a ridiculous cartoon or sitcom. So we are compelled to search among the detritus to find something of value in our lives—to become the man on, and not in, the dump, to paraphrase Wallace Stevens.

This is why some of the most sophisticated artists of my age are reduced to copying bad art in gestures that may or may not seem smart sometime in the future. Both the romantic and postmodern artist share the desire to recover the umediated purity of a child's perspective, but the base components that make up that perspective, along with the world in which we live, have changed radically. This is also true because implied access to childhood experience and imagery is more palpable now than ever before with snapshot photos, home movies, videos and other representational devices that give the illusion that the past can be packaged and carried conveniently into the future. This shift in the relation of consciousness to things is profound and effects more than just our relation to our own past and an ideal longing for a way to better understand ourselves, our place in the world, and the most effective way to communicate those ideas through visual forms. However, the measure of this shift in advanced art is particularly telling for two reasons. First, it provides tangible evidence that this shift is being felt by a wide range of highly aware individuals. And second, it helps to explain why certain apparently "bad" or "stupid" forms of making art are actually profound and necessary.

The history of this alchemy, wherein the shit of mass culture is transformed into the palace of art, can be traced back to Marcel Duchamp's exhibition of a common urinal. Duchamp not only set the stage by elevating a childish joke into art, but by foregrounding this gesture as conceptual. The bad joke, like a bad drawing, forced artist and viewer out of accepted patterns of observation. The degree to which the artist then did something interesting and profound with this knock-out

is the measure of his or her genius. Duchamp also set the groundwork for how to place the conceptual appropriation of a degraded object into an allegorical dimension. An individual readymade is virtually meaningless unless seen as part of the history of an individual artist's work. Consequently, Duchamp created the trajectory of his career as his greatest work of art. His literal growth became a manipulated myth about how to and how not to make art in the twentieth century. The childish toilet humor of the infamous readymade was repeated with much care and craft in the final work of Duchamp's career, *Etant Donées*, in which the peepshow glimpse of a nude woman holding a lamp is intended to be illuminating in more than an ironic fashion.

From this point of view it is a short leap to understanding the apparent stupidity of American art from Warhol to the present; ranging from the distanced irony of Jonathan Borofsky, Mike Kelly, or Richard Prince; the cartoonlike simplicity of Keith Haring, Rodney Alan Greenblatt, or Gary Panter; the gestural randomness of Elizabeth Murray, Jean-Michel Basquiat, Terry Winters, or Donald Baechler; to the allegorical and political manipulations of David Wojnarowicz, David Sandlin, or Suzan Pitt.

At first glance many of these artists appear to reject the classical minimalism of the kind of pop art best represented by Warhol and Lichtenstein for the raw existential Pop expressed in the work of Claes Oldenberg, H. C. Westerman, Peter Saul and the Hairy Who. A simple contrast can be drawn here between artists who appropriated elements of pop culture but then applied them to standard ideas of fine art and artists who literally wallowed in the complex vulgarity of pop culture itself. However, in many respects the 1980s artists mentioned above share a very different sensibility than either form of pop art. On one hand this can be expressed simply, as Keith Haring put it: "I feel more that I am a product of Pop, rather than a person who is calling attention to it."[16] On a more complex level, this generation seems much more comfortable with the proximity of their work to textual or semiotic, as opposed to purely visual or mimetic, forms of communication. I use the word "textual" here in the broad sense employed by deconstructive critics. These artists make work that exists comfortably and deliberately within language systems. They do not create isolated visual objects whose merit can be judged solely in relation to objects that exist in the "real" world, even if that "real" world has transformed from one of mountains and streams to one of billboards and comic books.

Haring's work is a perfect example in this regard (fig. 160). Not only did he use an image of what he termed the "radiant baby" as his signature in his early graffiti work, he also produced imagery of shocking childishness combined with extremely sophisticated notions of design and text. At first glance his work, like that of many of his generation, seems ridiculously simple—cartoon outline drawings depicting basic human urges of love and longing. Yet on another level the work exists as an intriguing series of nonlinear allegories that perfectly portray and suit the age in which they

160 Keith Haring, *Untitled*, 1980

were made. Haring's work is the graffiti with which our collective memories have been drawn and fixed for posterity. In that regard his work has far more power than would seem possible given the self-imposed technical limitations of his craft.

One can trace a similar use of childlike drawings and experience in the work of Jonathan Borofsky. One of the key works in his transformation from nonrepresentational conceptual artist to a voracious and profound image creator and manipulator is *Age Piece* from 1972. Borofsky describes the piece as a retrospective, beginning with a still life made at age eight and ending with the retrospective piece at age thirty. A piece made a year later repeats his childhood painting and continues its use as a fountainhead for his transformation into adult picture-making that builds upon not only the form of his earlier expression but its impressions and perceptions. Borofsky then ties this type of image-making with an exploration of his own dreams. Together, these two forms of expression deranged the cultured artist to the point where his later work literally exploded into an exploration of how play is a forgotten but crucial aspect of human existence.

Just as Borofsky's use of childlike drawings elevates dreaming and play into the center of "serious" art, A. R. Penck's revitalization of the relation of so-called primitive drawing with that of children in our own culture sets the stage and often overshadows Haring's use of similar themes and devices (fig. 160). Yet there is something in the lack of apparent sophistication in Haring's work that makes it hard to dismiss as either derivative or minor. Haring's work literally is the public blackboard on which his/my/our images, ideas and symbols are played out for all to see. It is the lack of mediation and manipulation of these symbols that may be their greatest strength. In Haring's work, the primitive, the preliterate, the present and the perpetual are perfectly fused. Underneath the happy, attractive, simple imagery is a world of complex confusion in which the innocence of the radiant child crashes into the often crass and soulless engine of mass media.

These concerns, and a similarly gifted ability to fuse primitive, childlike drawing with sophisticated designs and concepts, can also be found in the work of Haring's friend Jean-Michel Basquiat. Both artists also tragically died in their early thirties, apparently the victims of their own innocence and embrace of the world around them in the most open and unprotected way. It may be the case that artists of my generation are deemed in touch with their own inner child because they are children and often die before they reach middle age.

Another tragic example of this is David Wojnarowicz, whose work parallels that of Basquiat and Haring in terms of its manipulation of familiar imagery to better understand how the human soul is being hidden and wasted by the apparent fun and profit of pop culture. In many ways Wojnarowicz did so in a more profound and significant manner. His work is not intended to be as obviously entertaining or beautiful as is Haring's or Basquiat's. Wojnarowicz was a tougher and more difficult character. His childhood was not defined by innocence and joy, but by an abusive father; he became a child prostitute and drug addict. Wojnarowicz's work directly confronts these childhood experiences and the way in which the adult artist manipulates and transforms memories of his own past is what allowed him to transcend his childhood.

There are some interesting parallels between the way in which Wojnarowicz did so and another, very different artist who grew up in New Jersey, Robert Smithson. Both artists went outside of traditional art history to better understand the truths in how art relates to the self and society. Both artists were also obsessed with natural history and the use of travel across space to better understand mental travel across time. Finally, both artists were able to reintegrate their nontraditional experiments into a fine art tradition by linking symbols allegorically. The importance of this term to modern art is that "in allegorical actions...events do not even have to be plausibly connected....However, allegorical actions do hold together on their own principles of unity," as Angus Flechter explains in his classic *Allegory: The Theory of a Symbolic Mode.*[17]

Even though Flechter's book centers on classic Western literature, his theory offers insight into the complex way in which modern artists structure the relation of memory and experience in the form as well as the content of their work. As Flechter explains:

The mimetic poet using metaphor is only trying to understand nature; his art attempts to bring about catharsis of spent emotion. By means of his "message," on the other hand, the allegorical poet is...trying to control his audience. He seeks to sway them by magic devices to accept intellectual or moral or spiritual attitudes. Having assumed that the audience participates in whatever is represented, the poet represents reality in the form of doubled plots and doubled characters. Ultimately the imitative magic of allegory is based on the correspondence between microcosmos and macrocosmos, since it is necessary to have a system of images and agents that can be placed in relation to each other.[18]

This literary analysis helps to clarify the link between Whitman's deliberate doubleness to similar tendencies in postmodern American art, notably Wojnarowicz's fusion of apparently disparate symbols. Applying the notion of allegory to the way in which certain artists create and relate symbols to each other helps us to understand how the textual dimension of postmodern art goes beyond a simple use of language structures in visual art. This connection is interesting with respect to theme as well as structure, particularly in that Flechter quotes a study of allegory that focuses on how sin and death coexist in early Christian allegory. As he puts it, "There is no unified concept of infection, empirically related to a technique of mental hygiene, for example; there is only an endless sequence of spiritual risks to be run, any one of which may lead the Christian into sickness, that is, into a state of sin."[19] Although Wojnarowicz did not deliberately play off these traditional themes, his use of his infection by the AIDS virus and the "sinfulness" of his homosexuality vis-à-vis conservative American society played itself out in his work on the level of allegory. And that is what makes it more profound than a direct expression of a political point of view or a "mimetic" treatment of the relation of his autobiography to the form of his art.

Like many artists of his time, Wojnarowicz made works that combine various symbols, signs and techniques within one frame without showing any obvious link between them. At first glance, these relations may seem arbitrary. In most of the work made by Wojnarowicz's peers it is. The link between disparate imagery in their work is often more decorative than profound. In Wojnarowicz's work the theme is both deep and disturbing; he summed it up in the title of a major painting: *The Death of American Spirituality*. Wojnarowicz finished two major allegorical series before he died—four large collage paintings called *The Four Elements: Water, Fire, Earth and Wind* and eight photomontages called *The Sex Series*. Like all great allegorists, Wojnarowicz attempts to link nature and culture, body and mind, into a series of correspondences that help to explain the deeper relation between subjective emotions and objective things.

All four collage paintings on wood that comprise *The Four Elements* are divided roughly into four quadrants so that each repeats the overall structure of the series. These four sections tend to tell a story about the development of human civilization from a natural state to one of an extreme and often destructive culture. What is interesting about this work in relation to the concept of the innocent eye is how Wojnarowicz uses images remembered from childhood in a more profound and complex way than any other artist of his generation. However, Wojnarowicz shared with many such artists the appropriation of preexisting images from childhood in place of representing anything from actual memory or personal experience.

For example in *Fire* (fig. 161), the main imagery is derived from things Wojnarowicz recalled from childhood through his dreams: primarily commercial imagery (ads, "most wanted" posters, etc.) and images typically found in biology

161 David Wojnarowicz, *Fire* (from *The Four Elements: Water, Fire, Earth and Wind*), 1987

schoolbooks and natural history museum exhibits (bugs, monkeys, the human heart, etc.). Overall the picture links the idea of fire as a physical phenomenon with that of a basic human emotion. The upper left section is dominated by a circular image of a snake eating its tail. Inside the circle are four prominent images: a chimp holding a stick, a human hand striking a match, a volcano erupting and a simple commercial sign of a gun with the word "coins" painted above. Underneath this symbolic tapestry is a collage consisting of F.B.I. "most wanted" posters. The section to the upper left shows a giant beetle walking on a forest floor filled with equally giant dung balls that are painted, in color and shape, to resemble the human brain floating above the beetle's back and sending electrical charges into the air. The dung beetle is painted over a collage of supermarket coupons and ads. This section also contains the most immediately striking image in the painting: a glowing devil with upraised arms. The lower left shows a dried section of earth cut away like a science diorama, exposing something like an underground lair with a poisonous snakehead in a jar and a sculptural human figure without hands, feet or head. The final section, to the lower right, shows a giant car battery painted like a street sign with

accompanying advertising imagery announcing discounts and, possibly, spiritual potential. This is hinted at by the winged angel directly beneath the exclamatory word "potencia." This section is painted over a world map and also includes an image of a human heart floating at the middle of the bottom of the piece.

On a simple level, it is easy to see some of the clever correspondences put in motion by the artist. The chimp's stick is the primitive tool that set in motion the evolutionary chain that led to the discovery of how to harness fire, represented in its modern trivial form as the miracle of the phosphorus match. This triviality is underscored by its direct proximity with the volcano, whose underground source is not the molten core of the earth but some combination of art and sorcery. The dung beetle's undignified but essential task is related ironically to the supermarket coupons which indicate another form of labor and foraging. Overall, a story is told of how fire, as a natural element, has become part of human lore and civilization. This transformation, through metaphor and allegory, has become our state of nature. We are no longer defined by our primitive relation to nature and can never recover that state as Wordsworth and his fellow Romantics so gracefully tried to do. Instead, we are the heirs of Whitman's attempt to re-create the flux and flow of nature in our very inability to connect directly to it.

Whitman and Wojnarowicz both seem to say that we can measure only our attraction to things rather than ourselves or those things themselves. And their art, deliberately re-creates the pulse and lifelike movement of the attraction through the profound doubleness of symbolic allegory. Like Wordsworth, they attempt to recover lost time through art. What they add is an awareness that the attempt itself is their theme rather than the recovery itself. Moreover, that theme is represented not only as the content of their work, but is fused and found most importantly in its very style, which otherwise may appear more simple and child-like than befitting art of such cultural and personal significance.

There is also something particularly American about the way in which both Wojnarowicz and Whitman chose to invest themselves and their artistic methods rather than refining existing identities or styles. Another parallel exists here with Twain's *The Adventures of Huckleberry Finn*, a book about a fatherless child who learns to become a man by saving the life of another man, Big Jim, whom society treats like a child. Twain uses the experience of a child to undermine racism and slavery. At the same time, he rejects mannered European styles of writing in a way that parallels the content, thus entwining the two. At the same time, it is a book about the validity of art made from the American experience by Americans, rejecting the refinement of traditional European forms. This is clearly the serious purpose behind Twain's humorous explanatory note regarding dialect, quoted above. Symbolically, the child Huck is America itself, cut off from its patrimony and struggling to find an appropriate identity floating down the mighty river that separates and links America, North and South, East and West, literally and symbolically.

And here, Huck's raft is like Whitman's ferry crossing the river of sound, language and life, trying to re-create the child's wonder in the blundering course of nature itself.

This collection of essays addressing the idea of the child as a defining aspect of modern art points to a new chapter concerning the relation of consciousness to things. The importance of this history is not just to collect and define an art movement, but to better understand a basic strategy for relating to our own past and to the culture in which we exist. In the postmodern world artists have found their childlike self not in their own drawings or those of other children, but in the kid culture through which our memory is drawn. However, the strategy of crossing between different levels of perception and existence to forge a more profound and lasting art from the detritus of memory and culture remains the same.

1 Jean-Jacques Rousseau, *Emile* (London: Everyman's Library, 1961), 71.

2 Tony Tanner, *The Reign of Wonder* (Cambridge: Cambridge University Press, 1977), 4.

3 William Wordsworth, "My heart leaps up when I behold," (also known as "The Rainbow") [1802], in Stephen Gill, ed., *William Wordsworth*, The Oxford Authors (New York and London: Oxford University Press, 1984), 246; lines 7–9 were used as the epigraph to "Ode"; see the notes on page 703.

4 William Wordsworth, cited in Kermode and Hollander, eds., *Oxford Anthology of English Literature*, vol. 2 (London: Oxford University Press, 1974), 125.

5 This and the succeeding quotations from the "Ode" come from: William Wordsworth, "Ode," in Stephen Gill, ed., *William Wordsworth*, The Oxford Authors (New York and London: Oxford University Press, 1984), 297-302.

6 Walt Whitman, *Leaves of Grass*, in *Complete Poetry and Collected Prose*, ed. Justin Kaplan (New York: Literary Classics of the United States, The Library of America, 1982), 138.

7 Citations from "Crossing Brooklyn Ferry" are from Walt Whitman, *Leaves of Grass*, in *Complete Poetry and Collected Prose*, ed. Justin Kaplan, 307–13.

8 Ralph Waldo Emerson, *Works*, vol. 3 (Boston: Jefferson Press, 1910), 34.

9 *The Complete Poems of Emily Dickinson*, ed. Thomas H. Johnson, (Boston: Little, Brown & Co., 1960), 278–79.

10 Walt Whitman, "Song of Myself," *Leaves of Grass*, in *Complete Poetry and Collected Prose*, ed. Justin Kaplan, 213.

11 Walt Whitman, "Crossing Brooklyn Ferry," *Leaves of Grass*, in *Complete Poetry and Collected Prose*, ed. Justin Kaplan, 311.

12 Ralph Waldo Emerson, *Works*, vol. 1 (Boston: Jefferson Press, 1910), 10, 43.

13 Walt Whitman, "When Lilacs Last in the Dooryard Bloom'd," *Leaves of Grass*, in *Complete Poetry and Collected Prose*, ed. Justin Kaplan, 467.

14 Walt Whitman, "Crossing Brooklyn Ferry," *Leaves of Grass*, in *Complete Poetry and Collected Prose*, ed. Justin Kaplan, 311–12.

15 Ibid., 312.

16 Keith Haring, interview with Barry Blinderman, July 1981, in Barry Blinderman, *The Future Primeval*, exh. cat. (Normal, Ill.: University Galleries, Illinois State University, 1990), 18.

17 Angus Flechter, *Allegory: The Theory of a Symbolic Mode* (Ithaca, N.Y.: Cornell University Press, 1964), 192.

18 Ibid., 192.

19 Ibid., 204.

Notes on the Contributors

Troels Andersen has edited a four-volume edition of Malevich's writings (1968–77) and coauthored the oeuvre catalogue of Asger Jorn. Since 1973 he has been the director of the Silkeborg Kunstmuseum, which houses the Asger Jorn Donation.

Rudolf Arnheim, a pioneer in the field of the psychology of art, is Professor Emeritus of Visual Studies at Harvard University and the author of many standard books in the field, including *Towards a Psychology of Art, Art and Visual Perception, Visual Thinking, New Essays on the Psychology of Art* and *The Power of the Center*.

John Carlin is a New York–based critic of contemporary art, a curator, and the founder and director of The Red Hot Organization, an acclaimed record and television production company. He was the curator of the Whitney Museum exhibitions *The Comic Art Show* and *The Coney Island Show*. His most recent work for the Whitney has been a video and CD-ROM for *The Beat Experience* exhibition.

Jonathan Fineberg is Professor of Art History and University Scholar at the University of Illinois, Urbana-Champaign. His most recent books are *The Innocent Eye: Children's Art and the Modern Artist* and *Art since 1940: Strategies of Being*.

Marcel Franciscono's research has centered on early twentieth-century German art. He is Professor Emeritus of Art History at the University of Illinois at Urbana-Champaign and author of *Walter Gropius and the Creation of the Bauhaus at Weimar* and *Paul Klee: His Work and Thought*.

Sir Ernst Gombrich is Director Emeritus of the Warburg Institute (University of London) and the author of many books and essays, including *The Story of Art, Art and Illusion, Meditations on a Hobby Horse* and *The Sense of Order*.

Christopher Green is Professor in the History of Art at the Courtauld Institute, University of London. He has been involved in the organization of several major exhibitions, including: *Le Corbusier: Architect of the Century* (London, 1987) and *Juan Gris* (London, 1992). Among his books are *Léger and the Avant-Garde, Cubism and Its Enemies* and *The Thyssen-Bornemisza Collection: The European Avant Gardes. Art in France and Western Europe, 1904–c.1945*.

Josef Helfenstein is Curator of the Prints and Drawings Department at the Kunstmuseum Bern. He has written widely on modern art, including important books and articles on *Meret Oppenheim und der Surrealismus*, *Paul Klee: Das Schaffen im Todesjahr* and *Louise Bourgeois*.

Werner Hofmann is Director Emeritus of the Hamburger Kunsthalle and author of many books on art, including *The Earthly Paradise: Art in the Nineteenth Century* and *Turning Points in Twentieth-Century Art, 1890–1917*.

Dr. Yuri Molok is an expert on twentieth-century Russian art. He has written several books and essays on the theory and practice of the Russian avant-garde, including specialized studies on Chagall, Tatlin, Kamenskii, Chekrygyn and Favorskii. In addition, he has a special interest in children's art and illustrated books for children.

G. G. Pospelov is Professor and head of the Department of 18th–20th Century Art in the State Institute of Art in Moscow and a leading expert on the work of Mikhail Larionov. He has published more than a hundred articles in the field and several books, including two on Russian drawings of the eighteenth and early nineteenth centuries, and a book on the early twentieth-century avant-garde artists' group Jack of Diamonds.

Richard Shiff is Effie Marie Cain Regents Chair in Art at the University of Texas at Austin, where he directs the Center for the Study of Modernism. He is the author of *Cézanne and the End of Impressionism*, as well as many essays on twentieth-century art, from Henri Matisse to Jasper Johns and Chuck Close.

Dora Vallier is a celebrated French art critic whose interviews for *Cahiers d'Art* with such artists as Joan Miró, Jacques Villon and Georges Braque are landmarks in the field. She is also the author of many books on modern art, including *Abstract Art* and a definitive study of Henri Rousseau.

Barbara Wörwag earned her doctorate under Max Bense at the Universität Stuttgart and is a curator at the Städtische Galerie im Lenbachhaus, Munich, where she coauthored and organized a major retrospective of the works of Gabriele Münter.

Index

Pages with illustrations are listed in **boldface**.

101, 106, **107**; Kandinsky/Münter collection
of, 69, 70, **71**, **72**, **73**, **74**, 75, **76**, **78**, **79**, **80**,
81, **82**, **83**, **84**, 86, **87**, **88**, **89**, **90**, **91**; reflect-
ed in Klee, 98, 100–106, **107**, 108–11, **112**,
113–14; in Luquet's writings, 217, **218**, 219,
220, 221; reflected in Miró, **207**, **208**; Russ-
ian exhibitions of, 40, 55, 56–57, 58–59, 66,
69, 81, 93n.30; Russian publications of, 60,
61, **62**, **63**, 64, **65**; in World Exhibition
(1937), 236, **238**. *See also* children's art-
work, attributes of; drawing
children's artwork, attributes of, 16–23, 28–30,
34, 43, 95, 102, 118n.6, 201–202, 205, 206,
217–19; "first experience" as, 72, 86, 87, 220,
221; logical conception as, 219; mental
image as, 160, 163, 173, 236; process as, 46,
160, 161, 202; symmetry as, 16, 19, 22. *See
also* emotion; expression; form; human fig-
ure; immediacy; innocence; line; primitive;
representation; spatial organization; wonder
"Children's Drawings" (Fry), 160, 166, 177, 179
*Children's Drawing through the 14th Year of
Life* (Levinstein), 101
*Children's Own Drawings and Stories. Collected
by A. Kruchenykh*, 60, 61, **62**, 63–64, **65**, 66
Chukovskaya, Lidiya, 60
Civilization and its Discontents (Freud), 229, 231
civilized mentality, 215. *See also* logical
mentality
classical art. *See* antiquity
Cobra, 239–40
color, 20, 21, 23, 71, 202
commercial production, 167–68, 171–74
Compton, Susan, 64
"Content and Form" (Kandinsky), 69
Courbet, Gustave, 11, 13; *Painter's Studio, The*,
8, **9**; *Portrait of the Philosopher Proudhon*,
10, **11**
Crevel, René, 122
"Crossing Brooklyn Ferry" (Whitman), 248–53
cubism, 84, 103, 105, 108–9

David, Jacques-Louis, 7
depth. *See* spatial organization
Dessins d'un enfant, étude psychologique, Les
(Luquet), 211, 217–19, 221
destruction, 228–29
Development of the Gift of Drawing, The (Ker-

schensteiner), 101, 106, 107–108
Dewey, John, 166
Dickinson, Emily, 248
Diderot, Denis, 4
Discourses (Reynolds), 6
Documents (Leiris), 210, 211, 212, 223, 225, 229,
230
Dow, Arthur Wesley, 173
drawing, 6, 32, 55, 180, 214; public school,
169–70; Rousseau on, 3–5, 32–33; Viollet-
le-Duc on, 27–31, 33–34, 37, 38; Klee on,
155n.60. *See also* art education; children's
artwork, attributes of; handwriting; repre-
sentation
Dubuffet, Jean, 12, 13, 116–17; *Grand Jazz
Band*, 25, **26**
Duchamp, Marcel, 255–56; *Etant Donées*, 256
"Du Mur des cavernes au mur d'usine" (Bras-
saï), 223, **224**

egocentric thinking, 214, 216–17, 227, 230, 231,
232nn. 8, 21
Einstein, Carl, 211–12, 213, 230, 231
Eluard, Paul, 22–23
Emerson, Ralph Waldo, 247, 250
Emile (Rousseau), 32–33, 243
emotion, 81, 175, 230; in formalism, 157, 158,
159, 160, 177, 178. *See also* expression
"enfant, adulte at l'adulte enfantin, L'" (Jorn),
239
"English Handwriting" (Bridges), 181–82, **183**
Enlightenment, 214
Ensor, James, 119n.22
Erberg, Konst. *See* Syunnenberg, K. A.
"Essay in Aesthetics" (Fry), 158, 160, 182
expression, 96, 98, 175, 176, 178, 179; disinter-
ested, 160, 161, 164, 175, 177; in handcraft,
167–68, 172, 186; Matisse on, 174, 177; and
mechanization, 180, 185, 186, 187; Richard-
son's teaching of, 173–74

Fairbank, Alfred, 184
fetishism, 178, 179
figurative art, 220–21, 225, 228
Filosofov, Dmitry, 62
Flechter, Angus, 258–59
"Flowers of Evil" (Baudelaire), 246
Focillon, Henry, 180, 187